D0096279

"Packed with facts, fables, and anecdotes about the history of color, Finlay's detailed and brilliantly researched account makes for a fascinating read."                          —*Australian Interior Trends*

"Compelling . . . Curious social mores, serendipitous science, and lots of skullduggery are all part of the rich spectrum Finlay so cheerfully illuminates."                          —*Booklist*

# COLOR

*A Natural History of the Palette*

## VICTORIA FINLAY

RANDOM HOUSE TRADE PAPERBACKS

New York

*For my parents, Jeannie and Patrick,*
*who first showed me the place where light dances*

# CONTENTS

# CONTENTS

# ACKNOWLEDGMENTS

*I* had thought, when I set out on my travels—when I first tumbled
through that paintbox—that I would somehow find, in the original stories of colors, something pure. It was a naïve Garden of Eden
moment, and of course I forgot about the rainbow serpent that had to
be there in order to make it a real paradise. In the historical and chemical paintbox I have found more corruption, poisonings, wars and politics than even the Medicis could have appreciated. Killer wallpapers,
capital punishment for people using the wrong dyes, and beautiful
blue stones which murder the lungs of those who find them underground: these have all featured in my travels. But in the process of uncovering them I have also found more wonderful and helpful people
than I could have ever hoped. I can only thank some of them here.

For the Ochre chapter I should like to thank: the Australian Consulate General in Hong Kong, who awarded me an arts fellowship in
1999; everyone at Beswick including Alan Bunton who took me
fishing and the Popple family who looked after me on the night I was
homeless; Sean Arnold of Animal Tracks; Nina Bove; Malcolm
Jagamarra; Roqué Lee; Dave and Patsy at the Buffalo farm in
Kakadu; Allan Marett; Ken Methven; Hettie Perkins; Simon
Turner. And a particular thank you to Geoffrey and Dorn Bardon,
who were generous with both their information and their friendship.

For the Black and White chapters I should like to thank: Aidan
Hart; Ann Coate; Susan Whitfield at the Dunhuang project; the
Seniwati Gallery for Women's Art in Bali; Michael Skalka for a
happy day discussing Rembrandt's palette and many other things;
Norman Weiss; everyone who helped me at Farrow & Ball; Ralph
Boydell, Phil Harland, and everyone who helped me at Spode.

## ACKNOWLEDGMENTS

For my Red research I should particularly like to thank: Colores de Chile; Joyce Townsend at the Tate who also helped on many other paint history questions; and Dino Mahoney, Simon Wu and Barry Lowe who travelled with me on that underground train in Santiago.

For the Orange chapter I should like to thank: Peter and Charles Beare; Ricardo Bergonzi; Harald Boehmer; Ian Dejardin and Amy Dickson at Dulwich Picture Gallery; Michael Noone; Sandra Wagstaff; Maxim Vengerov; Mary Cahill and Gamini Abeysekera at UNICEF.

For Yellow, I am grateful to: Ana Alimardani; Fong So and Yeung Wai-man; Ian Garret at Winsor & Newton; Ebrahim Mukhtari; Tom and Emma Prentice for help in Saffron Walden; Mohammed Reza; Brian Lisus; Ellen Szita who appears for only a moment in the book, but our e-mail friendship has been stimulating and saffron-filled; Mahsoud and Nazanin and their family in Torbat; the Shariati family including Mrs. Shariati who provided a saffron feast to remember forever.

For help in the Green chapter, I thank: Chris Cooksey; Caroline Dalton at New College in Oxford; Michael Rogers at the School of Oriental and African Studies in London; Dawn Rooney; Rosemary Scott; Peter Zhao who translated through all the Famen celadon mysteries.

For my first Blue adventure in Afghanistan I am grateful to Jacquetta Hayes, who first invited me to cross the Khyber Pass; to Eric Donelli and Davide Giglio for their hospitality; Abdul Saboor Ulfat and his family and to Luc and everyone at Solidarité in Bamiyan for their help and their picnics at turquoise lakes. For my second journey I thank Gary Bowersox; Letizia Rossano; Atif Rizvi; Antonio Donini of UNOCHA for letting me on that plane to Faizabad; Mervyn Paterson and Khalid Mustafawi for looking after me when I arrived, Bob Nickelsberg, Tony Davis, Abdullah Buharistani, Yaqoub Khan and all the people at Sar-e-sang and elsewhere who shared

what they had, even when they had almost nothing. Also thanks to Louise Govier and her colleagues at the National Gallery in London.

For Indigo I should like to thank: Jenny Balfour-Paul and her husband Glencairn for patiently checking and rechecking; Giacomo Chiari; Debbie Crum; John Edmonds for all his advice on both woad and purple; Pat Fish; Munirenkatappa Sanjappa at the Calcutta Botanical Gardens; John Stoker; Lionel Titchener.

For my search for Violet, I am grateful to: Santiago de la Cruz; Zvi Koren; and Nell Nelson who ensured that the quest to find purple in Mexico featured almost as many margaritas as snails.

And in addition I should like to thank: Genevieve Fox and Richard McClure for their hospitality on my numerous research visits to London; Donald Francis; Valerie Garrett for guidance on how to write a book proposal when all this was just a colorful fantasy; Eric Hilaire for his generous photo research; James Hodge; Don Jusko for an afternoon in Maui discussing pigments; Ted Katsargiris for asking people all over Cambodia about a mysterious yellow resin; Charles Anderson for reminding me how much I love libraries; NicholasWalt at Cornelissen's in Great Russell Street, the most atmospheric artist's shop in England; Dominic Lam; Peter Lucas at the University of Hong Kong; Steve McCarty; Alison Nadel; Wing, my travel agent, for never shirking questions like "What's the cheapest route to Tehran? And can I go via Manchester?"; Martha Olo-an for looking after my home and animals so many times when I was away while if the world was fair she should have been with her own family in the Philippines; Hilary Goddard; Irene Nicholls for listening so patiently to all my draft chapters; Patrick Wolff; Ellen Pinto and Lawrence Herbert at Pantone; Martin Collins for solving my map crisis so quickly; Simon Trewin and Sarah Ballard at pfd for helping turn an idea into a book contract; Helen Garnon-Williams at Sceptre in London for helping making it into a better book; Dan Smetanka at Ballantine for his enthusiastic support from the very beginning and for champagne in

# ACKNOWLEDGMENTS

Bryant Park; Emma Pearce, Joan Joyce and Sarah Miller at Winsor & Newton for their help and their pictures; the staff at the University of Hong Kong Library, the New York Public Library, the Indian National Library in Calcutta, the Library of Congress, the Post Office Archives, the Library of Mount Vernon. And most of all the wonderful British Library in London which became my second home. And finally Martin Palmer, without whom this book would have been written much more quickly, but with far less joy.

# COLOR

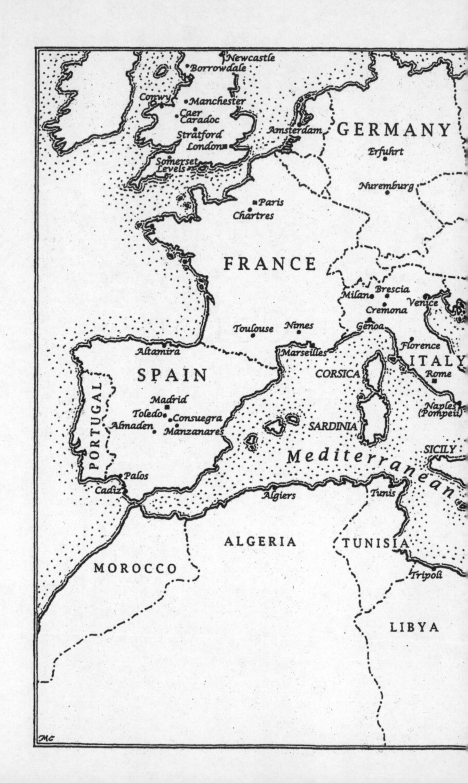

# TRAVELS THROUGH A EUROPEAN PAINTBOX

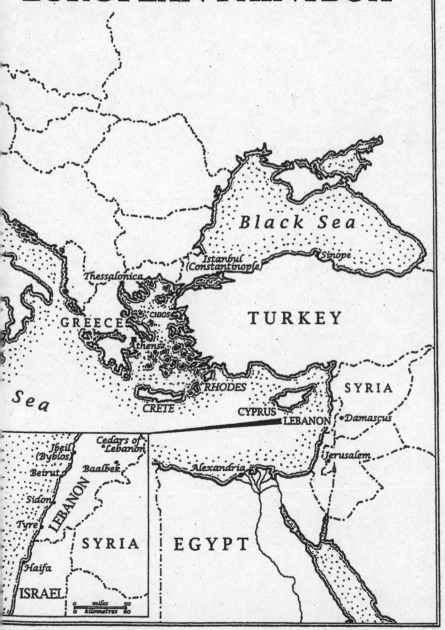

# The Beginning of the Rainbow

*"An image reflected in a mirror, a rainbow*
*in the sky, and a painted scene*
*Make their impressions upon the mind, but in*
*essence are other than what they seem*
*Look deeply at the world, and see an illusion,*
*a magician's dream."*

THE SEVENTH DALAI LAMA: *"Song of the*
*Immaculate Path"*[1]

*I*t was a sunny afternoon that still sparkled after earlier rain when I first entered Chartres cathedral. I don't remember the architecture, I don't even have a fixed idea of the space I was in that day, but what I do remember is the sense of blue and red lights dancing on white stones. And I remember my father taking me by the hand and telling me that the stained glass had been created nearly eight hundred years ago, "and today we don't know how to make that blue." I was eight years old, and his words knocked my explanation of the world into a tailspin. Up until then I had always believed that the world was getting better and better and more and more clever. But that day my tender theory about the Evolution of

History fell on its head, and it has—for better or for worse—never been quite right ever since. And sometime around about then I decided in my small but very determined heart that I would find out "about the colors." One day.

But then I forgot. I didn't follow a path that led me into glassmaking or even technically into art—my school did not offer the kind of creative environment where children without drawing skills were encouraged. Instead I discovered social anthropology, which was followed by a short spell in the business world, and then by newspaper journalism. But the news journalism became arts journalism, and every time I heard anecdotes about colors—an archaeologist explaining how the Chinese used to depend on Persia for the blue on their famous Ming porcelain; the astonishing discovery that English artists once smeared dead humans onto their canvases; artists in Hanoi talking about how their work had changed not just because they had new things to say as Vietnam opened up, but very simply because they had better and brighter paints—those childhood memories stirred.

Then, one day, I arrived in Melbourne to cover the city's arts festival for the *South China Morning Post*. I spent a spare hour between shows in a university bookshop. Casually picking up a heavy art book, I opened it at random and read these words: "INDIAN YELLOW: an obsolete lake of euxanthic acid made in India by heating the urine of cows fed on mango leaves." And then these: "EMERALD GREEN: the most brilliant of greens, now universally rejected because it is a dangerous poison . . . Sold as an insecticide." Art history is so often about looking at the people who made the art; but I realized at that moment there were also stories to be told about the people who made the things that made the art.

My heart started beating, and I had a bizarre sensation that was rather like being in love. This was an annoying feeling to have in a bookshop so I tested myself. Even the (arguably) more boring "DUTCH PINK: a fugitive yellow lake made from buckthorn" made me swoon with its paradox. I was smitten, so I did what any reluc-

tant lover might do when they don't know what is good for them. I turned my back on it, took no note of its name or how to get hold of it . . . and then dreamed about it for months. Arriving back in Melbourne a year or so later on an Australian government arts fellowship, the first thing I did was return to the shop. By then the book—Ralph Mayer's classic *The Artist's Handbook of Materials and Techniques*—was reduced in price because too many people had thumbed through it. I took this as a good sign, and I bought it.

In those twelve months I realized I had—almost subconsciously—been looking for a book that would answer my questions about paints and dyes: What does a cochineal beetle look like? Where on the map of Afghanistan can I find the ultramarine mines? Why is the sky blue?—and I could not find one anywhere. So I decided to write it myself. Since then a number of books about color have been published—Simon Garfield's *Mauve*, Robert Chenciner's *Madder Red*, François Delamare and Bernard Guineau's *Colour* and most recently Philip Ball's *Bright Earth*—and I have found some excellent sources in libraries, especially John Gage's *Colour and Culture* and Jenny Balfour-Paul's *Indigo*, but there are many more. I am glad I did not find them earlier or I would not have dared suggest my own book, and I would have missed some wonderful encounters and journeys discovering why red paint can really be the color of blood, or how indigo workers once threatened the foundations of the British Empire, or how an entire nation once made its trade—and got its name—from the color purple.

There is a little theory mixed in with the journeys but this is not the place to find detailed debates on color harmonies or color science. Instead this is a book full of stories and anecdotes, histories and adventures inspired by the human quest for color—mostly in art but sometimes in fashion and interior design, music, porcelain and even, in one example, on pillar boxes. Most of the stories take place before the end of the nineteenth century: not because the twentieth is not interesting, but because so much happened

after the 1850s in terms of color—in art, in music, in science, in health, in psychology, in fashion, indeed in every area—that these developments could be, and have been, each the subjects of their own books.

The first challenge in writing about colors is that they don't really exist. Or rather they do exist, but only because our minds create them as an interpretation of vibrations that are happening around us. Everything in the universe—whether it is classified as "solid" or "liquid" or "gas" or even "vacuum"—is shimmering and vibrating and constantly changing. But our brains don't find that a very useful way of comprehending the world. So we translate what we experience into concepts like "objects" and "smells" and "sounds" and, of course, "colors," which are altogether easier for us to understand.

The universe is pulsating with an energy that we call electromagnetic waves. The frequency range of electromagnetic waves is huge—from radio waves, which can sometimes have more than 10 kilometers between them to the tiny cosmic waves, which move in wavelengths of about a billionth of a millimeter—with X rays and ultraviolet and infrared and TV and gamma rays in between. But the average human eye can detect only a very small portion of this vast range—only, in fact, the portion with wavelengths between 0.00038 and 0.00075 millimeters. It seems a small differential, but these are magical numbers for our eyes and minds. We know this section as visible light, and we can distinguish about ten million variations within it. When our eyes see the whole range of visible light together, they read it as "white." When some of the wavelengths are missing, they see it as "colored."

So when we see "red," what we are actually seeing is that portion of the electromagnetic spectrum with a wavelength of about 0.0007 millimeters, in a situation where the other wavelengths are absent. It is our brains (and our language) which inform us it is "red," and at the same time they often attach cultural labels that

tell us it is powerful, or that it is the color of love, or that it is a traffic sign which means we have to stop.

In 1983 the American scientist Kurt Nassau identified fifteen ways in which something can be colored,[2] and the list can (if you're lucky) begin rather like a silly music-hall song: "Vibrations, excitations, incandescence of the limelight/Transitions and refractions, scattering of the white light . . . ." All very complicated. But, in simple terms, coloring can be divided into two main causes: chemical and physical. Within "chemical" causes of color we can include the vivid greens and yellows on the cover of this book, the delicate or brash hues of flower petals, the blue of lapis lazuli, the color of your skin and mine.

These chemical colors appear because they absorb some of the white light and reflect the rest. So the green glass on the book cover is simply absorbing the red and orange wavelengths from the white light around it, and is rejecting the green—so that is what we "see." But the big question is why? Why should some substances absorb red light and some absorb blue? And why should others—"white" ones—not absorb very much light at all?

If you are, like me, not a scientist, you're probably inclined to skip this section, but stay with me because it is quite an astonishing story. What is important to remember about "chemical" coloring is that the light actually does affect the object. When light shines on a leaf, or a daub of paint, or a lump of butter, it actually causes it to rearrange its electrons, in a process called "transition." There the electrons are, floating quietly in clouds within their atoms, and suddenly a ray of light shines on them. Imagine a soprano singing a high C and shattering a wineglass, because she catches its natural vibration. Something similar happens with the electrons, if a portion of the light happens to catch their natural vibration. It shoots them to another energy level and that relevant bit of light, that glass-shattering "note," is used up and absorbed. The rest is reflected out, and our brains read it as "color."

# COLOR

For some reason it is easier to understand this idea of electro-magnetic waves actually altering what they touch when you are talking about invisible ones like X rays. It is hard to believe that light—lovely friendly white light—also changes almost every object it hits, and not only the ones that contain chlorophyll which are waiting for the right wavebands of light to make them photo-synthesize.

The best way I've found of understanding this is to think not so much of something "being" a color but of it "doing" a color. The atoms in a ripe tomato are busy shivering—or dancing or singing; the metaphors can be as joyful as the colors they describe—in such a way that when white light falls on them they absorb most of the blue and yellow light and they reject the red—meaning paradoxi-cally that the "red" tomato is actually one that contains every wave-length except red. A week before, those atoms would have been doing a slightly different dance—absorbing the red light and re-jecting the rest, to give the appearance of a green tomato instead.

I saw what I understand to be transitional color only once, on a journey to Thailand to undertake a ten-day fast. I was feeling good (although I had never realized it is possible to smell chocolate ice cream at 20 meters), and on day nine I was walking through a gar-den when suddenly I stopped in amazement. In front of me was a bougainvillea bush covered in pink flowers. Only they were not pink, they were shimmering—almost as if a heartbeat had been transformed into something visible. I suddenly understood with my eyes and not just my mind how the phenomenon of color is about vibrations and the emission of energy. I must have stood there for five minutes, before I was distracted by a sound. When I looked back the bougainvillea had returned to being flowers, and nature had turned itself the right way round once more: it's usually easier that way. After I started eating, this never happened again.

There are several "physical" causes of color,[3] but one with which we are all familiar is the rainbow, which forms in the sky when light bounces around raindrops and gets divided—what is called "re-

# OPTICKS:

## OR, A

# TREATISE

### OF THE

## REFLEXIONS, REFRACTIONS,

## INFLEXIONS and COLOURS,

### OF

# LIGHT.

### ALSO

## Two TREATISES

### OF THE

## SPECIES and MAGNITUDE

### OF

## Curvilinear Figures.

*LONDON,*

Printed for Sam. Smith, and Benj. Walford,
Printers to the Royal Society, at the *Prince's Arms* in
St. *Paul's* Church-yard. MDCCIV.

*Preface for early edition of Newton's Opticks*

fracted"—into its separate wavelengths. This explanation was famously discovered in 1666 by a young man sitting in a dark room with two small pyramids, or prisms, made of glass in front of him. In the window shutter he had drilled a small hole, about a centimeter wide, which allowed a thin beam of sunlight to shine into the room. On a day that has become myth, the Cambridge student—whose name was Isaac Newton—held up the prism and saw how it made what he later described as a "colored image of the sun" on the opposite wall. He already knew that this would happen, but his genius lay in placing the second prism upside down so the multicolored light passed through it. And he found that this time the rainbow disappeared and white light was restored. It was the first time a scientist had acknowledged that white light was made up of rays of every color in the spectrum, and when Newton finally published his findings—it took him thirty-eight years[4]—it was the first real explanation of how the ray of each color bends at a certain fixed angle while passing through the prism. Red bends least, and violet bends most. And in the same book Newton named five other colors that lie between the two of them. One of his choices was extraordinary, as I would find out in my search for indigo.

## The Proof by Experiments.

*Exper.* 3. IN a very dark Chamber at a round hole about one third part of an Inch broad made in the Shut of a Window I placed a Glaſs Priſm, whereby the beam of the Sun's Light which came in at that hole might be refracted upwards toward the oppoſite Wall of the Chamber, and there form a coloured Image of the Sun.

*Preface for early edition of Newton's* Opticks

Years later the Romantic poet John Keats would complain that on that fateful day Newton had "destroyed all the poetry of the

rainbow by reducing it to prismatic colors." But color—like sound and scent—is just an invention of the human mind responding to waves and particles that are moving in particular patterns through the universe—and poets should not thank nature but themselves for the beauty and the rainbows they see around them.

While I was writing this book I went to a party one evening and a fellow guest looked at me sternly. "You have to have one character running through your book. That's how all those new nonfiction books work," he said firmly. "Who's your character?" But, as I hesitantly admitted, I didn't have one. Later I realized I don't have one character, I have many. Just as a prism shows us a multiple of different wavelengths—which our brains call colors—so each color has produced a spectrum of personalities. They are all people who through the ages have become fascinated by color. There's Thierry de Menonville, the arrogant French botanist, Isaac Newton in his dark chamber naming the rainbow, Santiago de la Cruz eking out a living embroidering shirts in the Mexican hills, dreaming of purple, Eliza Lucas foiling evil plans to prevent her making commercial indigo in Carolina, Geoffrey Bardon, whose generosity and poster paints allowed some equally generous Aboriginal men to create an art movement that would change lives. Few of these people ever encountered each other, even in books, but I've enjoyed meeting them all on my journeys, and I hope you do too.

# The Paintbox

*"In old days the secrets were the artist's; now he is the
first to be kept in ignorance of what he is using."*

WILLIAM HOLMAN HUNT, in an address to the
London Society of Arts

*"What did I learn at art school? I learned that art is
painting, not painted."*

HARVEY FIERSTEIN, quoted in the exhibition "A Family Album:
Brooklyn Collects" at Brooklyn Museum of Art, April 2001

*T*he prison was called "the stinker," and it was the place where debtors tended to disappear for years. This medieval Florentine institution would have lived up to its name particularly in summer, and it was on one such rank and smelly day in the mid-fifteenth century that a man sat at a wooden desk. To his left was a pile of handwritten papers, and to his right was one final page. Perhaps he paused for a moment before doing something that was probably forbidden to him as a prisoner of the Vatican: picking up his quill and marking the date—July 31, 1437—and the words "ex Stincharum, ecc." The postscript not only notified readers that the document was written in the heart of the Stinche itself, but it also puzzled scholars for years.

The book was *Il Libro dell'Arte* by Cennino d'Andrea Cennini, and it was to become one of the most influential painting manuals

written in the late medieval period—although it would take more than four centuries to find a publisher. It was not the first "how to" book of paint-making: there had been a few in the past, including the *Mappae Clavicula* from the ninth century which included a veritable hodgepodge of recipes for pigments and inks for illuminated manuscripts, and in the twelfth century the mysterious metalworking monk Theophilus wrote his *De Arte Diversibus* describing how to make stained glass and metalwork as well as paintings. But Cennino's book was special. He was an artist, the direct inheritor of a tradition[1] that stretched back to Giotto di Bondone in the late thirteenth century, and his *Handbook* was the first time a professional artist had revealed the secrets of his trade so comprehensively and openly. And when in the early nineteenth century the book was taken down from its shelf in the Vatican library, dusted off and published,[2] it was to cause a minor sensation in a European art world that was beginning to realize that in so single-mindedly pursuing its art it had neglected to remember enough of its craft.

At first, having read the "Stinche" postscript, art historians imagined that the manual—later translated into English as *The Craftsman's Handbook*—was written by a criminal. They fondly pictured Cennino as an old man writing his memoirs in a miserable lockup, so caught up by the beauty of the processes he was describing that he omitted to mention the ugliness of his present location. Just as Marco Polo only spoke of his travels into the heart of Asia many years later, when he had time on his hands and a willing scribe in his prison cell, so, people thought, his Tuscan compatriot only wrote about the mechanics of painting the shadows once he was locked firmly inside them. Sadly for the imagination, although rather happily for Cennino, later researchers found other copies of the manuscript without reference to any penitentiary. They had to concede reluctantly, that Cennino probably lived and died a free man, and that the version with the postscript was written by a literate prisoner who was condemned to copying books for the Pope.[3]

Whenever I open Cennino's book—and he has acted as my

"guide" for many of the journeys in this book—I often think about that copyist. What kind of man would he have been? An educated one certainly: something of a scoundrel perhaps—in prison for debt, or for a white-collar (or black medieval velvet-collar) crime. He may have been in there for years, copying out pious prayers and religious treatises in neat longhand. And then suddenly, somewhere between a prayer book and a Bible, the prison librarian handed him his next project: a treatise containing the kind of valuable secrets that a man would never have dreamed would fall into his hands—at least not while he was doing prison labor.

As he began writing, our scribe may have felt a kinship with those whom Cennino chides for having chosen their artistic careers "for profit"—as well as a distant curiosity about those others who had entered the profession "through a sense of enthusiasm and exaltation." And then a few pages later he may have felt a sense of exaltation himself. If he knew anything of the art world he would be aware of how secretive artists were about the tricks of their trade, and how in order to learn them apprentices lived in the studios of their masters for years, grinding pigments, preparing canvases, and then, after many years, being allowed to paint backgrounds and less important figures. It was usually only when they themselves became masters that they could stroll into their own studios to finish the faces and main figures on canvases their own apprentices had prepared earlier.

Here are some of the many things Cennino explains in his book: how to make imitations of expensive blue using cheaper pigments; how to use tracing paper (by scraping kidskin until "it barely holds together," then smearing it with linseed oil) to copy a master drawing; which types of panel were favored by thirteenth- and fourteenth-century masters (fig wood was good) and how to paste old parchments together. Cennino claimed, probably sincerely, that his *Handbook* was intended for the good of artists everywhere, but if there had ever been a *Teach Yourself Medieval Art Forgery* guide, this was it. And our man in the jail had the document.

We cannot know whether our copyist ever managed to take

advantage of his knowledge. I like to think so. I imagine him leaving the prison at the end of his term, and going into the equivalent of the antique business, touching up century-old panels with a judicious spot of gilded tin carefully prepared in the way that Cennino recommended, or mixing glues made of lime and cheese, just as Giotto might have used to fix his own painting boards.

But whether he capitalized on it or not there must have been days when our incarcerated scribe would have fantasized about cooking up green with good wine vinegar, or designing cloths of gold. No doubt he would have thought wistfully about being free to sit in chapels, sketching with the thigh bone of a gelded lamb and making sure the light was falling on his left side, so his drawing hand did not make a shadow across the paper. And he would certainly have paused for some kind of thought as he read Cennino's warning against something that can make your hand so unsteady "that it will waver more, and flutter far more, than leaves do in the wind, and this is indulging too much in the company of women."

The book has certainly inspired latter-day forgers. Eric Hebborn was one of Britain's best-known twentieth-century forgers, who became something of a celebrity. He wrote several books, but his last one, *The Art Forger's Handbook*, explicitly set out to teach the amateur how to make decent fakes in the kitchen. He used and adapted Cennino's advice extensively—preparing panels, tinting papers different colors, and making brand-new works look as if they had been varnished some time before (by using beaten egg-white, left overnight and then painted on with a brush), just as the master advised.

But as well as forgery, in the years since it was rediscovered, Cennino's book (along with other early manuals of how to make paints and dyes) has inspired something rather different: a nostalgia for the past, especially among Victorians, for whom the late medieval period was an idealized time of the best art and the most noble chivalry. Today, if I want to buy paint, I can go into an art shop and find any number of tubes, each labelled with a name, number and a colored pattern to tell me what its contents look like. Some paints have de-

scriptive names like "emerald green"; others have historical ones like "vermilion" or hard-to-pronounce chemical ones like "phthalo blue" or "dioxazine purple." Others, like "burnt sienna" or "lamp black," give clues about where the paint has come from and what has been done with it, even though it is unlikely that sienna still comes from the Tuscan town of Siena anymore, or that that particular black comes from lamps. If I feel overwhelmed, browsing along those laden art-shop shelves, the assistant will almost certainly have a chart to tell me the permanence, opacity or toxicity levels of my chosen paints, and will be able to direct me to a shelf of manuals that will tell me how to use them. But despite all this help it is easy for the beginner to feel a little lost. It is partly the terms—what, for example, is the difference between Cadmium red hue and Cadmium red?[4]—and it is partly the sheer breadth of choice. But it is also the sense that, not really knowing what these paints are or where they have come from, one is somehow alienated from the process of making them into art.

That uncertainty about materials is not restricted to amateurs alone, nor is it restricted to the present day. In the eighteenth and nineteenth centuries, European artists were already beginning to feel alienated from their materials—and to sound alarm bells about this once they saw the cracks in their canvases. In April 1880 the Pre-Raphaelite William Holman Hunt stood before an audience at the Royal Society of Arts in London[5] and gave a speech that summed up his despair about artists' loss of technical knowledge over the previous century or more.

The problem, he told his audience, was that artists had never learned the tricks their medieval predecessors had known from their first days as apprentices. What was the good of painting a masterpiece if its constituent elements would spend the next few years fighting together chemically on the canvas, and ultimately turn black? The early seventeenth-century painter Anthony Van Dyck knew how to employ varnish so that colors that would otherwise react with each other would be safe from ruin; Victorian artists, however, did not, and this was, Holman Hunt predicted, to be their downfall.

Part of the issue was that he—and his teachers, and his teachers' teachers—had rarely had to mix paint from basic materials. He had never had to grind a rock, or powder a root, or burn a twig, or crush a dried insect. Nor, more importantly, had he observed the chemical reactions involved in paint-making and seen how colors changed over the years. By his time, and in stark contrast with Cennino's pre-paintbox world, almost all artists' supplies were made and sold by professionals called colormen. Hunt was particularly passionate on the day he spoke—or at least the day he prepared his speech—because his own colorman had just sent him a bad batch of adulterated pigments, which had ruined one of his paintings.

The solution was not about doing everything oneself, he assured his listeners. Holman Hunt was the first to admit that some artists—like Leonardo da Vinci, whose patrons sometimes despaired that he would ever actually start the painting, he was kept so busy distilling and mixing—spent far too long on the preparation stages. After all, even the old-timers sometimes delegated— the excavations at Pompeii had unearthed paint pots in a workshop waiting for the artist to collect them, and Cennino himself had bought his vermilion ready made.

And the solution was also not to get rid of the colormen. Some were excellent, Holman Hunt said—recounting legendary stories of a pharmacist in Holland who could make vermilion that was "three times brighter" than anyone else's, and of Michelangelo's contemporary Antonio da Coreggio, who was famously helped to prepare oils and varnishes by a chemist whose portrait, in gratitude, "still exists in Dresden." But what was urgently needed, he said, was for artists to spend time learning the basics of their trade, so that when they collaborated with colormen they would know what they were talking about.[6]

Colormen[7] first appeared in the mid-seventeenth century, preparing canvases, supplying pigments and making brushes. In France some of them were originally luxury goods grocers, selling exotica like chocolate and vanilla alongside the cochineal, but

most of them quickly turned to full-time art supplying. The arrival of these professionals on the art scene was a sign—as Cennino's book was a much earlier sign—of how the act of painting was moving from a craft profession to an art one. For "craftspeople" the ability to manage one's materials was all important; for "artists" the dirty jobs of mixing and grinding were simply time-consuming obstacles to the main business of creation. There were of course enough scare stories of charlatans adulterating colors to keep some artists mixing their own for several centuries. But slowly and irrevocably artists began to push their porphyry pestles and mortars to the backs of their workshops, while professional colormen (or rather, in some cases, the horses of professional colormen) did the grinding.

As well as the alienation of artists, putting paint-making into the hands of a few commercial dealers had another radical effect on the art world: technical innovation. When Cennino wrote his *Handbook*, artists were going through the all-important transition period between using tempera (egg) and oils (linseed or walnut or poppy were popular) as binders. Later Giorgio Vasari would ascribe this invention to Johannes and Hubert Van Eyck. Certainly the Flemish brothers' brilliantly translucent fifteenth-century oil paintings were the new medium's greatest early advertiser, but oils had been used for many years before that. In the late 1300s Cennino was already using oils to paint the top layer on a picture of a velvet gown, for example,[8] and even in the sixth century a medical writer called Aetius was mentioning how artists used a "drying oil," which was probably linseed.[9] However, since the eighteenth century, inventions and innovations have been coming in so quickly it is not surprising that some artists have been bewildered. It is not just the hundreds of new paints but also the mediums—pigments can now be suspended in acrylics, fast-drying alkyds and a whole range of gums and exotic oils[10]—and even the packaging of paints which have changed.

One discovery that changed the art world was made by a young man called William Reeves in the late eighteenth century. He was a workman employed by a colorman called Middleton, but he spent some of his

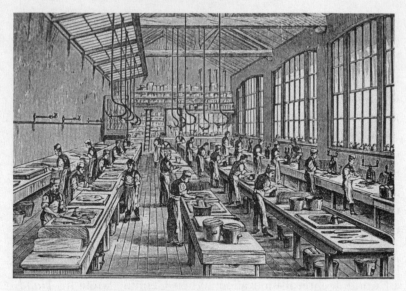

*The Watercolor room at Winsor & Newton in the mid-nineteenth century*

spare time doing experiments of his own. Up until then watercolors—which are basically pigments mixed with water-soluble gum—had been sold in dry lumps that had to be grated. But Reeves found that honey mixed with gum arabic would not only stop the cakes from drying out, but also allow them to be molded into regular shapes. His brother, who was a metalworker, made the molds, and in 1766 Reeves & Son opened near St. Paul's, supplying the army and the East India Company with the first watercolor paintboxes. It would take the collaboration of artist Henry Newton with chemist William Winsor in 1832 before anyone would think to add glycerine—meaning that watercolors no longer had to be rubbed and could be used straight from the pan. Suddenly it was easy—in terms of materials at least—to become an artist, and many enthusiastic amateurs followed Queen Victoria's lead in ordering the new paintboxes and using them out of doors to sketch landscapes.

Oil painting alfresco was naturally the next big change. For centuries, artists had stored their paints in pigs' bladders. It was a painstaking process: they, or their apprentices, would carefully cut

the thin skin into squares. Then they would spoon a nugget of wet paint onto each square, and tie up the little parcels at the top with string. When they wanted to paint, they would pierce the skin with a tack, squeeze the color onto their palette and then mend the puncture. It was messy, especially when the bladders burst, but it was also wasteful, as the paint would dry out quickly. Then in 1841 a fashionable American portrait painter called John Goffe Rand devised the first collapsible tube—which he made of tin and sealed with pliers. After he had improved it the following year and patented it, artists in both Europe and America really began to appreciate the wonder of the portable paintbox. Jean Renoir once told his son that without oil paints in tubes: "There would have been no Cézanne, no Monet, no Sisley or Pissarro: nothing of what the journalists were later to call Impressionism." Impressionism, after all, was a movement that depended on recording nature in nature. Without being able to use colors outside it would have been hard for an artist like Monet to record the impressions that the movements of the light had made on him, and so create his atmospheric effects.

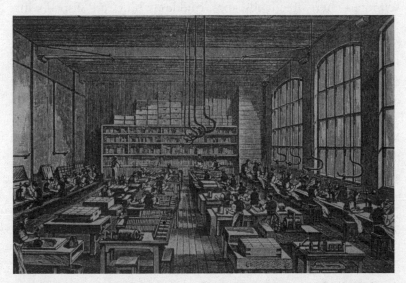

*The Oil-color Tube-filling room at Winsor & Newton in the early days*

# COLOR

One of the most popular colormen in Paris at the end of the nineteenth century was Julien Tanguy, affectionately nicknamed "Père." This jovial dealer and art supplier was an ex-convict who had once served time on a prison ship for subversion[11]—a biographical detail that no doubt endeared him to some of the post-Impressionists, who were his main customers. Paul Cézanne bought from him, as did Émile Bernard, who described going to Tanguy's shop at 14 rue Clauzel as being like "visiting a museum." Another famous (though impecunious) customer, Vincent van Gogh, painted three portraits of Père Tanguy. The first, from 1886, is very brown—the subject looking rather like a workman, with just a touch of red on his lips and a spot of green on his apron.[12] Then, in the spring of 1887, van Gogh changed his palette—experimenting with color oppositions of red against green, orange against blue—and his work was never the same again. The other two portraits of Tanguy (dated 1887 and 1888) are a raucous celebration of the dealer's paint products. They show him standing in front of Japanese prints, kabuki actors competing on the walls with soft-focus cherry-tree landscapes. Suddenly blues are striped with yellows, and on top of Tanguy's hat is Mount Fuji, giving him the conical look of a rice farmer, rather than the quizzical look of a French merchant. Both paintings were part of what van Gogh called his "gymnastics" of experimenting with how to put intense colors rather than gray harmonies in his paintings.[13]

Van Gogh's relationship with the Tanguys was turbulent—Mme. Tanguy frequently complained about the amount of credit the artist was given (blaming one's spouse for financial precision is a convenient way for a merchant to stay both amiable and solvent), and van Gogh often complained in turn about the insipidness of some of the products.[14] He may have been right: certainly someone was supplying him with fugitive paints, as there are several that have faded. One of the most popular works at Washington's National Gallery of Art is a van Gogh painting that for years has been titled *White Roses*. It was only in the late 1990s that it was realized

that it contained traces of what was probably madder red, and that the roses had originally been pink.[15] When I visited the gallery shop in early 2001, the postcards labelled the painting simply as *Roses* but the posters, which were older stock, still bore witness to van Gogh's choice of a paint that had faded.

Since the end of the eighteenth century we have seen dozens of new colors arrive on artists' palettes. The new colors are mostly beyond the scope of this book—but some of the more important were chromium (isolated by Louis Nicolas Vauquelin in 1797 from a rare orange mineral called crocoite), cadmium, which was discovered by accident in 1817 by a German chemist, Dr. Stromeyer, and the "aniline" colors first isolated from coal tar in 1856 by a teenage chemist called William Perkin, who reappears in my quest for purple.

But alongside the excitement of new discoveries, there has often been a parallel movement to rediscover the colors of the past. Shakespeare's birthplace in Stratford-upon-Avon is one of England's most popular tourist destinations. In 2000 it was redecorated—from an arrangement of white walls and what, in retrospect, look from the photographs like 1970s curtains, to an attempt to reproduce in an authentic way what Shakespeare actually grew up with in the sixteenth century. So "painted cloths"—the kind of cheap alternatives to tapestries that a middle-class glovemaker could have afforded—have been made on unbleached linen, with the designs of naked putti and satyrs colored in with ochre reds and yellows, lime white and soot, just as the Stratford "peynter-steyners" and "daubers" would have made them. Meanwhile the "second-best bed"[16] is now covered with curtains and bedspreads in astonishingly bright greens and oranges, as was the fashion of the time. The fabrics are made of a woven material called dornix—a wool-linen blend, dyed with natural plant extracts, which was last made in England in 1630.

It is a trend for authentication that is being followed by historical houses all over the world—from colonial Williamsburg in

Virginia, which has become a center for eighteenth-century paint technology, to a Tudor town house called Plas Mawr in Conwy, North Wales. At Plas Mawr the original wall decorations have been re-created—big-bosomed and near-naked caryatids leering pinkly from above fireplaces—so bright in their authentic organic and mineral colors (and certainly a shock if one had thought the Tudors liked whitewash or subtle effects best) that when I met the paint consultant, Peter Welford, he asked me whether I had my sunglasses with me.

This move to revisit the ghosts of pigments past, mixed with a sense of loss for what today we have forgotten, is not new at all. The Romans carefully copied the Greek polychrome techniques, the Chinese were always re-creating and adapting the crafts and colors of previous dynasties, while Cennino's book itself was an attempt to preserve methods that he feared were about to disappear. And in the 1880s one of Holman Hunt's friends, the designer William Morris, was a major force in bringing back some of the old colors being displaced by aniline dyes, calling the new ones "hideous"[17] and challenging people to take another look at the old colors, and see how "magnificent" they were. It is almost as if every few generations we seem to realize we have assigned our predecessors to a black-and-white past, and then rejoice together at rediscovering that they loved colors too.

One of the most extraordinary moments in the history of paint happened in eighth-century Byzantium, where painted icons had been all but destroyed after senior church members argued it was against God's teaching to make images. There was passionate debate on both sides, and in the end it was resolved that the works were celebrations of the natural gifts of God. Not only in their depictions but in their materials—and that by using plants and rocks and insects and eggs God was glorified through the very body of the artwork.[18] Which is one of the reasons why even today, when there is so much choice, it is an instinctive decision for an Orthodox icon painter to choose pigments that are as natural as possible.

*　*　*

"Look for the sign to Bog," my instructions read. "And then go along the other track." I was looking for the studio-cottage of Aidan Hart, a New Zealand icon painter. The former Brother Aidan had been a novice Orthodox monk for sixteen years before leaving, with the blessings of his church, to get married. He was living on a very remote hillside on the Welsh borders: it seemed a fitting place to find a man who works with natural paints. He is not a rigid purist— there was a small pot of zinc white and a few other manufactured paints on his shelves among the intriguing flasks of colored stones and powders from Siberian riverbanks, Turkish trees and Italian mountains—but over the years he had found that natural colors fitted not only with his sense of aesthetics, but with his theology.

"The natural paints aren't perfect . . . and that's the point," he said, in words that would echo so much of what I would hear, throughout my travels, from people who worked with paints and dyes. He then poured a little French ultramarine powder (invented in the nineteenth century) onto his palm, to demonstrate his point. "All these crystals are the same size, and they reflect the light too evenly. It makes the paint less interesting than if you used real ultramarine, from stones."

When Aidan starts an icon painting, he always begins in the traditional way, by applying gesso to a panel made of ash or oak. Gesso is the Italian word for gypsum or plaster of Paris, although in fact artists have a choice of "whitings," including chalk or alabaster. First he paints several layers of rabbit-skin glue (which before it is added to water looks like demerara sugar and smells like a pet shop), after which he lays a piece of linen on top, so if the wood cracks later it can be replaced without damaging the painting. Then he adds a dozen layers of glue and chalk, and sands them down so finely that the panel looks startlingly like white Formica. The Orthodox tradition emphasizes the light inside every human being: and so icon paintings also begin with light, which seems to shine through the pigments and through the gold laid on top.

# COLOR

Icons are not just stories in paintings, Hart explained. "The intention is to introduce you to reality, not to imitate nature. It is to show you not what you see, but what is real." So the figures of saints often go beyond the frame to show how there are no real boundaries, and buildings tend to have a strange perspective—you can see left and right and up and down, which is meant to represent the way God "sees" the whole world at once. The use of natural pigments is similarly embodied in the Orthodox teaching that humanity—like all Creation—was created pure but not perfect, and the purpose of being born is to reach your true potential. Grinding a piece of natural rock so that it becomes the blush on a saint's cheek can be seen as a parallel transformation.

If you open up a box of paints, there are numerous such stories hidden inside it. They are stories of sacredness and profanity, of nostalgia and innovation, of secrecy and myth, of luxury and texture, of profit and loss, of fading and poison, of cruelty and greed, and of the determination of some people to let nothing stop them in the pursuit of beauty. But in my travels through the paintbox I will start at the beginning: with the first colored paints, and with what happened to one group of artists when one day they woke up and found their colors had been taken away.

# 1

## Ochre

*"Art . . . must do something more than give pleasure: it
should relate to our own life so as to increase our
energy of spirit."*

SIR KENNETH CLARK, *Looking at Pictures*[1]

*I*n the lakelands of Italy there is a valley with ten thousand an-
cient rock carvings. These petroglyphs of Valle Camonica are
signs that Neolithic people lived there once, telling stories and il-
lustrating them with pictures. Some show strangely antlered beasts,
too thin to provide much meat for a feast, and others show stick-
people hunting them with stick-weapons. Another rock has a large
five-thousand-year-old butterfly carved into it—although my visit
coincided with that of a horde of German schoolchildren queuing
up to trace it, and sadly I couldn't see the original through all the
paper and wax crayons.

But in a quieter place, far away from the groups, I found a flat
dark rock covered with fifty or more designs for two-story houses
with pointy roofs. It didn't feel particularly sacred to me as I stood
looking at it. It was more like an ancient real estate office or an ar-
chitect's studio, or just a place where people sat and idly carved
their domestic dreams. The crude carvings are not colored now, of
course: any paints would have disappeared long ago in the Alpine
rain. But as I sat there, contemplating the past, I saw what looked
like a small stone on the ground. It was a different color from all
the other mountain rubble—whatever it was, it didn't belong.

# COLOR

I picked it up and realized something wonderful. It didn't look promising: a dirty pale brown stub of claylike earth about the size and shape of a chicken's heart. On the front it was flat and on the back there were three planes like a slightly rounded three-sided pyramid. But when I placed the thumb and the first two fingers of my right hand over those three small planes, it felt immensely comfortable to hold. And what I realized then was that this piece of clay was in fact ochre, and had come from a very ancient paint-box indeed. I wet the top of it with saliva, and once the mud had come off it was a dark yellow color, the color of a haystack. When, copying the carvings, I drew a picture of a two-story house on the rock, the ochre painted smoothly with no grit: a perfect little piece of paint. It was extraordinary to think that the last person who drew with it—the person whose fingers had formed the grooves—lived and died some five thousand years ago. He or she had probably thrown this piece away after it had become too small for painting. A storm must have uncovered it, and left it for me to find.

Ochre—iron oxide—was the first color paint. It has been used on every inhabited continent since painting began, and it has been around ever since, on the palettes of almost every artist in history. In classical times the best of it came from the Black Sea city of Sinope, in the area that is now Turkey, and was so valuable that the paint was stamped with a special seal and was known as "sealed Sinope": later the words "sinopia" or "sinoper" became general terms for red ochre.[2] The first white settlers in North America called the indigenous people "Red Indians" because of the way they painted themselves with ochre (as a shield against evil, symbolizing the good elements of the world,[3] or as a protection against the cold in winter and insects in summer[4]), while in Swaziland's Bomvu Ridge (Bomvu means "red" in Zulu), archaeologists have discovered mines that were used at least forty thousand years ago to excavate red and yellow pigments for body painting.[5] The word "ochre" comes from the Greek meaning "pale yellow," but somewhere along the way the word shifted to suggest something more

robust—something redder or browner or earthier. Now it can be used loosely to refer to almost any natural earthy pigment, although it most accurately describes earth that contains a measure of hematite, or iron ore.

There are big ochre mines in the Luberon in southern France and even more famous deposits in Siena in Tuscany: I like to think of my little stub of paint being brought from that area by Neolithic merchants, busily trading paint-stones for furs from the mountains. Cennino Cennini wrote of finding ochre in Tuscany when he was a boy walking with his father. "And upon reaching a little valley, a very wild steep place, scraping the steep with a spade, I beheld seams of many kinds of color," he wrote. He found yellow, red, blue and white earth, "and these colors showed up in this earth just the way a wrinkle shows in the face of a man or a woman."

I knew there would be stories to be uncovered in many ochre places—from Siena to Newfoundland to Japan. But for my travels in search of this first colored paint I wanted to go to Australia—because there I would find the longest continuous painting tradition in the world. If I had been charmed by my five-thousand-year-old ochre, how much more charmed would I be in Australia where cave painters used this paint more than forty thousand years ago? But I also knew that in the very center of Australia I would find the story of how that ancient painting tradition was transformed to become one of the most exciting new art movements in recent years.

Before I left for Australia I called an anthropologist friend in Sydney, who has worked with Aboriginal communities for many years. At the end of our phone conversation I looked at the notes I had scribbled. Here they are:

- It'll take time. Lots.
- Ochre is still traded, even now.
- Red is Men's Business. Be careful.

I had absentmindedly underlined the last point several times. It seemed that the most common paint on earth was also sometimes

the most secret. Finding out about ochre was going to be a little more complicated than I had thought.

## SYDNEY

Hetty Perkins, one of the Aboriginal curators at the Gallery of New South Wales, described the secrecy of indigenous traditions most vividly, as we drank coffee in the gallery garden after the opening of a major retrospective of Aboriginal art that she had organized.[6] "This is a blanket," she said, putting her hand on a piece of white paper in my notebook, "and this is Australia," she continued, touching the wooden table. "You lift the paper, and it's all underneath . . . Many paintings are like the blanket . . . we don't understand the full extent of the meanings, but we know that they mean country." I was intrigued to know whether she had peeked underneath—at the table, so to speak. "It's not my privilege," she said. "That's why I'm careful. It's not my place to ask anyone what anything means. That will come later on."

So, effectively—I summarized for myself that evening—I was going to look for a pigment that in one of its incarnations I wasn't allowed to see, and which was used to paint secrets I wasn't allowed to know. And I respected that secrecy. But what then, under those rather rigorous conditions, would I find in the north and then the center of Australia to help me understand the appeal of ochre?

## DARWIN

What I discovered was ochre itself. I found it immediately and I found miles of it. I had not quite appreciated how the Top End of Australia is a quarry of ochres—there is so much of it that people use it commercially for colored concrete. On my first morning in Darwin I went for an early morning walk along East Point beach, which is famous locally for its colors. The rocks were like raspberry ripple ice cream, as if some lazy Ancestral Being had been given

# TRAVELS THROUGH AN
# AUSTRALIAN PAINTBOX

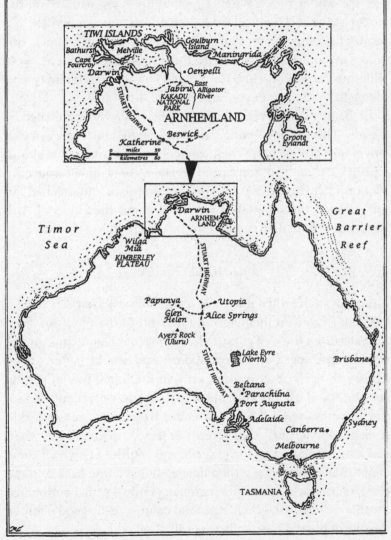

the job of mixing up the yellow, white, orange and red ingredients into the brown color of proper cliffs but had been distracted by a passing possum and ended up leaving them to dry in unmixed swirls of color. The crimson hematite was splashed like spilt blood over the whiter rocks. When I ground the loose pebbles on the mortar of the rock, and added a drop of seawater, I found I could paint with them—on my skin and on the pale parts of the rock. But unlike my smooth Italian ochre these Australian pigments were gritty and flaked unevenly. You wouldn't travel miles for this paint, I thought. Although, of course, I realized, I just had.

To the east I could see Arnhemland being slowly illuminated by the sun. This was the Aboriginal homeland that outsiders can visit only if they are invited. When you look at some maps, it is almost a blank: a place you don't need to know about unless you have your own map already. As I sat on the stone slabs and watched the sun painting the sky pink, I wondered about the colors of Arnhemland. Where they came from, and where they went to.

## TRADING OCHRE

There was a time when the whole of Australia was a network of trading posts.[7] From Arnhemland in the north to the tip of southern Australia, from the west coast to the beaches of Queensland, groups would come together for corroborees and would barter prized items with each other. It was partly an important way of getting good tools and useful items; but it was also a way of articulating social networks in (mostly) peaceful ways. If you were accustomed to trading with your neighbors every wet season, then that was when peace treaties could be maintained, and rivalries resolved. People might swap a boomerang (boomerangs didn't come back in those days) for a spear or an axe for a grinding stone—with a corroboree ritual to celebrate the exchange. And ochre—really good ochre— was one of the most prized items of all.

Wilga Mia in the Campbell Ranges of Western Australia is one

of the most sacred ochre mines in the continent. In 1985, Nicolas Peterson and Ronald Lampert[8] described going there with some of the traditional owners from the Warlpiri tribe. They had to ask permission for entry—not only from the owners but also from the sacred beings who, it was believed, lived beneath its ancient chambers. "Don't be unpleasant to us," the men once prayed before they went in with their torches and metal axes, while on another occasion they cajoled the spirit of the mine, saying how they wanted only a small amount. Before the 1940s the ochre had been traded for spears with tribes to the south and for shields and boomerangs with those from the north.[9] And—at least in the 1980s—it was still being mined and traded, although where once it had been collected in bark dishes, by the end of the twentieth century it was placed in plastic buckets.

Another famous deposit is in the Flinders Ranges of South Australia. For possibly thousands of years Aboriginal expeditions headed south into the area from Lake Eyre. In *Goods from Another Country*, Isabel McBryde writes about Diyari men taking two months to travel the thousand-mile round trip to collect their red gold from the Bookartoo mine at a place called Parachilna. They used to return home with 20 kilos of ochre each, already formed into baked round cakes. These would be carried on their backs in bags made of possum or kangaroo skin, and on their heads they would have huge seed-grinding stones from a nearby stone quarry. There would be seventy or eighty men travelling together: it must have been an impressive sight.

Then in 1860 the white farmers arrived, along with their sheep and their land registrations—and a series of skirmishes began. To the administrators in Adelaide these were known as the ochre wars, although the origins of the conflict had more to do with what happened on the way to and from the sacred mine than about what was found in it. The Aboriginals were not remotely interested in European notions of land ownership but they *were* interested in this new, bleating bush tucker. And when they made their yearly

expeditions to Bookartoo they took what meat they needed for their journey. The white communities were quick in their reprisals (on the "hanging for a sheep *or* a lamb" theory), and these were followed by counterreprisals from the Aboriginals. A nineteenth-century settler called Robert Bruce, quoted by Philip Jones of the South Australian Museum in a paper written in 1983,[10] wrote that "a solitary shepherd would have been about as safe [in the Flinders] as an unpopular land agent in Tiperary [sic] during the good ould toimes."

In November 1863 the ochre wars became an ochre massacre. Jones noted that, more than a century later, the Aboriginal people in the local area still knew the precise place where scores of Aboriginals were killed by the angry settlers. It is near Beltana, about 540 kilometers north of Adelaide. Throughout the 1860s there was terrible violence from both sides and eventually someone in the South Australian administration suggested a solution. If they couldn't stop the men going to the mountain, perhaps they could bring the mountain to the men. How about moving the mine? he said, arguing that the black fellas wouldn't know the difference. And unbelievably, in 1874, this is effectively what the settlers did. But they moved the wrong mine.

The decision-makers in Adelaide couldn't persuade any transport company to take the red rocks all the way from Parachilna (it was an almost impossible route for bullock carts then), so instead they removed four tons of ochre from a traditional mine owned by the Kaura people by the coast, and organized for it to be carted up to Lake Eyre—it took weeks, but the roads were at least negotiable. Once they reached their destination, they persuaded the German missionaries to distribute it, in the hope that the resulting glut in supply would mean the ochre collectors would find other things to do.

It was a wasted effort. All the Kaura red ochre in the world couldn't dissuade the men of Lake Eyre from making their annual expedition—for three reasons. First it was a kind of pilgrimage. You can probably buy Lourdes water in London, but part of its appeal is the transformation that occurs when you make the journey

yourself. The Aborigines had built elaborate ceremonies around collecting the red ochre and bringing it back. Trotting over to the mission to collect a little bag of free rocks rather missed the point. Stories can only be told by being told, and journeys can only be made by being travelled.

Second, ochre was essential for bartering. Trading happens when one item is seen to be almost equal in value to another. What value did free paint have? It wouldn't have bought very many precious pearl shells from the Kimberley coast, nor would it have bought much of the *pituri* tobacco the Diyari people were so keen to buy from other tribes. The recipe for making *pituri* leaves into a super-narcotic was a secret, kept only by the elders of certain tribes, so swapping ochre for *pituri* was swapping a secret for a secret and therefore appropriate. If the Lake Eyre tribes were denied sacred ochre then it would mean they were not able to play their part in the complex trading network that Aboriginal tribes depended on.

Third, the ochre was used for painting ritual designs, and the Kaura red simply wasn't either good enough or sacred enough: it did not contain the hint of mercury that made the Bookartoo paint so special. In 1882, a journalist called T. A. Masey wrote that: "the natives would not use [the Kaura ochre]. It did not give them that much-coveted shiny appearance that filled them with delight and admiration when contemplating their noble selves, and that also made them the envy of rival tribes."[11] For Masey this was probably an expression of a primitive urge for glittery things, but there are other explanations. The sense that light is a manifestation of the glory of the sacred—that the numinous is held within the luminous—is common to almost every faith. Perhaps by painting themselves with a color that gleamed, the Aboriginals were not only symbolizing the sacred; they were embodying it.

"Oh yeah, *pituri*," said Roqué Lee. "Tastes like shit but works like ten cups of coffee at once." I met Roqué (who pronounces his name "Rocky") at the Aboriginal Art Gallery in Darwin: he used to

be a ranger at Kakadu National Park, but for the past five years he'd mostly been demonstrating didgeridoos. His father is Chinese-Australian and his mother is Aboriginal. "I've got three cultures," he said happily. "You can see it in my cooking. I do *cha-siu* snake, long-neck turtle stuffed with ginger and stir-fry magpie goose." He lives in Darwin during the week but likes going hunting on weekends. "It's magpie goose season soon," he said. "We build a blind on the edge of a swamp, and then make a bundle of spears. When the geese come over we just throw the spears in the air. No need to aim." He often mixes white kaolin clay with seagull eggs, and uses it to paint stripes on his face while he's hunting. "Just to let Mother Nature know we're there." They don't do that for magpie geese, though: "They're so fat, we don't need luck." But they always paint the ends of the spears with white paint. For luck? "No." He grinned. "So we can find them more easily later."

He showed me around the gallery. Like many Darwin art shops, it has divided its paintings into two sections—the huge abstract paintings from the Central Desert, mostly in acrylic paints, with plastic as a binder rather than oil,[12] and the paintings from the Northern Territory. The former I knew I would find farther south together with—I hoped—the stories of their bright colors. The latter are still mostly in natural ochres as they were when the explorer and ethnologist Sir Baldwin Spencer began to collect them from Arnhemland tribes in around 1912, although today the black, white, red and yellow earths are now more often bound with synthetic glues. The new binders are easier to obtain, and they last longer than orchid juice or seagull egg.

The northern Aboriginal paintings were originally painted on the cut bark of the stringybark tree (which is more like paper than string) although they are now mainly on canvas—partly for ecological reasons and partly because that is what the buyers want, and because many paintings today tend to be created with the buyers in mind, rather than because they needed to be painted for their own sake. They are covered with patterns made up of diagonal stripes

and cross-hatching. The latter technique was apparently brought in by Macassan traders (from the island of Sulawesi which is now part of Indonesia) several hundred years before white settlers arrived on the continent. It is a reminder that Aboriginal culture has never been isolated, but instead has been influenced by (and perhaps has influenced) outside forces from Indonesia, Polynesia, China and elsewhere. It also, curiously, works as an optical illusion, the finely drawn parallel lines creating a shimmer in a similar way to paintings by British twentieth-century artist Bridget Reilly. Howard Morphy, in his book *Aboriginal Art*, suggested this "quiver"—which looks as if it had been painted with a shaking hand—was deliberate, and a way of making the painting shimmer and appear to move.[13]

The northern paintings tend to be highly figurative—showing, for example, the lightning-man Namarrkon, with his halo of electricity and axes stuck in his limbs (as humans stick them into logs), ready to be flung at humans who disobey the law; or the Luma Luma, who couldn't keep his hands off women, and was killed by the angry men (but not until he had told them his best stories). Others show the animal totems—fish or wallabies or turtles or crocodiles—placed around depictions of the humans and ancestors whose stories they share. When I first saw one of the turtle pictures I thought the diagonal lines around it were simply decoration. But then I spent one long night watching giant turtle eggs being laid on a desert island not far from Darwin—for a research project run by the University of the Northern Territory. And when I watched the mother green-back returning slowly into the ocean after laying eggs on the beach she had been born on forty years earlier, I realized the painting was an uncannily accurate picture of the tracks she made with her flippers.

Traditional Aboriginal life only makes sense in the context of the time when the Ancestors first arose out of the original mud or sea or sky and brought the first sunrise with them. In English it is articulated as the "Dreaming" or "Dreamtime"—a dream in the sense that it is not set in the past, but in a kind of parallel present

universe, rather like the one we operate in while we are asleep. In Aboriginal lore, the Dreaming is the reason for everything that has ever existed and ever will exist. And its stories are told in layers, depending on how ready, or authorized, the listener is to understand them. It is said that your personal Dreaming depends on where your mother was when she first felt you in the womb. The Ancestors who live in that place have given you "anima"—they have animated you—and when you grow up their stories and songs will be in your trust, and you in theirs.

There is very little that is gentle about the Dreaming; in fact a lot of it is very raunchy. Its stories often involve ancestral animals and people being killed or punished, or they include details of them moving through the land along paths that have become sacred tracks, finding food and allies and enemies. They are epic stories containing (as all the best epics do) universal truths. They are about the law of the land, but they are also the land itself, and only certain people are authorized to know them. So a story or song about, say, the Wawilak sisters—who set out on a journey at the beginning of time, and were swallowed by the Rainbow Serpent when one of them bled into his waterhole—works on several levels. It acts as a reminder of spiritual truths, as a warning to behave according to certain social rules, and as a map. It might—if you have been authorized to decode it—tell you to turn toward the east at this hill to find water, or to stop at that camp to find grubs, and it acts almost as a key to the country, a way of finding your way through it safely even if you have never been there before. And similarly the material—ochre—with which these stories are passed on in rituals or on caves is not only from the land. It *is* the land.

Red ochre has dreaming stories—there are probably as many stories as there are tribes, but most of them seem to hinge on the spilling of blood. Parachilna was said in some stories to be the blood of an ancestral emu, and by others to be the blood of the Marindi dog, which was tricked and killed by a lizard hanging at its throat.

Wilga Mia was, according to Warlpiri legend, made by a man who stole it from a deposit of congealed blood. And another story of red ochre from the Calgoorlie area[14] tells the tale of Kirkin, a man with sun-bleached hair, whose beauty dazzled everyone—especially himself.

At sunrise every morning this matinee idol of the Ancestral Age would stand on a high boulder, comb his golden hair and enjoy all the adulation and attention. But one person did not adore him. A healer called Wyju saw straight through Kirkin and laughed at him for his vanity. Naturally Kirkin hated him for this, and plotted revenge. He told Wyju he wanted to go out hunting with him to find a special bird that was wonderful to eat. The only problem was that a hunter could only catch it by jumping on top of it. The comedy of the chase was cut short by Wyju's jumping into a trap of spiked spears that Kirkin had set for him. The wicked Kirkin laughed and left Wyju to writhe around the valley, spikes piercing the tender soles of his feet, staining the earth with his blood. And ever since that time, the myth goes, Aboriginals have gone to that valley for red ochre. They have smeared the "blood" of the young ancestral healer on their sons before initiation, to teach them to be good men.

This is one of the reasons why ochre is not only sacred but also dangerous. Red ochre is an integral part of the initiation ceremony of young boys when they become men. In north-east Arnhemland, for example, novices are smeared with ochre in sacred clan patterns on their chests, with white clay masks on their faces. The paint is part of the secret of initiation—and perhaps it is even the secret itself. Many people have speculated on the significance of this red earth—and anthropologists have tended to focus on the symbolism of red as representing men's blood (meaning death), or women's menstrual blood (signifying, perhaps, the potential for giving birth). But there is an alternative theory, a curious one: that the iron in red ochre somehow acted as a kind of magnet, to show Ancestors and Aboriginal people the way along sacred paths.[15]

# COLOR

When I first heard this I dismissed it as New Age confusion, but then later I heard something new about red ochre—something that did not change my mind, but left it a little more open.

I learned that scientists in Italy have found a new technique for dating frescos almost to the year they were painted, simply by examining the red paint. "Red ochre contains iron, and the iron molecules act like compass needles," explained Professor Giacomo Chiari of the Department of Minerological and Petrological Sciences at the University of Turin. He said that in the few minutes between daubing red ochre onto wet clay, and the time it dries, the molecules realign themselves toward the direction of magnetic north. "And if you don't move the walls then that is how they stay," Professor Chiari said. Magnetic north changes every year—it can fluctuate over a range of 18 degrees, so you can learn when the fresco was painted from the direction in which the red ochre is pointing. This can lead to curious artistic discoveries: at the Vatican Library, for example, there were three frescos which were believed to have been painted in 1585, 1621 and 1660. The Turin scientists took tiny samples from the borders to see whether they could test their theory. "We couldn't understand the results. All the ochre was pointing the same way and it wasn't in any of the ways we were expecting," Professor Chiari said. And then they did more tests and realized the truth: the frescos were original, but all the borders had been repainted in 1870. Magnetic north is very erratic, though, Professor Chiari added. "So we can do it both ways: we sometimes use frescos—if we know when they were painted—to tell us where magnetic north was that year."

He was not aware of the technique being used to date bodies that had been painted in red ochre—as has been a funerary custom in Australia, Africa, America and Europe for thousands of years. Partly because nobody could be sure whether the body had been moved after the ochre had dried and partly because the burials had happened too far in the past. "You can't go too far back because we don't know so much about magnetic north thousands of years ago."

Roqué said there was no way I would learn about red ochre in ceremonies: "it's forbidden for anyone to talk about it," and he told me how it was far harder to learn about Aboriginal traditions in the 2000s than it was in the 1930s—not simply because there are few men and women who remember them, but also because there is a deliberate move toward hiding information in order to protect it. His sister was working on a project to put anthropological works about Aboriginal ceremonies into special places in libraries, where readers had to apply for permission to read them. But there were still plenty of other uses of ochre that I *could* see, he said. If I wanted to know about ochre in culture I should go to the Tiwi Islands. And if I wanted to know about ochre in art I had to go to Kakadu, on the edge of Arnhemland. "It's the biggest art gallery in the world."

## OCHRE INCEST TABOOS

The Tiwi Islands are just twenty minutes' flight across the Apsley Strait from Darwin, but when you first arrive at Bathurst air strip it seems as if you are in another country. Not Australia at all. The language is Tiwi, and the children at least scarcely speak any English. The people are represented by sixteen councillors who meet at the Tiwi White House to oversee the running of the islands. Although they like to keep themselves separate from the rest of Australia, some years ago the Council voted to allow a maximum of a dozen tourists a day, so that outsiders could understand their culture.

On the surface the Tiwi people have an idyllic island existence. Plenty of sunshine, bright shirts, pretty painted buildings surrounded by palms, lots of artists working in big bright art centers and everything fringed by immaculate beaches. But on other levels the islanders not only have to contend with some of the alcohol problems that threaten so many Aboriginal communities, they also have some of the most rigorously prescribed ways of social organization I have ever encountered.

# COLOR

The problem stems from the demographics. There are only 1,400 people on the two islands of Melville and Bathurst, and for many years they believed they were the only people in the world. So they developed strict ways of preventing intermarriage. And those ways have remained. There are no mixed schools on the island. Not for education theory reasons, but because sisters and brothers cannot even look at each other, let alone speak. Our guide, Richard Tungatulum—one of the councillors of Tiwi—related an anecdote of a man who arrived at the tiny field hospital one day in tremendous pain. The doctor was out, but instead of helping the patient the nurse went to make herself a cup of tea. "She had to," said Richard. "She was his sister."

Everyone is born as one of four moieties. You can be a sun, a stone, a mullet fish or a pandanus palm. If you are a sun then you can marry neither sun nor stone: your husband or wife must be either a mullet or a pandanus.[16] The Tiwi world is made up of four symbolic ochre colors—and each moiety is represented by one of them: sun is red, stone is black, pandanus is white and mullet is yellow. Red and black marry only white and yellow: the "strong" colors always marry the "gentle" ones.

Despite some of the best attempts by some of the worst missionaries,[17] Tiwi beliefs have survived alongside the biblical ones. The Tiwi Dreamtime story involves a blind woman bursting through the earth with her three babies in her arms and crawling over the dark and featureless land,[18] shaping its topography. Her daughter grows up to become the sun and marry the moon. And in the mornings the sun paints her body with red ochre to please her husband, and then when she reaches the western horizon at the end of the day she powders herself with yellow so she is beautiful for her night journey through the underworld.

In the past, there was no trade with the mainland so all the ochres came from the islands. The best white paints tend to be from One Tree Point and the yellows are from Cape Fourcray, and collecting them—in the days before four-wheel-drives—used to re-

quire a full-scale expedition. There are some natural reds, but they are rare, and most of the ordinary red paints are made by cooking the yellows. This is one extraordinary characteristic of this iron-oxide paint: heating the yellow ochre makes it turn red through a process called calcining. It is not a good enough red for the most sacred uses (it is not shiny enough), but it is valued for ordinary painting. And in Europe too, calcining is so common that some paints have two names because of it. Sienna is matched by the redder "burnt sienna," while in the eighteenth century Dutch paint-makers used to buy yellow ochre in France, heat it, and sell it as English Red.[19]

I was introduced to four women who explained some of the more exotic aspects of Tiwi culture. There are twenty-two different dances, and each person inherits one. There is, for example, a crocodile dance and a mosquito dance; there is even one for a battleship. I asked a woman called Doreen Tipiloura what her dance was. "My great-great-uncle saw a train once, on the mainland," she said. "So I dance train."

Each person also has their own face painting, according to what their Dreaming is, and they demonstrated the patterns for us by painting their own faces. Would it be possible to paint my face with ochre? I wondered. So Ruth Kerinauia gamely painted her Little Sheep Big Sheep totem on my cheeks and forehead—candy stripes above the eyes and beneath the chin, then smaller stripy lines along my cheekbones. It was only later—when I saw a photograph—that I realized she had altered the colors into a kind of tonal mirror image of her own painting. Where she painted white on her own face, she painted black on mine: where she had yellow looking luminous on her black skin, I had red looking luminous on mine. It was as if some of the lines and tonal contrasts were particularly important in the design, so she needed to paint them in a way that highlighted them. Caucasian people, incidentally, are not called "white" but "red" in Tiwi language. I was a *moretani*: a "hot red face," although they didn't call me that to my hot red face.

Ochre was also used on what are called "pokemani" poles. A death on Tiwi is mourned for a long time. For the first month after a close family member dies you literally cannot lift a hand and other people have to feed you like a baby. The name of the deceased cannot be mentioned for an agreed amount of time—sometimes years—which only ends when a ceremony is held in which the dead person's belongings are buried, and the family erects a series of slim painted poles to mark the place. Usually visitors cannot see these poles, but we were led to a quiet place in the forest, where the possessions of one of Richard's friends lay buried. He had died of a heart attack while playing football, when he was just thirty years old. He had been the first Tiwi tour guide and his family decided he would have liked his grave to be a place where strangers could learn more about the culture he was so proud of.

The poles are like an obituary, if you know how to read them. Richard's friend was a sun moiety so there was a predominance of red in the designs. And the patterns each showed something about the dead person's life. "The dots are people and the lines are pathways," Richard explained. "And what are these strange shapes?" someone asked, pointing to big yellow ovals on one of the poles. "Those? Oh, those are Aussie Rules footballs."

## The edges of Arnhemland

Roqué had told me that if I wanted to see ochre in ancient art, I had to go to Arnhemland. And two days later I found myself at its fringes. Kakadu is the section of western Arnhemland that has been opened up to visitors, as part of a national park. The rest—everything to the east of the East Alligator River—is open only to residents and permit holders. Yet I was lucky. On my first night there was a one-off theatre performance—a collaboration between the people who lived in the settlement of Oenpelli and the Stalker Stilt Company from Perth. *Crying Baby* was a highlight of the Festival of Darwin, and was performed under the stars. It was the only

theater show that I have been to that has been dependent on river tides, with the extra frisson that if you were caught in the middle you might get eaten alive—not by alligators, though: the river was wrongly named and the huge reptiles that skulk around this fast-running river are actually crocodiles, but no less fierce for that. "Man got eaten last year," a ranger said cheerfully, when we were waiting to cross into what one of the white theatergoers gleefully called "the forbidden land."

The play was based on the personal history of a storyteller called Thompson Yulidjirri, whose family members were removed from their homes by missionaries and taken to Goulburn Island, mixed up with the Dreaming story of a Crying Child, whose parents did not look after it, their lack of care resulting in the Rainbow Serpent taking its revenge. The story was chosen to highlight some of the problems of so many settlements throughout Australia, where alcoholism is rife, and children can too often be abandoned. In the audience Old Bill Neidje—one of the respected elders of Oenpelli—was sitting in a wheelchair. When Neidje was a child the missionaries gave him and his family white flour. They didn't know what it was and they used it as body paint. "You're wasting food," the missionaries told them, laughing, before introducing them to the mysteries of damper—a flour-and-water glue that is cooked over a fire into an unleavened bread. But the Aboriginals would have been wise to have stuck to the body paint theory. Their new diet of wheat and sugar was the first step on a journey toward diabetes and dialysis.[20]

At the end of the play I went to talk to Thompson and his fellow elders. They were daubed in white ochre, and said they would be happy to talk about their use of the pigment. We could talk now, they said, or I could go to Oenpelli to see them. But now was impossible—the Alligator tides were turning and we would soon be unable to return to Kakadu—and the next day I learned that, invitation or not, it would probably take at least ten days to get a permit. I thought I could just make it, I said, filling in the form.

# COLOR

"That's ten *working* days," said the white administrator, reluctantly taking the application from me anyway.

I spent some of the intervening time looking at part of one of the biggest collections of art in the world. There are many thousands of paintings in caves and rock shelters all over the plateau. Some of them tell sacred stories—of rainbow snakes and lightning gods, of hunting grounds, and of ancient sisters who walked across the land making waterholes and hillocks and places so dangerous that only initiated men can go there. Then there are Mimi paintings, said to have been made by the shy stick-like spirits who live in the cracks between the rocks. You can see the work of the Mimi in the highest paintings at the tops of caves, which can only have been executed by very tall creatures, or perhaps by humans with scaffolding. There are also spray paintings, probably done by someone putting wet paint in his or her mouth and spraying it over their hand (or a child's hand) or foot. And then there are the so-called "rubbish" paintings—with a whole host of subjects, some of which are rude, some historical—including three-hundred-year-old paintings of Macassan traders arriving in their boats—and some the kind of dis-tilled Dreaming stories designed to be told to children.

Although the most sacred paintings were believed not only to de-pict the Ancestors but to embody them, many of the other cave paintings were never meant to last. They were illustrated lessons and they had a similar significance to, say, blackboards in a religious col-lege. What they signified was precious, but what they were was not. However, today, when much of Aboriginal tradition has disap-peared, all the paintings have become valuable in their own right, both as artifacts and as ancient messages for future generations.

According to George Chaloupka, in his book about the paint-ings of Arnhemland entitled *Journey in Time*, there are eight main color terms for the paints: black, yellow, deep yellow, the red that is made by burning yellow, a light pink and the shiny hematite red with a purple tint. A color from the twentieth century is "blu" or Reckitt's Blue, introduced in the missionaries' laundry baskets

in the 1920s. And then there is *delek*, which is the word both for "white" in particular and for "color" in general—a linguistic affirmation perhaps that although red is sacred in these parts, a good white is also very precious. It is valued partly because it shows up well on both caves and bodies, partly because it is useful for painting both spears and coffins (one evening I found myself in the Aboriginal Town Camp in Jabiru, in the middle of Kakadu, and was taken to the home where a man had just died, and where his relatives were painting around the car with white paint) but partly because the best of it—a clay called huntite—is believed to be the feces of the Rainbow Snake.[21]

When I first heard this I was rather taken by the metaphor: the idea that the rainbow spectrum should somehow shimmer through the sky and over the earth, and that it should leave a dazzling white behind it. The truth was rather more prosaic. "Have you ever seen reptile droppings?" asked Alex Dudley, a ranger with whom I discussed the myths one evening. I hadn't, I admitted. So with his penlight we went hunting for gecko droppings, and soon found some on the glass dome of a Telstra phone box. They looked like little white slugs. A python's droppings are bigger, he said, making a shape in his hand that suggested feces the size of a tennis ball. "Imagine what the Rainbow Serpent could do after a good meal."

A few mornings later I was disconsolate—I had returned to the permit office and no progress had been made. "Thompson invited me," I said. "How do we know?" was the answer. I knew no Oenpelli phone numbers except for the arts center telephone, which rang and rang. I asked the woman whether she could try again, and went for a long walk to think about what I was going to do instead in order to learn more about this elusive paint. During the walk I bumped into a guide who specialized in animal tours. "You'd better go to the buffalo farm," he said. "Patsy will show you how colors work." Which is why the next morning I found myself pulling up to what appeared to be a deserted homestead at the end of long tracks guarded by plenty of "Trespassers Will Be Prosecuted" and

"Attention: Electric Fence" signs. It was a strange place: there were huge bits of iron everywhere—red and raw as if a container ship had rusted in the desert. I got out of the car and looked around. It was one of those mornings that shimmer with heat and silence, warning that it is going to be hot. There were flies buzzing around a buffalo horn that had been neatly sawed in several places and left lying on the ground, exposing blood and marrow, and everywhere there was the sweet smell of the abattoir.

Just when it seemed as if there was nobody there at all, Patsy and her husband Dave appeared from a shed. Patsy was born in Arnhemland and had grown up in a traditional community; Dave was a white Australian who had been a ranger for many years and was now managing the farm as a live larder for the local Aboriginals. When they wanted meat they would come and get it from him. Patsy had been married to a man in Maningrida, a coastal settlement in the heart of Arnhemland, but when he died she was pursued by a man she disliked. "My uncle Paddy said marry Dave, so I did."

Patsy was quiet at first, then she warmed up. Later she told me why she was so sad: her younger brother had died the Sunday before. He had been thirty-one and one of the last true bushmen, I heard from someone in town later. He had also not been a drinker. On that Saturday night he had seen a cat in the darkness, and the next morning he was dead. He had had an argument with a close relative a year back, Patsy said, and shrugged. In our different ways we both paused to picture a world that encompassed sorcery and revenge. She agreed to take me into the bush, to show me how she finds the dyes for baskets. We drove for several kilometers past electric fences that Dave had promised he would switch off—and as Patsy leapt out of the car with her axe and started digging up a small bush lying near one of them, I prayed that he had remembered. "Yellow color," she explained. "And red too." I asked what she meant, but she said she would show me later. She also showed me how she found gray from the green fruit of the kapok tree,

which contained gray feathery intestines also used to stuff mattresses in the old days.

Breakfast was the white heart of a sand palm—succulent and bittersweet—and for "jam" we ate bush apples and red ants with green bottoms that were so full of vitamin C they tasted like stings. As I looked out for buffalo (which apparently could be dangerous) Patsy chopped down half a tree to make a forked stick, and then started hooking out the leaves of a pandanus tree—a palm with long spiky leaves bursting out from it like wild thick hair. This was the raw material for making baskets, she said, and when we returned to the farm we sat on a mat made of corrugated iron and she showed me how to strip the leaves, separating the soft underside from the hard top. She completed fifty to my one, but we sat companionably for an hour or so. Her puppy was getting tangled up in all the leaves. Patsy smacked him and then hugged him and then smacked him again. Suddenly a dinosaur crossed the path near us. "That's just Stumpy," she said, laughing at my look of alarm. Stumpy was a goanna—a meter-long lizard with a fierce face that gives a good clue to his general disposition, and no tail, having lost it in a fight.

Patsy took the roots of the yellow bush—which she called *anjundum*—and scraped off the skin. She divided them between two saucepans and started to boil them with the stripped pandanus. All my many wasted pandanus-stripping attempts were then gathered up and burned into ashes on our corrugated mat. "This is the red one," she said, adding the ashes to one of the pots. "And this is the yellow one," she added, pointing to the other. I realized that *anjundum* had a similar characteristic to pieces of ochre, in that the yellow ones could be transformed into red through cooking—although for the dyes it was a matter of adding some kind of alkali, like wood ash, and not just heat. She showed me a book: Penny Tweedie's *Spirit of Arnhemland*—which contained photographs of a boy called Jazmin being decorated for a ceremony, his face

sprayed from a man's mouth with white ochre, rather like the technique of hand painting I had seen in the caves, and his thin chest painted with a singlet of yellow, white and red ochre stripes.

Another picture showed a ceremonial dilly bag on the back of an elder. It was cylindrical, hard like a basket, and covered in white, red and yellow diamonds. I suddenly realized how strongly the natural dye colors mirror the ochres—red, white, yellow and black. "Dangerous," Patsy commented casually, flicking through the pages. "Women can't see this," she said, pointing at other pictures. I asked her whether it was dangerous for us to see the pictures. "No, we can see the photos, just can't see in real life," she explained, suggesting that by the very act of being set up for a photograph, the subjects had suspended their sacredness for the camera. Her sense of danger was reinforced by stories of women being killed for looking at ceremonies. "It happened before whitefellas came," she said. "But even now too," she added pensively. "Maybe."

Three days later my permit was turned down again: I realized I might not get my interviews. I had been circling carefully around both ochre and Arnhemland. I had talked to people who used it for hunting, and seen how it was still used for funerals. I had seen the colors that women use to imitate sacred patterns. But now it was time to meet some painters. "There's a good mob down Barunga way: they do painting," said a man I met at the Jabiru Social Club. So I called them. The Beswick and Barunga areas are in a protected area to the south-east of Kakadu. Could I come? How could I request a permit? I asked the arts coordinator, David Lane. "You've got a permit," he said generously. "Come down when you like." And yes, he confirmed, they did use natural ochres. "We'll take you to find them if you want."

I hired the only available four-wheel-drive in the area—a huge Nissan Patrol that made me feel I was Queen of the Road. When I arrived at Beswick, which was at the end of a red dust road so well made I felt a bit of a fraud in my grand car, I found a pleasant rural

community of about five hundred people. There were picket fences and a well-tended playground and community center, with big houses set off the road and surrounded by grass and old mattresses. Beswick had been built in the 1940s when there was an emergency relocation of Aboriginal people from the coastal areas after the Japanese started bombing. Some had returned to Arnhemland but many had stayed, although some still dreamed of going home—and one of those dreamers was Tom Kelly.

Tom—a man in his sixties with a timeless etched face—was sitting on the porch of the main offices of Beswick. He had been a hand on a cattle station for many years but he had retired to Beswick to make and play didgeridoos—or "bamboos" as they call them in the creole that the people (who come from seven language groups) tend to use. "Tom's one of the best," David Lane told me. "He's travelled the world with his didge." Tom nodded matter-of-factly. "Been around," he murmured. His group, the White Cockatoos, had been to many international music festivals, although now his dream was only to go back to live in Maningrida—the Arnhemland community where he was born—before his wife became too ill. Of all the places he had visited he'd liked America the best, especially meeting "them Indians," who, he said, "also paint with ochre like us."

He and David first showed me the didgeridoos. The stick-like instruments were covered in stories and pictures of lilies and file snakes and turtles in different ochre colors. One was decorated with a series of concentric red circles filled with white dashes, all on a black background. It represented water, Tom said, and the dashes were the effect of leaves falling on a waterhole. "It's not country," he said. "We don't paint country on bamboos. Just pictures."

He and two relatives—Abraham Kelly and Tango Lane Birrell—were to take me to find ochre from a nearby source called Jumped Up Creek, and suddenly my Nissan no longer seemed like an embarrassing overestimation of the terrain. Ten minutes out of town we turned off the main road onto what they said was a track, but I

had my doubts. We churned up spiky spinifex for about a kilometer when Tom suddenly told us to stop. So we stopped in what seemed the middle of nowhere, got out, and suddenly I realized we were standing in a giant paintbox. The dried-up creek bed didn't just have one color, it had dozens, all combinations of the basic four colors—dark red hematite, lemon yellow, white pipeclay and black manganese that looked like chewing gum spat out by dinosaurs and left to ossify. The colored stones and pebbles were strewn in every direction. You could pick up almost any of them and you had paint in your hands.

Abraham found a big flat white stone from beyond the creek. That was to be our palette and canvas, and Tango—who had a water bottle with him—showed me how to pour water on to it then take a stone and rub it vigorously over the water to make it into pigment. The stones had the right combination of clay and color to make painting easy; they were even smoother than my little Italian stone. Is this what they use for the didgeridoos? I wondered. "Yeah," said Abraham. "We used to," said Tango. "Now we use acrylics. Ochre needs a vehicle, it's too far to walk. We had a vehicle before but the engine got buggered."

Beswick is the last domain in the area to the south of Arnhemland that is considered culturally "intact." Its inhabitants still organize initiation ceremonies, with boys going into the bush for four or five months to prepare. "We've only got five or six old men left now to teach the young ones," Tango said. In all the settlements there were problems, he said. "Ganja, petrol-sniffing, all that." But one of the biggest problems for cultural life was that the old men were dying. "Me, I'm forty-eight years old. If I don't get anyone to teach me then I'll fade away, the whole thing will just fade away." The multicolored stones of Jumped Up Creek were used for both art and ceremonies, Tom said. "But we don't tell you about ceremony," he added firmly. "It's secret."

"Secret" is such a vulnerable thing in Aboriginal communities today. The stories have been passed on only with difficulty. Yet they

have probably never been so important—not only in the religious sense, but also in the sense of identity. What meaning do stories and paintings about land and country actually have for a sedentary person who rarely sees the places they refer to? Today, when there are so few stories for men like Tom Kelly to pass on, it is important to pay attention to what is left, and to respect the very thin blanket of secrecy that can be spread over them. Things were not in fact so secret sixty years ago, when there were more stories and they were told fairly freely to anthropologists.

## ALICE SPRINGS

Theodor Strehlow was the son of a missionary; he grew up with Aranda playmates, spoke the language fluently, and kept diaries and accounts of the ceremonies and traditions that he witnessed. His papers and pictures are held in the Museum of Central Australia, just outside the center of Alice Springs and an overnight bus journey from Beswick. To access them I turned away from the dark display cases of stuffed possums and exotic rock samples, and went through a nondescript door into a triangular room with space for four chairs, a telephone and what looked like a two-way mirror. I felt as if I were in a spy film, or entering the secret headquarters of a cult.

I sat down in a chair and looked at the telephone for a while, wondering whether I had a good enough reason to dial 11–111 and ask to consult the files in order to learn more about ochre. Then— and as I write this a few months later I'm surprised I did this—I stood up and left the room without even picking up the phone. These were secret documents, so secret that in 1992 they had been confiscated from Strehlow's widow's home and put into the safe-keeping of the museum, for whenever the Aboriginal elders or scholars wanted to consult them. It wasn't right for me even to try to see them, I decided. Whatever I was to find out about red ochre would either be things people told me in full knowledge of why I was asking, or things I found in public libraries, open to anyone.

Even if that meant I knew less, it meant I knew it fairly. And, to my surprise, that afternoon I found in the reference section of Alice Springs's public library some of the information I had been looking for. It was an account—written up in Strehlow's *Songs of Central Australia*—of a sacred ritual that might help me understand why red ochre was so sacred.

In the hot summer of 1933, Strehlow was invited by four elders of the Loritja tribe to see a rain ceremony at a place called Horseshoe Bend, not far from Alice. He described how the men—having approached the cave banging shields and boomerangs to warn the Ancestors of their arrival—pulled three sacred rain sticks or *tjurunga* from the bottom of the cave. Two were slim poles, about the size and shape of didgeridoos, representing rain brothers who had travelled through the Central Desert country at the beginning of time. The third was smaller, and symbolized the brothers' two grandchildren: greedy infants screaming for blood.

The thirst of even the most hemoglobin-challenged of ritual objects was satisfied that afternoon. In order to honor the rain ancestors, the four blood donors cheerfully set to work tying their arms and opening the veins on the forearms, Strehlow wrote. They all had problems getting a good flow and spent the first five minutes cutting, splintering glass chips, and pulling at the opening of the cuts. But when the jets came they came quickly, spraying the *tjurunga* and then drizzling on top, bottom and sides of the cave entrance. It was, the missionary's son noted, the greatest quantity of blood he had ever seen sprinkled about for a ceremony.

The account is written in a very matter-of-fact way, but Strehlow added in a footnote that he had to brace himself for this "orgy of bleeding" by downing several good brandies, and even then he had to watch it through the lens of his Graflex camera, standing a short distance away, so he did not feel too sick. It was a hot day and a small gully, and he found the smell of blood quite overpowering. He was told that these three *tjurunga* were unique among the Loritja in that they were never painted with red ochre, but instead

had to be refreshed with human blood at frequent intervals. Later he speculated that the usual practice of smearing *tjurunga* with red ochre might be a substitute for covering them with blood, although this was, he emphasized, purely a guess.

When the ceremony ended, the bloodstained sand was trampled until all signs had been wiped away; each man had to scrape the marks from his arms, and wash himself before returning to camp. It was important that the women shouldn't smell the blood, Strehlow noted. I was reminded of a story I had heard a couple of weeks before, whispered over a beer by a man in the Northern Territory. He knew a man, he said, who had been to an initiation ceremony in the mid-1990s, and had carelessly left the ceremonial red ochre glistening on his arm so that the women could see it. He had carried something dangerous into the world where it could not be contained, and the penalty for that was death. "They did it with spears," the man whispered, glancing melodramatically over his shoulder.

In the same library was a book about the Dreaming places of Alice Springs—which directed me to the road running along the Todd River (so dry that there is an annual regatta where the racers run, carrying the boats) and leading to the casino. The map recorded it as Barrett Drive; the Aboriginals preferred to call it Broken Promises Drive. When it was first proposed, the Aboriginal guardians gave permission for it to be built—as long as it wriggled round a spot that was known as the Caterpillar Dreaming because it included a long mound believed to mark the space where the caterpillar Ancestor rested beneath the earth. But the road builders were greedy; the wriggle would cost dollars. They blocked the road off and a few months later opened it unrepentantly—with several meters cut off the tail of the caterpillar. The wound was still there. From the road I could see a long mound about three meters high and five meters wide curling away into the distance, covered with eucalyptus and grass and signposts warning people to stay away. The mound ended abruptly at the road, where it had been chopped,

and I saw something glinting in the debris. In fact I saw a lot of things glinting. It turned out that the "caterpillar" was made of a rock that flaked off with shiny silica dandruff. This rock on the road to the casino was not just ordinary stone, it was stone that changed color as you moved. Once again I saw how the "sacred" was something that was full of gleaming colors.

Everywhere in Alice Springs you can find Aboriginal designs. They are on logos and place mats, T-shirts and didgeridoos, and, of course, they are on canvases—in the dozens of art shops that line the streets of the town center. There were a few of the Northern Territory ochre paintings I had seen at the beginning of my journey, and there were others that seemed to represent some kind of stylistic transition—by artists who came from the Kimberleys to the north-west of Alice, who still used ochre but in ways that involved large areas of paint, rather than either dotting or stripes. One of the most powerful of these was a man called Rover Thomas, who lived between 1926 and 1998 in Warmum, Turkey Creek, just to the west of the Darwin–Alice road, and about halfway along it. His paintings look like pieces of kangaroo skin stretched taut with pins of white pigment. The work seems less a painting of the country than a kind of wrapping up of the country—rather as Christo did with the Reichstag in Berlin. He uses a deep chestnut brown and his skies are the color of bitter chocolate. He always uses natural pigments, often mixed with bush gum and applied to marine ply.

But most of the paintings in Alice were, quite naturally, from the Central Desert. They were bright acrylic canvases in patterns of dots and curls and splashes and concentric circles. If they had been from Europe or America they would have been given labels like "abstract expressionist" or "neopointillist," and the influence of such artists as Miró and Picasso would have been discussed in unending detail. But they were from Australia with their own distinctive artistic inheritance, so although those comparisons have been made, they have mostly been allowed just to stand for themselves. Many of the

paintings had a title like "Two Snakes Dreaming" or "Dingo Dreaming," and some included explanations of the iconography—that, for example, a concentric circle meant a waterhole, or that an oval shape was a shield, or that little curled lines represented men sitting at fires. These were some of the stories that had so intrigued Bruce Chatwin, in his journeys for the book that became *Songlines*, describing the way Aborigines traditionally conceptualize Australia as a series of sung stories, criss-crossing the land.

The paintings, when you look at them for more than a few minutes, seem to be an exercise in optical effects—like one of those Magic Eye games, with an obvious picture in the front and another picture "behind" it which you can see if you focus away from the paper. Like the shiny red ochres that I had not seen but had heard of in Arnhemland and South Australia, the paintings from the Central Desert seemed almost like another way of flipping reality. In their case by dotting it into non-existence.

I began to recognize some of the different artists—particularly the more famous ones. Ronnie Tjampitjinpa, whose work was made up of bold squares, either set inside each other or spiralling geometrically into a central point. Then there was Rover Thomas, of course. And the Petyarre sisters—Ada Bird, Gloria and several others, much of whose work is made of small, swiftly painted dashes in contrasting colors such as green and purple, giving the effect of a weeping willow shivering in the wind. Listening quietly to conversations in different galleries, I learned that "Glorias" were getting more expensive, while "two Ronnies" cost about the same as a car nowadays. "Though good Ronnies are so hard to get nowadays," was the sad comment from the dealer I was eavesdropping on. "He's having domestic problems."

## UTOPIA

The Petyarre family comes from a place called Utopia. Perhaps it was the name or perhaps it was the art from that Central Desert

settlement—with its bold control of color contrasts—which intrigued me. But I was determined to go there, and was fortunate enough to get an invitation from Simon Turner, the arts administrator who works as a go-between connecting dealers and artists. The settlement is about 100 kilometers north-east of Alice Springs. To get there from the Darwin Highway you turn east onto a dusty track and north onto an even dustier one. For kilometer after kilometer the land stays flat, a dry plain of gum trees. Then there is a tiny rise. Just 10 meters elevation or less, but suddenly you are in another world. The Aboriginals describe it, when they do, as the Mountain Lizard Dreaming or the Bush Plum Dreaming, and they tell its stories in layers and paint them in dots. With my stranger's eye, I knew only that the country was suddenly greener and lusher. The land had lumped itself into rocky formations like stone citadels, or entrance gates to another country. In a strange way it felt as if I had really arrived somewhere.

And then, a few kilometers later, I did indeed arrive somewhere. Utopia was named a long time ago before there was a settled community here, and so the name was not as ironic as it may have appeared. It was certainly a strange, dislocated place. It was a scattered series of seemingly unplanned houses or "camps" separated by trees and tracks and "humpies," which were blocks of corrugated iron surrounded by mattresses and bits of dirty clothing, where many people stayed outside on the warmer nights. There was a convenience store—containing the strangest mixture of highly priced items such as televisions combined with cheap ones like white bread and fried food. And there was a playground with broken equipment. One swing had curled up on top of the frame and begun to rust up there. Helped by two half-naked children, I prodded it with a stick until it swung down again. They grinned and jumped on it. The job had taken only ten minutes, but nobody had bothered to do it.

Utopia is what is called a decentralized community, consisting of sixteen outstations. I had been invited to the main one, called

Yuendumu. It was the first dry Aboriginal community I had visited (which made it safer, especially for children and women who lived there), although the place had other problems, largely due to boredom and lethargy. It is a terrible thing to lose your land, but when (as in traditional Aboriginal culture) that land is not only physical but also an embodiment of the spiritual, it is hard to find anything to take its place. The nomadic life has its own purpose to it: without the need to walk, what do you do? On my first morning I went for a walk and some women beckoned me over to their "camp." From the outside it looked like a house with a verandah but inside it was like some of the air-raid bunkers I used to break into in my childhood: bleak and dank, covered in graffiti and radiating a sense of unkemptness. One woman had a black eye. The others had invited me over because they wanted to see whether I had any clout with the arts administrator and, more importantly, whether I could use it to get them new canvases. "Finished this one," one said, pointing to a painting that showed her "country" in tiny dot patterns of bright greens and whites. "Without a canvas, nothing to do."

Later I went down with Simon to the arts center—a tumbledown place, although recently built. So many things in these communities age too quickly. The Formica cupboard doors were hanging off their hinges and rubbish threatened to take over; there was a sign stating (on behalf of Arapuntja Artists Inc.) that no dogs were allowed in the studio. This one-room building was not intended to be a retail point—few individual art-buyers reach Utopia—but a place where art was made, although now it is more like a place where canvases are doled out and cash transactions arranged.

Utopia was the country of the late Emily Kame Kngwarreye, dubbed "the old lady," a former horseback rider in the stock camps who became one of Australia's most famous female artists (whose paintings of her country were used as evidence in land rights hearings). Many of the artists of Utopia are women, and it seemed that most of them were at the arts center that morning handing in their

COLOR

latest works, and lobbying for new canvases, while their toddlers and babies played on the dirty floor of the center. The paintings were made up of pointillist dots, and the effect was rather similar to looking at spring meadows full of flowers—but with blurred eyes and from a vantage point high above them. "What do you want to say here?" Simon asked each of them as she handed in her completed painting. "White is flowers," Polly Ngalr said. What kind of flower? "Yam flower. And yellow is seeds." What kind? "Yam seed," she said, being patient. Some of the titles of the paintings shifted during the morning from *Emu Tucker* to *Bush Plum Dreaming*, and back again. Nobody seemed too bothered once the price had been set and the negotiations started for another fresh canvas.

Amy Nelson Napangardi hadn't been given a canvas last time, so this time she was desperate. She has custodianship for the Witchdoctor Dreaming, which describes how bush medicine can be found. "Like that one," she said, pointing to the Bush Plum Dreaming someone else had painted—interlapping dot patches in pinks and yellows. "But my colors are not pink, " she added emphatically, and explained that the Witchdoctor Dreaming used just four colors—yellow, red, white and brown. That morning I had found myself desperate to somehow understand the paintings better—to understand what made them represent "country" or a Dreaming story, to appreciate them for more than their (often spectacular) color contrasts. I had hoped that perhaps by knowing what was not allowed, or at least not appropriate I could understand the paintings better. "Why not pink?" I asked her. " 'Cos whitefella buyers don't like it, " she said.

And this is one of the curiosities of this extraordinary art movement. The buyers seem to want a sense of "authenticity" and yet nobody is quite sure what that means, nor indeed what it should mean. The fact that the painting is done by Aboriginal people seems to be vital—when, in 1977, it was revealed that the "Aboriginal" artist Eddie Burrup was in fact an eighty-two-year-old white woman called Elizabeth Durack, there was national out-

rage—and that it is made by Aboriginal people who somehow have some insight into nature seems to make it even more "valuable." The fact that many "whitefella buyers" demand paintings in the natural colors of the land (ochre colors, although in acrylic versions of the original earth) also suggests they are searching for that ever elusive authenticity—a country and a history embodied in the canvas of a painting available in an art gallery or auction house. In Alice Springs I had visited one gallery advertising the work of an artist "who had come in from the desert." Somehow his work was seen to have more integrity because he was a nomad—by buying it, or having it, there was a sense of being part of a world that has now disappeared. Yet in truth, as I would learn later from the man who helped start it, the painting styles of the Central Desert Art Movement are actually combinations of Aboriginal patterns and colors and the visions of white art administrators. And the two influences can scarcely be separated anymore.

Gloria and Ada Petyarre were away from Utopia—invited by art galleries to tour with their own paintings. But their sister, Margaret Turner Petyarre, was there at the arts center. So I sat down next to her on the floor and—struggling to understand what it was to paint a "Dreaming" rather than a mere representation of a story—asked her several questions about what the paintings meant. Suddenly she looked at me kindly: "You gotta garden, right? You must have nice flowers in your garden; lovely flowers?" I nodded, not wanting to go into the issues of space limitations in Hong Kong. "Well then, you know; that's what this is," she said. "Flowers." I felt rather foolish, almost as if I had pointed to a landscape painting in a European art gallery and asked for its meaning, only to be told that it was trees and water and hills. Couldn't I see?

My question hadn't been entirely misguided, of course. This art, like the shine of the ochre it was originally painted in, is elusive. Yes, it is about texture and tone and contrast and technique, but it is also about something else, something I couldn't quite grasp. Sometimes, in my travels through the Outback meeting artists,

dealers and dyers, I had the fleeting impression that we were not talking about art at all, but about the universality of the human spirit. And then that feeling would disappear again and the talk would be of dollars and four-wheel-drives.

On the way out of Utopia I went to see Greenie and Kathleen Purvis at Boundary Bore, about ten kilometers away, past a shallow lake that stretched through the middle of this parched land. Greenie had the famous name but it was his wife, Kathleen, who was doing the painting, sitting in the sunshine on the ground, surrounded by slobbering dogs, while her husband dozed in the shade of his "humpy" or corrugated-iron windbreaker. These two old people have a house—quite a big one—but as Kathleen explained they don't use it much "because it's full of dogs." Unless it's too cold they like to sleep outside, on swag mattresses under the moonlight: given the choice, I thought, I would do the same. There are few things as spectacular as the night sky in the Outback. They looked poor, but their work was selling well. They were planning to get a satellite television and a Toyota was being delivered the next day. Four-wheel-drives have been a popular means of payment for Aboriginal desert art—in the early days it was second-hand Holdens from a car dealership in Alice, now it is new Toyotas—and in many ways this is appropriate. In the past, the act of painting (as body art or on sand) was one way of passing on the wisdom and the maps, so other people could know both the land and what lies beneath it. It seems right that today the act of painting should still help Aboriginals reclaim the land. Even if it is from behind a steering wheel.

I had seen how the Central Desert painting movement had not only transformed people's lives but also how it had provided a language through which outsiders could try to understand something of Aboriginal culture, as well as helping to keep some of the traditional stories and Dreamings alive in people's memories. And I was intrigued by a tale I had heard again and again about how the movement had started in the early 1970s, with the gift of paint.

## WHEN THE COLORS WERE TAKEN AWAY

Geoffrey Bardon was a young man full of ideas and ideals when he went to the Aboriginal settlement of Papunya in 1971 as an art teacher turned social studies teacher. "A dreamer in a blue VW Kombi van," he once described himself. When he left that place eighteen months later he was in some ways a broken man, as his story would tell. But in that short time he had helped start up perhaps one of the most astonishing art movements of the twentieth century.

I contacted him, and flew up to the small town north of Sydney where he now lives with his wife and two sons. He picked me up from the airport in a VW Kombi van—the kind of van you can just get into and travel wherever you want to go, with your swag mattress in the back. I commented on how he was still driving the same type of vehicle he had been using so many years before. It was a cherished possession, he told me: a reminder of the days before things went wrong.

When we got to his home, we sat on the porch overlooking a garden full of gum trees and flowers, and talked for hours—although he sometimes found it hard, and we would stop and talk about something else. I wanted to learn about the paint, of course. But first he told me about Papunya. It was a hell on earth, he said. A shameful place that in just one year lost half of its population to disease, a so-called "community" where there were five tribal groups speaking at least five languages, trying to coexist and find a new purpose in life when everything they knew had been forbidden to them. It was as if the colors in their lives had been taken away along with their land, and all that was left was lethargy and depression. They were being administrated by arrogant white officials "in white socks"—most of whom, according to Bardon, did not care anything for their charges. "Some of them hadn't talked to a blackfellow in ten years," he said. And as for the 1,400 or so Aboriginal residents of Papunya, "they were retiring, withdrawn,

and outnumbered," he remembered. "And they didn't have the kind of leaders anyone else understood, so they weren't properly represented." But as a teacher he was full of ideals and a desire to challenge the system. And although he knew that many of the children went to school only to get hot meals, he tried to teach them as well as he could.

At first the children's paintings were crude drawings of cowboys and Indians—mimicking the exciting films that were shown on a big screen at Papunya. But Bardon noticed that when they were out of school, talking and playing in the playground, they would draw designs—dots and semicircles and curvilinear lines—in the sand with their fingers and with sticks. So one day he asked them to draw their own designs, and with a little bit of persuasion they began to do so.

The old Pintupi tribesmen were watching, interested, as Bardon's lessons progressed. The children started calling him "Mr. Patterns" because of his insistence on neatness and careful presentation—and, as he says, it is hard to know just how much this kind of early guidance (from him and from the art coordinators who followed) influenced the work we see today. The elders had their own rich painting traditions that had in the distant past been concentrated on body and sand painting, with some more lasting ochre designs on the walls of caves and the sides of rocks. They had tried a few times to revive the practice. But they had almost no modern paints and no encouragement, and Bardon gave them both. And he did something extraordinary. He asked them what they wanted. "This was an amazing inquiry: I saw that in their faces. Nobody ever asked them what they wanted, they were always being told what to do. The slogan was that if you help one fellow you help them all . . . so nobody helped anybody at all." When Bardon asked them there *was* something the Pintupi elders wanted desperately: paint. And what they offered in exchange—what a delegation of men came over to Bardon's apartment and offered one evening—was to paint one of their sacred Dreamings on the gray

concrete outside wall of the school. It was to be a work of art that was significant to the black people themselves, in contrast to much of what is painted today which as I had seen in Utopia is designed for white buyers.

The Honey Ant Dreaming (describing a story, or songline, that runs through Papunya from west to east and was felt to represent all the people of that troubled settlement) had three incarnations on the school wall. All the versions were in ochre colors, red, yellow and black, and all of them showed a long straight line with patterns of concentric circles posted along it at irregular distances, making it seem like string with enormous knots. The first version included little semicircular lines like double bananas, placed around the "knots," and representing the honey ant Ancestors. When it was finished, some elders were horrified that it revealed too many of their tribal secrets, and they held an emergency meeting. The next day the controversial curved lines were scrubbed off and replaced by very realistic little line drawings of ants. But this time it was Bardon who objected, saying he didn't like them: they were too much like "whitefella" painting. So on the third attempt, the "honey ants" were replaced by symbols that all parties agreed on. In retrospect they looked like little fast-food hamburgers, a yellow filling between red burger buns, but it was an important moment in the development of this new art movement. It was probably the first time that symbols had been deliberately swapped in order to show the "blanket" and yet keep the secrets that lay beneath it. In a way it marked the beginning of these dispossessed people finding a way of representing what was esoteric by something that was exoteric—something that was hidden by something that could be shown.

It was an amazing act of generosity for these men to paint their Dreaming—the representation of their layered system of knowledge—on the walls of a whitefellow building, Bardon said. "But few people really appreciated it. Nobody cared what they were doing." In those days he used to joke that with the industrial-strength glue

he had provided to bind the colored poster paint, the Honey Ant Dreaming would last a thousand years. But it didn't, it lasted only until 1974, when a maintenance man, on someone's orders, painted over it with acrylics. If it existed today it would be one of Australia's greatest pieces of art.

The honey ant was just the beginning of the journey. A few men—like Old Mick Tjakamarra, or Clifford Possum Tjapaltjarri or Kaapa Tjampitjinpa, whose names are now huge in the Aboriginal art world—started painting a few canvases in a converted storage area that they had fixed up like a cave. Bardon took the works into Alice Springs (about 250 kilometers to the east of Papunya), and to everyone's surprise came back with substantial amounts of money. Suddenly everyone went wild for materials. The crates that held the oranges for school break would be dismantled as soon as they had been emptied, and used as canvases; "people were painting on matchboxes and bits of board; anything," said Bardon, who remembered one day even using toothpaste as a primer to prepare the wooden planking, because he had run out of everything else. He used up the substantial poster paint supplies in the school and then ordered more. "They particularly liked the bright orange paint," he said. "They said it was from the land—it was the color of the ochre pits."

His first thought was to continue the tradition of painting in ochre or ochre-like colors, and one day he was taken by some of the Anmatjirra artists to a mine in the McDonnell Ranges to the north of Papunya. It is called Glen Helen and has river cliffs of yellow and white paint running through it, representing 700 million years of geological history. "I thought we could have truckloads of this stuff and big cauldrons of glue and we could paint the town red ochre." But the artists, despite being aware of this great natural paintbox, preferred to use non-traditional paints. Perhaps because they were brighter on the canvas, or smoother to use, or easier to find. But perhaps also because it made it less complicated for them to represent their Dreaming stories for outsiders if the materials themselves were not sacred but only represented sacred colors—

like images in a mirror. It was almost as if by changing the paint, the designs had begun to lose the things that made them dangerous and powerful. It was also an immensely practical choice: as I had seen with Katherine and Greenie Purvis at Boundary Bore, much of the work is done outside. The advantage of acrylic-based paints is that they dry fast. Ochre mixed with linseed oil would be corrupted by red sand long before it dried.

The story of Papunya (the art movement was labelled Papunya Tula, with Tula meaning the meeting place of siblings or cousins) seems on the surface a simple and heart-warming tale of success despite the odds. Having been released from the pressure of being powerful, having even been released from the pressure of being ochre, ochre paintings became a way for dispossessed people to operate in their new environment, as well as also being extraordinarily moving works of art in their own right. But Bardon's story—partly told in his 1991 book *Papunya Tula: Art of the Western Desert*—has many layers too. And the ones below the sparkling surface are darker and more difficult.

At first it was exciting; he was selling the art in Alice, bringing back money—and later cars—for the painters. But within a few months, he said, things started turning bad, until they culminated in one terrible night that Bardon will never forget, and will still not talk about. The white administrators started to resent the fact that their "dispossessed" people began to have possessions. The paintings suddenly had a value, and as Bardon said: "Anything the Aboriginals had of value they had to be relieved of. It was that kind of place." One constant threat was that Kaapa Tjampitjimpa, one of the star artists and a respected man in the community, would be deported from Papunya. "They had a game with me, I can't be more emphatic than that." But Bardon kept selling the paintings, and returning with increasingly large amounts of cash for the artists. He started giving driving lessons on the air strip—although, as he said, the police discouraged Aboriginal men from having licenses, and nobody was granted one while he was there.

And then there were more threats, with the superintendent telling Bardon that the paintings were by "government Aborigines" and were therefore "government paintings." One day, while Bardon was away from the settlement, an administrator went to visit the painters—to tell them that, of a consignment of paintings worth $700 and left in Alice Springs, they were owed just $21, with the rest deducted as expenses. When he came back, oblivious of the lies that had been spread, Bardon felt shunned by both white and black communities: "I couldn't have been more isolated than if I had gone to the South Pole on my own. There weren't even penguins for company."

The way he describes the end of his time in Papunya, it is like a bad dream—he fell sick, the Aboriginals began to distrust him and once even chanted the words "money, money, money" in their own languages outside the school in protest at what they felt was his perfidy. It seemed, he wrote later,[22] as if he was becoming quite separate from the artists and, in a way, even from himself. "From my window I'd see strange and wistful caravans of black faces coming back and forth along the spinifex tracks. I'd see someone I thought was one of the painters, and then whoever it was would walk away." It was finished, he knew, but it really ended late one night, when someone or several visitors knocked at his door and demanded to talk to him.

Whatever happened under the Southern Cross in the bush that night shocked him so much that he left Papunya in despair and in a hurry, and a few days later had a nervous breakdown and was admitted to the hospital. Thirty years later he has recovered from it, but the pain is still there. "There are certain things which can't be said, so I can't say them either," Bardon said as we sat companionably on the verandah looking out at his garden. "I'll stop now," he said. And we stopped; it wasn't right to look under the blanket of secrets anymore.

After you take off in a 747 from Sydney's International Airport it takes nearly five hours to leave Australian airspace, and I spent

most of that time just gazing out at the bush below. From above, the whole desert is a strangely mesmerizing shimmering orange. Whenever a friend was asked what his favorite color was, he would say it was just that: the red of the Australian center, when you flew over it in the morning. From this bird's-eye perspective, the spinifex and other bushes made little dots on the landscape, just like so many of the Central Desert paintings I had seen. And from a plane the dried-up creeks and the curves of rocks turned into whorls and wiggles that no doubt had whole epic choral symphonies enclosed in them. But I had seen that before, and what I took back from this journey was something extra, something more complex.

It was a sense of ancientness, in a way—the ancientness that had so charmed me with that little yellow stone in Italy—but it was also a sense of the land as a conscious thing. And about how although on the top there is, along with all the beauty, a great deal of misery—alcoholism, racism, ill-treatment of women, and that terrible dull sense of boredom and pointlessness that I had seen in my travels—there was still a sense that below that ochre surface there is a different reality. It is a reality that the best red paint and perhaps the best art can give a glimpse of, but just a glimpse. Old Bill Neidje from Oenpelli had tried to explain its elusiveness. We don't know what it is, he had said, in words that were recorded in his book *Kakadu Man*, "but something underneath, under the ground."[23]

Eight months after my journey to find ochre, Christie's held an auction of Aboriginal artworks in Melbourne. "What a night," art dealer Nina Bove wrote to me a few days later. "The atmosphere was electric." There were a few big sales that night—of "Emilies" and "Clifford Possums" and "Ronnies"—but the biggest interest was when Rover Thomas's 1991 ochre-and-gum painting of *All That Big Rain Coming from Topside* was brought onto the stage. It is an extraordinarily powerful depiction of something elemental: the white dots pouring down the ochre-brown canvas, seeming to

settle for a moment in a ridge and then cascading to the bottom in floods. And that is a fair description of what happened in the auction room that night: a cautious start increasing in momentum until it reached an unprecedented high tide.

There were several big foreign buyers pushing up the price, but every time they did there was a phone bidder who matched them until it reached 786,625 Australian dollars and the hammer came down. As everyone was speculating on who the mystery buyer was, Wally Caruana of the National Gallery of Australia slipped back into the reserved seating section. He must have been shaken by his own actions, but from a telephone in the downstairs bar he had just paid more money than anybody had ever paid before for an Aboriginal artwork in order to keep the ochre painting (quickly dubbed by the local press *All That Big Dough Coming from Topside*) for Australia.

The modern art movement that had started in a place that wasn't loved, pioneered by people who weren't valued, had come a long way from the early days of Papunya. People who buy Aboriginal art are looking for many things: for movement and texture and tonal hue and stories. But they are also, I believe (in this coming together of paint, canvas and of the patterns made by people sitting under humpies in the desert and surrounded by dogs and four-wheel-drives but with glory in their minds) looking for something else. They are looking for country. They are looking for the crock of earth at the beginning of the Rainbow Serpent. And yet they don't have to look so carefully anymore to see how it glitters.

# 2

# Black and Brown

*"As has been said, you begin with drawing."*

CENNINO CENNINI

*"Give me some mud off a city crossing, some ochre out*

*of a gravel pit and a little whitening*

*and some coal dust and I will paint you a luminous*

*picture if you give me time to gradate*

*my mud and subdue my dust."*

JOHN RUSKIN

*A*t first I found it odd to include black or brown in a book called *Color*. After all, one thing that had intrigued me originally was the brightness of my quest, and how our magpie needs for shiny colors had inspired incredible journeys. And anyway, I thought, there probably aren't many interesting stories connected with people burning lumps of wood to make charcoal crayons, or collecting mud for dyeing. But I was wrong. As I read more, I began to hear intriguing stories about the "non-colors." Of how black dye used to be sold by retired pirates in the Caribbean, how "pencil lead" was once so rare that armed security guards in northern England used to strip-search miners as they left after a long day in the heart of a hill, how white paint was a poison (but tantalizingly sweet

tasting), and how both brown and black paints were once said to be made from dead bodies.

So before I set out on my travels to see Afghan jewels on a Virgin's scarf, to enjoy the richness of an iodine sunset or to discover the secrets of lost green vases, I went first to the land of shadows. Every part of life has them, and in art, perhaps more obviously than anywhere else, it's the shadows and the shit which make the light bits believable. "Ashes and decomposition" was how I described the non-colors dismissively to a conservator friend, before my research had really started. "Exactly," she said with satisfaction. "Sums up the painter's art perfectly . . . Have you watched an artist start a painting?" Of course, I protested. "Then watch again." So I did. In rural Shropshire I watched the icon painter Aidan Hart transfer his pencil sketch of the head of Christ to a gessoed panel— by tracing it onto the back of paper that had been rubbed with brown ochre; in Indonesia I watched artists sketch with charcoal before adding any paint to their Hindu story designs; in China I watched a calligrapher painstakingly grind his pine-soot ink onto his grandfather's ink stone before even selecting the paper he was to write on; in the National Gallery in London I stood for a long time in the near-darkness before Leonardo da Vinci's full-size cartoon of the Virgin and Child with St. Anne and St. John the Baptist, drawn in charcoal and black and white chalk—soft materials to smooth in the highlights of the Christ Child's shoulder and the tenderness of a mother's face.

And each time I marvelled at how so many paintings begin with a period of alert attention accompanied by the careful rubbing of dirt—earth or mud or dust or soot or rock—onto a piece of cloth or paper or wood or wall. The bright colors and the translucence come later, and when the highlights are added they always need the lowlights or shadows to make them seem real. Sometimes the drawings are even better than the paintings. Giorgio Vasari[1] wrote vividly about how sketches, "born in a moment from the fire of art," have a quality that finished works sometimes lack. Perhaps it is simply the

spontaneity, but perhaps it is also the effect of black, gray and white which makes a sketch seem so complete. Just as white light contains all the colors, so—as I would discover in my travels through the inkwell—black paint can incorporate the spectrum too.

It was this theory—that "black" happens when an object is absorbing all the colored wavelengths—which led many of the Impressionist painters to stop using black pigments in favor of mixtures of red, yellow and blue. "There is no black in nature" was the popular refrain of this group of nineteenth-century artists, whose intention was to capture the fleeting effects of light in their paintings. In Claude Monet's *Gare Saint-Lazare*, for example, the pitch-dark locomotives in his busy station are actually made up of extremely vivid colors—including bright vermilion red, French ultramarine blue, and emerald green. Conservators at the National Gallery of Art in London report that in this painting Monet used almost no black pigment at all.[2]

## THE FIRST PAINTING

According to one Western classical legend, the first paint was black and the first artist female. When Pliny the Elder was writing his *Natural History*—a summary of everything available in the Roman marketplace and quite a few other things besides—he told a story of how the origin of art was found in epic love. After all, what better inspiration for art is there than passion? According to Pliny one of the first artists was a young woman in the town of Corinth in Greece who one evening was weepily saying good-bye to her lover before he set out on a long journey. Suddenly, between impassioned embraces, she noticed his shadow on the wall, cast by the light of a candle. So, spontaneously, she reached out for a piece of charcoal from the fire and filled in the pattern. I imagine her kissing the image and thinking that in this way something of his physical presence would be fixed close to her while his beloved body was far away in the distant Mediterranean.

COLOR

As an origin theory it is a mythic image that has reappeared in paintings and drawings throughout the centuries since. It particularly appealed to the Georgians and Victorians, with their fashions both for cut-paper silhouettes and stories of desperate love.[3] In 1775 the Scottish portrait artist David Allan painted *The Origin of Painting*, showing a very flirty lady sitting on her film-star boyfriend's knee as she fills in his profile on the wall. Her flowing robes have slipped to reveal her right breast, the sight of which is evidently keeping the young man occupied while she gets on with the serious business of the first portrait. Quite apart from the toga effect, it is a deliciously challenging image—of using something that has already burned out to symbolize a love you want to last forever.

## THE OTHER EARLIEST PAINTINGS

Pliny had no access to anything like our modern theories about the world's earliest paintings, which suggest that the first human artists were inspired by things like winter boredom, techniques of hunting lore, sacred ritual practices or even just by the simple joys of illustrated storytelling. The proof was there if he or anyone else had wanted to find it—beneath the Niaux cave paintings in the French Pyrenees, for example, the imprint of a Roman centurion's sandal testifies that the Neolithic paintings had been seen by at least one man in the classical world. But the scholarly world was not, apparently, ready for anything more than Pliny's charming mixture of anecdote and mythology, and the first of Europe's major prehistoric cave-painting galleries would not be discovered by the academic world for nearly two millennia.

However, if this opinionated Roman natural historian had been given the chance to move forward through time, and witness the discovery of the Altamira caves in northern Spain, for example, I think he would have felt a little smug. He was not necessarily accurate about the inspiration for early Spanish paintings. There is a lot more hunting than lovemaking in these caves, although inter-

estingly some Swedish petroglyphs of a slightly later date contained so many pictures of men with impressively large erections that their documenter, Carl Georg Brunius, had to consult his colleagues about whether or not the mid-nineteenth century audience was ready to see these early examples of Swedish porn.[4] The colleagues were divided on the matter. But Pliny was at least right about the painting materials. Ochre may have been undeniably the first colored paint, but even the earliest artists usually liked to draw their designs first with charcoal—sometimes just to make sure they got the shapes right before they committed to coloring them in, and sometimes to give their works powerful outlines. And if it was not necessarily a woman who had scribbled the early images with a lump of burned wood (and we do not know that it was not), it was at least a girl who discovered the extraordinary caves at Altamira.

In 1868 a hunter, stalking birds or deer one day in the area near Santander between the Atlantic Ocean and the mountains of northern Spain, stumbled across the entrance to a series of caves. After Modesto Peres told his landlord about it they led several amateur expeditions—lots of topcoats and tall candles—into a 20-meter-long cavern with a sloping roof and an uneven floor. There they found signs in the form of bear bones and fire ashes, intriguing trash from ancient human (and animal) habitation. But the real treasure of this long, rectangular gallery was only discovered eleven years later, in 1879: 1,800 years to the summer since Pliny suffocated under the most infamous flow of black gunge in history, in his hometown of Pompeii.

And if on that particular day Don Marcelino Sanz de Sautuola had been able to find a babysitter for his eight-year-old daughter Maria and had not taken her out of the afternoon sunshine and into a strange and rather dangerous playroom, no one might have found the treasure for several decades. Later, in his darker moments, he must have wished that it had not been noticed and that his daughter had remained silent.

# COLOR

De Sautuola was an aristocrat, a hunter and a landowner, but most of all he was a man who liked finding things. His eyes were always fixed on the ground, checking for things that did not fit, things that had been introduced by humans and not by nature, and which could explain the history of the world in new ways. He must have been thrilled when his tenant found the cave entrance. It would have seemed a God-given opportunity to test out some of the theories of evolution and human history that no doubt he, like the rest of European intellectual society, was debating with his friends and associates at every opportunity.

So he went looking for information. Just a few minutes before de Sautuola's life changed, the forty-eight-year-old was sitting on the cave floor, busily looking for Paleolithic bear droppings, early meal middens or other signs of ancient habitation. His daughter—who, from a photograph of her held at the Altamira museum, seems to have been a pretty child with short dark hair, who might have looked boyish were it not for her long earrings—was running around the cavern, inventing her own games in the torchlight. Suddenly, according to the well-told legend of the discovery, she stopped, and squealed in surprise, *"Mira, Papa, bueyes"*—Look, Papa, oxen. De Sautuola stood up, and he must have exclaimed too—although probably with stronger language. Because there, above them both, the ceiling was covered with huge red-and-black bison thundering across a stone field.

The charcoal of Altamira was applied in wide, confident sweeps—simple bold lines that double up as shadow and outline—and then red and yellow ochre were painted on, either with a brush or perhaps with soft chamois leather pads. There were twelve complete bison, two headless ones (powerful nevertheless, looking more as if the heads had disappeared into another dimension than that the beasts had been decapitated), three boars, three red deer looking rather bedazzled and a wild horse. There is a sense of speed and energy about them that suggests they were created quickly and without hesitation. And the bison in particular—

each two meters long or more—are bristling with muscle and power. Vasari would have approved of the energy of these sketches.

De Sautuola and his adult friends had walked beneath them a dozen times and never looked up. Before that afternoon they had perhaps not been seen by human eyes for 15,000 years. They would have been drawn by men or perhaps women (several of them: the styles vary widely) by the light of burning torches that were vital not only for light but for heat. It was the end of the Ice Age in Europe and *Homo sapiens* would have been living and hunting—and painting, of course—in a very cool world indeed.

On that warm day in 1879 I imagine de Sautuola shivering with the premonition that this might be the greatest ever discovery of ancient art so far. Yet I wonder whether anything forewarned him that it would also spell his own ruin. He died just nine years later at the age of fifty-seven, a broken man accused of fraud and forgery because the paintings of bison created with charcoal and red ochre were deemed simply too beautiful to have been made by "savages."

It is curious how artifacts often seem to be found just when history is almost ready for them. Since the publication of *The Origin of Species* in 1859, Charles Darwin's evolutionary theories had swept through Western thought. Many people were suddenly open to the notion that humans may have been on earth for longer than the 4,000 years or so the Bible allowed them to be, and fossils and prehistory were even more of a fad among scholars than dinosaurs are among schoolchildren today. Yet this was in the years before carbon dating, and after publishing his amateur pamphlet on the findings at Altamira, de Sautuola had to live with what an English-language guidebook to the caves described as "a veritable shower of misunderstandings," as well as taunts and accusations. Some gossips even suggested the paintings had been executed by a mute painter called Retier, who had been de Sautuola's houseguest some time earlier. The artist's inability to express his denial verbally would no doubt have been agonizing both to himself and his host. Twenty years later the academic world was forced to eat its

archaeological top hat, and admit that the paintings were not for-
geries. Maria, by then an adult, would no doubt have taken some
pleasure in that, although having seen her father's suffering before
his death she would almost certainly have had mixed feelings
about the whole episode.

In the twentieth century the French found other caves—most
famously Lascaux in the Dordogne in 1940, when some children
were caught in a storm and stumbled across the ancient pictures
by accident. The Russians, not to be outdone in the Cold War, dis-
covered their own painted caves in the Urals in 1959—complete
with a 14,000-year-old depiction of a now-extinct mammoth, with
tusks and a trunk and what looks rather like a bowler hat on its
head. All of these caves were painted with charcoal and ochres, al-
though occasionally more unusual pigments were used as well—
the Magura caves in Bulgaria were apparently painted deep brown
with a thick application of bat guano.[5]

Then in 1994 an extraordinary discovery by three cave explorers
in the Ardeche Valley in southern France revealed paintings that
were at least twice as old as those in Lascaux or Altamira or any-
where else in Europe. They were the oldest European cave paint-
ings known to modern science, and the Panel of the Horses
represents one of the most astonishing uses of charcoal ever seen
in prehistoric art. In his book, *Chauvet Cave: The Discovery of the
World's Oldest Paintings*, Jean-Marie Chauvet described the
breathless moment of discovering the cave that would later be
named after him[6]—of walking up a steep slope of stone blocks and
suddenly coming across a monumental frieze, covering 10 meters
of one wall. "There was a burst of shouts of joy and tears. We felt
gripped by madness and dizziness. The animals were innumer-
able, a dozen lions or lionesses, rhinoceroses, bison, mammoths, a
reindeer," he wrote. And then, to one side, he said, they saw on an
overhang a human figure with a bison's head—which seemed to
them to be a magician, supervising the entire painting.

Even from photographs you can understand the explorers' ex-

citement. The rocks look even more dramatic because of the natural yellow color all over the walls, which creates a swirling caramel effect. Other paintings in the Chauvet cave include ochre, but the animals in the Panel of the Horses are entirely in charcoal. In one place four horses seem to rear up, ready to gallop; their heads are skillfully shadowed in charcoal while their bodies are just sketched roughly. This tendency to concentrate on the fronts of the animals gives the sense not just of movement but of stampede. On a wall near the horses Chauvet saw what he described as "engravings of animals and stylized vulvas (one of which seemed to have a phallus drawn on it)." He or his publisher decided not to include an illustration of this example of Paleolithic sexuality, but perhaps Pliny was right after all, and he was merely being coy when he suggested it was the beloved's face that was being drawn on that ancient wall in Greece.

## IMPERMANENCE

Would the maid of Corinth have gazed at her painting often after her lover's ship had left? If so, then I wonder whether it could have lasted until his return. On their own, without human observers to wonder at them, these ancient charcoal cave drawings—especially if mixed with glue or fat or blood or egg—can last for an ice age and through another 10,000 years of summer rains. But as soon as people find them and pay them any kind of attention the drawings start to fade, almost as if too much looking wears them out. Keeping one's work permanent is a perennial problem for all artists, but few people dare hope that the marks they have made can last for 15,000 years. And these paintings of the past, unprotected by varnish, but protected by their own stable environment, are vulnerable as soon as that environment changes. They were painted with ashes and they are returning to dust.

Anthropologist Desmond Morris described how he had first been entranced by the cave paintings at Lascaux a few years after

their discovery, but when he returned four decades later he was disappointed. At first he wondered whether his memory was playing tricks with him, but later he learned from a report that it was not his memory but the paintings themselves which had faded, because so many people were entering the caves to see them.[7] Shortly after that report was written, in the mid-1990s, the authorities closed Lascaux, and spent many millions of francs creating replica chambers to enable tourists to get an idea of the paintings without damaging them with the moisture from their breath. The trouble is, the true wonder of all of these caves is not really in the accurate charcoal shapes of the bison, or even the shade of the ochres. It is that one day or night by torchlight, 15,000 years ago—or, in the case of Chauvet, 30,000 years ago—those rocks were once touched by artists. They were talking to each other in tongues we could not understand today, their minds were full of images and rituals and rules that we can hardly guess at, yet their messages from the other side of the Ice Age stretch toward us through their drawings. A reproduction of a cave in even the most tasteful of concretes and newly burned charcoals cannot even begin to reproduce that magic of communication across time—and the reminder that wherever and whenever men and women have lived, they have also painted.

## CHARCOAL

As the Corinth couple realized, charcoal can be found almost anywhere there has been a fire. But in my own initial search for this early pigment I decided to be more discerning than simply looking in the nearest grate. One of the finer versions of this drawing material is willow charcoal, which Cennino Cennini had recommended his fourteenth-century Italian readers use for drawing, "for there are no better coals anywhere." And indeed the highly detailed Leonardo da Vinci cartoon I saw in the National Gallery in London shows how the best charcoal can be soft and spontaneous, yet precise enough for making outlines for frescos. (That cartoon was inci-

dentally never used for a fresco—if it had been, it would be full of little holes where the artist had "pounced" or "pierced" it, and then rubbed charcoal powder through the holes to transfer the design.) Today this same kind of charcoal is found, among other places, in the land of the cider apple—the flatlands of south-west England, where I discovered a compelling story of biscuit tins, burned crops and a sick man's fierce determination to fight bankruptcy.

The charcoal willow is quite different from the weeping willow of ancient Chinese paintings, or the tree on which the Jews hung their harps by the Babylon river, just before they sat down to weep for their homeland. That tree was an import to Europe and America in the eighteenth century at a time when most oriental things were in fashion. Instead, this is the ancient plant that Viking women wove into useful containers while their men were out exploring and pillaging. They called it "viker," from which Old English derived the verb "wican," meaning to bend, and modern English gets the adjective "weak," even though the baskets are remarkably strong. When it is growing in the fields, willow looks more like a cereal crop than anything resembling trees; after it is first cut it looks like the thickest of orange hay, taller than a man but only as wide as a twig. It is planted in springtime, and the early growth is controlled by letting cattle graze on it. Without this, the early plants would be stunted by frost, and the rods would be curled and unusable.

Charcoal is an ancient drawing material, but Britain's main supplier—PH Coate's—has only been producing it for just over forty years, and only, astonishingly, because of an accident. Or rather because of two accidents, the first one being a slipped disk, when the late Percy Coate fell over one autumn day in the mid-1950s. He spent two months lying on the floor, as weak as his own wicker and worrying about money. Once upon a time willow was good business—it was the bubble wrap of its time, and almost every merchant ship leaving Liverpool or London had its valuables secured in wicker hampers. But then, between the wars, it went out of fashion.

# COLOR

Old-fashioned baskets had no role in the post-nuclear world of plastic, and the company was about to go bankrupt. But it was hard to know what they could turn to instead. The Coate family's land was perfect for this one crop—this particular part of Somerset is below sea level, and willow loves water—but not for much else.

One morning Percy was lying in front of the fire, fretting, when he saw among the ashes something that would change his life. It was a piece of burned willow, slim and perfect. The person who had lit the fire had used willow for kindling, as the family had done for generations. Usually it dissolves into cinders and merges with the ashes. "But for some reason this little piece had survived, and rolled out of the fire on its own," his daughter-in-law Ann Coate told me.

Percy picked it up and started to scribble, and suddenly a new venture was born. He would burn his business, in order to survive. He spent the rest of his convalescence experimenting by roasting little bits of willow in biscuit tins. In his *Craftsman's Handbook*, Cennino Cennini had advised fourteenth-century charcoal-makers to tie up the willow sticks in bunches, put them in a brand-new airtight casserole, "then go to the baker's in the evening, after he has stopped work, and put this casserole into the oven; let it stay there until morning and see whether these coals are well roasted and good and black."

Six centuries later, Percy Coate's first experiments were similar: he would leave his willow stubs in an old oven for different amounts of time, and check how good the results were for drawing. It wasn't quite as easy as it sounds, though, and sometimes those biscuit tins would end up in the courtyard, thrown out in anger at a failed experiment. Artists' charcoal is tricky; it has to be charred uniformly right through in order for the artist to draw a consistent black. But eventually Percy got it right, and today there is scarcely a classroom in Britain without its box of PH Coate's charcoal.[8]

## SEDUCTIVE MASCARA

History—or at least Pliny—does not relate what happened to the young woman of Corinth after her man left. She had, after all, played out her mythical role in the Roman's legend. But then one day, missing my own lover who was far away in distant lands, I got to wondering about the maid, and what could have happened next. Having invented, in a fit of passion, a whole new form of human expression, she was suddenly on her own. She was evidently a creative person, and I imagined her whiling away her now too-spare hours with other art experiments. She may, I fancied, have sketched her beloved's image over the wall until it was full of him, then the floor or the ceiling. Then, as the hours stretched into days and weeks, she may have become accustomed to his absence enough to extend her boundaries. Perhaps she added her own self-portrait, or played with her young nephews and nieces by drawing around their feet or hands (as I saw in those early Aboriginal caves in Australia) to entertain them. She may then have tried to draw trees and dogs and horses and little two-story houses to represent her dreams for the future.

But what if she became tired of using just one variety of paint material? Perhaps, I thought, she may have tried out new blacks and browns. Would she, given the chance to try out charcoal's successors, have preferred lead pencils or Indian ink? Would she have dyed her clothes deepest black, or was it only in the palest of classical robes that she wanted to be seen? And if her boyfriend ever returned to Greece between voyages, would she have used her new knowledge of pigments to decorate her own face for the occasion?

I imagined our heroine experimenting idly with mascaras and liners. First she may have used her own painting material, charcoal, but she would have found it stung a little, when brought too close to sensitive eyes. So then she may have tried an alchemical metal called antimony or "kohl." It is the traditional component of many Middle Eastern eyeliners, and is still used today by cosmetics

companies. The word "kohl" comes from the Arabic word *kahala*, meaning to stain the eyes. Today in Europe kohl is usually seen as an ornament, but in Asia it has often been used as both spiritual protection and health cure. In Taliban-run Kabul you could always tell the fundamentalist soldiers because their eyes were lined with black. It made them look as pretty as girls, but it was worn explicitly to show that Allah was protecting them. I once saw an Afghan father painting his small son's eyes with kohl. He was doing it to protect the boy from conjunctivitis, he said. But that was because he was a modern thinker, he told me. For other parents it was sometimes an attempt to charm demons away. Allah, incidentally, may not have approved of what the Europeans did with the word "kohl." In 1626 Francis Bacon reported in his book *Sylva* that "the Turkes have a black powder, made of a Mineral called Alcohole; which with a fine long Pencil they lay under their Eyelid." Seeing the purity of the dark gray powder, they had associated it with something else that had been refined and sublimed, and so found a name for alcohol, the bane of Islam.

If my almost imaginary maid was as interested in the dark arts as in the art of making dark pigments, she may well have tried a little black love magic of her own. Among a myriad of pieces of advice for lovers contained in the *Kama Sutra* is the tantalizing recipe for the ultimate sexual mascara. It recommends taking the bone of a camel, dipping it into the juice of the *Eclipta prostrata* (which is also called the tattoo plant because of the dark blue dye that comes from it) and then burning it. The makeup-maker should then store the black pigment in a camel-bone box, later applying it to the eyelashes using a camel-bone pencil. The reward, promises Richard Burton's unexpurgated 1883 translation of the Indian love manual, is not only that the pigment will be "Very pure and wholesome for the eyes," but that it also "Serves as a means of subjugating others to the person who uses it." Let us hope, though, that the woman's boyfriend hadn't read the same text. One section recommends that men make a powder out of certain sprouts mixed with red arsenic,

then mix it all with monkey excrement. If an ardent lover throws this "Upon a maiden, she will not be given in marriage to anybody else," the good book promises. Probably fairly accurately.

# PENCILS

The woman was primarily an artist, and she would surely have liked the idea of trying out alternatives to charcoal as a drawing material. There is a popular anecdote to the effect that NASA scientists in the 1960s spent millions of dollars developing writing instruments that would work in zero gravity. "What have *you* done?" they then asked their Russian counterparts, who looked bewildered. "We have the common pencil," they said.

Nowadays we can call the lead pencil "common" with impunity, but once this stuff was valued so highly that people risked their lives to find it and steal it. The maid of Corinth would probably have had to wait until the sixteenth century before she found anything like lead pencils in Europe—up until then artists tended to sketch using what they called "silverpoint"—pens with tips made of silver wire, which made dark marks on surfaces covered with chalk or bone ash. However, had she been a maid of Copacabana or of Colombia then she might have had a chance to use them in her own classical world several millennia before that. When Hernando Cortés arrived in Mexico in 1519 he recorded that the Aztecs used crayons made of a gray mineral,[9] although he did not say what they were for.

The first curious discovery—for me—was that pencil "lead" had no lead in it at all. The rules I remember from my schooldays about not chewing our pencils were not misplaced (pencils are not the healthiest of snacks) but they were not life-saving either. At several points in history real lead was used for drawing—Pliny refers to lead being used for ruling lines on papyrus, perhaps to keep junior scribes from making unsightly notes, and in fourteenth-century Italy early artists' pencils were sometimes made of a cocktail of

lead and tin which could, apparently, be rubbed out using bread-crumbs, just like charcoal. But ever since the middle of the six-teenth century "lead" drawing materials have been made of a very different material, a material that is scarcely metallic at all.

It was a slip of the divine compressing machine which decreed that the treasure hidden in the hills of the British Lake District should not be diamonds but a black carbon cousin known as graphite. It may not have been useful for cutting or for dazzling, but it too was valuable in its own way. Not, in the beginning, as a draw-ing material, however. The big money from graphite in the six-teenth century (when it was called plumbago, blacklead or wad) was in ammunition. Rubbing a thin layer of graphite around the in-side of a cannonball would make the finished missile pop out of the cast like a cooked cake from a buttered tin. It was only much later—at the end of the eighteenth century—that this oily stone was re-named "graphite" for its potential for making marks on paper.

There is a Pencil Museum in Keswick, in the heart of the Lake District, built to celebrate the area's famous graphite deposit and its later reputation for world-class crayons. It has a mock tunnel with life-size models of miners extracting plumbago with pickaxes, a full-scale diagram of the three-hundred-year-old trunk of a Cali-fornian cedar (thousands of which are felled to keep the world pro-ducing six billion pencils a year) and even an example of the only painted pencils to be made in Britain during World War II. They were green (every other British pencil was left plain because of the war effort) and they contained silk maps and even a tiny compass hidden under the eraser, for use by airmen flying over enemy ter-ritory. They were invented by Charles Fraser-Smith, who was the inspiration for the character Q in the James Bond films. The mu-seum is full of information, but when it came to actually locating the mine itself—which was not on my Ordnance Survey map—nobody could help. "No point in going there," said the friendly woman at the desk. "All you'll find is a hole in the ground." I ex-plained that this was exactly what I wanted. She wasn't sure where

it was, so I drove to the place where graphite was first discovered—
a hamlet called Seathwaite—and then I looked around the steep
fells to see what I could see.

At first it was hard to see anything: snow had fallen all morning,
and the whole landscape looked like a pencil drawing—a few black
lines on white. This was the wettest inhabited place in England,
with 3.5 meters of rain a year, a National Trust information board
told me: it was enough water to cover the board three times over. I
knocked on the door of what in summer is a tearoom and in winter
is closed, and a woman almost toppled off her ladder. The mines
are up there, she said when she had recovered herself, and she
pointed to a steep peak on the road toward another hamlet called
Seatoller. "Can you see those slag heaps?" I could: they were three
great white mounds in the snow that looked as if they had been
made by a monster mole—but more alarmingly they seemed aw-
fully far up. "Be careful," she said. "You can fall a long way."

There was an upturned tree on the path—and I looked carefully
at the roots, to see whether there was any graphite shining there.
One legend of Borrowdale's graphite is that the treasure of the val-
ley was uncovered in 1565 when a traveller noticed what seemed
to be silver caught up in the roots of a storm-damaged tree. I saw
nothing on my tree, but that earlier discovery caused a flurry of in-
terest in London. Queen Elizabeth I was particularly keen to hear
all about the new discovery in the Lakes, and ordered a Company
of Mines Royal to be set up at Keswick, employing German min-
ers (accustomed to working in the small Bavarian graphite mines)
to tunnel into the volcanic mountain.

There is another Borrowdale legend which had caught my at-
tention. It suggested that the earliest use of graphite was long
before 1565, and it was neither for drawing nor for cannonballs,
but for marking sheep. However, I wonder now whether those
writers who have repeated this story had ever been to Seathwaite.
Because when I arrived at the remote valley I laughed aloud. All
the sheep looked as if they had been painted with gray graphite,

which covered their bodies naturally in uneven markings, as if God had been absentminded with his shading. Why should people mark sheep with graphite when there were perfectly good dyes like walnut available? It would be much easier to daub a colored solution than to hold down a bleating animal and rub it with a great heavy silvery stone. But more importantly why should they do that to sheep that were already naturally marked with gray patches? Surely it was a joke told to gullible visitors which eventually, as these things do, became taken as truth. Later that night I tried painting my sheepskin slippers with a small lump of greasy graphite I had bought from the museum. It was possible but it took quite a lot of time. And my slippers weren't wriggling.

"I'm curious about the sheep," I said to the local farmer, when I passed him on the path. "They're a strange color," I elaborated. "They're not strange, they're beautiful," he said, correctly. "They're the color of these walls," he continued, pointing at the mossy dry-stone boundaries of his land. They are called Herdwicks, and sheep like that have been in the area since the Norsemen. The tragedy, he said, is that the market thinks they're odd too: farmers can't sell the gray wool for as much as it costs to shear it.

To get to the plumbago slag heap I had to cross many little streams covered by the snow, and by the time I reached it my right glove was dripping with icy water and my left boot was full of brown bog. But it was worth it: there was the promised hole in the ground—not used for a hundred years or more, ever since the graphite ran out. It had not been blocked, but I didn't go inside. It was very low—no more than a meter high—and very wet, leading to a nearly horizontal tunnel. But when I threw a stone along it, it sounded as if it were falling into an underground lake. Flanking the mine shaft were two ruined stone rooms, and (standing in one of them) I tried to imagine what had happened in this place, 250 years before. In the seventeenth and eighteenth centuries, graphite was worth hundreds of thousands of pounds—and a considerable defense advantage—to the English Treasury, and the operations of

the mine were kept as secret as if it were a military base. At one time there were plenty of mysterious comings and goings around this desolate place—which was open for only about seven weeks a year (and at the end of the seventeenth century it was closed for several decades) to keep the international price of graphite high. Armed security guards used to stand in those two rooms, forcing the men to strip and allow their clothes to be examined at the end of each shift to check they weren't concealing valuable nuggets. Wad was worth the equivalent of £1,300 a ton, and some people felt it was worth risking a whipping to smuggle it out.

Some of the thieves became legends in their own lifetimes—one woman who became known as Black Sal was one of the most efficient wad smugglers in the Lakes, although myth has it she was hunted to death by the mine owner's wolfhounds. And a man called William Hetherington resourcefully opened a small copper mine on the same mountain in 1749, with a secret passage leading straight to the wad.[10] He was lucky—had he been caught three years later he might never have seen Borrowdale again. In 1751 there was a particularly violent showdown between the guards and one especially notorious gang of smugglers, who were stealing the modern equivalent of about £150,000 a year. The following year Parliament passed an act decreeing that anyone caught in possession of illegal graphite could face a year's hard labor, or be transported into slavery in the colonies.

Although the war industry was where the big money was, some graphite was always used for drawing. The Keswick museum reports how in 1580 Borrowdale graphite was being sent to the "Michelangelo School of Art in Italy" (Michelangelo died in 1564, but that evidently didn't deter an art school from taking his name). The artists would wrap the graphite with string or wool: it was too brittle to hold in the hand and nobody thought of putting it in a hollow stick of wood until the seventeenth century. By the time of the Napoleonic wars the British army was using dry sand to cast its

bullets, and graphite became less important. But, curiously, just as it started being more useful in art than in war, blacklead was to be the cause of a different row between the British and the French. It is not a well-known feud, but I like to think of it as the War of the Pencil.

The battle lines were drawn, so to speak, in 1794, when a Frenchman called Nicolas Conté was asked to find a substitute for the English pencil. Inventors had spent years trying (and failing) to stop the British near-monopoly on pencils, but Conté managed it in just eight days. He took low-quality graphite—which could be sourced in France—and found a way of powdering it and mixing it with clay so that not only could it do justice to the sketches of the most prestigious French artists, like the portraitist Jacques-Louis David, for example, but it could also be made in different grades of softness. It is ironic that Conté, whose inventions included hot-air balloons for military reconnaissance, should best be remembered for the humble pencil. Although he probably would have been pleased: his first job, before the French Revolution in 1789, was as an artist.

The grading system came later, but it is because of Conté's discovery that today we can select our pencils depending on how much clay was used in the recipe. In English the grades are given in Hs and Bs. H refers to hardness while B is a measure of a pencil's "blackness." The more Hs there are, up to a maximum of 9H, the lighter the pencil mark and the easier to erase, while 9B pencils have the least clay, and are the most satisfying for smudgy sketching. HB is traditionally the middle grade.

Within thirty years of Conté's invention there were pencil factories all over Europe.[11] England's first pencil factory opened in Cumbria in around 1792, although the management must have been furious at having to buy all their graphite in London, as the mine owners insisted that everything had to go through their London warehouse and then be sold at auction on the first Monday of every month.

The next challenge to world pencil dominance was also from a Frenchman: and it started unexpectedly in 1847 beside an icy river in Siberia. Jean-Pierre Alibert was looking for gold that morning, although probably the twenty-seven-year-old merchant was looking for *anything* that might help pay for the mad expedition he had embarked on. I wonder what it was that—as his pan came up once again from the streambed with no buttery nuggets in its mesh— made him look again at the smoothed and rounded black pebbles that had washed in instead. Could it be that he knew this was a rare formation of carbon, and that it was valuable? Perhaps he recognized it from some half-forgotten geology class, but I like to think that on this particular morning the Siberian sunshine caught on the edge of the graphite and made it shine like precious metal.

Certainly the experience was startling enough to force him to divert his group by 430 mountainous kilometers as he followed the river back to the deposit. His determination was rewarded, and at a place called Botogol Peak, Alibert found the world's richest seam of blacklead, just a graphite pebble's throw from the Chinese border. English scientists reluctantly conceded that it was as good as the Borrowdale supply, which had almost run out. French scientists, naturally enough, testified that it was much better, and the Americans agreed.

Suddenly everyone wanted "Chinese" pencils. It was therefore a brilliant marketing move a few decades later when mass-produced pencils in America began to be painted bright yellow. They copied the color of Manchu imperial robes, and symbolized the romance of the Orient, while suggesting that the pencils came from that valuable Alibert mine, even though they probably did not. Most pencils made in the United States are still painted yellow today, even though Siberian graphite has not been used for years. Alibert began to mine a kind of gold that day, even though it was not quite in the form he had expected.

# INK

Pencils are all very well, but our Corinthian artist would probably have rejected graphite. She was, we can assume, not out for profit but for permanence, and she was most likely looking for a nice stable ink instead of a fickle charcoal or an erasable pencil. Ink would be far more symbolic of the longevity of her love and, of course, would also be particularly useful for writing letters to her sailor on his foreign travels.

Nobody knows when ink was first discovered, but scholars tend to agree that it was already well established in both China and Egypt (as well as plenty of places in between) by about four thousand years ago. The Biblical Joseph—he of the multicolored coat—was viceroy of Egypt in around 1700 BC. He was able to manage all those famines and other agricultural crises only with the help of a huge city of scribes to record everything and send letters—written in the cursive or "hieratic" version of hieroglyphics—which would be posted by teams of runners. Each Egyptian clerk had two kinds of ink—red and black—which they used to carry around in pots set into portable desks. The black was made of soot, mixed with gum to make it stick to the papyrus.

Chinese ink—also known, confusingly, as Indian ink—is also made mainly of soot, and the best of it is made when a pine log, or oil, or lacquer resin, or even the lees of wine, have been burned. One vivid description from ancient China[12] is of hundreds of small earthenware oil lamps enclosed in a bamboo screen to keep out the breeze. Every half an hour or so, workers would remove the soot from the lamp funnels, using feathers. When I first read about the feathers I thought the manufacturing process sounded delightfully flouncy, but actually it must have been a nasty smoky job, which would have left treacherous carbon deposits on the lungs of every employee.

When this ink meets dampened blotting paper it doesn't leak into the kind of multicolored spider's webs we see with modern

fountain-pen inks[13]—in fact the ink must not leak at all, since Chinese paintings are stretched onto scrolls by wetting them. And yet, conceptually, for Chinese artists a thousand years ago, black ink did contain all the colors, just as in Zen philosophy a grain of rice contains the whole world. The Daoist classic text, the *Dao De Jing* (*Tao Te Ching*), warns that dividing the world into the five colors (black, white, yellow, red and blue) would "blind the eye" to true perception. The message is that we would all think so much more clearly if we didn't divide the world at all.

The Daoists were reacting to a strict Confucian world, of course, where everything was separated into neat categories. The Confucians would define a cup by what it looked like, the Daoists by the nothing in the middle, because without that it wouldn't be a cup. So in terms of colors, the greatest of artists should be able to make a peacock seem iridescent, or a peach seem pink, without using any colored pigments at all, and in that way they would get closer to understanding its true nature. By the time of the Tang dynasty this is exactly what the amateur artists were trying to do. Colors were for professional painters—who were rather sneered upon by the elite, as creating something necessary but vulgar. Black, on the other hand, was for the gentleman artists, who combined the skills of poetry and painting, and who wanted to portray the landscape of the mind, not of the eye. Unfortunately none of the Tang monochrome paintings has survived—but during the Southern Song dynasty in the thirteenth century this became quite a mainstream artistic theory, and there are plenty of examples from this period. One of the most precious paintings in the National Palace Museum collection in Taipei is a monochrome scroll painting by the thirteenth-century landscape painter Xia Gui.[14] It is called *Remote View of Streams and Hills*, and I love it because like so many so-called "scholar's paintings" it is much more than a landscape: it is a mental journey. You can't try to pretend you are really looking at hills and streams from some kind of remote vantage point. Because as your eyes move along the eight-meter-long scroll the viewpoint

keeps changing and sometimes you are above the landforms and sometimes below them, as if you are soaring on the wings of a crane or an *apsara*—a Chinese angel. It doesn't matter what the colors are: angels (or probably cranes) do not divide the world into colors anyway.

This monochrome philosophy can be summed up in an anecdote about Su Dongpo, an infamous scholar-artist living in the eleventh century. He created marvellous paintings and poems, but he also left a mythology of endearing misadventures. Tales of Su Dongpo sometimes read like wise fables of a naughty innocent. Once, for example, Su was criticized for painting a picture of a leafy bamboo using red ink. Not realistic, his critics said gleefully. "Then what color should I have used?" he asked. "Black, of course," came the answer.

Another time Su Dongpo (who apparently ate three hundred lychees a day, and once announced that he liked living next to a cattle farm as it meant he would never get lost because he could always follow the cow pats home) was experimenting with making ink. According to legend, he was so enthusiastic in his endeavor (and in his wine-drinking) that he almost burned down his house. "Soot from poets' burned homes" was not something he wanted added to the litany of ink recipe ingredients, although it has something of the whimsical about it, and I am sure he would have been wryly amused by the idea.

From early times both the Persians and the Chinese thought it was desirable to have ink that not only travelled seductively across the paper, but which also smelled wonderful. So they would add perfumes, to make writing the sensual experience that scholars deserved. Sometimes recipes for ink read like the random elements of a love poem: cloves, honey, locusts, the virgin pressing of olives, powdered pearl, scented musk, rhinoceros horn, jade, jasper, as well as, of course—most poignant and most common—that exquisite smoke of pine trees in autumn. Of all the luxury ingredients they probably needed the musk most: sometimes the binding glue

*The oak and the oak galls (1640)*

was from rhino horn or yak skin, but sometimes it was from fish intestines, as it sometimes still is, and in its raw state it must have been horribly smelly.

Another kind of medieval ink was made in the spring, by a wasp. The female *Cynips quercus folii* is notable for her unusual nestmaking—puncturing a home for her eggs in the soft young buds of the oak tree. The tree quite naturally protests at the invasion and forms little nutlike growths around the wasp holes, and it is these protective oak galls which (when collected before the wasp eggs hatch) form the basis of an intense black. It was used throughout Europe from at least medieval times, and the process was probably learned from the Arabs, who used it for ink, clothes dyeing and some mascara. It contains tannin—a highly astringent, acidic substance found in many plants, although rarely in such concentrated

form as in nut galls—and the recipe can also be replicated with tea leaves. The Prado Museum in Madrid owns two small ink sketches by Goya which demonstrate the difference between iron and soot inks. *And a Pity You Aren't Interested in Something Else* shows a woman holding a water jar, stopping to flirt with somebody just out of the frame. *The Egg Vendor* shows a courageous young woman striding across the country with her egg basket, stopping for nothing, not even bandits, certainly not flirtation. This one was made with Indian ink and it has a much finer definition—almost like charcoal, with a dryness to it. The first was sketched with iron gall ink: it is much softer, as if it had been soaked in the contents of the girl's water jar.

In *The Art Forger's Handbook*, Eric Hebborn bemoaned the difficulty of finding iron gall ink in artist-supply shops in the 1980s and 1990s and described how to recreate this ink's curious tints which range from faded yellow to strong black (via rusty browns and greens)—he followed an ancient recipe requiring either water or wine. He would mix the liquid with gum arabic, galls and coconut kernels, and leave the stew covered under warm sunlight for several days. If you cannot find galls, then rotten acorns were almost as good, Hebborn added.[15] And as for the wine, he preferred to drink it rather than add it to the broth.

## PERMANENCE

The Corinthian artist would have been amazed to think that her struggle for permanence—to capture a fleeting image or idea forever—would be mirrored throughout the millennia, although with varying results. Even as recently as the early twentieth century a Professor Traill in the United States became obsessed by finding a perfectly permanent ink. According to ink specialist David Carvalho, Traill was convinced he had found something that would last for aeons. He observed how it resisted the action of all acids and alkalis he tried it with, and so he sent it off to banks and

schools for testing. Most thought it was excellent, "but, alas, an experimenting scribbler, thoughtlessly or otherwise, applied a simple test undreamt of by the Professor, and with a wet sponge completely washed off his 'indelible,' and thereby finished his career as an amateur ink-maker!"[16]

Today's black inks tend to be made of aniline blues, reds, yellows and purples, blending together so they absorb most of the light rays that shine on them, and give the impression of being black. There is, however, one notable exception to this standard recipe, which I came across during my brother's wedding. My mother was one of two witnesses, and when it came to the appropriate moment she took her fountain pen out of her handbag and prepared to sign. "No," cried the registrar in alarm, stopping her hand. "You have to use this pen." She explained later that it contained special ink for legal documents: it is designed to last for many generations, and has the unusual quality of growing darker with age. It comes from the Central Registry Office and it arrives in an inkpot, not in cartridges. "Actually we hate it: it's too thick to use in a normal fountain pen, and if we get it on our clothes it burns into them and we can't remove it."

The Liverpool-based ink manufacturer Dormy Ltd. supplies the Central Registry Office of England and Wales with around half a ton of registrar's ink every year: births, deaths and marriages involve a lot of writing. Peter Thelfall, who is a chemist at Dormy, explained why it is different from any other ink. Most fountain-pen inks today, he said, are made up of colored dyes and water, and if you leave something written with them on a sunny window ledge then the words will quickly fade. There are dyes in registrar's ink too, and they will fade. But that doesn't matter, because the ink also contains a cocktail of chemicals that react with the surface of the paper and oxidize, turning to a black that will not fade in sunlight and is resistant to water. "You could sign with purple registrar's ink, or red—it doesn't matter what the undertone dye is, it will still go black on the paper," he explained. The substances in

registrar's ink that make it burn into the paper are tannic and gallic acid (today Dormy uses a synthetic version of natural oak galls), mixed with iron sulphate, a chemical that is better known as vitriol. It is curious that every legal wedding in England and Wales should be recorded with such a high content of a substance that symbolically suggests acidity and dissent.[17]

Today when you order a three-hundred-year-old book from the British Library you can be fairly certain that the ink will still be dark enough to be legible. This was not, however, apparent to the first publisher of printed books, and when Johannes Gutenberg invented the moving-type printing press in Germany in the 1450s, he realized he had a serious problem: his first trials showed up as faded and brown, even when he used the best ink available. There was no point in being able to mass-produce books if you couldn't read them and Gutenberg recognized that he had to invent a decent printing ink if he was going to change the world. He was lucky. A few years before, the Flemish artist Jan van Eyck had helped revitalize the use of oils rather than egg in paints. And the new printers found they could use that same technology to create oily inks—it was just a matter of playing around with combinations of turpentine, linseed oil, walnut oil, pitch, lampblack and resin until they got it right. The final recipe used on the forty-two-line Gutenberg Bible is lost to posterity, but we do know that its admirers were impressed by the blackness of the print.

Linseed oil was a near-perfect binding medium, but it needed to be treated before it could be used. *The Printing Ink Manual*, published in 1961, gives a wonderful image of a seventeenth-century printer and his employees taking a day off to replenish their ink supplies. They would go beyond the city walls to an open space, and there they would set up great pots for heating the oil. When it was boiling, the mucilage separated off, and the apprentices would sop it up by throwing bread into the vats: it must have smelled like a huge greasy fry-up. The whole process took hours, so the master

would traditionally give the men flasks of schnapps, which they would soak up with the fried bread. Lampblack and the other ingredients would be added the next day, when "both oil and heads had cooled."

## DARK DYES

In Western culture black often represents death. Blackness is, after all, a description of what happens when all light is absorbed and when nothing is reflected back, so if you believe that there is no return from death then black is a marvellous symbol. It is also, in the West, a sign of seriousness, so for example when the sixteenth-century Venetians were thought to be too frivolous a law was passed to the effect that all gondolas should be painted black, to signify the end of the party. As such, black was adopted enthusiastically—if any group so historically subdued could do anything enthusiastically—by the Puritans who emerged in Europe in the seventeenth century.

For true Protestant symbolism you needed true Protestant black clothes—and that was an unbelievably complex issue for dyers. There had not been so much of a call for such colors before, and technology was not quite prepared for the rush. Many black clothes were dyed with oak galls fixed with alum (a vital substance for dyers which I will describe in my quest for red) but the color tended both to fade and to eat into the fabric. Other recipes included plants and nutshells—alder and blackberry, walnuts and meadowsweet and others—but again these tended toward gray.

The problem is that there are no true black dyes.[18] There are black pigments—charcoal is one, soot is another—but pigments do not tend to be soluble in water, so it is hard to make them fix onto fabric. What many people did was dye clothes in several vats— blue, red and yellow—until the impression was one of blackness. However, that was expensive. Another option had to be found. And it is particularly ironic that the clothes of the most puritanical of

Puritans were often made with a color collected by rough retired pirates, and paid for by exchange for rum and enough cash to keep several brothels busy on the Caribbean coast.

The Spaniards brought logwood, or "campeachy" wood, in some of the first ships arriving back from the New World. It was marketed as a good ingredient for both red and black dyes, although in England it was not used much until about 1575. And almost as soon as it was used, it was banned. Parliament claimed it was "because the colors produced from it were of a fugacious character," and pretended they were looking after the interests of the users, although the fact that it represented a profit for the Spaniards cannot have helped. The law banning logwood dyeing was passed in 1581; the sea battle of the Armada occurred in 1588.

Then in 1673 the antilogwood laws were repealed. Parliament now claimed it was because "the ingenious industry of modern times hath taught the dyers of England the art of fixing the colours made of logwood." But a cynic might wonder whether it was not something to do with the fact that the British suddenly had access to the natural logwood plantations of Central America, and needed a home market for their new resource. England and Spain had signed a peace treaty in 1667—with the Spanish granting trading rights in return for the British suppressing piracy. This made the Caribbean safer, but had the side effect of putting large numbers of pirates out of work. Without much in the way of savings or pension plans—not everyone had a treasure map with a cross marking the spot—these newly redundant buccaneers were doing what they could to make ends meet. One of the best get-rich-quick schemes of the day was collecting logwood—the newly trendy black dye, much in demand in Europe.

In 1675 a young man who was later to become one of England's great admirals (and the man who dropped Alexander Selkirk off on his castaway island and picked him up five years later when he would become the inspiration for *Robinson Crusoe*) spent six months with the retired pirates. We can be grateful that he did, for

his account of life in this particularly wild strand of the dye indus-
try is both lively and horrifying.

William Dampier was twenty-two, and already a seasoned trav-
eller, when he first had the idea of going to the Caribbean. In the
late seventeenth century it was *the* place for adventurers, and by all
accounts Dampier was an adventurous young man. As he re-
counted with boyish excitement in his journal (which he would
later publish under the title of *Dampier's Voyages*), in those days
many of the islands were still inhabited by the "fierce Caribbees
who would murder their own brothers if the return was good
enough." The logwood men he was to meet were not dissimilar.
He left Port-Royal in August 1675 and a few weeks later he began
his extraordinary education in the mangrove swamps—an educa-
tion that would give him a rare insight into the dyeing industry, as
well as less welcome knowledge of the inside of his knee.

· There were about 260 Englishmen in the lagoon, on what is
now the border between Mexico and Belize. Dampier joined five
of them—three hardened Scots who liked the life, and two young
middle-class merchants who couldn't wait to get home. They had
a hundred tons of tree already cut into chunks—but it was all still
in the middle of the mangroves, and needed to be moved to the
coast, which involved cutting a special path with cutlasses. The
men were in a hurry, as a ship from New England was expected in
a month or two, so they hired the young sailor to help them at the
salary of a ton of wood for the first month—a payment he would
be able to exchange for fifteen shillings with the New England
ship's captain.

The loggers lived by the creeks to get the benefit of the sea
breezes and would commute into the swamp by canoe every morn-
ing. They lived on wooden frames set a meter above the ground,
and would sleep under what they grandly called "pavilions." Log-
wood trees thrive in mangrove lands, but men do not, and
Dampier was there during the wet season, which was the worst. It
was so flooded that the loggers "step from their beds into the water

perhaps two foot deep, and continue standing in the wet all day, till they go to bed again."

This muddy border between the land and the sea would later be called the "Mosquito Coast," and it would be well named. "I lay down on the grass a good distance from the woods, for the benefit of the wind to keep the muskitoes from me," recounted Dampier in a typical journal entry. "But in vain," he continued, "for in less than an hour's time I was so persecuted, that though I endeavored to keep them off by fanning myself with boughs and shifting my quarters three or four times; yet still they haunted me so I could get no sleep." And when the worms came, they came with a vengeance. On one memorable day, Dampier found he had a boil on his right leg. Following the advice of the older men, he applied white lilies to it until two specks appeared. When he squeezed them, two huge white worms, each with three rows of black hair running round them, spurted out. "I never saw worms of this sort breed in any man's flesh," he observed, with impressive sangfroid.

The best trees were the old ones, because they had less sap, and were easier to cut. "The sap is white and the heart red. The heart is used much for dyeing; therefore we chip off all the white sap till we come to the heart . . . After it has been chip'd a little while, it turns black, and if it lyes in the water it dyes it like ink, and sometimes it has been used to write with." Some trees, he said, were nearly two meters around. These couldn't be cut into logs small enough for a man to carry, "and [we] therefore are forced to blow them up."

The ship arrived a month later—and Dampier was astonished at how the logwood cutters "would extravagantly squander away their time and money in drinking and making a bluster." They had not forgotten their old buccaneer drinking binges and would spend thirty or forty shillings at one sitting (remember that for his month's labor Dampier had received just fifteen shillings) on drinking and carousing.

He was also amazed at the rules of honor between pirates. Gen-

erous captains would be well rewarded; mean ones would get the pirates' revenge. "If the commanders of these ships are free and treat all that come the first day with punch they will be much respected, and every man will pay honestly for what he drinks afterwards. But if he be niggardly, they will pay him with their worst wood, and commonly they have a stock of such laid by for that purpose." In fact the very meanest captains got a very bad deal indeed—the ex-pirates would punish them by giving them hollow logs specially filled with dirt and with both ends plugged up "and then sawed off so neatly that it's hard to find out the deceit." The "niggardly" captains would probably not find out until the end of the voyage, at a marketplace in Cadiz or Holland, that their dyewood was doctored and worthless.

Logwood was actually very vulnerable to doctoring at all stages. Even if the loggers had sent a good stock of heartwood, there were still some fraudulent dyers in Europe who favored cutting—or literally painting—corners. To last more than a few days in the sunshine, the crushed logwood needed to be overdyed on woad- or indigo-colored fabric. The way to prove this was usually to leave a little triangle of blue on the black cloth, to show that indigo lay underneath. But sometimes lazy dyers would just dip the corners into indigo, and the poor Puritans, who had presumably bought in good faith, would see the black fade to orange within weeks. And they would know they had been cheated.

There is a curious postscript to the story. The British and Spanish fought over the mangroves until 1798, when the British won the battle of St. George's Cay—and the rights to the area they later called British Honduras, and which is now called Belize. One of the main reasons for the British determination over 150 years to make this part of their empire was the logwood concessions. Many Belizeans today are descended from the slaves who were forced to cut down this heavy dye-wood. For no other reason than to help Europe be more black.

## DEAD BODIES

Black paint can be made of soot and galls, peach stones and vine twigs or even ivory—which was Auguste Renoir's favorite, when he used black at all. But one of the more notorious ingredients in the seventeenth century was bone black, which was said by some to be made from human corpses.[19] I imagine the apprentices in artists' studios would have told wonderful ghost stories about bone black, although there is little reason to think these rumors were based on anything more than ghoulishness. In truth, bone black—a rich deep blue-black pigment—was usually derived from the thighs of cattle or the limbs of lambs: uncontroversial powdered and burned scraps from the slaughterhouse's remainder pit.[20] And in fact it was not black—the apprentices would learn from their more knowledgeable colleagues—which was sometimes made from dead human beings. It was brown.

Brown has been such an abused color in terms of names: "drab" is now a definition of dullness but was once the technical term for a hue basking boringly on that middle line between olive and puce. "Puce"—meaning flea colored—was once a fairly nice thing to say about Marie Antoinette's favorite color. Or how about "*caca du dauphin*," a favorite in National Trust houses in the 1930s, and loosely translatable as "princely crap"? But even the color "isabella," which sounds so pretty, has its origins in decay and bad smells. Rudyard Kipling loved this color term, and used it twice in his books. It refers to a curious decision by Queen Isabella (the queen who allegedly pawned her jewels to enable Columbus to make his voyage in 1492) to give moral support to the defenders of a siege near her hometown of Castile. Most ladies of her time would just have prayed supportively for the besieged soldiers. Not so Isabella, who apparently made the unusual (and as far as I know never repeated) pledge not to change her bodice until that particular town was liberated. She overestimated the skill of the opposite army. Perhaps if she—or her long-suffering husband Ferdinand—

had known the town would be six months or more in the freeing, she would never have made the promise.

Brown is in a curious nonposition in terms of color hierarchy.[21] It is certainly a color—more so than black is, or white—but like pink it has no place in the spectrum. It was, however, the need to distinguish specifically between different brown colors which led to the world's first colorimeter. Joseph Lovibond was an Englishman who will be remembered for two things: his pioneering work with colors and the terrible moment when, as a teenager who had just made a fortune in the gold fields of South Australia, he waved too enthusiastically at the friends left behind on the wharf and all his money spun out of his hat and into Sydney Harbor.[22] Poor once again, he returned home and joined his father and two brothers in the family brewing business. He began to realize that the variations in color of his different brews were a good guide to their quality, but found there was no established way of categorizing them—he needed some kind of graded scale. He tried different pigments, painting them on to a card and holding them up against the beer. But they were unreliable and tended to fade, and anyway, how do you compare a liquid against a paint? Inspiration for improving the world's beer quality arrived one day in church. Lovibond was attending a service at Salisbury Cathedral, and suddenly realized the answer lay in finding the right shades of brown stained glass as a standard against which to compare the colors of his amber-colored brew. Five years later, in 1885, he produced the first colorimeter, with a scale of many different kinds of brown, and later adapted it, in the form of the Lovibond Color Scale, to measure the three primary hues, red, blue, and yellow, and so revolutionized color testing.

After the eighteenth century, brown ink was often made from sepia, the dark liquor secreted by cuttlefish when they are afraid,[23] but most brown paints traditionally came from the earth. Umber (and burned umber, which is redder) is an ochre sometimes thought to be named after the Italian province of Umbria. But it is

more likely to take its name from its effectiveness in making shadows, with the same Latin root as umbrella. Along with burnt sienna—which *is* named after the Tuscan town—umber was a key color for Italian Renaissance artists in creating a sense of depth, and a gentle transition from light to dark. The British forger Eric Hebborn said his first teacher used to promote the use of earth colors. Not because they were finer or stronger or better. But—and this was Hebborn's theory—because he was Scottish, and they were cheaper.

In European art history the two most controversial browns are asphaltum and mommia. Asphaltum is an oily bitumen from the Dead Sea and was first used in the sixteenth century as a lustrous brown. But as the artist Holman Hunt told the Royal Society of Arts in his impassioned speech of 1880 about how painters could no longer remember how to use paint, by the time Joshua Reynolds decided to use asphaltum in the 1780s he "had not had experiments of generations to show him the course of safety . . . and it is owing to this, alas, that many of his pictures are now in ruins."[24]

When used beneath other pigments, asphaltum behaves like melting treacle, making everything drip down the canvas and the surface wrinkle up. "It never dries and the paintings are a mess," said Michael Skalka, conservation administrator at Washington's National Gallery of Art, about the work done by bohemian American artist Albert Pinkham Ryder in the 1880s. Ryder was a guru figure for artists like Jackson Pollock,[25] but his paintings were never intended to be as splodgy as they have turned out. "The asphaltum is a nuisance," Skalka said. "But it is also a beautiful translucent brown: I can see why they wanted to use it."

But the most extraordinary brown was called mommia or "mummy," and it was, as its name promised, made of dead Ancient Egyptians. In her book *Artists' Pigments 1600 to 1835* Rosamund Harley quotes from the journal of an English traveller who in 1586 visited a mass grave in Egypt. He was let down into the pit by a

rope, and strolled around the corpses, which were illuminated by torchlight. He was a cool customer, and described how he "broke of all parts of the bodies . . . and brought home divers heads, hands, arms and feete for a shewe." Mommia was a thick bitumen-like substance and was apparently excellent for shading, although no good as a watercolor. The British colorman George Field recorded getting a delivery of "Mummy" from Sir William Beechey in 1809. It arrived "in a mass, containing and permeating rib-bone etc.—of a strong smell resembling Garlic and Ammonia—grinds easily—works rather pasty—unaffected by damp and foul air." By then it was a well-established color: as early as 1712 an artists' supply shop rather jokily called "A la Momie" opened in Paris,[26] selling paints and varnish, as well as—most appropriately—the funeral ritual substances of incense and myrrh.

*Mummy. From a 1640 Herbal*

# COLOR

The Egyptians mummified their dead in a complicated process which involved pulling the brain through the nostrils with an iron hook, washing the body with incense and, in later dynasties, covering it with bitumen and linen. They did this because they believed that one day the Ka or spirit double would return. In some cases the Ka might be kept busy for years, trotting sadly around the museums and art galleries of the world where its earthly remains are now smeared on eighteenth- and nineteenth-century canvases.

If the suppliers ran out of Egyptian brown, they could always make their own. In 1691 William Salmon, a "Professor of Physick" working out of High Holborn,[27] gave a recipe for artificial mummy, as follows: "Take the carcase of a young man (some say red hair'd) not dying of a Disease but killed; let it lie 24 hours in clear water in the Air: cut the flesh in pieces, to which add Powder of Myrrh and a little Aloes, imbibe it 24 hours in the Spirit of Wine and Turpentine . . ." It was a particularly good remedy for dissolving congealed blood and expelling wind "out of both Bowels and Veins," he said.

My favorite story about mummy brown is told by Aidan Dodson and Salima Ikram, in their book, *The Mummy in Ancient Egypt*. They recount how one nineteenth-century artist was so upset to learn that his paint was mixed from real human bodies that he took all his tubes of this pigment into the garden "and gave them a decent burial." When I contacted Ikram for more details, she admitted that her computer hard disk had also suffered from an excess of mortality and had given up the ghost without leaving her the reference for the anecdote. But I like to imagine this being a real ritual, with mourners and candles and a wake to follow. I also fancy that this unnamed artist may have been an Englishman. It seems such a British thing to do.

## THE JOURNEY

But to return from Egypt to Corinth, what of the sailor? Did he miss her? Or did he have women in every port wanting to change

the world for him? Did he, knowing her sudden interest in this art thing she had discovered, send her souvenirs from his travels? First it might have been ochres or chalky whites, but perhaps, as he saw more of the world, or at least the Mediterranean, he may have sent more exotic gifts: pretty minerals in little glass bottles, or exotic dyes for her clothes. Would little packages of saffron for her hair and malachite for her eyes have arrived unexpectedly at her door, bringing unknown scents and stones into that first art-studio home? Would she, over the years, have received purple shawls from the Levant, red skirts from Turkey and indigo carpets from Persia?

I like to think so; but more than that I like to think that perhaps one day she—being an independent soul and a little tired of black and brown—just picked up the ancient equivalents of her passport, credit card and driver's license, and went out to find the other colors for herself.

# 3

# White

*"For those colors which you wish to be beautiful,*
*always first prepare a pure white ground."*

LEONARDO DA VINCI[1]

O ne morning, so the story goes, the American artist James
Abbott McNeill Whistler was feeling a little off-color. Of
course he is, boomed a friend unsympathetically. "He's been paint-
ing that white girl for days."[2] In Western culture a woman wearing
white so often represents purity that it is easy to imagine the paint
itself having that squeaky-clean reputation as well. But in China
and Japan the color represents death and sickness in general and
funerals in particular—and for some white paint at least this is a
more appropriate way to think about the color. In Whistler's case
it was the white paint he used for his model's gown and for the ab-
stract drapery behind which was probably making him feel ill (al-
though perhaps the redness of her hair and the pout of her lips may
also have contributed to the young artist's confusion).

White paint can be made of many things. It can come from
chalk or zinc, barium or rice, or from little fossilized sea creatures
in limestone graves. The Dutch artist Jan Vermeer even made some
of his luminescent whites with a recipe that included alabaster and
quartz—in lumps that took the light reflected into the painting and
made it dance.[3] In 1670 he painted the picture of a young woman
standing up to play a little harpsichord, or virginal.[4] Her thoughts
are far away, and if we are in any doubt about whether or not she

might be wishing that she herself were not so virginal, the artist has placed a painting of Cupid above her head as a clue. Most entrancingly, the white-walled room is suffused with an extraordinary light, streaming through the window. The rough grains of the white paint (and the consummate skill of the artist) make that cool northern light seem to shift, and it becomes easy to believe in the young musician's dreams of being somewhere different, away from the ordinariness of her childhood home.

The greatest of the whites, and certainly the cruellest, is made of lead. European artists for hundreds of years have rated lead white as one of the most important paints on their palette—it would often be used in the primer to prepare their boards and canvases, and then they would mix it with other pigments to build up layers of color. Finally it would be used to dot the eyes, and for the highlights. If you look at Dutch still-life paintings, lead white is everywhere. You can see it in the glimmer on a silver jar, the snarl on a dog's canines, the slimy shine on a mass of deer entrails, or the shimmer on a pomegranate seed. Fresh or putrid, they all need to shine.

White paint is white because it reflects most light rays away from it. The penalty it pays for this apparent purity is that it absorbs almost no light into its own body, and—for lead white at least—this means that its own heart is black. In its time it has poisoned artists and factory workers, women looking for beauty fixes and even little children playing on slides who have been attracted to the strange sweet taste. The poison in this pretty paint has been written about since Roman times, but somehow nobody has seemed to care about the consequences too much.

Pliny included lead white in his *Natural History*. He said it was poisonous if swallowed, although he didn't comment about the dismal effects of absorbing it through the skin, or of breathing in the dust while grinding it. In his time the best quality of lead white came from Rhodes, and he described how it was made. Workers would put shavings of thin lead over a bowl filled with vinegar. The action of the acid on the thin metal would cause a chemical

*Setting the Beds for White Lead*

reaction and leave a white deposit of lead carbonate. The lead-workers of Rhodes then powdered it, flattened it into little cakes and left it to dry in the summer sun. The small amount of lead white made nowadays still basically follows the formula Pliny wrote about, of acid plus metal equals paint. In fact the most radical change in the recipe was introduced in Holland in Rembrandt's time. It included a new and nasty ingredient—one that must have had all art studio apprentices dreading the unveiling of the latest batch of white.

The Dutch or "stack" process involved using clay pots divided into two sections—one for the lead and the other for vinegar. The apprentices would line up several dozen of these, and then they would add the secret ingredient—great bucketsful of manure straight from the farm, which would be heaped all around the pots to produce not only the heat to evaporate the acid but also the carbon dioxide to transform the substance from lead acetate to basic lead carbonate. The room would be sealed, and was left closed for ninety days, after which the apprentices would no doubt draw

straws to see who got the unpopular job of going in to get it. But for the one who pulled the short straw there must—at least the first time he did it—have been a moment of amazement. In those three months the stagnant heat, gurgling excrement, sour wine and poisonous metal would have worked their alchemical magic, the dirt and the smells metamorphosing into the purest and cleanest white, which formed in flakes or scales[5] on the gray metal. It was one of the many small miracles of the paintbox, the transformation of shit into sugar.

"Do not ingest, do not breathe dust," warns Ralph Mayer in *The Artist's Handbook of Materials and Techniques* in the lead white section, and indeed, since 1994, the paint has been banned from sale within the European Union except under special conditions. Winsor & Newton warn that lead white is only "available in selected sizes, in selected countries, in childproof tins from either a locked display area or from behind the counter"[6] and recommend that artists use a white made from titanium instead—a paint so opaque that the same pigment is used in correction fluid. Not everyone is happy with this: I met hand painters at Spode's porcelain factory in the Midlands in March 2001, just three months after they were forbidden to use lead-based paints. They complained that the replacements were "rubbish: not as vibrant and nothing near as sharp." The risk was for the employees, not the buyers, said Clare Beeston, who had been gilding and painting at Spode for sixteen years. "We've always had blood tests, and we've always been careful." She told me about a colleague who had just retired in a state of happy health after fifty-two years of painting five days a week. For her, as for many artists, it was worth taking the small risk for the paints to be right.

## Dying to be white

Lead white was rarely more insidious than when it was used for makeup. In the 1870s the cosmetics company George W. Laird ran

a series of cartoon-style advertisements in fashionable New York magazines.[7] In one of them a young man asks his uncle, an old chap in a monocle (and very tight hunting trousers) the name of the "lovely young creature on whom all the heavy swells in the room are dancing attendance." We then cut to the lady, on the arm of a pompous-looking man with sideburns. She is looking mysterious—or perhaps that is just a look of pain at the tightness of her corset. The uncle agrees with the young man that the woman is indeed lovely, but adds, "Young, that's a different question." He observes that she is forty-five if she's a day, and whispers that the secret of her conquests lies in the Laird's Bloom of Youth foundation she uses on her face. "Of course this is *entre nous*," the uncle warns the young man. He would have been kinder to have warned the woman. Her youthful appearance would have come at a high price.

There was a famous case study of a housewife in St. Louis, mentioned in Maggie Angeloglou's A *History of Makeup,* who bought several bottles of Bloom of Youth. She applied it diligently and in 1877 she died of lead poisoning. She was by no means the first. Lead white had been used unsparingly in face cream and makeup since Egyptian times: the Roman ladies swore by it; Japanese geishas used it—it contrasted beautifully with their teeth which they had fashionably blackened with oak galls and vinegar.[8] But even in the nineteenth century, when the dangers must have been better known, it was common on the dressing tables of women of all complexions.

Today too, women die for beauty: they starve themselves too thin, or employ surgeons to tuck their skin too tightly. Was the white lead death any more monstrous? I wondered. One of the problems was that in the beginning—as with consumption—the damage caused would sometimes even make its victim feel more attractive. Lead exposure made women seem like ethereal spirits, almost like angels—which was part of its fraud. By the time the truth was clear, it was probably already too late.

I consulted a book on poisons[9] and imagined being one of those

nineteenth-century fashion victims. If I had assiduously applied Bloom of Youth every morning, I would first feel a sense of lethargy: I'd probably blame it on those wretched corsets. I would then, perhaps, stop sleeping, which would give a pallid hollow to my cheeks. My Victorian suitors might even find this an attractive look, fitting the idea of what a woman should be like: "dead-pale," but with a lovely face, a Lady of Shalott. And then my legs might begin to feel a bit wobbly, so I might take to my bed, like the consumptive heroine of a Puccini opera. Rather romantic really, I'd joke with my girlfriends.

At this point I would pull down the sleeves on my dress to hide the little blue marks—tiny plumb lines—that were forming on my wrists. At least no one would notice the ones on my ankles, I'd think. And then—and this would be more of a secret—my need for the chamber pot would change. Constipation would set in early and I would no longer need to urinate much either—but the pot would be useful for containing the vomit, which I would produce biliously and often. That sounds bad, but it would be just the beginning of the discomfort, which could later involve kidney collapse and what are kindly described as "behavioral abnormalities." Not even the champions of the accidental beauty of the consumptive could support such painful final hours as those suffered by a woman who had smoothed a surfeit of white lead into her cheeks. I wonder at what point I would have realized what was wrong.

The sickness had two names. It was called either "plumbism," because of the lead content, or "saturnism"—because lead has traditionally been associated with the planet Saturn, which apparently brings gloominess to anyone born under its influence. One popular remedy was a liter of milk. In the early 1900s a French toxicologist called Georges Petit spent a day at a lead white factory in France and reported on what safety precautions they were taking.[10] He saw three distributions of free milk. The first was at 6 A.M., the second at 9 A.M. and the third at 3 P.M., when everyone knocked off work. Using a healthy white thing—milk—to stop the effects of

an unhealthy white thing—lead powder—seems at first like a
bizarre example of sympathetic magic. But in fact milk contains a
good natural antidote to lead poisoning—calcium—and it was
probably one of the best things the workers could have done in
those days before protective masks. The other effective precaution
was for workers to hand-grind lead while next to a roaring fire so
that the updraft would carry the dust away.[11]

## THE STORY OF THE SKELETONS

Lead is not only poisonous; it is also—when suspended in water-
based media—not even particularly stable. When Cennino de-
scribed this particular "brilliant" paint in his *Handbook* he
included a warning. It should be avoided "as much as you can . . .
For in the course of time it turns black." There are many examples
of when an artist has not heeded his advice and the lead carbonate
has lost its oxygen and turned into black lead sulphide. But the
most startling examples of lead blackening I have seen were in
paintings done six hundred years before Cennino lived and an en-
tire trade route away—in the sacred caves of Dunhuang, in western
China.

Dunhuang today is a remote town in Gansu province, an hour's
flight and about 1,800 kilometers by camel from the start of the Silk
Road in Xian. If it weren't for its famous caves, it would now be for-
gotten. But in the eighth century this oasis in the Gobi desert was
one of the busiest towns in China, full of merchants, monks and
mendicants. It was the place where the northern and southern Silk
Road routes divided, and it was known for its good food, excellent
markets and, most importantly, the chance it gave to buy favors
with fate by becoming an art patron through sponsoring a fresco.

The Mogao caves are 20 kilometers from Dunhuang across a
desert full of graveyards. Today the Chinese government presents
them as a series of art galleries, great painted treasure houses in the
desert. But thirteen hundred years ago they were holy places, and

Mogao was a city of shrines. At one point there were more than a thousand caves here, painted between the fifth and eleventh centuries. They were mostly paid for by people making bargains with the divine. The pacts would often be on the lines of: "if I get to Kashgar with my camels/ if I have a son/ if I win an inheritance . . . then I will sponsor a new painted cave." Some caves, of course, were painted for more spiritual reasons. These were a celebration of the transcendent, without earthly terms and conditions, and they are probably the finest.

As recently as the 1970s, the 492 remaining caves were visited only by the lucky few. In his book about the raids on ancient Chinese cities—*Foreign Devils along the Silk Road*—published in 1979, Peter Hopkirk described how occasional tour groups and scholars would traipse freely around the picturesquely rickety scaffolding. They could mostly shine their torches wherever they wanted, to discover for themselves the magical images of azure fairies swooshing energetically over the ceiling, or ancient depictions of the Buddha sacrificing his body to save starving tiger cubs.

Today the caves are rather like a cultural motel. The exteriors have been squared up and covered with a pebble-dashed façade, each grotto accessed by a metal hotel-style door, with a room number outside. Young female guides in short turquoise skirts trip along the concrete balcony paths with torches, visiting the same ten or so caves each time. Every year the authorities sensibly change the tour itinerary, to preserve the murals. On a summer's day, with so many humans breathing in them, the smaller ones can be like a sauna.

The guide escorting my group was so bored that while she was waiting for us to move from one cave to the next she kept having a little snooze with her head resting against the door. But her sense of tedium was not contagious, and inside, once the nasty door had opened, the caves were full of visual treasure. It was hard not to be entranced by the ancient Buddhas painted in bright malachite greens, their haloes luminous with blue or even with real gold

leaf—in the places where the fleeing White Russians didn't scrape it off with their penknives in the 1920s. We had to stay alert to see even half of the murals: a few minutes' chat, some quick flicks with the flashlight, and the group was ushered out blinking into the desert sunlight.

In some caves I had to be dragged out of the grotto, the last to leave. But others were disappointing. This was among the most prized Buddhist art in China, and some of it, especially some of the paintings from the Northern Zhou period in the sixth century, looked like slightly ludicrous children's cartoons, with harsh black outlines. In cave 428 there were pictures of enlightened beings who looked like joke skeletons in reverse. Their crudely daubed black bones, limbs and bellies contrasted curiously with the delicate folds of their headwear and robes—it looked as if a primary school student had helped with the artwork. Meanwhile cave 419 was full of holy men and Buddhist fairies whose faces were startlingly black. And, even more odd, outside cave 455 there were some frescos painted minimally in navy, black and white, looking more like an indigo textile from Nigeria than a Buddhist painting from China. What had gone wrong? Had they been overpainted by later restorers? Or was this just the style of the Northern Zhou?

Cennino warned his artists not to use lead white on frescos at all. But then he warned them not to use yellow orpiment, red vermilion, blue azurite, red lead (which is what you get when you heat white lead) or green verdigris either. So the fresco painters of Dunhuang—who used all of the above—seem to have got off remarkably lightly, considering. Most of the paintings are still almost as bright as they were 1,400 years ago. But the worst damage can be seen where white lead or red lead[12] paints have come into contact with hydrogen sulphide, and have oxidized.[13] Those odd figures I saw in cave 428 had once been a pale shade of pink, the lead paint just a subtle lowlight on the skin in an attempt to make the paintings more realistic.[14] It was only over the years that the pink flesh

turned to blackened bone: an intriguing example from 1,400 years ago of how art follows life.

## THE SACRIFICE OF THE FIVE-PIGMENT GIRL

The local people of Dunhuang have their own version of where the pigments came from. It contains the elements of the best folk stories: a crisis, a deity who appears in a dream with a dangerous solution, and a virgin who is willing to risk everything for what she believes in. It was recorded by Chinese anthropologist Chen Yu in the 1980s, and was set in the eighth century. At the time, Mogao was attracting tens of thousands of people, who came to seek their fortune there. Among them were the widower Zhang and his teenage daughter. Zhang was one of the most talented artists in China, known for his exquisite *apsaras* fairy figures, which floated over turquoise skies as if the breath of the Buddha were guiding them. The most powerful warlord in the area, His Excellency Cao, had heard of the reputation of this father-daughter team, and had hired them to paint a new cave. There was one condition. They had to finish by the Buddha's birthday on the eighth of April. Easy, thought Zhang, and said yes. They spent days balancing on scaffolding, painting the most exquisite images. But the most beautiful painting of all was their deity Guanyin, who radiated compassion throughout the cave.

And then, disaster. They ran out of paint. They ran out of the white for the Buddha's body, and the green for his ribbons. There was no blue for the robes of his attendants, no red ochre for his face, and no black to draw the outlines of his enlightenment. It should not have been a problem: Dunhuang was a major stopping point on the Silk Road. In a normal year there would always be merchants in the marketplace selling sachets of vermilion and malachite and orpiment and all the other precious pigments that artists needed. But this was not a normal year: hundreds of artists

were staked out in the caves and in tent cities around them, painting to the same deadline. The only paints available were cut with dross to make them go farther, and were unusable.

Zhang and his daughter knew the penalties for not finishing on time. His Excellency Cao was not a man known for his kindness and patience. They were sick with worry. Then one night the daughter dreamed she was in a high valley of the San Wei Mountain, not far from Dunhuang. In her dream she was surrounded by powdered pigments of every possible hue, but every time she tried to pick them up they would slip out of her hand. Then the Guanyin of her cave painting appeared. There were plenty of pigments in this valley, the deity said. But only if the girl had the courage to find them. She said she did, and was given instructions to go to the bottom of a well, a special well, which was hidden beneath white sand and protected by black cliffs. Only a girl could descend the well, the deity said. Only someone who was pure could find the pure colors.

The next day the girl and her father and their two assistants went on an expedition to this monochrome landscape. They tied her carefully to a piece of rope and eased her down. She was only halfway into the well when the knot slipped and she tumbled to the bottom. The last thing she must have felt was the thin stone at the base as her body crashed through it, because when the grieving father looked down all he could see was a gushing new spring, from which flowed the five pigments he had prayed for. Black and red, green and blue and, of course, the precious and pure white, all flowing out in a magical waterfall of paints.

It is of course a superbly Confucian morality tale of individuals sacrificing their lives for the good of society. But it also shows that the local people were asking the same question that art scholars would later ask: where could all those wonderful colors have come from?

# THE ADVENTURES OF LANGDON WARNER

My guide at Dunhuang was most animated in cave 16, where there were some hideous early-twentieth-century restorations, making some of the Buddhas look like Teletubbies, with unskillfully touched-up eye-dots. But it was not this that she was referring to. "One of our statues is missing," she said ominously, waving her hands to where a Tang dynasty Buddha was waited on by an asymmetrical gathering of just three attendants rather than four. "The American stole our treasure."

"The American" was a young explorer-archaeologist called Langdon Warner, who had gone to Dunhuang in 1925, sponsored by Harvard. And the main reason he had been sponsored to travel so far and for so long, risking his life journeying through a country that was going through a particularly violently anti-foreigner phase,[15] was because the university was anxious to learn about the pigments. Were they local colors, or were they carried for long distances? Did the colors change or did they stay the same for the six hundred years that there were artists at Dunhuang? The story of the paints was the story of the ancient trade routes, Warner's paymasters at Harvard had decided. And they wanted to know it.

Of course, Harvard's eminent scholars were also hoping for something more concrete in exchange for their sponsorship dollars. They wanted a share in the archaeological loot that Europeans had been taking out of China by the donkey-load. The Hungarian-British archaeologist Marc Aurel Stein had started the looting when he arrived in 1907 to find that a few years before a monk had accidentally discovered a secret door, that revealed a secret library room, full of ancient documents. Stein took about eight thousand of them—everything from Buddhist sutras to early Eastern Christian writings to a timelessly useful model letter to send to your host apologizing for drunken behavior the night before. He was closely followed by the polyglot Frenchman Paul Pelliot, some Russians and a number of Japanese explorers, who seemed to be working for

a mysterious cult. They all took souvenirs, which nowadays are in the proud possession of various national museums, but none of them actually gouged paintings out of the walls of Dunhuang.

Langdon Warner did. He cut out several paintings. Partly because that was the only way he knew to collect pigment samples. Partly because he was shocked at how a few years before a band of White Russian soldiers had covered the caves with graffiti, and he had the idea of saving art from vandals by becoming a vandal himself. But most of all he took the murals because he was determined that he had not gone all that way "Plodding beside my cart these weary months" to fail in his mission.

Not only did he cut out those ugly square holes, but—and the Chinese find this the hardest to forgive—just as he left Dunhuang he caught sight of an exquisite kneeling Bodhisattva. He was so taken by its beauty that he took it too, wrapping it up in blankets, sheepskin breeches and his undergarments. "If I lacked for underwear and socks on the return journey my heart was kept warm by the thought of the service which my things were performing when they kept that fresh smooth skin and those crumbling pigments from harm," he wrote in his account of the journey.[16] The Bodhisattva is, of course, the missing attendant in cave 16, and the gap where it used to kneel is pointed out to every tour group today to explain why China considers that the nation's "heart was broken" (as an inscription in Chinese characters at Dunhuang asserts) when the foreign archaeologists took its art in order to learn more about the colors.

## WHITER SHADES OF PALE

Rutherford Gettens, chief chemist at the Fogg Museum when Warner's stolen Bodhisattva arrived, called lead white "the most important pigment in the history of Western painting" and was thrilled to find it lying "thickly" on the precious sculpture.[17] He was grateful to it—as many art historians are grateful—because

x-radiography of old paintings depends on the artist's generous use of lead. X rays are electromagnetic waves, just like light except they have a much smaller frequency than light and so can pass through more objects.[18] Lead, however, is dense, so it shows up in x-radiographs much more than, say, ochre. So, for example, in *The Death of Actaeon* by the sixteenth-century Venetian artist Titian, the painting shows Diana getting her terrible revenge on a hunter whom she has caught spying on her while she was naked. She transforms Actaeon into a stag, at which point the hunter becomes the hunted. With the benefit of x-radiography we can see that Titian had some problems with painting the poor hunter. In trying to portray that critical moment of the man changing form, the artist himself made many changes to the form of his painting, and there is a swirl of painting and overpainting in white lead over Actaeon's area of the canvas, which presumably only stopped when Titian was satisfied with the effect of a no doubt extremely penitent peeping Tom being mauled by his own dogs.[19]

As Michael Skalka at the National Gallery of Art in Washington explained, conservators today rarely see a painting that is five hundred years old that hasn't been damaged or had some restoration performed on it. "People who worked on paintings in the past had very little training—and there was no code of ethics to give them rules about the right things to do," he said. They felt they had the right to do anything—scrub the paint, change garments or hat styles—which is very different from current practice, where conservators work on securing and preserving the original paints and supports, without adding anything new of their own. With techniques like x-radiography, art experts now have a "road map" of the past of a painting. For example, a sixteenth-century painting in the National Gallery collection titled *The Feast of the Gods* has been worked on by three artists. It was painted by Bellini and then altered by the court artist Dosso Dossi, and later by Titian, who added a dramatic mountain landscape to the left of the canvas, covering Bellini's original band of trees. It is possible to see many

of these stages of the painting's development by looking at the x-radiographs, as well as making cross-sections and doing pigment analysis. "It's like a geology of layers," Skalka said, "and you need to use science to excavate it."

It is undeniably useful for conservators, but if white lead did so much damage, why did so many artists use it? Certainly not to make it easier on future art historians. The simple answer is that there was very little else. In fact, in Europe at least, there was nothing else very promising in the white line for watercolors until the 1780s—and nothing to replace white lead in oils until just before World War I when titanium paint was invented.[20]

There was bone white (from burned lamb bones) but artists found it gritty and gray. Then there were the "shell" paints, made of seashells, eggshells, oysters, chalk[21] and even pearls. The Japanese and Chinese liked these whites, and they can be found on many woodblocks and paintings, even though they often believed the best white was the paper, unpainted. European artists often used chalky whites on frescos. In the early nineteenth century the English chemist Sir Humphry Davy travelled to Italy to examine the wall paintings at Pompeii. Most of the visitors (who had been including Pompeii on their Grand Tour of Europe since the site was opened in 1748) were full of wonder at the subject matter of the frescos that covered the walls of almost every wealthy home in that doomed Roman town. They showed beautiful objects, languorous gods, luscious gardens, and plenty of erotica. But Davy was more interested in the pigments they used, and he was disappointed to find that all the whites were made of chalk, not lead, even though "we know from Theophrastus, Vitruvius and Pliny that [lead] was a popular color." But the ancients had been right in their choices: chalks and limes didn't alter, and unlike lead white they could even be used safely with yellow orpiment. Those were the advantages. The disadvantages were that chalk whites look very transparent—anemic even—in oils, and don't have the texture and shine of lead.[22]

In 1780 two Frenchmen started trying to find a good white that

did not have corruption at its heart. Monsieur Courtois was a science demonstrator at the Academy of Dijon and Louis-Bernard Guyton de Morveau was a magistrate who would later be better known as one of France's most innovative chemists. A spirit of social activism was raging through Europe in the wake of America's Declaration of Independence (and nine years later both men would support the French Revolution, with Guyton de Morveau rapidly dropping his "de Morveau") and this activism extended into paint. Lead white was made by the poor and it poisoned the poor. Was it not time to find an alternative?

They experimented for two years. The newly discovered element barium, when combined with sulphur (to make barium sulphate), made a non-poisonous paint that was reasonably permanent; indeed in 1924 it would be given the name "*blanc fixe*." But barium was rare, and artists didn't much like it as an oil paint as it was too transparent. So they turned to zinc oxide, a substance that the Greeks had used as an antiseptic. The first findings were promising: artists pronounced the color good and the absorption excellent. But the issue was cash: lead paint cost less than two francs a pound; zinc white was four times this amount. Nobody wanted to buy it.

For the two scientists this was the end of the story; as far as they were concerned their plan had failed. Courtois turned to saltpeter production and Guyton de Morveau to proving that all metals gained weight after heating—and perhaps they forgot about the joys of inventing paint. But not everybody did, and one of the people who remembered was probably Courtois's own son. Bernard Courtois would grow up to become a great scientist. Like his father he would be best remembered for his own experiments with white powder, although his would be morphine. But in 1811 he also discovered his own paint: iodine scarlet. And when he found it, he surely cast his mind back to the days when he was a little boy of six, playing among the smells and solutions as his father and namesake stood above him, testing out paints.

Zinc white did have a future, if only Guyton de Morveau and Courtois could have known it. By 1834, Winsor & Newton were selling it as a watercolor, which they called "Chinese White," even though they acknowledged[23] it had nothing to do with China. The new paint met with considerable opposition. In 1837 a chemist called G. H. Bachhoffner criticized Chinese White, suggesting it was no more stable than lead white, and recommending his own "Flemish White" instead. Messrs. Winsor & Newton were furious and wrote an open letter to Bachhoffner refuting his claims and revealing some experiments of their own.

"Acting on a sense of duty," they had mixed Flemish White with hydrosulphuret of ammonia and saw that it immediately blackened — just like the damage to the paintings I had seen on the cave walls of Dunhuang. "It exhibited the usual signs of being a salt of lead," they wrote with barely concealed triumph, concluding that: "The extracts from your own work save us the trouble of remarking on the extreme impropriety of offering to the artist a pigment so destructive."

From its days in the alchemists' laboratories before the element was isolated, zinc oxide had been given many wonderful names, including "tutty" (from the Persian word "*dud*" for smoke), "zinc flowers," "philosopher's wool" and *blutenweiss* or "blood white."[24] Each name gives a different clue to the story of zinc oxide. The smoke refers to its genesis in the coal-fired ovens of brass furnaces and the flowers and wool describe the way in which it forms fluffily in the upper chamber of the oven. The blood white reference is the oddest of them all, a reminder of how this white paint starts off as red, having been colored in the ground by manganese.[25]

## WHITE HOUSES

Today in England and Wales, lead white paint is only allowed on Grades I and II star listed houses — and even then it can only be on the outside. In the past, this paint was chosen because it was long

lasting; the cheaper lime whites had to be repainted every year. This did have some advantages. In Hong Kong in the early 1900s lime washing was believed to be the best precaution against the plague, and the police would regularly raid the colony's slum houses to make sure they were white enough.

The British paint company Farrow & Ball has made its name selling housepaints in historical hues. It has plenty of enticing colors like "Sudbury Yellow" and "Chartwell Green" (modelled on Winston Churchill's favorite bench), and yet its most popular range is off-white—colors like "String," "Pointing" and "Slipper Satin," with "Dead Salmon" coming in fairly close behind (although that one is so "off" that it's almost brown).

The company started as a small-scale project mixing paints for National Trust houses that needed to be redecorated. But within a few years it had become an international business: thousands of people, it seemed, wanted the colors in their sitting rooms to be just like the ones in British stately homes. Mostly people buy off the shelves, but some even send in specific color requests. What was oddest? I wondered, when I visited the company's factory in Dorset. There were quite a few odd ones, admitted company director Tom Helme. He showed me a sample he had received a few days before. It was a minuscule dot of red, scarcely more than a millimeter across, which had been chipped out of a stately wall. "We've got a spectrometer for measuring color," Helme said. "So we'll be able to match it."

They do not use the same ingredients that a Georgian decorator would have mixed—many of those colors are now illegal (including lead white, and chrome-based colors), and others, like Prussian blue, are simply unstable. Instead, Farrow & Ball mix other pigments (some ochres, some synthetic colors) to produce the same visual effect. As Helme pointed out: "Nowadays people want the color on their walls to stay constant. In the past, people knew it would change quickly, and they were resigned to it."

The company is proud of its wonderful and eccentric paint

names. "String" was originally called "Straw Left out in the Rain" and was designed by the 1930s paint genius John Fowler, who used both words and colors with enthusiasm. "Clunch" is named from the East Anglian slang for a hard chalk building block while "Blackened" is actually another off-white—in which soot is used to make a pigment with a silver tinge.

As for "Dead Salmon," the name has nothing to do with death at all. It was inspired by an invoice for decorating a house in 1850: "It just means a dead flat finish," Helme said. When people used lead paint it was sometimes too shiny, so they would "flatten" or "deaden" it with turpentine to make it look more matte. When he first proposed the name, the people from the National Trust were firm. "They said we can't allow you that one, Tom, nobody would buy it." But it was launched anyway, and became a big seller.

In the past ten years there has been a big increase in nostalgia for old paints in Britain—and particularly for one paint that the trade had almost discounted. "By the 1970s we had really forgotten how to use lime plaster," Helme remembered. "And then people began to say, 'Hey, if you want walls to breathe you'd better use this stuff,' and they're using it more and more often."

It took 100 tons of lime to allow the world's most famous white-colored house to breathe, and it covered it in style. By 1800, when the new President's House was opened, it was the talk of the newly named city of Washington. It was the grandest home in America, and workmen were constantly being diverted by members of the public wandering in to watch the place being finished. It was to be a classical building, the freemason founders of America had decided—and should therefore be white like the ancient Greek buildings they so admired.[26]

At that time nobody had any idea that Greek temples had not been white at all, but covered with incredibly bright colors. It wasn't until the mid-nineteenth century that scholars would begin to realize there were probably no white surfaces at all on classical

Greek buildings. Doric columns were striped red and blue; the Ionic capitals sported gold as well. The findings were not generally welcomed. There is a story of the sculptor Auguste Rodin once famously beating his chest: "I feel *here* that they were never colored," he proclaimed passionately. Color historian Faber Birren[27] recounted an anecdote in which two archaeologists went into a Greek temple. One climbed to the cornice and the other yelled: "Do you find any traces of color?" When he heard an affirmative answer he howled: "Come down instantly!"

The intention among the new Americans was for their "White House" to be the neoclassical equivalent of anything in Europe. Sometimes they were a little overenthusiastic. When George Washington (by then in retirement) first visited the site in 1797 he saw the white Ionic capitals, with great cabbage roses bursting fruitfully from their tops. Hold back on the stone carving, he wrote with some urgency to the commissioners. "I believe it is not so much the taste now as formerly."[28] Inside the house it took two tons of white lead to paint the woodwork, and in the fashion of the time some of it was tinted with yellow ochre, Prussian blue and red lead. If the newly elected John Adams was impressed during his first tour of the building in June 1801 he didn't show it. He complained there was no wallpaper, no bells in the house, the mantelpiece decorations were hideous, and what was more there was no vegetable garden.

## PERFECT WHITES

Whistler's painting—which now hangs in the National Gallery in Washington—shows a woman dressed in a white gown. She is standing in front of a white curtain, and is holding a lily. Her face is quite dark: she probably did not use the fashionable Bloom of Youth, which was lucky for her. Her hair is long and red, in a shade beloved by Whistler's Pre-Raphaelite contemporaries. The effect of all the white is dazzling, but as you fix your eyes on the painting,

the snow blindness begins to have a curious effect. Two patches of color begin to emerge from the canvas, almost as if they are two separate concepts framed in a foggy dream. There is the woman's face, of course, but then rather improbably at her feet there is a wolf's or bear's head that seems to be part of an animal-skin rug. Why would Whistler have chosen to place it there?

The painting was first shown in London in 1862. At first it was called *The Woman in White*, but the writer Wilkie Collins had just published a ghost novel with that title — which confused everyone. The artist pretended to despise the confusion, but it was in retrospect a canny marketing move: in the two years since it had appeared, the novel had already precipitated an extraordinary fashion for white dresses, white handbags, white lilies and even what were called "white" waltzes. This painting, then, was sure to find a buyer.

A decade later, after the first title had caused a storm of complaints from people claiming the model did not remotely resemble Collins's heroine, Whistler decided to rename it *Symphony in White No. 1: The White Girl*. But the painting was jinxed, and he merely attracted more peppery comments from the London art world. The critic Philip Gilbert Hamerton complained that it was not precisely a symphony in white, since anyone could see that it also included yellow, brown, blue, red and green. "Does he then," asked Whistler, "believe that a Symphony in F contains no other note, but shall be a continued repetition of F, F, F . . . ? Fool."[29]

In Whistler's day and for centuries before, it was unusual — almost outrageous — for an artist to paint a white background, especially when the subject was also so light. White lead was mainly for "priming" or preparing the canvas to make it more luminous,[30] for mixing later with other pigments to lighten them and then for the final highlighting and the dotting of the eyes. It wasn't used so much for backgrounds. Backgrounds were mainly made up of darkness and shadows, or they were landscapes or interior scenes intended to create a context for the main subject. They weren't usually supposed to be light. But in the Hindu arts of Indonesia it

was a convention for artists to emphasize the main characters in a story by painting them on a pale background. Lead white and chalks were available to these artists, but many felt they were not subtle enough. They preferred to make their own whites, as I discovered, from stones.

The town of Ubud on the Indonesian island of Bali is full of art studios. Everyone is an artist, it seems, in a place where every tourist seems to want to buy a painted souvenir of paradise. Most use acrylic paints and copy each other shamelessly—and even some of the so-called "classical" paintings are done with new paints and burnished to look old. But in one less-visited corner of the island, in a small town called Kamasan, a handful of artists still hold out against the onslaught of acrylics. I went there to find an artist and grandmother who is in one way the Balinese art scene's greatest traditionalist, and in another one of its iconoclasts. But this wasn't the reason for my journey. I went because I had heard that Ni Made Suciarmi had her own secret source of white paint, and I hoped that she might show me.

Her studio was in her home, and it was traditional. In the middle of the rush matting floor she had neatly set out the tools of her trade. There were little colored stones carefully placed in boxes; yellow and red powders were set in bowls that were already brightly stained. There was a small bundle of charcoal—homemade from twigs and wound around with cotton—and a couple of cowrie shells. The only nods to modernity were a couple of HB pencils, which she explained made marks that were easier to erase than the charcoal. I couldn't see any white.

Behind the array of pigments were some of her paintings—of demon kings and dancing gods. She pointed out one showing the famous legend of the Ramayana where the demon king Ravana kidnaps the beautiful Sita—and her husband Rama and the monkey king come zooming to her rescue. Good wins against evil, light prevails against darkness, and many demons are killed on the way. The

black paint against the white was a representation of that duality. Suciarmi's paintings—where every pattern is dictated by tradition, and every color has its fixed symbolism—were in a style that India, which developed it, forgot two centuries ago: a white background and the stories painted over the top like dramatic cartoons—or more accurately like the *wayan kulit* shadow puppet shows that, despite the arrival of television, are still popular entertainment throughout Indonesia. Over in India you can only find this kind of work in museums. On Bali it is still part of the living tradition.

I stood up to look at the work more closely, and she stood up as well, to point out the details. The canvases are made of cotton, she explained, "and we have a very particular way of preparing them." With the white paint? I wondered. "No," she said firmly. "Not with the white paint. With rice powder, dried in the sun." And I could see that, in the best storytelling tradition, I was going to have to wait. I was going to have to see another white paint first. She summoned her sister, who was seventy, and two years older than Suciarmi. The sister took me across the central courtyard and into a dark room that she called the "artist's kitchen." She showed me how she used the cowrie shells to rub rice powder into a canvas until the rice had become absorbed into the grain and the surface was completely smooth. White-priming Bali style is not easy. Apparently it takes hours of this cowrie-rubbing to get the surface perfectly ready for the paint.

We returned to Suciarmi, who was sitting on the ground, pounding a little nugget of red in her bowl. Preparing pigments was one of the first artistic skills she learned as a child, and she does it well. She had to: when she was a little girl she didn't just have to prove her own ability as an artist, she had to prove the ability of her whole gender. Painting was not girls' territory; no women were artists or even thought of being artists. And when Suciarmi wanted to be one her father—who was one of the artists employed to paint the ceiling in the Palace of Justice at Klung-Klung under the Dutch in 1938—said no. Firmly. But fortunately his daughter did not listen.

"I painted in silence in my room. And when I was nine, I was ready." The first painting she did was an Arjuna meditation, the second was of eight monks, "and I showed them to my teacher and he liked them."

There were big rows at home, she told me. Why couldn't she weave or dance like the other girls? "But I didn't like weaving, I liked sketching," she said. "I only liked the men's jobs. I was like a boy, always fighting." And she was obviously rather good at the fighting, and eventually wore down resistance to her ambition to paint. Her only brother had died, leaving Suciarmi and her three sisters; "I was supposed to be a boy, and eventually they accepted I could do boys' things as well, and learn the secrets of how to paint and do puppets."

It was perhaps the word "secrets" that reminded her of why I was there. She suddenly stood up and said: "I expect you would like to see the white?" I would, I said, and she led me back out into the courtyard, and over to a wooden shed. There was a rattling of keys, and the wooden door opened clunkily. There, in rough wooden boxes, were dozens of what looked like slightly dirty cream-colored stones. Some were in chunks bigger than a fist, others much smaller. "This is my most precious color," she said, and—as we squatted down in front of them, testing the texture of one fragment that was so rich it was almost oily—she told me about where the paint stones came from.

They were the remnants, she explained, of rocks that were carried over the sea many years ago, long before she was born. The sailors came from the Celebes, now called Sulawesi. Some say they were fishermen, and some say they were pirates. But whatever their mission, they used the white stones as ballast. When they got to Serangan Island, on the south coast of Bali, their journey—whether it had involved the bloodshed of fish or of men—was over, and they dumped the stones over the side, to be exchanged for new cargoes.

"The sailors just threw them away," Suciarmi said. "But for me they are the most valuable things that I own. They feel good to

use." She did not know who in her family first learned about the stones, but even when she was a small girl she used to go with her father to Serangan, borrowing kayaks to find the stones, and looking out for the rare turtles that used to live there. Then in the mid-1980s the authorities built a causeway to the temple on Serangan and these soft stones—as well as the turtle breeding grounds—were lost in the construction. She told me how she powdered the stone, mixed it with calcium, and then added a glue that she said—rather incredibly—is made with flaked yak skin brought down from the Himalayas to Jakarta. Then she paused, as if she had already told me enough, and adopted a mischievous expression. "I told you a lot today," she said. "But there are some things I didn't tell you: I kept some secrets for myself."

As we walked back to the studio she pointed to a bit of ground, underneath an old tree. "I used to bury them in the garden so that people couldn't steal them. But then I couldn't remember where I'd left them, so I had to move them to the shed." What I had seen was her entire supply of her special white. "This is all I have left: I just pray I have enough to last the rest of my life," she said. "Because I don't want to paint with anything else."

And perhaps this was the clue I had been searching for about why artists insisted on using lead white despite everything. Whistler could have used zinc, and saved his malaise. But he didn't. If he had been asked, he would probably have dismissed the other paints as not being quite opaque enough, or given some other logical explanation. But perhaps the truth of the matter was simpler than that—it was just that it didn't feel right. That it wasn't buttery enough, or had the wrong consistency.

When we see a finished painting we tend to assess it for such things as composition, emotion, color and perspective. But what the artist experiences moment by moment in his or her turpentine-smelling studio is the scrape or smear or splatter or stir of one substance against another. Does the artist think of butter, tiramisu or of diesel as the paint is applied? Or does the laying down of paint

happen without mental images at all? It depends, of course, entirely on the individual. But either way, painting is sometimes an entirely tactile act where time is forgotten, and it is sometimes a paint's ability to drip—or not to drip—and the colors it goes with rather than its propensity to poison which has been the deciding factor in whether it is welcomed on the palette. As James Elkins writes in *What Painting Is,* where he explores the parallels between art and alchemy: "A painter knows what to do by the tug of the brush as it pulls through a mixture of oils, and by the look of colored slurries on the palette."[31]

## THE WOMAN IN WHITE: *A POSTSCRIPT*

At first sight the *Symphony in White* seems to be a study in innocence. But on closer inspection it turns out to be a study in anything but. In the painting, the model—Joanna Heffernan—looks demure, even ethereal. But the artist called her "fiery Jo," and at the time he was painting the woman in white (at a friend's studio in Paris, where they spent the winter of 1861) they had been having a tempestuous affair for several months already, despite the best efforts of Whistler's mother and other members of his family back in America to prevent it. While the twenty-eight-year-old artist was feeling faint among the lead dust, he was also flirting with his Irish girlfriend. And that fierce creature below her feet could well be a raucous joke between lovers—Beauty and the Beast-Who-Bites, perhaps—and a chance, I imagine, for Whistler to say to the viewer: "You might think this is innocent, but look again. We have had fun on this carpet."

The French Realist artist Gustave Courbet always hated that painting and disdainfully called it *"une apparition du spiritisme"*— a spirit medium summoned by clairvoyants. But then four years later he had an affair with fiery Jo, so he may have been biased.

# 4

# Red

*Gentlemen, I send you by this same post a little French*
*box of — so called — "safe" colours. We have various*
*scares here about scarlet-pink — girofleé — and*
*carnation-darnation fevers; and I've just given this*
*dozen of mortal sins to a young convalescent of six.*
*Will you kindly analyse the temptations and see if*
*they're — not worse than apples and currents — if only*
*mildly licked? And if really right — will you please make*
*me another box, like this exactly, for ten pence . . .*

Letter from JOHN RUSKIN to Messrs. Winsor & Newton, August 9, 1889

*T*he painting should have had a streak of color in a sunset sky,
but instead it just shows a gray wash over a dull afternoon.
When Joseph Mallord William Turner ran his sable brush swiftly
across the canvas of *Waves Breaking against the Wind* it carried a
ruby slick of oil paint where the sun's last colors were supposed to
hit the clouds. But when you see it today the carmine pigment, like
the day the artist was imagining, has disappeared into memory.[1]

They didn't always listen, the Great Masters. Turner had been
warned many times not to use paints that faded,[2] but that day in
1835 or so when he was gazing at his workbox thinking of the pink
sunset and a violent sea, he chose his brightest red, even though he
knew it would not last. Or perhaps he even liked the idea. After all,

his paintings celebrate change—his skies and seas are a stormy riot of variety in nature and light—and the notion that the work would alter over time as well as canvas space may have been a delightful personal joke. According to Joyce Townsend, who is senior conservation scientist at Tate Britain in London: "Mr. Winsor, of Winsor & Newton, remonstrated with him about some of the pigments he was buying, saying he knew that these 'aren't going to last,' but Turner told him to mind his own business. He didn't care."

Dr. Townsend has spent many hours in the studios and laboratories of the Tate's Conservation Department poring over canvases and tiny fragments of paint with a microscope. "You learn a surprising amount about artists when you're that close," she said. In Turner's case she has not only learned about his sloppy work practices, but has found that his bequest to the nation is considerably less colorful now than when he left it for future generations of art experts to study. Apparently if a customer marched in brandishing an oil painting or a watercolor that had already faded, Turner would not even deal with the issue. "He once said that if he repainted a watercolor for one person he would have to do it for everyone. And that would be to acknowledge publicly that there was a problem."

No picture of Turner's "is seen in perfection a month after it is painted," wrote the art critic John Ruskin, adding that one painting—The Opening of the Wallhalla—had cracked within just eight days of being hung in the heated Royal Academy of Arts for the annual exhibition, because the artist had only just finished painting it. If Turner (who used to leave finished canvases in the damper corners of his studio, letting the rain drizzle on to them and green mold thrive on the egg-based primer, and who even ripped a tear into one painting to make a flap for his seven Manx cats[3]) cared little about eight days, it was unlikely he would have wasted his energy thinking 80 or 180 years ahead. Notoriously careless of posterity, at the moment that his art most mattered to him—which was the very moment it was being created—Turner would use the paint that served his immediate desire. And damn the future.

# COLOR

This particular red, carmine, is really made of blood. For centuries it was the treasure of the Incas and the Aztecs, and for centuries after that it was the treasure of the Spaniards, who guarded their secret crop jealously. It has been used on the robes of kings and cardinals, on the lips of screen goddesses, on the camel bags of nomads and on the canvases of great artists. And if it disappeared the next day many of its users didn't care, because on the day it is fresh, carmine—or cochineal or crimson; it has many names—is one of the reddest dyes that the natural world has produced.

To understand how this particular color came to be in Turner's paintbox, as well as in the makeup boxes of women and in the fridges of families around the world today, requires a journey through time and space. The quest for carmine leads to precolonial America, to the swaggering Conquistadors who exported it to the world, and into the private diaries of a young French adventurer. But the journey begins, as it should, with the little creature that was once the basis of a big industry. And for me the journey began, to my surprise, on a very short journey indeed: on an underground train in Santiago, Chile.

In the end it *was* the right train—zooming through dark corridors away from Las Condes, "the mountain end" of Santiago. But it didn't feel right and my friends and I conferred loudly about station names. "Can I help?" came the words, in an Irish accent, from the crowd of dark-clothed Chilean commuters. Alan had blue eyes and a Guernsey sweater, and worked "in agriculture," he said, once he had confirmed we were going the right way.

"You don't know anything about cochineal, I suppose?" I asked optimistically. My color quests had not yet started then. But I had heard of the ancient Inca insects and knew that some were being cultivated in the deserts to the north of Chile, and I was curious to learn more. By coincidence it turned out that not only had he heard of cochineal, but his father had helped introduce the industry to the country a decade before. In fact, he added nonchalantly,

he was just going to a meeting with the manager of a carmine plant—a man responsible for processing the cochineal into the bright scarlet sludge for which it is so greatly valued. Would I like to come too?

I never reached my planned destination that day—I left my friends to see the seashell collections of poet Pablo Neruda on their own, and instead found myself walking through the hard winter rain of Santiago with a complete stranger, to learn about bug blood. As we walked he talked about an episode in which one plantation owner apparently put poison in a consignment of cochineal from Peru. "Peruvian cochineal is cheaper—labor costs less and the cochineal grows wild so you don't have all the hassle cultivating it. The only hope for Chile was if the Peruvian stuff was tainted," he said.

He led me up to his small, grimy office where a man and a woman were peering in 40-watt gloom at the green screens of ancient computers. They told him the carmine man had cancelled, so he strode out again with me following through wintry, soggy streets without an umbrella. We sat in an empty restaurant drinking cold percolated coffee as Alan drew pictures of the cochineal bug on a notepad: an oval cartoon insect the size of a little fingernail, with tiny wavy legs and a big body bursting with potential. "Is it cruel?" I asked him about the cochineal industry in general. "Only for the cactuses: the insects eat them alive."

Spanish Red, I noted in my diary that night, is usually born between the fog and the frost in places where land is cheap and the prickly pear, on which it is a parasite, grows in abundance on the desert sands. It is a holy blight, a noble rot where the treasure is rubies rather than the gold of dessert wine. It is a deep, intensely colored organic red, but it will never be used for Buddhist robes because there is too much death in it. In the twenty-first century women around the world coat their lips with insect blood, we apparently dab our cheeks with it, and in the United States it is one of few permitted red constituents of eye shadow. "And finally,"

I wrote with a happy frisson, "Cherry Coke is full of it; it is color additive E120."

## THE PLANTATION

A week later I took a short flight to the Colores de Chile plantation in the Elqui Valley near La Serena—an attractive colonial town 350 kilometers north of the capital. While Santiago had been icy and wet, La Serena was dry and perfectly spring warm. I was picked up by the station manager, Javier Lavin Carrusco, in his new four-wheel-drive. As we headed toward the mountains, the air was clear and smelled of eucalyptus. It seemed we had passed several miles of umbrella-like papaya trees, chirimoya orchards and vineyards when he turned right onto an unmarked driveway and we bumped our way past gorse underbrush. "There," he said, and waved his hands dramatically toward the gently sloping hillsides, spreading out into the distance. "That's the first infestation: the pregnancy." Everywhere there were prickly pears, huddling sullenly and cruelly together in long rows, 45,000 of them per hectare. I imagined a spaghetti western scene with the horses rearing up and the most cowardly cowboy saying: "We can't go on through this goddamn country: let's turn back."

Javier switched off the engine and we got out. From the sunny side of the hill it looked as if it had been snowing in the desert—everything was clouded in white flour. On the shadowy side the thick, flat nopal leaves looked almost healthy. The noisy picaflor bird flew from plant to plant: "It's greedy, it likes the cactus flower," he said. He scooped a tiny white creature—big as a bedbug—and put it on my hand. "Squeeze," he said, and I squeezed, and for a moment the creature's hard body resisted, and then it popped like a piece of bubble wrap, leaving a thick dark scarlet stain on my palm. "These are the women," he said, indicating the fat ones, covered in a white down, one of which I had just killed. "And this is the man." The "men," thin, ghost-like creatures, have even shorter

*Prickly pear*

lives than the females—they live for only two or three days, using their energy to fly through the air and fertilize their species. We looked up to the mountains, haloed with wisps of ice cloud. "You have a virgin nose," Javier said, which bewildered me until I realized he was talking about the fresh fall of snows on the Andes.

Prickly pear, or "nopal" as the Spaniards call it, is easy to grow in the right conditions—25 degrees Centigrade, little rain—but it is temperamental. Two degrees more or less and it dies. The leaves propagate without human interference: they fall off naturally and their tiny prickles turn into roots. The nopal even waters itself. The

wide surface of the leaf is its own water bowl—it draws the dew in the night, and drinks it during the day. If they are left to their own devices the insects kill the plants: it is the farm manager's job to strike a balance between letting the cochineals grow to their maximum size and keeping the cactuses alive. "In two weeks we will go through this field with an air compressor and collect the cochineal," Javier explained, when we stopped on another hill. "The plants will have two to three months' rest, and then we will infest them again," he said, showing me one of the little boxes full of pregnant insects that would be tucked under each prickly plant. They would live for five months before collection time came round again.

Harvesting the cochineal—or "grana" as it is locally called—is intensive work. The plantation employs fourteen human laborers per hectare: we watched them silently trudging along the rows with their compressors, shooting the live snow into buckets. They made a surreal scene, with their hoods and gloves and glasses, and the constant hiss of the compressors echoing around the fields like the soundtrack of a science fiction film. The protection was necessary: one of those fine spines in the eye and a worker can go blind; even on the skin it is difficult to remove. "We're used to the prickles round here," Javier said, flicking at his hand.

The owner of the plantation was Antonio Bustamante. He appeared as if from nowhere, just as I was taking a photograph of a woman scooping the insects off the leaves. I looked around and suddenly he was there. With his keen eyes, charisma and jaunty panama hat, he looked like an adventurer. And he probably was. He had lived in Africa for many years, he told me in immaculate English. Then in the 1970s he moved to Peru, starting a business selling tractors. But in 1982 El Niño arrived, and that mischievous weather urchin put all the local farmers into terrible debt. "I was wiped out: they couldn't pay me," Antonio said. But one farmer could pay him—in land. He gave Antonio a tract in the Peruvian desert. It had only a small well and brackish water. The only thing that could grow

*Female cochineal beetle*

there were cactuses, "and that's how it all started: I got advice about cochineal from the Indians, and I never looked back."

Moving his business to Chile was harder: Chile has such strict import laws for fruits and vegetables that you can't even take apples between some of its zones, and have to throw them away in special bags provided by the bus companies. So naturally, with Antonio the authorities were particularly vigilant, worried he might be bringing a plague in his baskets. In the end, his bags of cochineal were with the government for two full years. In cochineal terms that meant seven generations of bugs. "I was the only person able to tend them, and I had to go in with gloves and glasses and look after them," he said almost tenderly. "I'm a romantic," he added, in partial explanation. "Everyone is who works in cochineal." He showed me a rug he had just commissioned from the local Indian Mapuche community, with stripes of different reds. They ranged from pastel pink to deep purple, each dyed with a slightly different recipe of cochineal with metal salts. "Beautiful, yes?" he asked. And "yes," I nodded, it really was.

Yet there is that dark side to the cochineal industry. The steel vats that I had seen earlier in the factory were full of live, pregnant insects being churned into Color Index Number 4. "Are you a vegetarian?" Antonio asked suddenly. And I said that I was not, although I grieved a little for the three or four bugs I had killed that

day to see the blood spurt maroon onto my hand. "I don't want to think what is going on in their heads," Antonio continued grimly. He often got letters from animal rights groups asking him to stop his business. But we agreed there were worse things: once animal lovers had got rid of pig farming and beakless battery chickens it might then be time to look at the carmine plants.

After a day in the Elqui Valley, my hands were stained with blood.

When the newly appointed American cardinal Edward Egan returned home from his investiture in Rome in 2001 he sported a red silk hat, signifying that the Pope had made him a prince of the Church. "What does the red symbolize?" a New York reporter asked him. Cardinal Egan said it meant you had to be so willing to protect the faith that you would even go to death. Mary Queen of Scots might have agreed. On the day in 1587 she was fated to meet the hooded executioner she chose to wear a black-and-red dress. The black was for her death, but the red dye (no doubt made with beetle blood) symbolized, or perhaps summoned, her courage meeting it.

For many cultures red is both death and life—a beautiful and terrible paradox. In our modern language of metaphors, red is anger, it is fire, it is the stormy feelings of the heart, it is love, it is the god of war, and it is power. These are concepts that the ancient color coders understood very well. In Comanche the same word—*ekapi*—is used for color, circle and red.[4] Which suggests that in that Native American culture at least it was seen as something fundamental, encompassing everything.

Nearly twenty years ago, in the National Museum of Peru in Lima, I remember seeing a dusty selection of strange multicolored cords hidden in the "ethnic" section. They looked like complicated necklaces: faded threads hung off a central string, and further smaller cords were tied to them in a curious system of knots. On some of them, different-colored strands were wound around

each other, giving a candy cane effect. But what appeared to be macramé was in fact one of the most sophisticated pieces of color coding that the world has ever known.

At the height of its powers, the Inca Empire controlled 10,000 kilometers of roads. In the absence of wheels and horses, let alone telephones and e-mails, the government ruled it with a huge relay team of runners who would sprint for 20 kilometers at a time before passing the message on. The system was made trickier by the fact that the people had no sophisticated writing system, and when the message of the Inca civil service was too hard for a simple runner to remember, which was often, he carried coded cords, or "quipus," to pass on the information. Every color and knot meant something different. So a black string represented time, yellow was gold, and blue referred to the sky and—by extension—the gods. But red, deep purplish red, represented the Incas themselves, their armies, and their all-powerful emperor. It was life, power and death all bound up in a single piece of string. So, for example, a red cord tied with knots at the top would mean a great battle, and the blood-colored knots would represent how many people had died: vital information for generals preparing to fight their own skirmishes on the borders of an empire.

The Incas had several reds. They could macerate the wood of the brazil tree to make a deep pink, they could make an orange dye with the dried seeds of the annatto plant, and of course there was logwood, which I found in my search for black, and was actually better black than red. But they used to treasure the ruby color from the cochineal insect as the best of them. Women used cochineal as a blusher, potters used it as decoration, home decorators used it on walls, and artists used it in their frescos. But most of all it was found in textiles, most of which have now been destroyed by time and sunlight.

The beetle blood alone would not pass any color fastness tests—without any additives the quipus and the clothes would have faded with the first wash. To make the color fix, the ancient

Meso-Americans used to mix it either with tin or with alum. They did this much as the colormen of Winsor & Newton would have done in their early factory in Harrow, and much as modern carmine dye-makers like Antonio Bustamente do today in their great stainless steel vats.

Today alum is so cheap and such a specialist substance in industry that scarcely any attention is paid to it. Indeed, most people who are neither dyers nor chemists have never heard of it. But at one time this substance (actually several substances as it could be made up of aluminium sulphate and either potassium or ammonia) was one of the most important chemicals in the world. It was used in large quantities by tanners, papermakers and particularly dyers.[5] Without alum you could hardly put any color onto clothes: you were condemned to a drab wardrobe, and few societies from the Egyptians onwards were satisfied with that.

Alum is what is called a "mordant," relating to the fact that it is so astringent that it "bites" onto the color and makes it stick to the textile with its metallic teeth. In Book 35 of his *Natural History*, Pliny described how the Egyptians dyed clothes by a "very remarkable process" which first involved saturating the fabric with mordants after which "the fabrics, still unchanged in appearance, are plunged into a cauldron of boiling dye."

In the Middle Ages the main European alum market was in Champagne: dyers from as far as Flanders and Germany would travel to France to buy this valuable raw material imported on donkey-back from Aleppo in the east and Castile in the west,[6] with some of the best alum coming from Smyrna on the Turkish coast. With such a strong Muslim control of the world's alum resources,[7] it was a relief to the Catholic world when in 1458 a man called Giovanni di Castro found a large deposit within 100 kilometers of Rome at a town called Tolfa. For several decades the Vatican had a near-monopoly of this valuable commodity, although in the sixteenth century deposits were found in Flanders (there were rumors

that Henry VIII of England only married Ann of Cleves to get his hands on her alum), and in around 1620 a Yorkshireman called Sir Thomas Chaloner risked his life to smuggle two of the papal alum workers to England to learn the secret of extracting it from shale. As geologist Roger Osborne describes in his book *The Floating Egg*, from that moment on the Lower Jurassic cliffs from Whitby to Redcar "were ripped open and thrown onto the beach." And when in the mid-nineteenth century the scientific and religious worlds opened their minds to the possibilities of prehistory, it was in the rubble-strewn alum quarries of Yorkshire that some of the most exciting finds of marine fossils were discovered. Fossils, as Osborne writes, that enabled us "to think the unthinkable."

## THE OLD WORLD BUG

When Turner bought his carmine from his paint suppliers in London it was certainly made from cochineal, imported by the ton from the Americas and then turned into a lake pigment.[8] But had he lived a few centuries earlier he would have used something also called "carmine," which came from an Old World bug, as long as but thinner than a five-year-old child's fingernail and almost as hard. It is the kermes insect—the Indo-European cousin of the cochineal, chemically related but with a much weaker concentration of color.[9] From its Sanskrit name, *krim-dja*, came the words carmine and crimson. And today's Persian speakers still use the word "kermes" if they want to describe red.

Among the Roman soldiers who travelled around Europe conquering land for Nero in the first century A.D. was a Greek doctor. No doubt Dioscorides did his duty in the camp hospitals, tending battle-wounded soldiers with the medicines and sharp-toothed saws provided by the military, but his heart wasn't really in it. What he loved most was the days he could spend escaping on to the hillsides, heading away from the battle cries and collecting medicinal

plants. He wrote a textbook about his discoveries, and the *Materia Medica* has been a useful source of information for botanists, physicians and historians ever since.

Dioscorides described how kermes was harvested with the fingernails — scraped carefully from the scarlet oak it lives on. But curiously he described it as "coccus," meaning "berry," and did not explain that it was an insect at all. Some people have said that meant he had never actually seen it. I think there is a different explanation. One of the beauties of language is its built-in metaphors. Kermes had probably been called the "oak berry" for so long that everyone knew it as that. Perhaps in two thousand years someone will unearth an ancient spy story and laugh at us for our own use of the word "bug." "How innocent they were in those days, how animist in their beliefs," this future reader might muse. "To think that an insect could listen in to conversations and report them back!" Pliny the Elder, who lived at the same time as Dioscorides, was also either incredibly confused by the dye's origins or was also using the accepted metaphorical language of the day. In his *Natural History* he called the kermes both a berry and a grain, yet also described it as a small worm, or "scolecium."

Whatever it was called, this little insect was big business. Since the Ancient Egyptians had started importing it by the camel-load from Persia and Mesopotamia, the kermes trade routes had increased to cover the known world, from Europe to China. The Romans liked it so much that they would sometimes demand that taxes should be paid in sacks of kermes. When it was ruled by Rome, half of Spain's taxes to the capital were in the form of kermes — which they called "grana" — and the rest would mostly consist of more conventional grains like wheat. With such guaranteed demand the industry was always well paid and kermes-collecting was the kind of business that families could trace back through generations. Instead of being sun dried like cochineal, kermes insects suffered murder by slow subjection to vinegar fumes or death by immersion in a vinegar bath. It didn't always work. Dr. Harald

Boehmer, who has spent twenty-five years resuscitating the natural-dye carpet industry in Turkey, tells of how he went collecting wild kermes on the trees around the weavers' villages, after which he popped them into a vinegar bath as his books suggested. "But they loved it and started swimming around and jumping out. That day the back of my car was full of lively insects," he said.

A fashion statement in medieval Europe was to wear clothes made of a new cloth, imported from central Asia. The cloth was called "scarlet" and it was the pashmina of its time: vastly popular, frequently imitated but at its highest quality extremely expensive — at least four times the price of ordinary cloth. But the curious thing is, scarlet was not always red. Sometimes it was blue or green or occasionally black, and the reason that in English "scarlet" now means "red" and not "chic-textile-that-only-socialites-can-afford-but-which-we-all-aspire-to" is because of kermes.

By the Middle Ages, kermes was one of the most expensive dyes in Europe. Painters rarely used it: even then, more than five hundred years before Turner was making those rash pigment decisions about his wild skies, most people knew it wasn't colorfast. But the dyers loved it. And what else would they use for their most valuable textile? There was madder, a plant root, which was relatively cheap and which I would find in my search for orange. It was fine for carpets and ordinary people's clothes, and it was reasonably light fast. But it tended toward brown, and did not have that rich crimson hue that was so valued. Greens and blues had their fans, but ultimately the most valuable cloth deserved the most valuable dye, and kermes won out. So "a scarlet woman" actually means "a woman of the cloth," which would be particularly galling to some members of the Christian Church, accustomed as some of their scarlet-clad bishops are to denouncing the world's oldest profession.

In 1949 the Russian archaeologist Sergei Rudenko was excavating burial mounds in Siberia's Altai Mountains — and made an extraordinary discovery: the earliest known Persian carpet, now called the Pazyryk Rug and knotted 2,500 years ago. It proved to be one

of history's few grave-robber "success stories." In the fourth century
A.D. a band of robbers had discovered the tomb and stole its more
portable treasures. They left the rug—probably it was a bit heavy
for them. But they were in a hurry and they left the tomb door
open after the bolts of silk had left. That winter, water flooded the
cave and—Siberia being cold—the carpet froze for posterity. The
rug shows deer and Persian horsemen prancing on a red field
that scientists believe was dyed with what we now call "Polish
cochineal," which was a cousin to kermes. Incidentally, the ar-
chaeologists also unearthed a deposit of hemp seeds and pipes that
had been used for smoking hashish[10]—a find that has excited hal-
lucinogen historians ever since.

## New World insect

The first Europeans arrived on the American mainland in 1499,
seven years after Christopher Columbus and his seasick crew first
set their grateful eyes on the Bahamas. Fourteen years later, in
1513, the dreamer and failed farmer Vasco Nuñez de Balboa
crossed the isthmus of Panama and became the first European to
see the Pacific from that angle. On his return, he and his men built
houses and sowed crops. The Age of the Conquistadors had offi-
cially begun, although it was to be remembered not for its archi-
tecture or agriculture, but for its guns and its greed.

The armed men found gold and silver in their New World, but
they also found red. Within a few years they had taken over control
of the cochineal industry from the locals. Like the Romans so many
centuries before, the Spaniards took their red taxes seriously, and
soon one of the biggest color export businesses that the world has
seen started up. In Mexico they left its harvesting in the care of the
indigenous Indians. They knew how to care for it—and what was
more they wanted to do so, because it was so central to their cul-
ture. The Zapotec word for red, "tlapalli," is the same as the word
for "color," so important is the crop to their traditional culture.

In 1575 alone about 80 metric tons of red arrived in Spain in the form of dried brown pellets, on what became known as the cochineal fleet. Over the next quarter-century the annual shipments fluctuated from 50 to 160 tons—several trillion insect bodies every year. The quantities depended not only on the weather and the market demand, but also on the state of health of the native workers. Whenever a flu bug hit the Americas, the harvest of red bugs was vastly reduced.

The fashion world reacts quickly to new materials, and suddenly wealthy Europeans were demanding that their cloth be made in this new deep red, often called either "grana" or "in grain." Women were also going crazy for what was seen as the ultimate cosmetic. There is a moment in Shakespeare's *Twelfth Night*—written a few decades after cochineal first arrived in the Port of London—when the Countess Olivia describes the rouge on the cheeks of her portrait as "in grain sir! 'twill endure wind and weather." By this wordplay on the similarity between "in grain" and "ingrained"—or natural—the Elizabethan audience would have understood her to be at the cutting edge of cosmetic fashion. In the sixteenth century, Venice became the most important trading center for red. While Venetian businessmen sent it on to the Middle East, to be used for carpets and fabrics, Venetian women demanded a reserve to be kept for their own use. In around 1700, according to Jan Morris in her book *Venice*, there were just 2,508 nuns in that city and 11,654 prostitutes. No wonder there was a market for rouge.

When I started telling my stories about cochineal, many people were horrified, or at least surprised, to learn where it comes from. If they didn't already know it was made from insects, they found the truth hard to believe. Sixteenth-century Europeans had the same problem. They were desperate to know what this wonderful new color was made of. But the Spanish weren't telling. It was in the colonizers' interest—a kind of financial alchemy—to guard the secret of red as carefully as they guarded their gold, which they managed to turn it into rather successfully.

# COLOR

They couldn't hold out forever, and ultimately it was a French-
man in his mid-twenties—a man called Nicolas Joseph Thierry de
Menonville—who made the most daring raid of the eighteenth
century on the cochineal fields of Central America, and broke the
story of cochineal to the world. And he did it alone, against the ad-
vice of friends and family, and with just a meager subsidy from his
own government, for whom he was later, as reward for his deter-
mination, to be appointed Royal Botanist.

## A SPY IN MEXICO

When Thierry de Menonville's 1787 *Traité de la Culture du
Nopal . . . précédé d'un Voyage à Guaxaca* arrived from the ar-
chieves of the British Library, the book was in a cardboard cover
marked "fragile." As I tenderly lifted the volume out of its crisp case,
little scraps of leather binding fell onto the desk and the covers fell
off—a legacy, I hope, of researchers who had been there before me.
This book is a rarity now, available only in a few private collections
and the national libraries, and if, in the early nineteenth century, it
had not been discovered and translated by English armchair adven-
turer John Pinkerton, the story might have faded from the modern
imagination—in Britain at least—as truly as Turner's own carmine
lake pigment. The translation—in Volume XIII of Pinkerton's 1812
*Collection of the Best and Most Interesting Voyages and Travels in
All Parts of the World*—is sandwiched between accounts of North
American travels, from an era when Manhattan consisted of two
thousand households and had porpoises frolicking in its waters.

De Menonville was a teenager in Lorraine when he first heard
the details of Spanish Red. It had only been fairly recently that any-
body had had any idea about what this "carmine" actually was.
Many people in the sixteenth century thought it was a fruit or a
nut, or anything but a bug. In 1555 a British traveller called Robert
Tomson got permission to visit the new Spanish colonies in the
Americas. On his return he declared that: "cochinilla is not a

worme or a flye as some say it is, but a berrie that groweth upon certaine bushes." Nearly fifty years later the French writer Samuel de Champlain explained confidently that cochineal "comes from a fruit the size of a walnut which is full of seed within." These confusions find echoes in the ways that Roman scientists described kermes fifteen hundred years earlier. De Menonville knew it was an insect, although he didn't quite know what it looked like. And he knew it lived on a cactus, although he wasn't quite sure which.

His father and grandfather had been lawyers—the only other acceptable career choice in his family was, it seemed, to join the clergy. But de Menonville was interested in another kind of cloth—and most importantly, how to color it. Immediately after finishing his law degree he moved to Paris to study botany. In the pre-Revolution days of his childhood, he had been taught by liberal thinkers to believe that science should not be arcane or elitist but should benefit the people directly. So his youthful patriotic fervor was fully engaged when he read the political writings of the Abbé Raynal, who was an economist as well as a cleric. "Cochineal, whose price is always high, should excite the interest of those nations that are cultivating crops on American soil. It should also excite other people who live where the temperature is suitable for this insect and the plant on which it is nourished," Raynal wrote. He noted with a sense of regret that "in the meantime New Spain remains in complete possession of this rich industry." De Menonville took this as his mission statement—and started planning his great adventure: to steal the secret of cochineal.

In January 1777, when Spanish eyes were turning to the immediate aftermath of the Thirteen Colonies' War of Independence against the British—and even more importantly to Peru and Colombia, where insurrections over the next four years were to challenge their dominance of South America—de Menonville landed in Havana, Cuba, on the brigantine *Dauphin*. As his ship came in from French Haiti, he looked in awe at the assembled batteries, citadels and forts, with their "innumerable mouths of

thundering cannon," and imagined them all pointed against him, intent on preventing his scheme of obtaining cochineal. He failed to realize, as they sailed into port without obeying—or indeed hearing—the commands issued through a Spanish "speaking trumpet" to cast anchor outside the harbor, that they were perilously close to receiving a "few ungrateful salutes from twenty-four pounders."

He carried "a few clothes, some fruit and other refreshments, but especially a number of phials, flasks, cases and boxes of all sizes." He also had a passport from Port au Prince, a letter describing him as botanist and physician ("to which I had a fair claim, possessing a diploma for the practice of physic," he wrote defensively in his journal, probably having more certificates than years of practical experience in medicine) and the blessings of the French government. Cash had been less easily forthcoming than blessings: "I received, instead of the 6,000 livres promised to me by the minister of the navy, no more than 4,000: a circumstance occasioned by the deficiency of money in the treasury."

His next task was to get to Mexico—but the Spaniards were already suspicious. "Are there not plants growing in your own country?" they asked. De Menonville answered that indeed there were, but Central America possessed superior examples. And then came the waiting time: six months during which "time flew with leaden wings" for the impatient botanist. He then decided on a new strategy—one that by all accounts suited his character perfectly. "Pretending to be actuated by that volatility and inconstancy of disposition, often with so little fairness ascribed to Frenchmen, I feigned to be overcome with ennui from my long stay in Havana." Within six weeks the Spaniards, with a spot of ennui themselves no doubt from all that Gallic sighing and prancing, yet enjoying the way it confirmed their prejudices, had helped him get the precious visa to Mexico. Plenty more gesticulating and nationalistic stereotyping ensued down at the busy Havana harbor as he negotiated his ticket. "The master of the packet would take no less than 100 hard dollars: the demand was exorbitant but it was vain to reason:

his avarice was inflexible. To all my arguments he opposed a truly Spanish phlegm and gravity and coolly pocketed my money without once taking his cigar from his mouth."

In Vera Cruz, where he was incidentally thrilled to find pineapple ice cream, he found another method of getting his own way: by appealing directly to the Spaniards' bowels. The laxative plant root jalap was so much in demand—despite the presence of hot peppers that could doubtless produce a similar effect—that the city of Jalapa, which supplied the Mexican world with the natural remedy, had been named after it in gratitude. Until de Menonville's arrival the constipated citizens of Vera Cruz had transported their medicine at great cost from Jalapa, 100 kilometers away. To their evident relief the young botanist showed them how they could find it locally.

It was not the only local remedy the Spaniards used. From the first years after they conquered Central America they had been using cochineal not just as a dye, paint and cosmetic, but also as a medicine. When Philip II of Spain was sick he would get a mixture of ground beetles and vinegar served to him on his silver spoon. The physicians were flexible: they plastered it on wounds, recommended it for cleaning the teeth and, according to King Philip's doctor, Francisco Hernández, they used it "to relieve ailments of the head, heart and stomach." It is curious that today's pharmaceutical and food industries treat cochineal as a harmless coloring agent, while for thousands of years it has been prized not only for its color, but for its ability to heal.[11]

The laxative discovery made de Menonville the hero of the moment, and he used that position to continue his undercover investigations—discovering that the mountain town of Guaxaca (now Oaxaca, pronounced Wa-har-ka) was the main center for cochineal production. But the governor quickly became suspicious of his questions, told de Menonville he had to leave on the next boat out, and this time the young adventurer's dramatic posturing was for real. "I repaired to my lodging deadly sick at heart: I walked backward

and forward, now threw myself on a seat and now into my cot, swinging it from one side to the other with such violence as to risk breaking my head against the ceiling." With what he later called the "voice of anguish" he began to criticize himself: "Your plan of four years standing now falls to wreck: four years are lost of the profession you chose yourself, the bounties of your king have vainly and stupidly disappeared, you fail in an endeavor undertaken against the advice of your father, your friends, and everyone else." But then another voice—of reason perhaps, or of foolhardiness—began to speak, reminding him that there were no ships leaving Vera Cruz for another three weeks. Perhaps, if he hurried, he could cover the 600 kilometers to Oaxaca on time. He wrote himself a firm directive in his journal: "You absolutely must, I said to myself, penetrate into the interior despite your lack of passport, and you must bear away the fleece, despite all the dragons on the way."

And so the real adventure began: a day later, at three in the morning, he scaled the city walls and set off on his impossible journey. He wore a broad-brimmed hat and carried a rosary and a few "neat" clothes, in order "to assume the appearance of taking a walk rather than a journey." He avoided the toll gates, stayed with Indians, pretended to be constantly lost to explain his strange location, and to be a Catalan from the French-Spanish border to explain his strange accent.

Bad roads, appalling weather, days without food and the dangers posed variously by the Spanish king's soldiers and raging torrents were all par for the cochineal course—but de Menonville faltered only when he met a beautiful woman in an Indian home. "I looked for faultiness in her, but—almost naked as she was, having nothing on but a flounced muslin petticoat trimmed with a rose-colored cord, and a shift which left her shoulders bare—the nicest scrutiny discovered no defect." Learning that she was married and had children "only rendered her more interesting, and her charms had a disorderly effect on my senses." The Frenchman was close to pulling out a gold coin from his pocket with which to buy her

favors, but then that useful inner voice became vocal once again—leave, it said, or your plans of four years will fall to nothing—"and I left the cottage without speaking a word, or daring to take another glance and dragged myself, sighing, along."

A few days later, and having found a horse, a companion and excellent directions (the last from a "round and jolly" Carmelite), he arrived at a small hamlet called Galiatitlan, and finally saw, for the first time, and on the leaves of a cactus, what he thought could be the treasure he had come so far and risked so much to find. He leapt from his horse, pretending to alter his stirrups, and entered the grounds. Seeing the Indian owner walking toward him, he struck up what he tried to make seem like a casual conversation. Endeavoring to disguise his excitement, he asked the man what the plants were for. When he was told it was "to cultivate grana," de Menonville pretended surprise and begged to see.

"But my surprise was real when he brought it to me, for instead of the red insect I expected there appeared one covered with a white powder," de Menonville wrote. Was this a false ending to his quest? Could he have travelled so far for the wrong insect? "I was tormented with doubts," he wrote. "And to resolve them thought of crushing one on white paper, and what was the result?" It yielded a royal purple hue. "Intoxicated with joy and admiration, I hastily left my Indian, throwing him two coins for his pain, and galloped at full speed after my companion." Having discovered that red paint was made from white bugs, he "even trembled with ecstasy," he wrote happily in his journal. Grand plans for a huge French national color industry, credited in future history books to none other than Thierry de Menonville, no doubt filled his dreams that night, although they shared their space in his head with more practical worries to the effect that "I should have to bring to a safe haven an animal so light, so pliable, so easy to crush: an animal which, once separated from the plant, could never settle on it again."

It was not only France which was desperate for this dye, the young explorer knew. If de Menonville could get those insects

home and if the venture was a success he knew he could export to Holland and Britain and a dozen other countries full of people who were tired of buying red from Spain's overpriced monopoly. Britain was particularly vulnerable. By the time our young botanist was scaling the walls of Vera Cruz, British dyers were finding themselves in a quandary. Britain had a successful cotton industry but continental Europeans used to joke about English dyeing with the same amusement as they have joked, over the centuries, about English cooking. Of the 340 tons a year that New Spain was importing to Europe by the end of the eighteenth century, British dyers were claiming nearly one-fifth. It wasn't all for fashion: much of that insect blood was intended to hide the stains of human blood, and was heading straight for the military dyeing vats, after an accidental discovery by a Dutchman living in London.

Cornelius Drebbel had not actually been working on dyes at all, that day in 1607, but had been sitting in his laboratory gazing out of the window, probably thinking about the world's first "scuba" gear. He would eventually demonstrate his ideas in the world's first submarine (or at least subriverine), which was rowed underwater from Westminster to Greenwich under his direction to the enthusiastic roar of crowds. But these moments of an eccentric's glory were in the future. On the day in question, the glory was not at all obvious. Drebbel was absorbed in his thoughts, and he carelessly knocked over a glass thermometer containing a mixture of cochineal and aqua fortis.[12] It spilled all over the windowsill and onto the pewter frame of the window. To Drebbel's surprise it made a bright red dye. He did some more experiments, using pewter and then just tin as a mordant, and ultimately set up a dye works in Bow in East London with his son-in-law Abraham Kuffler. By 1645 Oliver Cromwell had fitted out his New Model Army with Kuffler tunics and from then on the British army was to be famous for its red coats. The scarlet broadcloth for British officers' uniforms would be dyed with cochineal until as late as 1952. So in the

heady days of 1777 it was immensely valuable stuff, and for any young man who had the secret fortune and fame seemed assured.

Soon after that first sighting of cochineal, de Menonville arrived in the mountain city of Oaxaca. He begged the black owner of a plantation to sell him some nopal leaves with the bugs on them. He pretended it was for an urgent medical salve. "He permitted me to take as much as I pleased: I did not require twice bidding but immediately selected eight of the handsomest branches, each two feet long and consisting of seven or eight leaves in length but so perfectly covered with cochineals as to be quite white with them. I cut them off myself, placed them in the best possible manner in the boxes and covered them with the towels . . . I gave him a dollar . . . and while he overwhelmed me with gratitude I called in my Indians, loaded them with the two baskets and made off with the rapidity of lightning."

At this point de Menonville could not help contemplating the terrible punishment he would meet if his cargo were discovered. Spanish justice was strict; smuggling carried strict penalties, and although he did not know exactly what they were, he did know that forgers were punished at the stake. If it was death by fire for making a few fake coins, what would the Spaniards conjure up for a man caught stealing the ingredients of their most lucrative trade? "My heart beat in a manner that beggars description: it seemed to me as if I was bearing away the golden fleece, but at the same time as if the furious dragon, placed over it as a guard, was following close at my heels: all the way I kept humming the famous lines of the song 'At last I have it in my Power' and should willingly have sung it aloud, but for fear of being heard." He carefully packed up the boxes with plenty of other plants and started out on the return journey, itself full of adventures, with authorities almost guessing his trickery, and drivers attempting their own trickery.

"By accident a mirror happened to hang before me, and seeing myself in it, dirty and with my clothes torn, I could not but feel

amazement and gratification at the little difficulty I had met with. In France, taken for a highwayman, I should have been stopped by the police: in Mexico I was not even asked for my passport." He arrived back in Vera Cruz sixteen days after he had left, with his new friends believing he had been enjoying the baths at the nearby seaside town of Madeleine.

A week later he found himself at the port at dawn. "I was not without some dread," he admitted, "and, in real truth, this appeared to me the decisive day. At day-break I caused all my cases of plants, as well as all my empty boxes, to be carried from my lodgings, and every thing had reached the gate of the quay before six o'clock. I computed that at this hour the idle would still be asleep, that the soldiers and officers, tied with the night-guard, would be at rest in their hammocks, and that all unoccupied and inquisitive would be at the market." He was right about the streets, which were almost empty, but with thirty porters following him it was hard not to be noticed. The customs officers asked to see what the botanist had in his packs, and to his horror he was suddenly surrounded by a crowd of soldiers, sailors and tradespeople who could not contain their curiosity. De Menonville opened his boxes, as if he were proud to show off his findings—and to his huge relief, he got away with the bluff. "The officer of the guard complimented me on my researches and collection of herbs: the searchers admired them in stupid astonishment but at the same time were so civil as not to check any of the cases, though they might have done so without injuring my plants, and the head of the office, satisfied with my readiness to suffer examination, told me I might pass on."

It was not an easy journey—it took an astonishing three months to reach Port au Prince in Haiti—but when he finally opened his cases, quivering with anxiety over the condition of his state secret, he was relieved to find that some of the bugs had survived. Moreover, the navy paid him the 2,000 livres they owed him, which he used to start his own nopalerie in Santo Domingo. It must have seemed ironic, if not cruel, that he went out one day for a walk

near his house on Santo Domingo—and discovered indigenous cochineal.

De Menonville continued to publish research on whether it mattered if the cochineal lived on an opuntia with red flowers or white, yellow or violet ones (it didn't), on how many different species of cactus the insect could successfully thrive on (about five or six), and on whether Mexican or Santo Domingan cochineal gave the better paint (he was undecided)—until his death three years later in 1780, when he was probably not even thirty years old. Doctors may have ascribed his fatal sickness to a "maligne" virus, but the word from those who knew him was that his death was caused by disappointment. The King—who was to die on the guillotine block in 1789—had made him Royal Botanist, but de Menonville had not become the hero he wanted to be. First there were rumors, which he strongly denied, that he had stolen the cochineal. Later the consignment he sent to the King's garden in Paris was lost when the ship—the *Postillon de Rochelle*—was sunk. He had also not been popular among his colleagues: a subject delicately mentioned in an elegy given five years after his death by the president of the Société Royale de Médecine, Monsieur Arthaud. "People have reproached Monsieur Thiery [sic] for his violence, his posturing, and the hardness in his character . . . but it is an indifferent person who either will not or can not recognise the merit of a superior man, and who only looks at him from the outside," Arthaud said, adding diplomatically that de Menonville was a French hero, albeit one with character flaws. The cactus garden that de Menonville tended in Santo Domingo—ironically only the wild cochineals survived—allowed the French cochineal industry to thrive for some years, until the arrival of new synthetic fabric dyes in the 1870s made this color a rarity in the world's dyeing vats.

Today, in Oaxaca, the cochineal industry has almost vanished from the landscape,[13] although it is still there in the stones. The town's colonial heritage is intact, and many of the grandest buildings, including the huge Santo Domingo church and its

neighboring convent, now one of Mexico's best provincial museums, could be said to be built on the bodies of beetles. But the city's libraries do not easily yield the letters and records of Mexico's red barons. With the help of librarians I found just one book—a school textbook with a mere one page of information about the industry that built the town, and even that information is based on the research of an English scholar—R. A. Donkin from Cambridge—not a Mexican.

## INDIAN RED

De Menonville's journey was, in his own mind, a failure. He may have found his fleece, but it had not brought him the gold he hoped for. But his work inspired others to try to introduce cochineal to the Old World. Having read his work, the decision-makers of the British East India Company became excited by the possibilities offered by insect harvests. There was, after all, a market: if they managed to make the red dye themselves, they calculated, they could sell it not only to Europeans but to the Chinese—who had been importing cochineal from the Americas for at least a hundred years on the fabled Manila Galleon. There was also a thriving market for red in Central Asia: the carpet dyers had long been experimenting with cochineal, and by the end of the eighteenth century it had begun displacing the more traditional red rug dyes.

Throughout the 1780s Dr. James Anderson in Madras made a bid to be the cochineal king of the British Empire. He imported several different kinds of opuntia from Kew Gardens, so that he was able to write home to England—with unmistakable delight—about a certain Captain Parker, who had called in to visit. "He was not a little surprised to find himself in a grove of upward of Two Thousand of the Kew Plants; many of them covered with the Fruit, of which he inadvertently eat [sic]; til his lips were deeply tinged and filled with small prickles." Dr. Anderson—whose letters show a missionary zeal

for introducing cochineal—also sent the plants on to remoter colonial stations, including the island of St. Helena in the Atlantic—more famously Napoleon's last home—where the governor, Robert Brooke, pronounced them to be "growing luxuriantly . . . we have now a variety of the species here, and only want the insect."

Indeed, everyone wanted the insect. Dr. Anderson kept writing letters trying, unsuccessfully, to persuade the British government to offer a cash prize to anyone who could bring live cochineals to India. In 1789 he was getting desperate and sent a letter to the Hon. John Holland back in England, telling him that "there are 500 copies of the *Directions for Taking care of the Insects at Sea*, returned from the Press," and pushing him to get a budget for translating the document, "for it is evident that the French lost the Fruits of Mr. Tierry's [*sic*] zeal by his want of time to establish rooted Plants for transporting the Insects."

Everything seemed to have changed when, in 1795, a Captain Neilson sailed into the port of Calcutta. He had some cochineals—and a story to tell. The ship had stopped a few months earlier in Rio de Janeiro, and Captain Neilson had gone for a stroll outside town, attended by "the usual" Portuguese guard. He saw a plantation of cactus with the insect on it, and (having been stationed at Madras with the 52nd Regiment five years before) remembered Dr. Anderson's appeals for help. He pretended to be an amateur naturalist and asked the locals for some samples. By the time he got to India they had all died, except for one leaf with a few dozen sickly little insects—on which rested the hope of Britain for a new and grand industrial venture.

Despite the paucity of their sample, the top men at the East India Company started imagining their fortunes were made. William Roxburgh, the superintendent of the botanical garden in Calcutta, was given the job of insect rearing, and the letters started flying around the sub-continent again. Imagine, wrote Dr. Anderson to the regional governor, Lord Nobart, "the opportunity of converting the most waste, barren and dry lands in your possession to great

advantage, by encouraging the cultivation of the plant." It took several decades of experimenting to realize that what they had got from Brazil was an inferior species to the prized "grana fina," that it was expensive to tend, and that, in the words of an observer in 1813, it was "not very abundant in coloring matter and very inferior to any brought from New Spain."[14]

So the English experiment, which could have brought home-grown Indian carmine to Turner's palette, was mostly abandoned—although by chance, on a walk through the Buddhist ruins of Taxila in Pakistan, I did spot a sickly bug on a wild prickly pear, so the infestation still occurs naturally. Cochineal was only ever successfully introduced to one place outside the Americas— the Canary Islands off the coast of Africa, where it has been harvested on a small scale since the nineteenth century. The islands are owned by Spain, which therefore effectively kept its red monopoly. And by then it was almost too late. Some artists still used the color—Raoul Dufy, Paul Cézanne, Georges Braque and others kept carmine for rare uses—but by the 1870s the colormen had mostly stopped selling it; most artists moved on to newer, stronger reds, and cochineal was destined to fill the market demands of today: to make faces more pink, and processed ham less anemic.

## THE DRAGON AND THE ELEPHANT

Turner's many paintboxes—which remain in Tate Britain, the Ashmolean Museum in Oxford and the Royal Academy of Arts in London, as well as in private collections—show that, in common with other artists of his day, he had plenty of reds in his artistic armory. As well as that fugitive carmine—which shows up as a deep crimson on those paintings on which it has survived—there were many natural red ochres, taken from the earth, making the browner shades of red on his palette. He had at least twelve kinds of madder—an extract from the root of the rubia tree—but most madders were as fugitive as cochineal and, by 1900, less than fifty years after Turner put down his

paintbrush for the last time, there were only two varieties still available commercially to London artists. He also had red lead—a color usually made by heating white lead—which was called minium and was almost orange. It was so popular among Persian and Indian Mughal artists that their work became known as "miniatures": the word is nothing to do with the size of their paintings.

But one of Turner's favorite reds may well have been cinnabar—which he used in its manufactured form, vermilion, and which Pliny described as the result of an epic struggle by an elephant and a dragon. These two troublemakers were always fighting, Pliny recounted, and the battle eventually ended with the dragon—evidently a rather snaky one—wrapping its coils around its heavy enemy. But as the elephant fell it crushed the dragon with its weight and they both died. The merging of their blood made cinnabar.[15] It is a marvellous metaphor for this expensive paint, which is made from the conjunction of heavy mercury and burning sulphur. Its chemical designation is HgS, which indicates that both elements are equally matched. Combined, the silver elephant and the yellow fire-breathing reptile miraculously make something that is blood red.

The Romans loved raw cinnabar. They painted their gladiatorial heroes with it; rich women sacrificed their health for beauty using a lipstick made of it, and it was used to paint the statues of the gods and the emperors on festival days. Most murals in Pompeii took their reds from ochre, but interior designers hired by the richest and most powerful tended to choose cinnabar. At the beginning of the nineteenth century the chemist Sir Humphry Davy found that the Pompeiian baths of Titus were covered with this color—which, he argued, "affords proof in favor of their being intended for imperial use." The Romans got this vermilion from the greatest mercury mine in the classical world—Almaden, about 200 kilometers south of Madrid. Two thousand years later it is still the world's most productive mercury mine.

I visited it one misty morning in autumn. Almaden is surrounded

by curiously shaped hills, filled with shiny mica. If it was in Australia, I thought, as I explored them later, it would be a sacred place. Even in Spain there is a strange otherworldly feeling to the town, and especially to the mine, with the picturesque sixteenth-century church ruins framing the contemporary rusting machinery.

I was shown around by two engineers—José Manuel ("Poto") Amor and Saturnino Lorenzo. I wasn't allowed to descend into the mine for safety reasons, but anyway the present workings are very different from the ancient workings, and I was more curious about what happened at the top. Conveyor belts carry the rocks from deep underground through the open air and into the furnaces. We watched them emerging out of the ground. Everywhere there was the faintly eggy smell of sulphur: down there it must be really strong. The mine company now processes all the rocks on the surface—they are not sorted underground, it's cheaper that way. Most of what we saw coming up on the belt was useless gray matter, but every minute or so, rocks of a deep and silvery pink could be spotted making their way out of the earth and into the sunshine. "The red ones are real cinnabar," Poto confirmed, "and they have the most mercury in them."

In the sixteenth century there was famously a choice of two punishments for prisoners: the galleys or Almaden. A lucky man got sent to the prison ships. Just a couple of years mining for red—twelve hours a day with no protection and no air conditioning—would fill a prisoner's body with so much heavy metal that he would die a nasty death. The writer Manuel de Falla published a terrible account of gypsies and prisoners who were forced to work the tunnels of Almaden until they could no longer walk straight. Today's miners—who work 700 meters below ground, which is about 600 meters below the structurally treacherous early workings—are luckier. They get six eight-hour shifts a month, with full masks and ventilation, and even after twenty years they seem to be able to look forward to a long retirement.

Smiling, as if holding a secret, my two guides invited me to pick

up a two-liter bottle of mercury. In the end I had to do it with both hands, bracing myself a little: mercury is seventeen times as dense as water. When the settlers in the New World found a new cache of gold and silver the first supplier they would contact would be Almaden: mercury is one of the main purifying agents for precious metals. Poto and Saturnino showed me a tub like a concrete paddling pool full of this strange liquid-solid. "You can put your hand in it," Saturnino said, putting his in to demonstrate. "But take your jewelry off first." It would have eaten my rings with enthusiasm. I submerged my arm and swirled this pool of pure mercury around: it was a wonderful sensation. When I went with it, it felt like water. When I went against it, it was an almost unstoppable force. An elephant of elements.

Even though the cinnabar is rich in its raw state, which is how the Romans tended to use it, most of the medieval artists who followed them preferred to make a pure version by mixing refined mercury with sulphur. "Take one part of mercury and one of white sulphur, as much of one as of the other," advised a fifteenth-century expert on manuscript illumination techniques, Simone de Monte Dante dela Zazera. "Put it in a glass bottle, thoroughly clad with clay. Put it on a moderate fire and cover the mouth of a bottle with a tile. Close it when you see yellow smoke coming out of the bottle, until you see the red and almost vermilion-colored smoke. Then take it from the fire and the vermilion will be ready." Turner, of course, like his contemporaries, was too busy to be messing with tiles and bottles—and bought most of his paint from a colorman in London. Vermilion had the added attraction of being fairly resistant to blackening or fading (as long as it wasn't exposed to bright sunlight[16]), especially in the thick slabs of color that Turner liked to daub directly with his palette knife.[17]

Artists were not the only ones in the nineteenth century to run into trouble with their fading reds. The Post Office too had problems. Early British pillar boxes were originally painted green, but people complained about bumping into them, so between 1874

SAMUEL WILLS & COMPANY, LIMITED.

**Bristol and London.**

VARNISH WORKS:
AVONSIDE, ST PHILIPS, BRISTOL.
COLOUR AND ENAMEL WORKS:
CASTLE GREEN, BRISTOL.
LONDON OFFICE:
6, ELDON STREET, E.C.

TRADE MARK

ESTABLISHED 1812.

TELEGRAMS: "CASTLE BRISTOL."
TELEPHONES { BRISTOL 131.
{ LONDON, 6906 CENTRAL.

Reg⁰ Offices.

Castle Green,

BRISTOL, 5th September 19 21.

OUR REFERENCE. WJR/G

YOUR REFERENCE.

ackd.
H. Sept

The Post Master,
BRISTOL.

Dear Sir,

　　　　　At the junction of Somerville & Chesterfield Roads
there is a Pillar Box where the Red Paint has bleached to an
almost White, the colour evidently not being able to resist the
strong sunlight in that position.

　　　　　We have wondered whether you would care to have
the same Pillar Box painted in our Norman Red if we supplied *gratis*
sufficient paint and Red Flatting for the purpose, as we have
every confidence that our Red will stand such and even more
exacting conditions,

　　　　　We have been exporting this Norman Red to India for a
considerable time where the conditions are far more exacting in heat
and sunlight than anything could be in this town.　Only last mail we
had a report from one of the Railway Companies out there that they
were well satisfied with this Red.　　The only condition we sugge
if you will accept the above offer, is that the present paint be
entirely removed and we would also supply the necessary Paint

P.T.

*One of the many letters to the Post Office on the subject
of fading postboxes*

and 1884 they were repainted a bright red silicate enamel. However, the Post Office archives in central London contain several letters suggesting this was not the best choice of pigment. In 1887 a member of the public complained that his local boxes had turned a "pinky white" and suggested the Post Office try a crimson lake instead. But the problem they faced was finding a red that was bright but could also withstand the rigors of frost and sunshine. In 1919 a Nottingham resident wrote a letter observing that the top of the pillar boxes "look as if snow covered," and in 1922 a helpful former naval officer suggested the Post Office follow the navy's example, and change their paints to something a little duller but longer lasting. Everyone knew where the postboxes were, he said. They didn't have to be bright anymore. His suggestion was not taken up, and eventually the arrival of better synthetic reds eliminated the problem anyway. By the late twentieth century red pillar boxes had become so symbolic of Britain that when Hong Kong reverted to China in 1997, post office employees were out on the streets within days, repainting the postboxes in a new livery of emerald green and purple. Somehow the new coat of paint was a gentle symbol of the end of empire.

Turner died in 1851, in Chelsea, just eight years before new aniline colors made from the otherwise useless petrochemical extract of coal tar would continue the process—started, in a way, when painting began—of revolutionizing artists' palettes around the world. So he just missed the artificial magenta and solferino, both invented in 1859 by English chemists and named after battles in Italy, which the Austrians lost that year against the French and Italians. But even for Turner there were always new colors to try, and he almost always tried them.

The National Gallery in London is the home of the painting that is probably today the artist's most famous, and the one he called "my Darling." *The Fighting Téméraire, tugged to her last berth to be broken up, 1838* is the picture of a ninety-eight-gun fighting ship, launched in 1798, its crowning achievement its victory in the Battle

of Trafalgar alongside Nelson's flagship *Victory*. When Turner painted her she was a ghostly victim of more than three decades of relative peace. The painting is hung today opposite George Stubbs's spectacularly realistic portrait of the horse Whistlejacket—a life-size stallion that from a distance looks as if it is the example of the taxidermist's rather than the painter's art.

While Stubbs dispensed with sky for his masterpiece, Turner concentrated on it, and for his "Darling" he wanted the best and most moody sky. Notes from staff in 1859, three years after the painting arrived at the gallery, show that even by then it was deteriorating. "Under glass, good state but slightly [bitumen] cracked on Steam Boat; and pigment change around the sun," one curator scribbled. For as Turner had reached for the right red with which to paint the dying sun over a dying ship, he had characteristically ignored all the colors he was familiar with—vermilion, madder, ochre and even that old fading friend carmine—and his palatte knife had scooped up a new paint, iodine scarlet.[18]

Iodine scarlet, or mercury iodide, had been invented by Bernard Courtois—the son of the Courtois who had worked on zinc white paint—just before the Battle of Waterloo. It had been further developed by Turner's friend, the chemist Humphry Davy, a few years later, although the warnings of its fugitive nature had been there from the beginning. Even Davy, when describing his experiments in 1815, admitted that the color "appears to change more by the action of light." And George Field said: "certainly nothing can approach it as a color for scarlet geraniums; but its beauty is almost as fleeting as the flowers."[19]

But when it was fresh it was startlingly bright, and Turner happily took the chance, painting coral clouds in the color he knew they should be and which, visiting the gallery today, we can only imagine. For Turner, as for color-users around the world, the search for the perfect red—with all the risks that it sometimes involved—never really ended.

# 5

# Orange

*"Dance the orange."*

RAINER MARIA RILKE

On August 2, 1492, Christopher Columbus sailed from Spain to find a new world. But as the three little ships, the *Santa Maria*, the *Niña* and the *Pinta*, pulled out of the harbor of Palos they had to steer carefully to avoid several small boats bobbing in the water, full of frightened men, women and children. All the Jews in Spain—nearly a quarter of a million people—had been given four months to leave the country, and the edict had been issued four months and two days before. No wonder they were in a hurry: they knew only too well what would happen to them if they didn't leave. Even before Ferdinand and Isabella had issued their proclamation that God wanted Spain for Catholics only, there had been terrible violence against Jews—burnings, brutality and at the very least confiscation of property. The year before, Sephardic communities all over the country had breathed a sigh of relief that the centenary of a terrible massacre in 1391 had not been marked by more killings. But they knew something was about to happen. The Inquisition had started in Spain, and the warning fires were burning.

These little boats leaving two days after the deadline would probably have been full of artisans—leather-workers, dyers and jewelers—as well as physicians, musicians and others who simply could not bear to leave the places where their families had lived for centuries. Their last Passover in Spain would have been celebrated

within weeks or even days of the royal proclamation on March 31, and they must have sat around their family tables late into the night discussing what this latest exodus would mean. And perhaps in one of those boats sat a young man, holding an object wrapped in cloth on his knees, as if it were a child. His pockets would have been full of metal tools with wooden handles: they would have dug into his legs as the boat rocked, and he wouldn't have known whether the pain was unbearable or comforting.

This man was also going to help to make a new world. But, rather like Columbus, on that warm day in 1492 Juan Leonardo didn't have any idea of whether he was travelling to death or to discovery. In fact, as it would turn out, the Italian's voyage would lead to Spain's secret red, and the Jew's would lead eventually to a mysterious orange.

## CREMONA

The guidebooks had been rude about Cremona. "Nice but boring" was the general opinion. It was neither as exciting as Milan to the west, nor as picturesque as anything around the lakes to the north. But I was heading to this small town in northern Italy on a mission. "Dance the orange," the German poet Rainer Maria Rilke had written, in a wonderful waltzing poem about a fruit and a color that pretend to be sweet but are actually rather rambunctious and challenging. And I remembered the words—I almost sang them to myself—as I drove into Cremona on a warm day in August, to find out how one particular orange can—perhaps—make musical instruments sing. Some of the greatest instruments in the world came from Cremona, and yet the composition of the varnishes that make them shine almost as sweetly as they play is still a mystery. In around 1750 the secret of how Antonio Stradivari made his orange varnish was lost; and to this day nobody knows what he put in it. Instrument-makers have been trying to find the recipe for years: for some the search has become an obsession. It is

almost as if they believed that once they had the secret of the instrument's skin, they would be able to find the mystery of its soul — and there would be nothing stopping them from making something very much like a Stradivarius[1] for themselves. Some have even whimsically suggested that the best violins are so full of life and tragedy that they may have been painted with blood.[2] However, dried blood is more brown than orange, and it is probably better as a metaphor than as a material.

Cremona is on the banks of the River Po. At one point the city was big enough to be an enemy of Milan; today it is just one of its many commuter satellite towns. Yet there is something charming about the place — its slightly run-down condition and general sense of surprise at the arrival of visitors give it a sense of authenticity. The heart of the city is the Plaza del Commune next to the thirteenth-century cathedral, and as I sat there on my first morning drinking lattes in the sunshine I saw a man riding past. Strapped to his back was a black viola case. He swung off his bicycle and marched into a shop. Later I peeked through the window of what turned out to be a violin workshop, and I could see him deep in discussion with a middle-aged man. The owner of the instrument was emotional — there was clearly something wrong with the bridge — and the craftsman was trying to placate him. It struck me as quintessentially Italian moment, and certainly a scene that has been played out numerous times in this city. For this is the place where the three biggest names in violin history were based: Stradivari, Guarneri and the whole Amati family. It is a place where people have cared passionately about violins.

And marvellously some people still care. Today, if you walk along certain streets, you can still catch the pine scents of turpentine floating on the breeze, and see shop after shop of craftspeople working with delicate slices of maple. "But why Cremona?" was my question. "What's so special about this city that it has nurtured such talent?" "I don't know," answered the woman at the tourist office. "Because we are lucky?" she suggested.

# COLOR

Cremona has not always thought itself particularly lucky to have this tradition; in fact for years it didn't seem to care at all. By the late nineteenth century violins had been largely forgotten: like Stradivari's varnish, the knowledge had been almost completely lost. And then a fascist dictator stepped in. Perhaps it was one of the few good things he did in his life, and his motives were certainly dubiously nationalistic ones, but in 1937 Benito Mussolini started a school for violin-making—and opened a music museum to celebrate the city's past.

The Stradivari Museum in Cremona was built at speed, and it shows. With its dry displays of old carpentry tools scattered between bits of instruments (none of them Strads) it must qualify as one of the most boring museums about an interesting subject in the whole of Europe. It houses the unique forms that the master used to make his instruments, but there is little effort to explain them to a non-expert. However, there was one item that for me at least was worth the entrance fee: a letter, in Stradivari's own hand, talking about the varnish. "Most illustrious, most reverend and worthy Patron," he had written on August 12, 1708. "I beg you will forgive the delay with the violins occasioned by the varnishing of the large cracks, that the sun may not re-open them." The handwriting is of a man who was an artisan rather than a scholar; he even, charmingly, decorated his Fs and the tails of the Ps, with curls that are reminiscent of the curved F-hole on the front of every violin. Stradivari's letter ends with his deliciously cheeky bill: "For my work, please send me a filippo, it is worth more, but for the pleasure of serving you I am satisfied with this sum."

That sentence about the "varnishing of the large cracks" has been examined and unravelled numerous times over the intervening centuries to see what clues it might reveal about the secret of Stradivari—and of the Amatis before him. The varnish must have been very soft for it to take so long to dry. Was the sun-drying part of the secret? people have wondered. And was Stradivari's recipe similar to that of Jan van Eyck, who used to put his altarpieces out-

Stradivari's "varnish" letter

side to dry in the sunshine—and once left one out so long that the whole painting split apart?[3]

A student was manning the museum's front desk. "Why Cremona?" I asked him. He shrugged and said he didn't know. But he passed me an expensive color book in English about the history of the violin. I flicked through it and suddenly a single paragraph caught my eye. It explained how the instrument-making tradition started in 1499 when a man called Giovanni Leonardo da Martinengo arrived in town. He was a lute-maker and a Sephardic Jew, and many years later he would teach his art to two brothers: Andrea and Giovanni Antonio Amati. In the 1550s Andrea would make some of the first violins, after a musician in nearby Brescia decided to take a bow to the lute-guitar and play it like an Arabic *rebab* rather than plucking it. And two generations later, Andrea's grandson Niccolo would teach this new craft to both Stradivari and Andrea Guarneri.

This might, I realized, be the answer to my question. Perhaps it all started in Cremona because one day a man turned up at the gates of the city, a man who had such knowledge that when he passed on his skills to two talented boys they became geniuses. He must also have had a rare knowledge of varnish: nobody knows where the recipe came from, but the Amatis must have learned it from someone, as it is there in their earliest pieces.[4]

We know almost nothing about this lute-maker except the year he arrived, the fact that he must have been one of the thousands of Jews expelled from Spain in 1492, and that by the time of a census in 1526 he had the two Amatis (Andrea would have been twenty-one by then) working in his shop. We don't even know his real name: Martinengo is a town in Austrian Italy where he may have lived for a while, Leonardo could have been his baptismal name—if he had been one of the thousands of Spanish Jews who turned Christian[5]—and Giovanni is an Italian version of Juan. So our luthier's name was itself a collection of stories. He was a composite man—made up of many different parts, rather like one of his own lutes.

I think of him that first day in Cremona not as a man exhausted

after a long journey, but as a storyteller walking proudly along the Via Brescia toward the center of town, surely attracting the attention of local urchins, who would be fascinated by the strange deep-bellied beast that he carried and which they would have pestered him to play. And perhaps he would have sat down and strummed them a ballad. Not for too long: like many instrument-makers he would probably never have thought of himself as a musician; but also he may not have wanted to think too much about the home he had lost. It would hurt too much.

What could this man have seen in those seven years? Had the terrible times won out, or had the experience of journeying through Europe just as the Renaissance was starting brought him and his art alive? Either way, something happened, because the skills taught by this refugee to those two Italian boys had not been taught before. Half the Jews in Spain went to Portugal. I hope for Martinengo's sake he wasn't one of them. A wealthy man had paid a ducat a head to the King of Portugal, which bought him and half his countrymen the right to stay for six months. After their time was up, the Portuguese treated them as cruelly as the Spanish, and the lucky ones left. It was their second sad exodus in a year.

Our luthier would have eventually headed east through the Mediterranean, and as he travelled he would have inevitably collected objects and colors and experiences that would be useful to him later. I imagine he was a creative, experimental and individualistic man. And he was certainly moving inexorably into the kind of world that valued exactly those qualities. Today there is a desire among some artists to rediscover the methods of the past—hence the interest in Stradivari's orange varnish. But this search for something "authentic" is nothing new; art history is so full of nostalgia that to some extent it has been shaped by it. The search for lost knowledge has been a driving force in many art movements. The Victorians created neo-Gothic, but the creators of what was called Gothic were simply harking back to an imagined time in the Dark Ages. Even Roman style was neo-Greek.

And in the same way it was almost by chance that the end of the fifteenth century was a time of discovery. Because for the people actually living through it, it would have seemed more like a time of rediscovery. Artists and architects were busy trying to regain the spirit of Ancient Rome, while priests were trying to recapture the sense of wonder in the early Church. Even navigators were trying to rediscover rather than discover: Columbus's original brief was not to find new land, but to investigate an alternative trading route to Asia. So a brilliant young artisan travelling through the Mediterranean would, in the spirit of his time, have been fascinated by the wealth of old materials. And he could well have sampled them all—the woods, the pigments, the oils and the varnishes—in an attempt to try to re-create the best instruments from the past: the Stradivaris of his own time.

## BASTARD SAFFRON AND THE BLOOD OF DRAGONS

Jews were more welcome in Muslim North Africa than in Catholic France. So Martinengo's first stops would probably have been the southern ports—Algiers, Tunis, Tripoli. And in the covered bazaars of those cities this Renaissance refugee would have found the first of many potential coloring ingredients for his portable studio: an orange flower, rather like a marigold.

Safflower is unusual: if you add alkalis to the dye broth it is yellow; with acids it goes a beautiful crimson pink which is the color of the original "red" tape once tied around legal documents in England and now gives its name to any bureaucratic knotty procedures. It would have been known to traders in the busy North African bazaars for more generations than anyone could count: Ancient Egyptians used it to dye mummy wrappings and to turn their ceremonial ointments an oily orange. They valued it so much that they put garlands of safflowers entwined with willow leaves in their relatives' tombs, to comfort them after death.

It is also a plant to be wary of. Throughout its five thousand years

of cultivation, safflower pickers have been easily spotted going to work in the fields—they have been the ones with leather chaps from thigh to boot to protect them from its spines. Today, if safflower stems get into the throat of a combine harvester, it is almost impossible to get them out. "Burn the combine" is the joke solution.[6] And an American safflower producer in the 1940s had a favorite story of a dog he saw chasing a rabbit: just when it seemed to be caught the rabbit dashed into a safflower field. The dog followed, but a few seconds later was seen sheepishly backing out, one paw at a time.

For buyers of colors, safflower is a dye to be careful of too, especially if you are not looking for it. This plant has been switched so often for another more expensive yellow dye that one of its names is "bastard saffron." And indeed nobody is actually sure of its parentage—whether it first came from India or North Africa. It is celebrated in both places, and in India and Nepal it has been a holy color, perhaps because it is close to the color of gold. I remember visiting the great Buddhist stupa of Bodhnath just outside Kathmandu and seeing how its pure white body was marked by swirling rust-like stains. At first I thought it was a shame, but then I was told it was a sign that a devotee had given donations to the temple. Washing a few buckets of safflower over such an important stupa is equal to lighting thousands of butter lamps, and is excellent for karma.

But no offerings to their own God seemed to help the Jews in those difficult days of the 1490s. As Martinengo may have found, even North Africa was not a reliable refuge. There were stories of the Moors banning Jews from the cities, and forcing them to stay in the countryside—where they starved. So if our refugee had the money he would have continued along the coast, looking for somewhere to live peacefully. And the next major stop—avoiding Sicily, part of the Spanish empire and another place from which Jews had been exiled—would be Alexandria. In that busy port, named after Alexander the Great, a wandering lute-maker would have found a marketplace full of exciting materials.

*Dragon's blood tree*
*seventeenth-century woodcut*

One of them was "dragon's blood," which had been carried up the Red Sea in ships from Yemen and perhaps even from the islands that today make up Indonesia. If he had taken the time, Martinengo could have sat down in the market and heard the stories of how this brownish-red powder had gained its curious name. For a few coins, people would have told him as many tales of saints and princes and maidens and great angry green beasts as he would have had the time to hear. Perhaps he would have been disappointed to hear eventually that it was simply the sap of a special "dragon's blood" tree, so called because the resin was so dark it must surely be reptilian. Cennino Cennini, a century earlier,

hadn't liked it. "Leave it alone," he warned his readers. But the colored resin is highly prized for violins, even today.

The sheer range of oils from nuts and seeds in the bazaars of North Africa and the eastern Mediterranean would have been intoxicating. Linseed oil was the new material for artists, and had recently replaced tempera as a binding ingredient. But there would also be oils from cloves and aniseed, walnut and safflower, as well as from the seed of the opium poppy.[7] There would have been many gums and resins in these markets for our lute-maker to bind his wood with: sandarac resin from North African pines, gum arabic from Egypt, gum benjamin (now called benzoin) from Sumatra; gum tragacanth from Aleppo, which would be sold as thin and wrinkled worm-like pieces of shrub.[8] Gums and resins come from trees—but gums turn to jelly when they are mixed with water, while resins only dissolve in oils, alcohol and the spirit of turpentine.

The tale of how the Ottoman ruler Bezar II had mocked Spain for expelling the Jews is perhaps apocryphal, but news travels fast among beleaguered people, and the legend of how he had said: "You call Ferdinand a wise king, he who impoverished his country and enriched mine" may well have travelled down to the Jewish communities in Egypt within months. They would have found it immensely comforting. And for Martinengo it may have provided the reason to move on from Alexandria: this time to Turkey, home of the lute.

He would take with him red brasilwood from the East Indies—a dye-wood that was so valued that when a few years later the Portuguese found it in the New World, they would name a country after it. Ironically another dye from the Americas would cast it out of favor, and when cochineal had taken over from all the other organic reds, brasilwood was worth next to nothing; it could sometimes just be found rotting at the docks. It was in this cheapened state that violin bow-makers discovered it in the eighteenth century, and pernambucco—the finest brasil from Brazil, so strong it

almost resembles iron—became the favored material for good bows. One celebrated English bow-maker called James Tubbs was known for his extraordinary chocolate-colored pernambucco. Some said he stained it with stale urine, although when I tried this—a process I cannot recommend—it made the wood more treacly than chocolatey: a slight shade darker than in its natural state and just a little shinier. Perhaps it made a difference that I hadn't consumed a bottle of whiskey that day. Tubbs was known to have enjoyed his drink.

Martinengo would have found a ship heading north, bisecting the Mediterranean and then taking him along the Turkish coast. And on the way he would have wanted to stop on the island of Chios, almost within hailing distance of the mainland. For Chios was the home of one of the most important items in a stringed instrument-maker's workbox: a lemon-colored resin that is so chewy it is called "mastic." And which was then so highly priced it would have made anyone gulp. But if, arriving at the port, our travelling lute-maker had asked to see the famous *Pistacia lentiscus* trees for himself, then people in town would have smiled sadly and shaken their heads. And if he had found someone to translate then he would have heard a story that would have reminded him of his own troubles as a man punished for his faith.

The legend tells of how a Roman soldier called Isidore landed there one day in 250 A.D. He was a Christian, and he refused to make sacrifices to the Roman gods. The Governor thought carefully about this odd man, and decided he would first be whipped and then burned alive for his insolence. But when the Roman soldiers tied Isidore to a stake, the flames played over him but they did not burn his flesh. So they tied him to a horse and dragged him over the rocks on the south side of the island; and just in case that hadn't killed him, they cut off his head.

At that moment, the story goes, every tree on the south side of the island wept for the martyr, and their tears hardened, and became mastic. And it turned out to be not only an excellent golden

varnish for paintings and for musical instruments, but also a natural chewing gum. It was, and still is, collected every summer by making cuts in the trunks of the little mastic trees. After a few hours the trees weep for St. Isidore, and the resin falls onto the carefully cleaned ground.

Throughout the Middle Ages, Genoese, Venetians and Pisans fought for possession of the island and of its prized crop. And each time it was the people of Chios who wept. The Genoese were the cruellest, banning anybody from even touching the trees: sometimes they would kill the offenders; sometimes they would remove their right hands or noses. It was ironic to lose your nose for the sake of a breath freshener.

In the late fifteenth century the island was under Ottoman control and punishments were lighter, but the villagers were still weighed down by oppressive taxation. It was the privilege of the Sultan's mother to take what she wanted for the royal harem. And she wanted a lot—one year Chios had to supply Constantinople with 3,000 kilos. Either she sold it quietly in the bazaar or there were a lot of women in that harem with bad breath or a chewing-gum addiction. In the 1920s a French traveller, Francesco Perilla, wrote about going to dinner with a family on Chios. He was given a lump of mastic at the end of the meal, and put it in his mouth uncertainly. "The old mistress of the house asked me to give it to her. I was not happy, but I had to do it," Perilla recalled.[9] "The lady then took the gum and put it in her own mouth, and gravely told me I was doing it wrong." To the visitor's horror she then took the chewed piece out of her mouth and "with a gracious gesture offered it back to me, insisting I learn 'how to do it.' I tried every excuse I could think of, but in the end it was too hard to say no. So with eyes closed I had to accept it and taste it. I even had to smile."

It was this chewiness which attracted artists to mastic. Cennino used it for pulling the impurities out of lapis lazuli to make it into blue pigment, and for sticking broken pottery back together. And dissolved in turpentine or alcohol it certainly makes a beautiful

varnish for paintings. There is just one problem. It doesn't mix well with oil. Mastic was one of the main culprits in a major misjudgment of materials in the eighteenth and nineteenth centuries. Just as, a few decades later, the violin world would be full of questions about Stradivari's varnish, in the 1760s the art world was full of questions about what the Old Masters could have used to get the incredible glow to their work that is so characteristic of works by Rubens or Rembrandt.

In the 1760s there was tremendous excitement about a substance called "megilp," which was a combination of mastic and linseed oil. It made a beautiful buttery varnish, which was satisfyingly thick to apply and gave an instant mellow golden quality to the painting. Megilp sounds like an ugly made-up word, and probably is. It was also sometimes called "majellup," which could well be a shortening of "mastic jelly"—and it was certainly a very jelly-like substance. Joshua Reynolds was one of its greatest fans, despite cautions from the Irish artist James Barry, who warned him about people "who are floating about after Magilphs and mysteries."[10] Separately both mastic and linseed are wonderful on paintings: it is just their jellified marriage which is so dangerous. In 1789 Reynolds was commissioned by Noel Desenfans, the founder of the Dulwich Picture Gallery in London, to copy a portrait he had done five years before—of the actress Sarah Siddons as a tragic muse sitting on an armchair so huge it is almost a balcony. He was in a hurry—or perhaps he allowed his dislike of Desenfans to affect his choice of materials—and instead of replicating the twenty or so layers of paint in the original[11] he used megilp to give the impression of thickly applied paint. Probably because of this the later picture—now in the Dulwich Picture Gallery—has darkened prematurely, making her a doubly tragic muse. Nearby is another prime example of the degradation of megilp in Reynolds's work. A *Girl with a Baby* is thought to be a portrait of the future Lady Hamilton with her first child. "It has, by an interesting irony, degraded disastrously into something that looks like a strikingly mod-

ern proto-Renoir," the curator of the Dulwich Picture Gallery, Ian Dejardin, told me, adding that it was therefore the favorite painting of a "frightening" number of people who leave the Gallery convinced that Reynolds was the first Impressionist, and complaining about the label on the painting, which describes it as "ruinous."[12] Needless to say, J.M.W. Turner, always so careless of his materials, was also an enthusiastic user of this gloriously sticky-textured but deceitful mixture.

## MAD ABOUT MADDER

Leaving the prematurely darkened island of Chios and its sad inhabitants, our traveller would have sailed north to Constantinople—now Istanbul—where he must have thought he had reached the end of his journey. There were already thousands of Sephardic Jews who had arrived before him, setting up shops and synagogues, mourning those who had died but also rejoicing in the chance to start new lives. It wasn't a promised land, but at least it was a safe one, he may have thought, as he found himself a room in the Jewish quarter, and put out the news that he was available to make instruments on commission. At first he would have concentrated on starting up his business, but I imagine that soon he couldn't resist exploring the city. Lutes were brought to Spain by the Arabs in the ninth century—the word in English comes from *al-ud*. They had come from Persia, but the Turkish *saz* is a close cousin, and our lute-maker would certainly have been interested in seeing the local instruments.

As he lounged in a sherbet house, sipping sweet drinks and listening to fine Ottoman music, he would have looked around him at the carpets from all over Central Asia, from Armenia to Samarkand—and he would have felt himself floating in a sea of blue and red. The blues were from the indigo plant, and the dark reds were from kermes, but most of the richest orange reds were from a small bush with a pink root, called madder.

*Music in Turkey*

Martinengo would have liked the effect it had on his instruments—coloring them a fine orange red. He would probably not have wanted his lutes to be too yellow, but would always have given them a darker final coat to make them a warmer orange. Perhaps his color choice would be for the tone, or perhaps it was simply the fashion. But maybe it was because, since 1215, yellow had been a difficult color for the Jews in Europe. In that year Pope Innocent III declared, on behalf of the Fourth Lateran Council, that Jews of both sexes should wear yellow badges, beginning a trend that would end with the Nazis ordering Jews to wear yellow stars as part of their persecution during World War II. By Martinengo's time these vile laws had been adopted throughout the continent.[13] In Spain and then later in Italy, Martinengo would have been forced to wear such a patch, or perhaps a yellow hat. It would be hard to imagine him liking the color very much.

To make a lute the translucent color of rich egg yolk, Martinengo would have bought madder—*Rubia tinctorum*—in its root form,

each piece the thickness of a pencil, although much longer. The roots grow so long and so quickly that in seventeenth-century Holland, for example—when the Dutch were the European leaders in madder production—farmers working on reclaimed land were legally obliged to harvest their crop after two years, in case the roots grew too deeply into the dykes and caused floods. The lute-maker would have dried it in the sunshine—to give it a richness that northern European madder could never quite achieve from its sunless drying rooms—and then he would have pounded it with a pestle and mortar. The first pounding would separate the cheap madder, the second would be the average grade, and the third pounding would powder the heart of the madder root, the finest grade, which the Dutch would call "krap" and the English would adapt to "crop."

Most artists today would be bewildered to find madder in a chapter entitled "orange": for painters it tends to signify bright pink paint. But if dyers put white wool in a madder dye bath, with a little bit of alum to make the color stick, then it comes out the vibrant shade of a redhead's hair. I remember seeing fragments of an antique Japanese robe shown at an exhibition in New York about Frank Lloyd Wright's fascination with Japan.[14] They had been found "wadded together like dishrags, crumpled and soiled" in an old suitcase two decades after the architect's death. The seventeenth-century madder in those abused textiles had mostly faded to brown, but here and there, at those edges that had never been touched by the sun, there were glorious traces of what the cloth would once have looked like. It would have been brilliant orange, as bright as autumn.

The technique for making madder into pink paint by using filtration under pressure was invented by London colorman George Field at the beginning of the nineteenth century, and Winsor & Newton make it almost the same way today. When I visited their factory in Harrow I found the "madder room" was really a madder barn: it was huge, and the whole place was spattered with rose paint. It was too pretty ever to seem like the scene of a massacre, although if it

had been darker that would have been exactly the image. Instead it was more as if we had fallen through a dressing-room mirror and found ourselves in a box of theatrical rouge powder.

Even today, with mechanization, the whole process is extremely time-consuming. It takes more than three months from the time the shipment arrives from Iran to the day the tubes of watercolor labelled "Rose Madder Genuine" leave the factory. "When artists say it's expensive, I tell them that they're lucky they're not living two hundred years ago and they don't have to clean it and crush it and find the right gum," said Joan Joyce, who has been a guide through the paintbox factory for many years. I looked doubtfully at the huge apparatus busily crushing, cooking, mixing, drying and pressing over two floors, and wondered how easy it would be to prepare rose madder at home. According to Field's biographer John Gage, the colorman was perhaps inspired by William Harvey's seventeenth-century discovery of the circulation of blood—and certainly the room inspired by Field was full of tubes and pumps and a fairly regular mechanical pulse.[15]

Field's process—briefly—involves washing the crushed roots in oak barrels and then mixing the dye with alum and water until it looks like watermelon juice with a foaming cap. It is then drained through fine Irish linen for five days, after which it feels like the most luxurious face cream—so silky it is barely tangible. The water is then squeezed out of it, with Field's patent wooden press, after which it is sent to an oven. At no point can any metal touch the mixture, as it would react and change the final color. Instrument-makers would have followed a similar basic recipe—although in the fifteenth century they would have done it with little glass flasks burning slowly over fires for days. Some people may have thought they were alchemists, cooking up strange recipes to turn plain wood into gold.

Could I look upstairs? I asked, intrigued at the boilers and barrels I could see. "Sorry, it's a secret" was the friendly but firm response. It was intriguing that even today—when so much

information is in the public domain—a major paintmaker is able to keep the recipe for an old-fashioned paint to itself.

And "sorry, it's a secret" would have been the reaction in Turkey too if Martinengo had asked to see the process of making the luminous orange-red dye that he would have seen on the carpets of Constantinople, although probably the Ottoman dyers would have been less polite. After all, "Turkey Red" was one of the best-kept secrets of the dyeing world, and it would take European dyers several centuries of bribery, negotiation and no doubt not a small amount of spying to discover it. At one point in the early eighteenth century a young chemist called Henri-Louis Duhamel du Monceau approached the answer, finding that if he fed pigeons on madder their bones would become red in a spread that was consistent with the theory that it was the calcium which was holding the color. But it was the Dutch who found the full answer first—in the 1730s—closely followed by the French in 1747.[16] The British were slow to follow and were finally helped by two brothers from Rouen, Louis and Abraham Henry Borelle, who turned up in Manchester in 1787 offering the secret of Turkey Red to the city's Committee of Trade.

The recipe had arrived in Britain just in time, because the 1790s were the decade of the Red Bandanna. Today these bright cotton handkerchiefs are worn only occasionally, but once upon a time there were 1,500 looms and several dye factories in Glasgow alone that were dedicated to them. They were mostly for export to poor people in India, the Far East and West Africa. Others went to the recently independent America, and were often bought for slaves—they were good as sweatbands or for tying up food for midday meals. Others were worn by British sailors. Just a few months after the Battle of Trafalgar in 1806, the celebrity painter Benjamin West held a public viewing at his own home of a huge documentary painting entitled The Death of Nelson.[17] The hero dies dramatically at the center, but all around the edges are ordinary sailors living through their own dramas as the battle rages behind. And to

a man they are wearing red bandannas—on their heads, tied like belts at their waists, or most popularly in a loose knot around their necks. It is strange to think that factors like the ability to make little cloths with white spots on a red background can make or break a company, but such is the truth of the fashion business. It was done by the then very new technique of "discharge printing," which involved printing the cloth with madder, then bleaching out patterns with acid, and later printing other dyes on top. Logwood for black, Persian berries for yellow and Prussian blue were the most effective.

The bandanna boom ended in the early nineteenth century, but not before the madder dyers had moved out of Glasgow to the Vale of Leven. There were two reasons. The first is that Glasgow had become far too dirty for bleaching and dyeing—I imagine acres of little red-and-white handkerchiefs hanging out to dry and being covered by black particles before anybody had even thought to blow their nose on them. And the second was that the dyeing had become too dirty for Glasgow. Because the secret of Turkey Red was not a nice one at all for the neighbors. It involved applying alum, tin, calcium, tannin, ox blood and—most unpleasantly—sheep or cow dung to yarn that had been steeped in rancid castor oil. After the three weeks or more of going through one of the most complicated dyeing processes ever invented, the cloth and the dye works emitted a very peculiar stench indeed.[18] The secret of dyeing "krap" madder bright red, Europeans realized (although they didn't yet have the word to create the pun), was—partly—the crap that was in it.

The boom couldn't last, despite the success of orange mango-inspired patterns in the Scottish town of Paisley, and the Emperor Louis Philippe's command that soldiers' caps and trousers should be dyed red to keep the French madder industry in business. The death knell for this natural dye was not, in the end, rung by fashion but by science. In 1868 the price of madder in London was 30 shillings a hundred-weight. In 1869 it was just eight. The 22

shillings were lost in a triumphant moment in a German labora-
tory when Carl Graebe and Carl Liebermann found the formula
for alizarin—the chemical in madder that makes it red. Suddenly
the world's madder crops were doomed—until recently, that is,
when there has been a small but significant revival.

In 1976 a German chemistry teacher called Harald Boehmer
went to teach in Turkey. He was shocked at how hideous the car-
pets were. "I thought what a waste of time to make such ugly
things. Why can't they use the old dyes?" But then he realized that
nobody even knew how. A few women in remote villages used
madder for dowry carpets, but these tended to come out brown and
badly colored. So Boehmer did his own detective work—with
books, experiments and the friendly advice of professional dyers—
and, metaphorically speaking, he found his own "lost varnish." He
even found a way of making madder violet—although for a long
time he kept that quiet, as his own trade secret.[19]

Three years later he and his wife returned to Turkey with files
full of recipes. They set up a cooperative called DoBAG, and
twenty years on it now employs a hundred weavers and has in-
spired hundreds of others to use natural dyes. Dr. Boehmer ex-
plained the appeal. "Synthetic dyes just contain one color. But in
madder there is red, of course, but blue and yellow are in there as
well. It makes it softer, and at the same time more interesting." I
was reminded of a photograph I saw at the Winsor & Newton fac-
tory—of a piece of madder that had been magnified 240 times. It
was orange and blue and red, like a kingfisher's wings, and seemed
like a celebration of every color imaginable.

Today the impact of DoBAG has spread as far as the Afghan
refugee camps in Pakistan—where weavers are learning to make
the dyes their great-great-great-grandmothers were using. "They
have to," a carpet dealer in Peshawar told me. "Synthetic carpets
aren't selling." And even the madder industry has stirred again. At
first Dr. Boehmer and his colleagues were digging up the roots from
wild plants growing by the roadside. "But within a year a madder

trade started in Turkey: just to keep up with our demand," he told me. For him the biggest changes have been in the villages. "Suddenly women have money and so at last they have some power." And the dowry carpets? "Those?" He laughed. "Oh, the main things in dowries today are not carpets. They are refrigerators."

## ITALY

If Europe was going through a transition in the late fifteenth century, Italy was leading it. Almost no area of human endeavor was left untouched: architecture, technology, science, art—and music. In 1498 Ottaviano Petrucci of Venice printed sheet music using movable type; in a curious twist to my story, Ferdinand Columbus, the son of the explorer, was to become one of the great collectors of his volumes. The Ottoman Empire was culturally barren, but it was all just beginning to happen musically in Italy. How could our lute-maker resist? So he set off again, this time to the port of Venice.

Martinengo's bags would be full of samples by now, and in Venice he would find more. There was the famous Venetian turpentine from larches (in those days he would have bought it as solid sap, and would have distilled it himself) and even more exciting would have been the expensive amber from the north— thirty-million-year-old pieces of resin that bubbled up from the bed of the Baltic and in their time caused as much grief[20] to the residents of that seashore as mastic had caused to the people of Chios. Amber has the curious characteristic of attracting dust to it when it is rubbed vigorously. The Greek called it "electron," and from that we get our modern word "electricity."

Whether or not amber was used on Cremonese violins has been hotly debated for two hundred years. In 1873 a man called Charles Reade wrote an eloquent and opinionated letter to the *Pall Mall Gazette*[21] about the mystery of Stradivari's varnish, and how it had obsessed so many people. "Some have even cried Eureka!" he

wrote. But the moment they publicized their theory, "Inextinguishable laughter shook the skies." Some, he said, were sure the recipe included amber that had been boiled with turpentine. "To convince me they used to rub the worn part of a cremona with their sleeves, and then put the fiddle to their noses and smell amber. Then I, burning with love of knowledge, used to rub the fiddle very hard and whip it to my nose and not smell amber." His own conclusion, incidentally, was that the secret was in laying down three or four layers of varnish and finishing off the fiddle with a final coat of mastic and dragon's blood ("little lumps deeper in color than a carbuncle, clear as crystal and fiery as a ruby"). It was hard to find, he added, "but you can get it by groping in the City as hard as Diogenes had to grope for an honest man in a much less knavish town than London."

But Venice too was a knavish town; people there were prejudiced against Jews—as they would continue to be a century later when Shakespeare created the cruelly stereotyped Shylock in his *Merchant of Venice*—and Martinengo wouldn't have wanted to be noticed. So he would have kept on moving. And then one day, for reasons that have been lost to history, he arrived in Cremona. There he found a friendly enough welcome and sufficient interest in music to make him think he could stay.

Once he had found a good workshop, Martinengo would have bought or borrowed some benches, tables and clamps, and—after laying out his precious materials in jars—would have started work. In Cremona there were other useful pigments and materials—turpentine from local pines, which some people still say is among the finest in the world, and propolis, the sticky substance that bees collect from tree resins and then use to protect their cities from invasion. If a mouse enters the hive then the bees will kill it. But because its body is too large for little insects to shift, and because they don't want it to stink up their home, they mummify it in propolis. People use it as an antiseptic—or as an ingredient in varnish that has the bonus of scaring woodworm away. Like honey,

every propolis is different, depending on the local vegetation, and the one from Cremona is said to be very fine.

The miracle of the early Cremonese varnish is that it doesn't just make the maple and spruce woods look beautiful, but it makes the tone beautiful too. "One might say that when the strings are touched with the bow the instrument vibrates more, and with quicker response; that there is a greater palette of tonal color available to the player; a greater variety of sound," wrote leading violin authority Charles Beare about this nearly magical varnish. "If it looks good it tends to fly good," affirmed his son Peter, when I had visited J & A Beares' workshop in Queen Anne Street, London, before I set off for Cremona. Peter Beare both makes violins and restores them. Like his father, he has had the chance to see many of Stradivari's violins at close hand. He has also experimented with the varnishes—sometimes to the alarm of the neighbors. "The outside of our house is splattered with varnish," he said, explaining how one day he put too much nitric acid (a natural reducer) in the mixture and it exploded.

Experts have argued for years about whether there were two or three distinctly different varnish layers on a Stradivari. Peter Beare's feeling is that there were three: a ground layer that went into the wood, an isolating "mid coat" and then the color layer on top. "You have to look at the great fiddles. If they'd put the pigment straight on, then it would have got into the end grain, but it hasn't," he said. It is difficult, he told me, to tell how much the extraordinary tone of Amati and Stradivari violins comes simply from their age: the wood has become lighter in weight, the pigments have oxidized. "Who knows, it could be just that. Natural oxidation over three hundred years: there's nothing like it. But I think there was something else as well."

It is hard to guess now what pigments were used. Some people swear by dragon's blood. "But I use madder," he said, describing how he mixed rosin with alum and a tincture of madder. Is that because he believes it is what Stradivari used? "Perhaps," he said.

"But really because I've invested the time in it. If you start experimenting with everything then you could take ten lifetimes, and in the end you have to get some varnish on the wood."

There are five Cremonese violins and one viola held in air-conditioned splendor in the great town hall beside the cathedral in Cremona. But before I bought my ticket to see one of the greatest fiddles in the world, I noticed an old carriage in a nearby room and went to have a look. It was made in 1663—when Stradivari was twenty—and was owned by the Carozzas, the richest family in Cremona. Today it looks rather ridiculous, the kind of squat little pumpkin that Cinderella could have fled the ball in; it is even the same reddish orange color. It looks like the horse-drawn equivalent of a jolly Volkswagen Beetle, although I am sure, given its ownership credentials and its general lightness, in its time it was a cheeky Ferrari. Seeing the little coach so beautifully restored I could imagine it pulling up outside Stradivari's workshop, the footman grandly unfolding the steps with their soft leather covers, and a member of the Carozza family delicately stepping across mud to collect the latest instrument.

And then I could imagine her returning a few minutes later, grumbling into the white leather interior to report to her companion that the varnish was not ready: the violin couldn't be played for another month. The carriage would leave at a canter, its matching pumpkin-shaped lamps swinging grumpily behind it. But the coachman, overhearing, may well have smiled—in sympathy with the craftsman—because unlike his employers he would have known a great deal about the problems of varnish. He may also have had something to say about secret varnish recipes. In the eighteenth century they were quite a talking point.

For any coachman in those days it was a constant battle keeping the carriage shiny—the sun in summer and the ice in winter would do terrible damage to the resin. Sometimes coaches would be seen swerving dangerously from one side of the road to the other. No, not dangerous driving, the drivers would have said

triumphantly if anyone had stopped them. They were merely try-
ing to stay in the shadows to stop the sun from cracking their var-
nish. The British tended to feel this behavior was excessive, and "in
England many a fine varnished coach is totally spoiled soon after
its being used; by the indolence and slovenliness of the coach-
men,"[22] wrote one Frenchman, horrified at the shoddy state of the
nation's vehicles.

At the beginning of the eighteenth century there had been
tremendous excitement when a Parisian called Monsieur Martin
invented a long-lasting amber-colored varnish. People knew that
one of the ingredients was copal—an expensive resin from the
Americas that Stradivari could well have used (although of course
Martinengo would not have seen it until he was an old man). But
the rest of the recipe was kept a closely guarded secret. Rich peo-
ple had their carriages coated with it and the Society of Arts and
Sciences in London quickly offered a prize to any Englishman
who could make something similar. They virtually guaranteed
they would not have to pay out their thirty pounds by setting ridicu-
lously tough criteria. The successful varnish would be "hard, trans-
parent, of a light color, capable of the finest polish and not liable
to crack." And as a test it would be "exposed to the hot sun, frost or
wet for six months." Martin of Paris had laughed when he heard
about it, and had commented that if someone ever passed that test
"then I will have done with my Varnish."

An armed guard sat outside the violin room in Cremona, look-
ing bored, clicking his fingers one by one. The pleasures, if there
had ever been any, in being surrounded by eighteenth-century
paintings of great fat cherubs (they had just become plumper in
European painting with the arrival of chocolate and white sugar)
had evidently worn off, and after I paid my entrance fee he and a
colleague walked in with me wearily. It was a side room but a
grand one, full of candelabra and Corinthian columns. The six in-
struments were in individual display cases, so I could walk around
and see every detail. They have to be played every day, so that they

remain violins rather than reverting to their natural state of being pieces of wood. An unplayed instrument quickly loses its ability to vibrate properly: after a major restoration it takes a month or more to return to concert standard; rather like the musician who plays it, it has to practice regularly.

Orange is a warning color—dangerous parts of machinery are deliberately painted with it, the theory being that it is the most eye-catching color and people will see it and jump out of the way. And in Cremona's city hall it is the orange violin which jumps out straightaway, shouting: "Look at me first!"; the yellow and brown ones don't make the same demands. Almost all top violins have names—it is part of creating, or sustaining, a sense that they are all individuals. Mostly they are called after their most famous owners, but this one—Il Cremonese—is named after its birthplace. It was made in 1715, when Stradivari was seventy-one and at the height of his genius. It returned to Cremona in 1961, after a lot of wandering.

A week earlier I would have been surprised to think I could find wooden instruments fascinating to look at as well as to hear. But I had been well trained by Peter Beare, and this was an extraordinary piece. "Look at the back," he had advised. "And move your head, pretend the fiddle is moving in the light." As I walked toward it I gasped. The back of the instrument was crafted from one piece of maple, and it was boldly patterned like a tiger's coat—so full of life it seemed as if it was going to leap off the log and start to tango. How many people, I wondered, had stood here and taken notes and wondered what on earth the maestro had done to let the wood breathe and flex in exactly that way.

As I moved my head up and down, the patterns wiggled: it was the ripples in the wood that trapped the light and then refracted it away at angles which were mesmerizing. No wonder everyone wanted to replicate "the tiger." As a piece of abstract patterning in browns and oranges it was one of the most beautiful pieces of wood I had ever seen; as a musical instrument it was a masterpiece. I understood for the first time what I was looking for—and what so

many people were trying to reproduce. This violin had an inner flame to it, a fire in its back and to a lesser extent in its belly. As I moved on to the other instruments—thinking that I should have looked at them first, as their flames were there, but cooler—I saw that the two guards had moved toward Il Cremonese. They too were looking and comparing and moving their heads up and down. That day the delicate instrument had come alive for all of us.

The relationship between color and music is a strangely entwined one: sometimes people use the same language—words like "color," "tone," "shade" and "harmony"—to describe both. In *Brave New World*, Aldous Huxley imagined a future where people would go to concerts to experience "scent and color" instruments where each note transmitted enticing smells of sandalwood and other perfumes and projected pictures on the ceiling. Huxley was not looking to the future but was laughing at the present. In 1919 a Danish singer, Thomas Wilfred, designed the "Clavilux" (a combination word like megilp, combining "klavier" with "light"), which involved dreamy transmissions of colored light projected by revolving mirrors. His dream was that every household would have one. And in 1910 the Russian composer Alexander Scriabin wrote an entire composition—*Prometheus*—for a "Color Organ." His technology was even more basic than Wilfred's—Scriabin's composition was basically written for a musical instrument attached to a piece of wood and a few lightbulbs—but there was little to compare it with, and the composer was excited. It provided a chance for him to explain a relationship between color and music that was clear to him, yet which most people did not understand.

Scriabin was synaesthetic, which meant his brain made connections between things that the majority of people do not believe to be fundamentally connected. Synaesthesia can take several forms (people can see colors in pain, or in letters of the alphabet) but Scriabin "saw" music and "heard" colors. The Finnish composer Jean Sibelius had the same gift. "What color would you like

your stove, Mr. Sibelius?" he was once asked. "F Major," he said
vaguely. So it was duly painted green.[23]

Scriabin would incidentally have seen F major as being dark
red; his green stove would have been in the key of A. And that is
probably part of the problem with designing synaesthetic instru-
ments: nobody can agree what color goes with which note. If I
were Scriabin, for example, Il Cremonese would be visually
singing to me in G; if I were Isaac Newton it would be the color of
D; and if I were George Field the violin's orange would be my F.[24]
If there is indeed a direct relationship between music and color,
then every lucky individual who can perceive it is tuned slightly
differently.

I had found the Stradivari violin, but I had not really found
Stradivari. Because the curious thing is that in a way he wasn't
there. One oddity about Cremona is how little it seems to love its
most famous son. Which is not to say it doesn't love violins. They
are everywhere—pastry shops sell cakes in the shapes of fiddles,
sweet shops are full of Cremona candy, and everywhere there are
windows through which anyone can peer and see craftsmen and
women squinting over small slices of wood. But Stradivari seems
like an unloved child.

It took me three visits to find his gravestone in the Plaza Roma.
The first two times nobody could tell me where it was: on my third
attempt I asked a woman walking an Irish setter to help me, and
she led me to a place on the opposite side of the square from where
the tourist map had marked an X. Stradivari's body had been
tipped into the common grave long before, she said. This was just
a memorial. A man came up while I stood in front of the flat stone,
carefully making out the letters "STRA . . ." through the murk of a
puddle. It was just a replica, he said in a gravelly voice; the origi-
nal was in the town library. "Stradivari's workshop was over there,"
he said, pointing to a McDonald's hamburger outlet in an ugly
new office block. He looked scornfully at the red marble plinth on

which the stone sat. "It's dirty," he said. "They don't look after it, the council." I placed some scarlet geraniums from the municipal gardens beside Stradivari's puddle, and left it to dry out in the morning sunshine.

Stradivari's first home, on the Corso Garibaldi, was even more disappointing. The run-down town house was marked by a small plaque announcing that the *liutaio* Antonio Stradivari lived there from 1667 to 1680 with his first wife Francesca Ferraboschi. It didn't say they had six children there, but they did, and at one time the place must have been full of life. It was hard to imagine that now, or to know which was a worse sign of decay: the pigeons emerging from broken netting in the attic, or the kitsch German woodwork sold in the shop below. It was ironic: shiny pine kittens curled up in hideous hearts, in the home of a man whose work once required the most subtle awareness of grain and varnish.

Just five doors away I saw the studio of a violin-maker whose name I recognized: could Riccardo Bergonzi be a descendant of Carlo Bergonzi, who made some of the greatest violins after Stradivari died? I went in; Bergonzi was there, and agreed to show me his studio. If there really is anything in a violin that reflects its maker, then Bergonzi's instruments must be full of laughter and life. He was a jazz saxophonist in his spare time, and his artistic skills were evident throughout his workshop. Not just in the jazzy paintings—his upstairs showroom was startling in its breezy creativity, orange instruments contrasting spectacularly with bright turquoise walls. There was little on the shelves of his workshop that Martinengo wouldn't have recognized. There was madder and turpentine, safflower and dragon's blood, turmeric and propolis. The local propolis was "as yellow as gold" and as bendy as willow, Bergonzi said. Gamboge and saffron—which I would meet more formally in my search for yellow—were there too. There was plenty of mastic—which he let me taste, and it was horrible—and benzoin, which he said was "flexible and brilliant; better than mastic." Having made my imaginary journey with Martinengo, they all seemed like old friends.

He dismissed the speculation about Stradivari's varnish as simply that. Perhaps, he said, the recipe was lost because there wasn't a recipe. "My theory is that he never made his varnish, but bought it from a shop." So for Bergonzi the "trick" was in the tailoring. "Maybe Stradivari would go and see the professional varnish-maker and say that last one was nice, but it's summer now and I need something softer," he suggested. Perhaps Stradivari's "secret" was that he varied the varnish according to the needs of the violin, rather than keeping to a formula.

He was a descendant of Carlo Bergonzi, he confirmed, but he hadn't known that when he walked into a violin shop at the age of eleven to buy an instrument, "and fell in love with the smells and the wood and the atmosphere." It was as if his genes had jumped up and said "I belong here." Three years later he went to the violin school Mussolini had started. The place had been quiet for years, but in the 1970s it was beginning to boom: "It was full of Californians and Australians: men with long beards and big gestures." He remembered all sorts of hallucinogenic happenings: "there were green violins, blue ones, anything you could imagine . . ." And then he paused, suddenly serious. "But I do believe that when you make an instrument you have to respect that you are part of a story. You can't play around with that too much."

After I left Bergonzi's studio I went down to the cathedral and found two things. First, around the sacrament chapel, I saw a carved procession of three violins and several lutes marching up the columns. This is the part of the church where the sacrament is reserved—where the physical becomes sublime and the sublime becomes physical—so it is important for Cremona that this should be the place where music is honored. And the second thing I saw was some curious-looking wood in the choir stalls curving around the back of the altar. With an approving nod from the verger, I slipped under the rope, and found that behind each choir stall was a different picture, made of the contrast between delicately varnished maple woods, spruce, cherry and what looked like walnut.

Each one was a celebration of Cremona's fame for creating magic out of wood.

A few scenes were biblical—suffering Christs, patient Marys—although mostly they were secular—people tending cattle or returning home to medieval villages. Most interesting for me was a lute, alone on a mythical plain, waiting to be played. There were no violins: perhaps they had not been invented yet. I wondered whether the pictures were made by an anonymous luthier, taking time out from his usual line of work. Maybe even my Sephardic master, although that would have been too much to hope for.

I looked at that stained wood and remembered Stradivari's spirited bill for "one filippo," his astonishing tiger-like violin, and Riccardo Bergonzi's curious insistence that he was—they all were—part of a story. And looking again at that lonely, iconic lute, I was reminded also of a Jewish legend—of the Golem who can be created from mud by singing it to life with special sounds. The Golem lives and breathes, but always preserves deep inside it the spirit of the one who made it. But most of all I remembered an extraordinary musical performance—at a tiny AIDS hospice in Thailand, during a tour by violinist Maxim Vengerov in his role as a cultural ambassador for Unicef. Vengerov took out his Stradivarius violin (the "ex Kiesewetter" made in 1723) and played to the audience of fifteen—including visitors—with all the energy and concentration that I had seen him give to a packed Sydney Opera House a few months earlier. He played a fugue by Bach, and the music seemed to take on a life of its own. It floated around the bed where a young soldier lay: his AIDS was discovered after a sergeant beat him so badly his intestines fell out. And it rested for a moment on a little boy whose hill-tribesman father was HIV positive, and who would soon be an orphan. It swirled gently around a middle-aged woman with purple blotches on her arms, and an old man, so weak that he couldn't even raise his head.

And in the music there was not only the quiet drama of the present moment but also Vengerov's own memories—of growing up in

Siberia in an apartment so small they had to break down the kitchen wall to accommodate the grand piano, of children from his mother's orphanage coming round to listen to music, and his deeper story about how his grandparents had taught him humility—when as a little boy he wanted to boast about his talent. The whole history was there in that performance, as it is when a great player plays, and when the moment is right.

No one will ever know why Martinengo ended up in Cremona. But the story I have told—in order to bring alive some of the mysteries of orange and of varnishes—is culled from what we know happened to thousands of Jews at that time, as they tried to make a place for themselves in a changing world. Whichever way our luthier travelled from Spain, there would have been terrible things and wonderful things to be seen and collected by a refugee craftsman who was wandering Europe as Europe woke up to itself. And perhaps—while he taught the Amati brothers how to cut from patterns, set the ribs of a lute and how to boil up turpentine with dragon's blood—our luthier would have found them ready to learn a real secret.

It is the secret of knowing yourself and your materials so well that you can wrap your life's experiences into the very body of an instrument, just as a true musician puts his or her life experiences into the playing of it, as I had seen at the hospice. And when both elements are right, then together—maker and musician—you can persuade your violin to sing and cry and dance the orange.

# 6

# Yellow

*"There are painters who transform the sun into a yellow spot, but there are others who, thanks to their art and their intelligence, transform a yellow spot into the sun."*

PABLO PICASSO

*"What is purple in the earth, red in the market and yellow on the table?"*

*Iranian riddle* (answer below)

O n the shelf above my desk there is a box containing five things. They make an odd collection, and if anyone came across them by accident I'm sure they wouldn't think of them as particularly precious. But they have come a long way, and they all have stories to tell.

The first is my favorite—a bunch of mango leaves, which have turned moldy after only two months in the Hong Kong humidity. Then there is a small cylinder of what looks like dirty plastic; it's the color of dark amber, but when I touch it with even the tiniest amount of water it beads into an incredibly bright, fluorescent droplet of yellow. Once I thought it was a little miracle, and showed the trick to everyone I met, sometimes using spit if I didn't have water. But now that I have found out more about it, I have to

be careful of it. Then there is a little cardboard container the size of a matchbox: outside it is covered in Chinese writing and inside there are little yellow slabs. But I don't take them out much: I have to be careful of them too. And finally there are two small glass vials containing the world's most expensive spice. One of them is redder than the other, and the reason for that is part of my story too.

It isn't surprising, given the chapter heading, that all my little souvenirs can be used to make yellow paints and dyes. But what has surprised me, in the collecting of them, is how, with such a bright, happy color, it has been so necessary to use caution. No color has a neat unambiguous symbolism, but yellow gives some of the most mixed messages of all. It is the color of pulsating life—of corn and gold and angelic haloes—and it is also at the same time a color of bile, and in its sulphurous incarnation it is the color of the Devil. In animal life, yellow—especially mixed with black—is a warning. Don't come near, it commands, or you will be stung or poisoned or generally inconvenienced. In Asia yellow is the color of power— the emperors of China were the only ones allowed to sport sunshine-colored robes. But it is also the color of declining power. A sallow complexion comes with sickness; the yellow of leaves in autumn not only symbolizes their death, it indicates it. The change shows that the leaves are not absorbing the same light energy that they used to take in when they were green and full of chlorophyll. It shows they no longer have what it takes to nourish them.

## INDIAN YELLOW

In Mumbai's Prince of Wales museum there is an eighteenth-century watercolor of two lovers, sitting beneath a tree. One is Krishna, the playboy incarnation of Vishnu, the cloth of his yellow dhoti contrasting beautifully with his blue skin. He is playing the flute to his girlfriend Radha, who is looking at him with admiration. They are sitting under what is perhaps a mango tree, which is a symbol of love in Hindu mythology. What we cannot see

here—although we can see it in other watercolors nearby—is that on the other side of the garden there are cows eating grass and leaves, herded by pretty milkmaids. Krishna will later pursue them, which will wreak havoc in his relationship with his girlfriend. But this is in the future, and for the moment all is perfect. The miniatures illustrate a popular Hindu story of the playfulness of the gods, of tragedy and misunderstanding, and of course of the wonderful intoxication of romance. And they are also, with their cows, trees and yellow color, the summary of the story of one particular paint—the color, quite possibly, that adorns Krishna's clothes.

For years in both England and in parts of India the ingredients of Indian Yellow were a mystery. Throughout the nineteenth century little parcels arrived irregularly at the London docks from Calcutta, sealed no doubt with plenty of string and sealing wax, and addressed to colormen like George Field and Messrs Winsor & Newton. Those who sniffed the stale contents must have wondered where they came from and what they were made of, but if the companies made active enquiries about what they were buying, then the answers have been long since lost. Some suggested it was snake urine, others thought it might be something that had been dug out of the insides of animals (like the ox bile that had been used to make yellow in the previous century) and a German scientist called W. Schmidt stated authoritatively in 1855 that it had been excreted from camels that had eaten mango fruits. George Field didn't like it much—not because of the strange smell but because it faded quickly—and his theory, agreeing roughly with Professor Schmidt's, was that the "powdery, soft, light, spongy" lumps with their fetid odor, were derived from the urine of camels.[1]

Then, one day in 1883, a letter arrived at the Society of Arts in London, from a Mr. T. N. Mukharji of Calcutta. This gentleman had investigated Indian Yellow on the request of the eccentric but brilliant director of Kew Gardens, Sir Joseph Hooker, and said he could now confirm exactly what Indian Yellow was made from. Mr. Mukharji said he had recently visited the only place in India where

it came from—a town called Monghyr in Bihar state—and had actually seen it being made. The information that he gave them may have been a little shocking to some of his journal readers, but what he told them was that Indian Yellow, which was also known as *piuri*, was made from the urine of cows fed with mango leaves. He could assure readers that he had actually seen them eating mango leaves, and urinating—on demand—into buckets. And, he warned, the cows looked unhealthy and were said to die very early.

But here is another mystery about Indian Yellow. According to some accounts that letter, or at least the industry it described, started off protests, which culminated in laws—passed sometime between the 1890s and 1908 in Bengal—forbidding the making of Indian Yellow on the grounds of cruelty to animals. But I could find no records of such laws in either the India Library in London or the National Library in Calcutta, nor did either of those excellent archives contain any newspaper articles or correspondence on this intriguing slice of Indian art history. The four researchers for the Indian Yellow chapter in the National Gallery of Washington's excellent series on artists' pigments couldn't find any either.[2] In fact, the only piece of nineteenth-century documentation that anyone seems to have located in English was Mr. Mukharji's printed letter in the *Journal* of the Society of Arts. It seemed odd that nobody else had written anything—not even, it seems, a letter to a newspaper—about the mango cows of Monghyr. So, with photocopy firmly in hand, I decided to go to India on the trail of Indian Yellow.

Bihar is a large, mostly flat state between the Himalayas and Calcutta. It is the poorest state in India. I flew into the capital, Patna, which one guidebook described as a city you wouldn't want to spend much time in, in a state you wouldn't want to spend much time in either. That first night in Bihar, the night clerks at the one-star hotel I was staying in phoned me three times. "It's the middle of the night," I groaned. "Yes, madam, but it is Saturday night, and Patna is alive with disco." Mine was the first foreign name in their

visitors' book for a month, and the first single female name since the book started.

Monghyr is 150 kilometers from Patna, and the train journey takes four hours, through flat countryside showing the healthy green of well-nourished farmlands. This land I was passing through was important to art history not simply because it was the home of the yellow paint that had so caught my imagination but because, according to Tibetan tradition, this is the mythological birthplace of painting itself.

There were, so the story goes, two kings who lived in the sixth century B.C. Every year they would exchange gifts—outdoing each other, as rich people often try to do, with the cleverness and expense of their choices. One year one of the kings decided to give his rival the ultimate present—a painting of the Buddha, who was at that time still alive and living in Bihar. No painting had ever been done before, but, undeterred, the king assigned the job to a man who seemed to have potential. But when he arrived at the place where the Buddha was in meditation, our first artist realized he had a problem: he was so overwhelmed by his subject's enlightened glow that he could not look at him. But then the Buddha made a suggestion. "We will go down to the bank of a clear and limpid pool," he said helpfully. "And you will look at me in the reflection of the water." They found an appropriately limpid pond, and the man happily painted the reflection.

When the king received the gift and looked at the portrait, he had an intuitive understanding of reality.[3] In terms of Buddhist teachings he realized that the world we see with our eyes is just a reflection of a reality that we cannot quite grasp. But the story also gives an insight into the power of painting, suggesting that this thing that is a reflection of truth can also somehow *be* truth, and that the best art can give its viewers enlightened understandings of the world.

As my train slowly rattled through the countryside, it was as if the land itself conspired to celebrate the myth that it was here that

painting had begun: the whole landscape was covered with paint. It was harvest-time in Bihar, and the Hindu farmers celebrated the safe gathering of the crops by covering their animals in pigments. I saw a great cart moving toward the railway line. It was pulled by two white bullocks, both daubed in pink as if a child had been finger-painting over them. The paints I saw were synthetic, but there must have been similar scenes every harvest-time for hundreds of years. Perhaps it is what the Buddha saw, as he walked toward enlightenment; it is almost certainly what the Mughal rulers must have seen as they tried to conquer the predominantly Hindu sub-continent in the sixteenth century. And I am sure the British colonizers in the eighteenth and nineteenth centuries saw painted animals every September, celebrating the harvest.

I was not sure what to expect of Monghyr. My information was very out of date. In 1845 a Captain Sherwill, who had the job of revenue surveyor, described Monghyr as a town with "a probable population of 40,000 souls."[4] It was, he wrote, "a well-built, substantial and flourishing place, with about 300 brick houses and numerous markets carrying on a brisk trade in brassware, cutlery of an inferior kind, guns, rifles, pistols and ironware in general, but of a very doubtful and dangerous nature as far as regards firearms." I was intrigued by how, although Monghyr was clearly a welcoming place, the rest of the district was somehow shadowed by a kind of physical corruption that this British officer found threatening. The nearby town of Shaikpoora, he wrote with a horror that comes through even in his formal report to his bosses, was "remarkable for the great number of individuals who possess but one eye and have deformed noses, the effects of syphilis." That town was "composed of one long narrow street of disgustingly dirty and ruinous houses, with a filthy population and very little trade; grain and sugar are exported toward the Ganges, and an opium godown is situated to the east of the town."

There is a map that accompanies the statistics in Sherwill's report. Monghyr and the nasty Shaikpoora are in pink, but the

region of Bullah across the other side of the holy Ganges river is in a yellow that still shines. I like to think it was painted with Indian Yellow watercolor, even though when I sniffed it—making sure that my fellow library-users did not see what I was doing—I detected no faint 150-year-old scent of ammonia. Whether it was used on that map or not, Indian Yellow would almost certainly have been in the paintboxes of many of the surveyors and mapmakers sent to the colonies in the Victorian years. Captain Sherwill's report was extremely detailed about all the industries in the area—he even described a mysterious and obscure mineral found on a small hill, west of the station of Gya, "used for dyeing clothes, of an orange color, also for metalling the roads in the station. This mineral is either of an orange, purple, light-red or yellow color." So it is extraordinary that he didn't even mention Monghyr *piuri.*

Monghyr is a place that is entirely off the *Planet*—or any other guidebook—and I didn't have any clues about where to stay. I told the taxi driver I wanted to go to a hotel, but he took me instead to an ashram, insisting this was where I wanted to go. Acolytes dressed variously in orange, yellow and white strolled quietly along empty avenues. It was a complete contrast to the noisy mayhem a few kilometers away in the town, but I could see that it wasn't the place for me. White was for the uninitiated, I read in the brochure, aspirants wore yellow, and the teachers wore "geru." "Can I ask a funny question?" I asked a slim young man with white stripes on his forehead, who was manning the office. "You can ask a funny question and I will give a fine answer," he said. What is geru? "It is orange," he said, indicating his own clothes which put him firmly in the highest category of Bihar yogis. "It represents the luminosity within." And what does yellow represent? "Yellow is the light in nature. It invites the soul, as black protects the soul." I nodded, and thanked him, but he had one thing more to tell me. "You see the thing about yellow is that it has to be purified."

Bottles of powdered pigments from Winsor & Newton.

(above) Artists at Papunya, Australia.

(right) A natural paint box at Jumped Up Creek in the Northern Territory of Australia.

A *pattern book from 1763, made for John Kelly in Norwich, showing samples of wool covered with natural dyes. Below is a sampler from the 1860s that clearly celebrates the very recent arrival of synthetic dyes.*

When eighteenth-century British artist Joshua Reynolds painted this canvas of A Girl with a Baby he used a substance called megilp to try and imitate the Old Masters. But the Dulwich Picture Gallery describes this painting as "ruinous"—although many visitors like it because it now resembles the work of the Impressionists.

Boddhisattvas and wise men in Dunhuang's cave number 419: they were not meant to have black faces, but the lead-based paints have darkened over time.

(below) A page from a 1465 manuscript of Pliny the Elder's Natural History showing an artist painting a ceiling, another painting a marriage chest, and an apprentice grinding pigments for both of them.

Cochineal insects on a cactus leaf, just before they become Color Additive E120.

(above) *Michelangelo's unfin-
ished painting of* The
Entombment, 1501. *The space
in the lower right of the panel
was almost certainly intended to
be the Virgin Mary, but the
artist probably left it blank until
his valuable ultramarine paint
arrived from Afghanistan.*

A *poster for the 37th Consuegra
saffron festival showing women
plucking saffron stigmas from
the crocuses.*

Red trays in the Winsor & Newton factory.

(below) The Parke violin, made by Antonio Stradivari in 1711 and still showing signs of his mysterious orange varnish.

*The Hindu god Krishna wears yellow and charms the cows with his flute. Could this be the origin of the Indian Yellow legend?*

*Santiago de la Cruz, his shirt stained with the tears of sea snails, shows the skein of cotton that he has dyed with* Purpura pansa *from the Oaxaca coast in Mexico.*

(left) *A sprig of indigo. An eighteenth-century copy of the botanical painting commissioned by William Roxburgh in Calcutta in the 1780s.*

This bright yellow tile was made in Mughal India in the seventeenth century, using the Arabic cuerda seca technique of separating the different colored glazes with thin lines of grease.

A miner from Sar-e-Sang in Afghanistan shows some recent samples of his third grade lapis lazuli.

Lapis lazuli ready to be powdered and made up into ultramarine paint by Winsor & Newton.

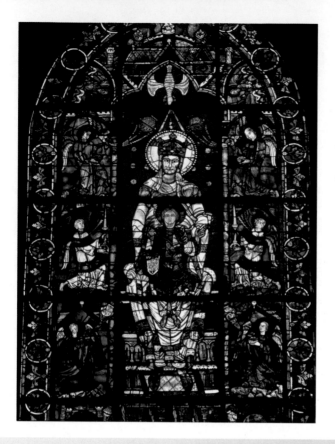

Notre Dame de la Belle Verrière *was one of the few pieces of twelfth-century stained glass in Chartres Cathedral to survive a fire in 1194.*

(below) *Indian Yellow pigment nuggets from Winsor & Newton.*

A friendly Bihar bank manager, fresh from a class, gave me and my bags a lift into town on the back of his scooter. "You have to go to see Monghyr's oldest artist," he said as I explained my quest above the sounds of the motor. "If anyone knows of this paint then Chaku Pandit at Mangal Bazaar will know." So the next day I crossed the railway line heading toward Mangal Bazaar. Monghyr is a simple town—it reminded me very much of the India I saw eighteen years earlier on my first visit as a teenager. Everything is rickety, with places that were once probably palaces now hidden behind padlocked railings and being pulled down by vines and mold. The gun shops had gone, but there were plenty of hardware stores selling the kind of "inferior cutlery" that Captain Sherwill had commented on 150 years before. The syphilis problem was evidently still there as well: on every street corner there were hand-painted promises for venereal disease checks as well as operations for piles, conducted "without anesthetic."

Everywhere the people seemed astonished to see me: they weren't used to visitors. "Mangal Bazaar?" I asked, and the world followed me. "You go down the street and turn left," an old man said, indicating right with his hand. You mean go right? I queried. "Yes," he said, "left." In the end neither was the correct way, but I did eventually find Chaku Pandit, a man with nearly blind blue eyes, in a blue house with round columns. We had a spontaneous conference organized by his son, with three of us on wooden chairs. One man went to get me a cold drink; another was summoned to sit on the floor and wave a punkah fan in my direction as the sweat ran down my nose onto my notes. "There are many kinds of *piuri*," his friend said carefully. Which one was I interested in? I felt highly optimistic that I was on track to discover something. Mr. Mukharji, after all, had stated in his letter that there were two kinds of *piuri*—a mineral one "imported from London" and an animal one, which is what I was looking for. "Any kind," I said airily, and a boy was sent off with careful instructions in Hindi.

I tried to explain it was Krishna's yellow, the one he always wears in watercolors, or at least the one he wears when he's not wearing orange. They explained to me sadly that Krishna was blue; and it was in vain to protest that I knew this.

Chaku Pandit brought in a very brown Monarch-of-the-Glen-like portrait of a stag, the canvas bloated and bumpy where the damp had settled. His other paintings were rather gaudy pictures of idealized landscapes. The boy came back with a paintbox of oil tubes, manufactured in Bombay. "I have not heard of your Indian Yellow before. But why would we use cow urine when we have these good paints?" mused Chaku Pandit. I had to concede he was right, and thanking him for his time, his son for the cola and the man crouched on the floor for the fan, I went outside and hailed a cycle rickshaw. It had the motto "enjoyment of lovers" written on its seat. "Mirzapur, please," I said. And we began to head out into the countryside.

I thought of Mr. Mukharji heading out on the same road 120 years before. What would he have been looking for? I wondered. Was he simply looking for a paint made by cowherds, or could there have been another reason for his interest? My predecessor had probably known that *piuri* had most likely been invented by the Persians in the late sixteenth century, and had mostly been used for miniatures—first by Mughal artists, later being adopted by the Hindus and the Jain painters. It was strange that the Jains—who are vegetarians and very strongly against inflicting pain on animals—should have painted with this apparently cruel color. "This is Mirzapur," announced my driver, and stopped. It seemed we were not stopping anywhere in particular: it was a bit of road like every other bit of road. I was briefly encouraged to see a bovine creature peeing in a nearby meadow, but then realized it was a buffalo.

There was a little tea stall nearby, so I decided to do what I usually do when I'm hoping for an adventure. Sit, have a drink—tea in this case—and wait for it to come to me. I went over and the man made space for me to perch on the edge of a well. I hoped the·

tea water came from somewhere else, as the well water was covered in scum. Usually in this kind of situation someone will ask in English "What are you doing?," leading me to my quest. But this time nobody did. Nobody could speak English. I cursed the fact that the young man I thought I had hired as my translator the night before had not turned up in the morning.

The stallholder was evidently a popular local character. He would leap up to put on the milk then go back to squatting on his wooden perch, carrying on conversations or handing a biscuit to a silent child. I was on to my second cup when I noticed his bare feet, and saw with surprise that this athletically built man had the worst case of elephantiasis I had ever seen on someone who was not a beggar. I asked him whether he knew of *piuri* but he just laughed nicely and asked me whether I knew of Hindi. I finished my tea and, wondering what the hell I was going to do without a translator and with a truly stupid and unlikely story about cow's urine, stood up and crossed the main road. I headed down a path, and suddenly things began to happen.

Two boys appeared, returning from school, perhaps. "What are you doing?" they asked. "I'm looking for a *gwala*," I answered, using the word for milkman that I had learned from Mr. Mukharji's letter. The only people—perhaps in the world, certainly in India—who made *piuri* at that time, he had written, were members of one sect of *gwalas* at Mirzapur. "My father is a *gwala*," one of the boys said happily, and pointed to his home at the end of the path. There were three cows in the shed and one by the trough. They looked well fed and the father seemed friendly. I began to draw in my notebook. "Buffalo?" they asked, as I drew something that I was convinced was an archetypal cow. "No, cow," I said firmly, and drew in what I hoped would look like udders, but realized too late that they were rather gender-ambiguous. By now the whole family had gathered to engage in art criticism. "Tail!" the father demanded enthusiastically, so I added a tail and he nodded approvingly, the udder fiasco forgotten. The

*A cow or a buffalo?*

mango was easy, then the mango leaves, and then . . . Well, that first time I was not courageous; I drew a little bucket that could have contained anything and then started pointing to the walls of a nearby house, which were conveniently yellow. The son tried to explain, but nobody had heard of any connection between cows and yellow walls. "Come now, come!" said the boys, impatient to show me off to the rest of the village. So we continued along the path with the younger one chanting "Where is *gwala*?" in great excitement.

Mirzapur was not a rich place, but it was not devastatingly poor: people lived in simple houses with clean pathways and plenty of fields around. As we walked, other people joined us, and at the next home someone brought out a chair for me, and I was invited to tell my story again. I was just getting to the mango leaves, and the crowd had swollen to a hundred strong, when there was a sort of hush, and along the path came a charismatic young man with a most infectious smile. He was riding a tricycle that had been rigged

up as a wheelchair. His knees were attached to the chair by small metal shields and he wheeled it with his arms, assisted by two friends. Here was another handsome young man of Mirzapur with a disability. He introduced himself as Rajiv Kumath; clearly he was a man to whom, when he spoke, people listened. So the cow thing started again, and the mango leaves, which was easy now because I knew the Hindi for leaf—but then came the moment of truth. Cow plus mango leaf plus . . . I drew a bucket then mimed squatting and made a ssssss-ing sound. "*Dudh?*" asked one boy, using the word for milk. "Er, no," I said, and did the "sssss-ing" more enthusiastically. Looks of disbelief passed between the sari-wearing grandmothers and the younger women holding babies. Even the little urchins of Mirzapur could not believe that this smiling stranger could be quite so crude. Then, in the silence, there was a burst of clear laughter. Rajiv Kumath roared with joy and the whole village roared with him.

So, he summarized, "in 1900"—he pointed to the date I had written down—"people make yellow from this plus this plus this?" He indicated the pictures. "Yes," I said. "Where?" he asked. "Here," I said. "In Mirzapur." He asked where else this happened. "Just in Mirzapur, nowhere else in India," I said, and we spluttered with laughter at the absolute absurdity of it. "It's called Monghyr *piuri*," I added, "and it travelled from Mirzapur to Monghyr to Calcutta to England." By this time both of us had tears running down our cheeks. Rajiv appealed to the crowd, but not even the old ones nodded in recognition of the practice. If *piuri* had ever been made in Monghyr it was not even a folk memory by the twenty-first century.

A few months earlier I had been in touch with Brian Lisus, a violin-maker in South Africa, who had experimented with real Indian Yellow as varnish. He had consulted a vet, who had recommended giving the cows mango leaves for one of two daily meals, which he did for a fortnight, "followed by some interesting times standing behind the cow to catch 'the treasure' in a bucket."[5] He then followed instructions from the National Gallery in London

about how to boil down the urine for several hours, a process that "kept visitors away," he said. The color, however, was not at all intense, and he guessed that to get enough color in the urine the cows would have to be fed more mango leaves; he didn't want to harm their digestive systems, so he gave up on the idea. His story of his very unusual "treasure" hunt had made me refer back to the 1883 letter for a section that I had never seen repeated in any secondary sources, for reasons no doubt of delicacy. It's all very well if you are doing an experiment with cows for just a fortnight and can wait around with a bucket and a sense of humor, but how did the original *gwalas* do it? Mr. Mukharji was very clear: "The cows treated with mango leaves are made to pass urine three or four times a day by having the urinary organ slightly rubbed with the hand, and they are so habituated to this process that they have become incapable of passing water of their own accord." It seemed highly suspicious that passing water on demand should be such a similar process to being milked.

I would at least like to see some cows, I decided. Yes, Rajiv said. "And you must see the mango garden." The mango garden? Of course. There had to be an orchard or two in the area, I suddenly realized. In a survey report from this area dated from 1905 to 1912, a P. W. Murphy reported plenty of excellent opium (slightly storm damaged) and some rather nasty mangoes. "The local mango is not good, and in the Jamui subdivision degenerates into a small hard fruit with an extremely acid taste," he had written. He had also counted all the adult cows (130,799) and buffaloes (45,164) in the area, and yet had not mentioned Indian Yellow. What he had noticed was "that the cows, bullocks and buffaloes of this district are much smaller and less well-nourished than in other districts"— but he included all of them in that appraisal, and he made no mention of a small minority whose digestive tracts were being ruined by the wrong diet.

"Yes, we have a very beautiful mango garden," Rajiv affirmed. It was beyond the power of his chair to accompany us, but led by a

ragtag crew of little boys and girls all chanting "Mango garden, mango garden," I crossed that road I had found so unpromising an hour before. And laughing at myself for feeling rather like an explorer, I suddenly found myself at the possible source of Winsor & Newton Indian Yellow. The end of my search, I thought dramatically and happily as I clambered with the children over a bit of broken wall. And as dusty and hot as it was outside, in the mango garden of Mirzapur it was green and quiet, and however far we walked we never saw the wall that marked its boundary on the other side. The children and I marched and chanted and whenever I decided to take a picture of the famous mango leaves they would rush to the tree of my choice and shimmy up it, perching like mynahs in the branches. There were several young couples walking there as well. The god Shiva married Parvati under a mango tree, and the leaves are often used to decorate marriage pavilions, even today.

One child was dispatched to find fruit for me. Not mangoes—it wasn't the season—but strange things called paniala that were slightly different from grapes, and eaten whole. They would have been nicely sweet but had the strange lemon-like aftereffect of squeezing the mouth dry. Whenever anyone new arrived I was asked to do the mime again, with everyone joining in the "ssss." I pictured a stranger arriving in that same village in ten years' time, and asking about *piuri*; and I imagined someone carefully explaining the cow and the mango leaves and the pissing in the bucket. And the stranger would write down the date that I had selected at random, 1900, and the folk memory would again be created.

I gathered the whole crowd for a photograph: five extra children ran into the group so I stepped back to include them and, suddenly, there was a loud splat. I looked down, and there covering my left foot from heel to lace was the gungiest, yellowest and smelliest example of bovine diarrhea I could imagine. Everyone held their noses in horror, and laughed with me, although none of them could have understood the true beauty of the joke. I had,

after all, gone to India to find bright yellow cow pee and had found something rather strikingly similar, all over my shoe. The gods had evidently heard about my search, but they were a little deaf.

They took me on a tour of the cows and the houses—but at each place, when we asked, nobody had heard of the *piuri*. I offered one cow a mango leaf, but it turned away. The cowherd offered it again, and it looked distressed. He tried to force-feed it by opening its mouth, but I asked him to stop. And I felt glad that, in Mirza-pur south of Monghyr, if Indian Yellow was ever made, it no longer is today.

As I returned to Monghyr, I thought of the ingredients of my story, and of Mr. Mukharji going back the same way. What kind of world did he live in? In the 1880s there was a rising national consciousness all over Asia—and in British-occupied Bengal it manifested itself in a desire to reassert and in a way reconstruct ancient Indian traditions. It was around 1883 that the world "desh" started being used to describe the whole of India or Bengal (part of which would later become "Bangladesh" with Independence), when originally it simply meant one's ancestral village. At the same time the early poems of the nationalist Rabindranath Tagore were just beginning to have an impact on Bengali thinking. The half-forgotten Vedas were being retranslated from Sanskrit, yoga was coming back into fashion, and Hinduism was suddenly a philosophy, not just a pantheistic religion. There was even the genesis of a movement to preserve the sacred cow—because in so many places the sacredness of cows had been forgotten. Cows were an important issue for many reasons, but a sense of national identity was one of them.

Perhaps Mr. Mukharji really was just an honest emissary, out to solve a simple mystery in the history of paint. But what if he was a nationalist, wanting to make a point, or at least a joke, at the expense of the British? Would it not have been tempting (when presented with the opportunity) to mix up the germs of truth—of a paint that was indeed made with some kind of urine[6] and some

kind of mangoes—with some random elements of Hindu mythology, and tell the British that their paint was not only totally impure but, since it involved cows, a violation against Hinduism?

Perhaps Mirzapur really was the only place in India where a particular paint was made, and perhaps the banning of that paint was really of so little interest to anyone that nobody bothered to record it, and perhaps the grandchildren of the people who supplied the world with this paint really have forgotten all about it. Maybe all those things are true. But when I think of Indian Yellow I will always wonder whether the explanation that I have heard is reality or merely a reflection of reality, and whether this story is simply an example of somebody gently, and literally, taking the piss.

## GAMBOGE AND ORPIMENT

Man Luen Choon[7] is on the second floor of an old building in the back streets of Hong Kong's Western District. It is hard to see the door for all the stalls selling fake bags, buttons and boas made of dyed chicken feathers. Just two blocks away from this old alleyway is the glass skyscraper that calls itself The Centre, but which locals tend to call the "Building of Color," because every night it lights the skyline with a computerized sequence of ever-shifting turquoises, pinks and greens. It is an example of the gracefully modern juxtaposed with the determinedly traditional. While The Centre blazes with millions of dollars of color technology, Man Luen Choon is Hong Kong's most famous Chinese art supplier. The first time I went there I wanted it to be dark and old fashioned, but instead it is bright and neon—a bit too much like The Centre for my liking. However, the lighting was probably a good thing. It meant I would see with neon clarity the miraculous transformation of one particular paint from something brown to something beautiful.

I was there with two friends—Fong So, who is an artist, and his partner Yeung Wai-man, a writer and photographer. They had offered to introduce me to the owner, Li Chingwan, who comes

from a family that ran a famous art shop in Guangzhou for many generations, and who has been in Hong Kong for twenty years. There were few mass-produced paint tubes in the shop—Mr. Li's pigments were proudly displayed on small white dishes under a glass cabinet. For a dedicated paint searcher it was a kind of heaven. Here was a pinch of cinnabar, there were lumps of azurite and malachite, and over there were even little clay-like squares of orpiment.

Orpiment means "gold pigment." For a long time it was an immensely exciting commodity for alchemists. If it was gold in color, went the argument, then it must surely share characteristics with gold, and could be used for transformations. Artists were less thrilled about it—partly because if anything is laid on top it blackens,[8] but mostly because it contains arsenic. It is "really poisonous," warned Cennini—and on the general toxicity scale it is beaten only by its more orange cousin realgar, which is even worse.[9] "We do not use [realgar], except sometimes on panel," Cennino warned. "There is no keeping company with it." And then he relented: "It wants to be ground a great deal with clear water. And look out for yourself."[10]

I shouldn't have been so surprised to find both orpiment and realgar so easily in a Chinese art shop. The Chinese have always had a less cautious attitude than Europeans toward these two paints. In 1705 an extraordinary book called *The Ambonese Curiosity Cabinet* was published posthumously in Holland.[11] It was written by a German called George Everhard Rumphius, who had spent most of his life working for the Dutch East Indies Company—and it led to him being dubbed the "Indian Pliny." Which was partly a positive reference to his infectious enthusiasm for knowledge, but also partly because of his notable reluctance to distinguish between myth and fact.

One can find on Java a kind of orpiment, he wrote. "Its taste is not astringent but almost tasteless, or perhaps veering a little to vitriolum," he continued, bravely. He had found it for sale in Javanese trade towns, as well as on Bali and in China. Apart from

painting on paper, it was also used to color a special gold, red and white linen, called krinsing. After smearing orpiment on the cloth, the krinsing-makers used to hang it up for days in a smoky room, to make the color fix. The Chinese and Javanese didn't see it as a poison, in fact quite the opposite: they would take it fearlessly as medicine, "but in small quantities, wherein they are not careful enough in my opinion." Once, in 1660 in Batavia—now Jakarta—he had seen a woman who had become mad from it, "and climbed up the walls like a cat."

Rumphius was not against orpiment in moderation. He recommended taking it in small doses to cure anemia, and for its tonic effect on the nervous system. People in the Tirol, he reported, ate arsenic regularly to improve their strength and complexion—a practice that was to continue until the end of the nineteenth century, and which led to the word "arsenicophagy." More intriguing, though, for our myth collector, was realgar or *hinghong*. It was easy to find: just look for a place "where the peacock has made its nest three years in a row." The peacocks, he explained, probably meaning the peahens, put it next to their eggs to keep snakes away. It could be useful, I decided, thinking of the pythons on the Peak, and I bought a few grams' worth in a small cardboard box printed with red Chinese characters. Mr. Li had samples of nearly all the natural pigments mentioned in this book. All the paint materials were from China except for two, he said: Japanese soot-based ink ("the most expensive in the world") and gamboge yellow. And it was gamboge that I had come to see.

This paint has been used in Chinese and Japanese paintings since at least the eighth century, and it has also been found on early Indian miniatures—in fact it was probably sometimes used to paint Krishna's yellow clothes, as a less smelly alternative to cow-urine yellow. It was always imported: gamboge comes mostly from Cambodia—its name is even a corruption of the name for that country.[12] It appears in other Southeast Asian countries as well, and there was certainly enough gamboge on the Thai border in the

1880s for King Chulalongkorn to send some good samples of the resin to the United States as part of a "gift of respect."

During the horrific Khmer Rouge regime in the 1980s, and then earlier in the Vietnam War, the color was almost impossible to find. "In wartime it gets mixed with mud," Mr. Li explained. "Once I imported fifty kilos of dirty gamboge, because even that was rare." He showed me a clean piece—a "peacetime piece," he called it. It was the shape of a lump of Brighton rock, although it was slightly squashed as if it had been in a child's pocket for too long. It had the smooth brittleness of hard toffee, and was the color of dry ear wax. But when Mr. Li dipped a paintbrush in water and waved it lightly over the unappetizingly brownish rock, he released a miraculous drop of the brightest yellow imaginable, almost fluorescent.

The Chinese call it "ivy yellow" or "rattan yellow," but gamboge comes from neither ivy nor rattan, but from the *Garcinia hanburyi*—a tall tree related to the mangosteen, but without such a delicious fruit. The paint in Mr. Li's hand was the resin of the garcinia, and had been tapped using a similar method to rubber extraction—except for one critical difference. A semicircular slash in a rubber tree's trunk bleeds white latex within a few hours which can be collected the next morning. By contrast, a gamboge collector makes his or her cut deeply in the trunk, carefully places a hollowed-out bamboo beneath the gash . . . and doesn't come back until the following year.

I wondered whether Mr. Li had any wartime pieces. "Somewhere," he said, and disappeared into one of the back rooms. A few minutes later he emerged with a dirty plastic Park N Shop bag from one of Hong Kong's big supermarket chains. It was full of dark green-brown crumbly versions of the clean gamboge: as if someone had chewed the toffee and spat it out onto dirt before leaving it to harden again. "This is the stuff we got during the war: very bad, full of impurities." Many of the bamboo gamboge-holders would have fallen onto the ground, so people would have gone looking for the resin that had dripped onto the soil. "I should

like to find some gamboge," I said, dreamily, imagining myself in a woodland grove deep in the jungle, learning how to make that gash in the trunk with a curved knife, and later being told the ancestral myths of the trees that bleed yellow paint. "No you wouldn't," said Mr. Li firmly. We all looked up in surprise. What did he mean? "There are landmines there: people get killed for gamboge," he said.

This pretty paint can be dangerous in other ways, I learned later. Winsor & Newton have been receiving small parcels of gamboge from their Southeast Asian suppliers since before anyone can remember, and probably since the company started in the mid-nineteenth century. When it arrives at the factory they grind it up carefully and sell it in tubes or pans as one of their more expensive watercolors. But some of the packages that arrived in the 1970s and 1980s from Cambodia and possibly Vietnam were different: the gamboge contained exploded bullets. The company's technical director, Ian Garrett, has five of them displayed in his office now: a reminder to him and his colleagues of how some of the paint materials they can so easily take for granted come from places where people have lived through unimaginable suffering. One day, during the height of the Vietnam War, or perhaps during the horrors of the murderous Pol Pot regime, a soldier, or a group of soldiers, must have gone into the garcinia grove and sprayed bullets around the area with machine guns. Some of these lodged safely in the bamboo, to be found months or years later by paint-makers in Harrow. What happened to the other bullets can only be imagined.

I liked my piece of gamboge from Man Luen Choon very much. When I added a drop of water to it and created bright yellow paint, I felt like a magician and showed the trick to all the children I met. Once, on a train in England, I sat opposite a nine-year-old boy who liked strange artifacts in the same way that I have always done. He was travelling with his grandmother and had just been to visit a relative who had given him a skin drum from Indonesia. He held it proudly—he knew this was a magical thing. I showed him my

gamboge trick and told him the story, explaining about the war, and why people are sometimes prepared to take different risks in wartime. He was interested, so I gave the piece to him. I now wish that I hadn't.

Four days later I was in America, talking to pigments specialist Michael Skalka at the National Gallery in Washington. I mentioned I had bought gamboge in Hong Kong. He commented that it made a pretty paint. "But it's poison," he said. Gamboge probably won't kill you like orpiment, I learned later to my relief—although it has been a possible murder weapon in at least one Chinese detective story, injected into a peach[13]—but it won't be nice. It is one of the most efficient diuretics that nature knows—put it accidentally in your mouth and you'll be in the bathroom all day. Another yellow dye—buckthorn—has the same effect. In fact it is quite a characteristic of things that are vibrating at the yellow resonance. Gourds, unripe pineapple, yellow dock root and yellow flag irises all have the same violently purgative effect. Perhaps it is not a coincidence that Indian Vedic tradition places yellow at the second chakra—the navel, just above the colon.

I called my friend Yeung Wai-man a few weeks later. Did she know that gamboge was really poisonous? Oh yes, she said cheerfully. "I did know that . . . Actually, it's the reason why no cockroaches will eat Fong So's paintings. He leaves them on the floor at night and at first I was worried that insects would eat them because they eat everything else." She called out to Fong So, who was painting in the other room, to check. He concurred that his art was preserved for posterity partly because the yellow paint scared away the hungry creepy-crawlies. "People would use gamboge as insect repellent, but it's too expensive," he said.

## SAFFRON

The last two souvenirs on my shelf are jars of the most expensive and most colorful spice in the world: saffron. And, like gamboge,

it is full of paradoxes. It is red but it is yellow; it is expensive but it is affordable; it can dry out your liver but it can make you roar with laughter; it has almost died out but it is produced in bulk. Unlike gamboge, however, saffron is frequently faked. As I found out to my cost.

My first encounter with saffron, in name at least, was in Kashmir in the mid-1980s. I visited the northern Indian state three summers in a row while I was a student, in the years before it started its messy fight for independence. I was waiting for the passes to open to the north, and one year the snow stayed longer than I expected, and I spent several days hanging out on a houseboat on Dal Lake in the capital of Srinagar, enjoying the home cooking and watching the shikara gondolier salesmen touting their wares. "You want marijuana?" they would cry, when I'd turned down the colas and sweets. No thanks. "Opium?" they would banter. No, really. "Aha, I know," they would say, in triumph, pulling out their last card in the poker game of Western decadence. "You want Tampax?"

I only ever bought one thing from a shikara man: a grubby packet of something yellow. "You want saffron?" he had asked, and I was curious and asked to see the goods. The man used far more subterfuge than his colleague, who was busily offloading stubs of hashish to more savvy travellers on the next-door houseboat. Of course he was acting suspiciously, I realized later. The bag was full of safflower—that cheaper red spice I encountered in the orange chapter, which doesn't have either the charm or the bitter earthiness of the real thing. And I, an ignorant teenager on my first travels, bought it eagerly. Perhaps it didn't matter that it wasn't saffron on that occasion: after all, at the time I didn't really know what to do with it.

I knew that it was the world's most expensive spice, I knew that it was yellow (although in the packet I had bought it looked orange and in fact, if it had been genuine, it should have been crimson red), and I knew it was from a flower. I also knew that the Indian government had restricted exports of Kashmiri saffron as part of the

same protectionist policy that meant I was drinking a drink called Campa Cola instead of any familiar American brands. But I didn't know then that a double pinch of saffron in hot water with honey can be an instant reviver, nor did I know how to add this spice to long-grained rice to make it taste like the earth and look like the sun; I didn't know that the flower it came from was the crocus, nor did I know how long it was going to take before I learned all these things.

A few years later I thought I found real saffron again, this time on Tibetan monastic robes. I had read many descriptions where the yellow (and sometimes even the red) robes are described as "saffron," and I had accepted the image gladly, probably using it myself. But where, I asked once, innocently, do they get the saffron for dyeing the robes? After all, although the spice had been grown in nearby Kashmir since at least 500 B.C. and probably much longer, Tibet was surely too high for anything so delicate to grow. My nun friend laughed. Buddhist robes are worn to show how humble one is, she explained, not to show off that one has had access to the most expensive spice in the world.

In Tibet, robes were usually dyed with turmeric, which was cheap and the color of the simple earth. And in Thailand the monks' robes are often colored with the heart of the jackfruit, and once a year—in November—is the official Day of Dyeing, when they go down to the river in the early morning with their fruits and their pots, and they color their robes again. Nowadays, of course, many robes are synthetically dyed, but even among the natural ones none is colored with saffron. I was going to have to look elsewhere to find this essentially sensual yellow. And it made sense to go straight to the harvest.

Not to the Kashmir one, I decided, even though the Kashmiri people claim (probably wrongly) that it is the place where saffron was born. After years of civil crisis, the industry there was in shreds, and producing less than a ton a year. But saffron crocuses are grown in many places. The most famous is Spain, home of the

paella, but they can also be found in Iran, Macedonia, France and Morocco, with bijou crops in New Zealand, Tasmania and North Wales among other places.[14] I played with the notion of visiting Macedonia, Alexander the Great's birthplace, after discovering there was a town called Krokos, named after the saffron flower. Then I thought of Iran—after all, the Persians were famous for their yellow rice—and called up my nearest Iranian embassy, which was in Canberra. "No problem," they said, telling me to send my passport down for a visa. I'm British, I added as an after-thought. "Very problem," was the cheerful reply.

So instead I went to La Mancha, the center of Spanish saffron production, at the peak of the harvest, the end of October. Surely there I would find my genuine yellow dye, I thought. But as I drove around on my first morning, eyes on high alert to spot anything brightly colored through the early mist, I realized that not only was I quite incapable of finding a saffron field without help, but that the Spanish saffron industry was in deep trouble. It wasn't that I didn't know what to look for: I did. I knew the astonishing fact that this perfectly yellow dye spice comes from a perfectly purple flower. With this crucial piece of information I thought even the most botanically inept saffron-seeker could spot a field in full bloom. But I couldn't.

I had a book with me—John Humphries's *The Essential Saffron Companion*, which was certainly essential, and full of wonderful recipes, but also, although only eight years old, quite out of date. In 1993 Humphries had spent several days in this rural area south of Madrid during the harvest. He had not only found a "mantle of purple; a sea of saffron," draped and washed over the Spanish landscape, he had also been introduced to contemporary cave-dwellers living just a few hundred meters from his hotel in the small town of Manzanares, and had vividly described how they ventured out at dawn to gather their harvest, bringing it back to their caves to be dried. Humphries had drawn an irresistibly romantic picture of a tradition that had evidently hardly changed in a thousand years.

Manzanares, then, was going to be my first stop: I couldn't wait to see the caves.

It was about eight o'clock, and it had just got light, when I arrived at the place Humphries had described. But however carefully I examined the surrounding fields and the fields surrounding those, I couldn't even find a purple petal. Let alone purple mantles or black-clad troglodytes. Disconsolate after my predawn start, I stopped at a café for espresso and advice. "No one grows saffron round Manzanares anymore," the *barristo* told me kindly. "There's no money in it."

I consoled myself with the fact that I wasn't the first one to go hunting for saffron and not find it, and I'm sure I won't be the last. In the mid-nineteenth century, for example, the eccentric Reverend William Herbert left his flock at Manchester Cathedral where he was dean, and set off around Europe in search of crocuses. He tried to find the birthplace of *Crocus sativus*—which he had tried to grow in his Yorkshire garden, although in thirty years he had seen it bloom only three times. In Greece and Italy he too had looked for purple mantles. But instead he just found a few bulbs. "I suspect that the birthplace of C. sativus has been long converted into vineyards," he concluded sadly.[15]

There is something magical about the saffron crocus. One evening the sun goes down on a bare field, then as if from nowhere the flower appears overnight, blooms for a morning, and then by the end of the day it has gone. The saffron business can be like its own flowers: here this morning, gone this afternoon, all at the whim of the market and the weather. Neither I nor the good Reverend Herbert should have been surprised that the European crop had shifted fields—the experience of English saffron, unlikely as it sounds today as a concept, should have told us how this industry is subject to tremendous shifts of fortune.

## SAFFRON WALDEN

It was a medieval pilgrim, the myth goes, who brought saffron to Essex. He apparently risked his life to get it out of the Holy Land and back to Chipping Walden's chalky soil, and he rather cleverly carried it in his hat. It is more likely, of course, if this chap existed at all, that he picked up the saffron corms—as the shallot-like bulbs are called—in a field in northern Greece on the long walk home, but a story is always so much more dramatic if there is a death penalty involved. Hats and pilgrims or no hats and pilgrims, it would actually have been extraordinary if saffron corms had not arrived in Britain by the Middle Ages, so great was the interest in spices of all kinds.

It was a curious time for cooks: the more pepper with the entrées, the richer the hosts showed themselves to be. Most people did not have the money even to taste these spices—at that time they were very rare and very expensive (partly because they came mostly from remote islands in Southeast Asia and partly because Venetian merchants held the monopoly so could inflate the prices[16]), and yet chefs in the big houses were busy inventing recipes with a kind of frenzy for exotica. Cloves, nutmeg and cinnamon from the distant Indies were all thrown in in eye-watering quantities—if advertising campaigns had been invented by then we could imagine the slogans: "Taste the bounty . . . prepare partridges with pinches of paradise." And "safroun" was, in its various spelling incarnations, one of the most popular ingredients. In 1380 Chaucer wrote about the doughty knight Sir Thopas whose "heer, his berd was lyk saffroun"—his hair and beard were the color of saffron.

Apart from in recipes, the chief use of saffron in the medieval period was in manuscripts, as a cheap alternative to gold leaf. A poor medieval artist[17] wanting to imitate gold on his Bible manuscript would have put a few dozen threads into a little dish, covered it with

beaten egg-white or "glair," and al-
lowed it to infuse. I tried it once:
overnight it had congealed and be-
come the color of blood oranges. On
paper the paint was luminous: not so
much like gold but rather as if, with
the help of the saffron, the separated
egg-white had successfully reclaimed
its yolk. Saffron was rarely used on its

own—it was not thought to last very long and indeed six months
later my own home experiments have already lost some of their lu-
minescence—but from the Middle Ages artists have often mixed it
with other pigments to make bright shades of green. It has never
been very popular as a dye—although U.S. saffron consultant Ellen
Szita reports that in Sardinia the women used it to color their
aprons until the middle of the twentieth century—and its main use
today is in cooking: as a color, and an intoxicating scent.

Perhaps saffron lost a little of its exotic cachet once it started
being grown in Britain, but it was still lucrative, and by the six-
teenth century Chipping Walden changed its name officially to
Saffron Walden. Perhaps this decision was a celebration of the fact
that Walden was now one of the richest towns in the county, thanks
to the yellow spice. Or perhaps it was a clever move by the town's
councillors to stake Walden's claim as the Capital of Saffron once
they saw how many of the surrounding villages had started copycat
cropping. They also changed the coat of arms to the official and
deliberately joky design of three crocuses surrounded by four walls
and a portcullis—Saffron Walled-In.[18]

But the town's fortunes waxed and waned, as those of saffron
towns tend to do. In 1540 demand plummeted as European wars
meant that the imported spice was cheaper. Then in 1571 there
was a crisis when farmers found they had overcropped and their
crocuses were limp shadows of what they should have been. Ob-
serving them, the Reverend William Harrison wished "to God"

that his countrymen "had been heretofore more careful of this commodity. Then would it no doubt have proved more beneficial to our island than cloth or wool."[19] In 1681 demand sank to new depths and a Thomas Baskerville noticed in despair how "saffron heads are now grown so cheap that you may now in these parts buy a bushel of them for 1 shilling and 6 pence."

There were good years too: 1556 saw a wonderful harvest when some of the "crokers" or saffron farmers were heard crowing that "God did shite saffron," and 1665 was a particularly good year for the burgers of Walden, with the price soaring to more than four pounds a pound (from just over two pounds a pound a few years before) when the story went round that saffron was an excellent remedy for the plague.

But sadly for saffron the wanings were ultimately more frequent than the waxings, until in 1720, when King George I made a formal visit to the nearby great house of Audley End, there was no home-grown saffron from the town to give him. I can imagine the private consternation as the family had to quietly send out for supplies to Bishop's Stortford a few kilometers away.[20] They would have tried to keep it secret, but how could they when everyone knew that Walden had grown no crocuses for years? The residents of the now falsely named saffron town were never allowed to forget the humiliation. But by 1790 there was no saffron being grown in Bishop's Stortford or anywhere else. *Crocus sativus* had almost completely disappeared from England.

## In which I find Jesus

Hoping that *Crocus sativus* had not almost completely disappeared from Spain, I ordered another coffee. The *barristo* had consulted with some local men, who were hidden in the early morning smoke farther down the bar. "Try Menbrillo down the road," they advised, and one of them drew a little diagram of what looked like a lollipop in my notebook. I followed his directions (looking out

carefully for saffron fields on the way), and when I had mastered the local circular system, Menbrillo turned out to be a village about four kilometers away. Twice I stopped and asked in my best Spanish for the *"campos de azafrán"* and was answered only by shaking heads and friendly shrugs. But then one old couple, both dressed in the dark clothes of rural Spain, started pointing and giving rapid directions. I must have looked blank because suddenly the man was sitting in the front seat, directing me into reverse. His name was Jesús Bellón, he told me, and I smiled to think that it would be Jesus who would lead me to saffron. We drove on bumpy unmade tracks into the countryside, and he told me—in a lovely mixture of languages, including German and French as well as rural Spanish—that he had spent his life as a professional harvester. In the old days he had gone anywhere there was work— Italy, Germany, the South of France—picking olives, melons and, later in the season, grapes for wine. "And sunbathing," he joked, doing a delightful mime of himself as a holidaymaker in a bikini. "In Saint Tropez."

We were still laughing when he indicated we had arrived. And there, glowing in the early sunshine, was my first field of *Crocus sativus*. The field was small and enclosed by fencing—reinforcing the sense that this was a valuable crop—and to my joy it was packed with the purple flowers I was looking for. We opened the gate and went in. I bent down and picked the crocus nearest to me, with Jesús pointing out the thin crimson stigmas that were the pure saffron.

The petals were an intoxicating color, fluttering on the edge of blue and purple. In the morning dew they glistened and shone, but what struck me most was their fragility. None of the books had mentioned this, and I had imagined something more robust. After a few seconds in my hand the bits I had touched were bruised—after being pressed in my Spanish pocket dictionary for more than a year the whole flower is now almost diaphanous. "It's like the wedding gown of a prostitute," a Spaniard once said, and I don't disagree.

There is something not quite innocent about this bright flower that flaunts its genitals—three red female stigmas and three yellow male stamens, exploding from the center—with such showy pride. But it wears its vulnerability on its sleeve as well: the stigmas have their own sad secret, although I wasn't to learn that until later. But also, saffron is so delicate. If it doesn't get the right tender loving care from both humans and the elements then it fades like those sixteenth-century flowers in Saffron Walden when the farmers stopped looking after them. I put one stigma in my mouth. It tasted bitter and was wetly crunchy like a single stem of fresh cress. From that point on, not only was I smitten by this extraordinary spice but also my tongue (I didn't realize until later) was totally yellow.

The field belonged to Vicente Morago Carrero and his wife, Teleforo. Their forebears on both sides had been growing crocuses for generations, and they had insisted on continuing the practice even though it had gradually become less lucrative. For harvest week they had enlisted their engineer sons José and Manuel, who were twenty-five and thirty, to help out at home. When we arrived, Vicente and the boys were bent double, nimbly filling straw baskets with flowers. They looked as if they had been doing this all their lives, and they probably had—it's normal to start helping out the family at around the age of eight. The straw baskets were pretty, but they were also necessary: saffron is a fussy flower. It doesn't like nylon or plastic.

The field was 80 meters long and 30 wide. Which is not impressive in terms of purple cloaks on the Spanish landscape, even though it is pretty when you are in it and very hard work when you are picking it. Jesús commented, making the sons and me blush, that they were both looking for a nice wife. I soon showed myself to be an unsuitable girl, however—just ten minutes of crocus plucking and my back was protesting.[21] Teleforo joined us, and I asked her whether she was going to the Saffron Festival at Consuegra, 40 kilometers away. "No time," she said, "we have so much to do here." The paradox of saffron farming is that everything has

to be done in a hurry (if you don't pick the flowers by noon you have missed their potency, and they bloom only once), and yet it is such a painstaking process that nothing can be rushed.

I gave Jesús a lift back to the village. He gallantly kissed me on both cheeks, as if this were a reward for his assistance. Then he wished me luck on my return journey. "Be careful. In Madrid they'll slit your throat for a few pesetas," he warned, with a shiver-inducing mime of banditry. "I'm worried about those boys," he continued in the same breath. Bandits? I asked, incredulously. "No, they are so old and not married yet," he said. "Actually the whole *pueblo* is worried."

That night I stayed in Consuegra. When I had asked at the Spanish consulate in Hong Kong about Consuegra the reply was "Where?," and when I got there I understood why. The town has only two claims to fame: a picturesque regiment of white wind-mills on the hills behind and the Rosa del Azafrán Festival every October. Consuegra is not a wealthy place, nor is it a pretentious one. In fact, as I looked around the door of a promising-looking bar in the main plaza and instead found Formica and video violence, I longed for just a little pretension. Half of the town is flat and full of garages and cheap furniture shops. The other half winds me-dievally up the hill toward the thirteen windmills, each of which has been given a name from Miguel Cervantes's seventeenth-century novel *Don Quixote*. In the book, the Don is a man who lives in the Renaissance but desperately wants to be a romantic medieval knight. Everyone, especially Cervantes, laughs at him for his desire to maintain the old ways of chivalry when times have so patently changed. The famous windmills incident, in which the Don attacks the mills thinking (or hoping) they are giants, is about holding onto old ideas, even when the evidence says you are wrong. And there are many people in Consuegra who fear that al-though saffron is a wonderfully historical thing which looks pretty on the landscape and nice on rice, keeping the harvest going in these days of modernization is simply a kind of tilting at windmills.

"Saffron is dead," said one man bitterly, while I was standing at my hotel bar. "I don't know why we have this festival."

By historical rights, the first Saffron Festival should have taken place more than a millennium ago, or perhaps even two. There are two theories about saffron's presence in La Mancha. One is that it was introduced by the Arabs in the eighth century. But then there is another story, which I like better, which suggests saffron has been in Consuegra since the time of the Romans. In the town's tiny museum there is a terracotta incense burner from Roman times. It is etched with full-moon fertility symbols, and apparently women used to burn saffron in it and then breathe it in to make them conceive boys. Saffron mythology is as fragile as the plant itself: there are other stories to the effect that drinking a big dose of saffron would lead to an abortion and that an even larger dose could kill.

The Saffron Festival is easier to date than the saffron. It was an invention by a tourist delegation from nearby Toledo in 1962, when they decided their hinterland needed more visitors. Nowadays several thousand people arrive in town for the last weekend in October to watch the competitions and processions and to fill the restaurants with smoke and laughter. This new festival gives families the excuse to get together once a year in the same way that the saffron harvest used to do in the old days. It also probably ensures that some families at least keep a field of crocuses going.

The next morning I met José Angel Ramón, an engineer in his early thirties. He was the first in his family not to grow crocuses. When he was a child his home would be full of visitors helping his mother pick out the red stigmas, and drying them on wood fires until the room was full of an earthy scent. "I remember lots of young women talking, and all the music. There would be parties until midnight." But that stopped about ten years ago. "It didn't make sense anymore." What had happened? "Economics," he said. Consuegra is a poor town, but it isn't poor enough. He introduced me to a group of international saffron exporters and we were

driven two kilometers outside town to a field owned by the Lozano family, Consuegra's biggest producers, with seven fields. Apart from the ugly financial sums, what is the biggest problem for saffron growers today? I asked Señor Lozano. "Mice," he said. They adore the sweet corms. And the cats can't catch them because the mice of Consuegra are faster than the felines. Which seemed comic until I learned that they have a far from funny death: farmers kill the mice by smoking them out with red chillies, the "natural way." It sounded like an unnatural way to go.

"The thing is," said one buyer from Switzerland, "La Mancha might be one of the centers of European production but Europe isn't where saffron is at right now." And where is it at? "It's all happening in Iran," he said, and then paused for effect. "In Iran the fields are as big as Holland." The rest of us were silent as we absorbed the concept. I looked over at the range of low-lying mountains to the west of Consuegra, shimmering mauve in the distance, and imagined the whole area, from my feet to those peaks, covered in a Persian carpet of flowers. It was a turning point. I had to get to Iran, I thought.

But for the moment I was in Consuegra, tilting at windmills, and down in the plaza an hour later the competitors were getting ready for the regional finals of the saffron stripping competition. How many pigments can a petal-plucker pluck if a petal plucker plucks in a competition? I went all the way from Hong Kong to central Spain to find out . . . and I still don't know. There were thirteen women and one man, all sitting along one side of a white table. In front of each of them was a bag with a hundred flower heads, and a plastic plate on which stones were laid out. I thought there was something significant about the arrangement, but someone pointed out gently that the wind was gusty and nobody wanted to chase the plates around the plaza. A little quiet was called for, and then at a signal they all started to pluck. They had to pick out only the red stigmas. Any stamens in the final bunch scored negative points.

I should have liked to have reported the tension, the cheering, the different villages rooting for their own neighbors in raucous Spanish style, the excited megaphone commentary about how the man from Tembleque was pulling himself up from last position (which, to be fair, he was never in). Or about how the Consuegra champion had been training for months by plucking burrs out of cotton wool or pine needles out of honey. But I can't. This is not an event with great potential for TV rights. Everything happened in near-total silence except for the racking cough of a grandmother to my right and the screams of a bored infant to my left. It was all very calm and, for a competition, almost disturbingly laid-back. The fingers were not exactly flying, more like scurrying or fumbling. But what the exercise made clear was why saffron is so expensive. Every thread you use has required somebody's concentrated attention. Each has been touched by a person, not by a machine. There have been attempts to mechanize this bit of the saffron process but it doesn't work: crocuses are too fragile and the tug at the center of each flower is just a little too hard to calibrate.

On one side of the table were the unwanted flowers: beautiful but rubbish. People have tried to find uses for them through the centuries, but crocus petals don't seem to contain enough of anything useful, and they are simply thrown away. In Saffron Walden they were at one time a real liability. In 1575 a royal decree prohibited crokers—saffron farmers—from "throwing of saffron flowers and other rubbish into the river in time of flood." The punishment was two days and nights in the stocks.

The fingers of the Consuegra competitors picked until there was nothing more to pick. The winner was Gabina García from Los Yebenes, closely followed by María Carmen Romero from Madridejos. They looked pleased, but not triumphant. It wasn't that kind of competition. I have a silly watch—it has a blue digital dial and can only be read if you press a big button. Children love it. But at critical unforeseeable moments, like open-air saffron plucking competitions, it is a liability, as its numbers do not show up in bright sunlight.

So I approached the organizers, asking for official times. But the man just shrugged. He said, simply, "The first is first," and explained how nobody bothered with stopwatches. So for the record, the Spanish October 2000 best time is one hundred sets of stigmas in about eight minutes. Or maybe ten minutes. Approximately.

## PERSIAN YELLOW

In the twelve months following my visit to Consuegra I travelled the world looking for color stories, and by October I should have finished my research. But I could not stop thinking about fields of purple stretching to a Persian horizon, and ignoring my looming deadline I applied for an Iranian visa again. However, it was the same week as the terrorist attack on the World Trade Center in New York, and Tehran turned down an entire batch of applications from Britain. Mine was in it. I tried again two weeks later, and got my visa. Then the Americans and British started bombing Afghanistan, and the northwest of Iran was suddenly off the list of recommended holiday destinations.

I began to hear wildly conflicting rumors. Some people said that Iran's saffron center of Mashhad was safe; others that it was closed to foreigners because it was so close to the Afghan border. The British Foreign Office had issued a travel warning and even the United Nations had stopped its staff going into some parts of the province. I wasn't sure what to do, so I contacted a saffron exporter in Mashhad. There's a problem, he replied immediately. Briefly I imagined refugee tents covering the fields of flowers, or armed Iranian militia keeping out saffron searchers, especially those with cameras and questions. Can't you come a week later? he continued. The harvest is late this year. I could not delay, and sent a reply saying I hoped there might be at least a couple of crocuses poking their noses out of the sandy soil. "The fields are full of flowers," he confirmed quickly. "But in a fortnight they will be even more wonderful."

Three days later I had not only arrived in Iran, but was on an overnight train travelling the thousand kilometers from Tehran to Mashhad. The set dinner was a promise of saffron things to come: boneless chicken kebabs nesting in a bowl of deeply yellow buttery rice. Of course it was saffron, one of my travel companions confirmed. "When an Iranian goes on a journey it is traditional to give them saffron rice. It's like saying: 'We give you our best; go with our blessing.'"

Before we went to sleep I walked the length of the train, looking for signs that my fellow travellers were on pilgrimage. Mashhad is the holiest city in Iran. It is where Emam Reza, whom the Shiite Muslims believe to have been the eighth leader of the Islamic faith, was murdered with poisoned pomegranate juice. Just as Muslims can call themselves "haji" after visiting Mecca, so they can call themselves "mashti" after praying at the Holy Shrine in Mashhad. I didn't necessarily find pilgrims, though certainly most women were wearing the full chador, next to which my own little black scarf and coat combination looked positively decadent. But what I did find was Persian classical music in the dining carriage. "Are you Mussulman?" whispered the man next to me. "On *ziyarah*?" I knew that meant pilgrimage, so grinned and whispered that I wasn't. "And you? On *ziyarah*?" I asked him politely in return. But my Persian accent must have been bad, because he promptly offered me a cigarette. Other people in the carriage tutted and told us crossly that we couldn't smoke in there. My protests that I had meant to say "pilgrimage" were in vain.

## THE LAUGHING SPICE

Before I ever saw a saffron field in Iran, or got close to finding the answer to my questions—about whether they were purple mantles and whether they were as big as Holland—I was given two contrasting images to play with. The first was from a film director, and was—in the metaphor of Don Quixote—the medieval image.

The second was from a businessman, and it was the full, modern story. I am still not sure which was more intriguing.

In 1992 Ebrahim Mukhtari made a documentary called *Saffron*, about a month in the life of the villagers of Bajestan, 500 kilometers south of Mashhad. What had touched him most about saffron, he said—when I met him in Tehran—was the fragility of the process: the delicacy of placing the corms into that rugged land, the way they open for one day only, and the brittleness of the little dried threads. Ebrahim had not realized it then, but when he filmed in Bajestan he was capturing one of the last old-style harvests. "That is the village I was in," he said suddenly, pointing to a framed picture on the wall behind me. I had thought, without looking carefully, that it was a Victorian orientalist painting in the style of someone like Lawrence Alma-Tadema: a romantic scene of women weaving in a courtyard, framed by the laden branches of a pomegranate tree. It was actually a framed photograph. That idyllic scene was a real one, and the villagers in the picture were still alive and probably weaving.

My second foretaste of Iranian saffron came from a man who could be called the Sultan of Saffron. Ali Shariati is the general manager of Novin Saffron, the biggest saffron company in the world. It sells 25 tons a year, more than five times the total production of Spain. To get to his office we walked past a truck full of white sacks. A man stood on top of the pile, throwing down the bales to his companions, who would pass them through a doorway. There was a wonderful bounce to the process: those sacks were light. The truck carried about 50 kilos: the dried stigmas of eight million crocuses, each of which had been picked by hand that morning. And this was a small haul: we were still early in the harvest.

It was about seven times that amount which caused a short war in Switzerland six centuries ago. The nobles were trying to assert ancient claims to take land and power from the commoners, and one day in 1374 the businesspeople of Basle decided they were having none of it. They sent saboteurs to the hunts, and put a guer-

rilla force in the woods to attack the nobles. The aristocrats retaliated by hijacking the merchants' most valuable trade item: 800 pounds of saffron, freshly arrived from Greece.[22] The Saffron War lasted for more than three months, with the spice held hostage in a castle; I like to imagine the mythical Chipping Walden pilgrim walking past the rumpus one day on his way home and casually doffing his hat.

As I waited, the assistant manager, Ana Alimardani, played "Mellow Yellow" on her computer, with the singer Donovan crooning that he was "just mad about saffron." It was hard to stop humming it. What had I expected? I had read the legends of Darius's men wearing saffron uniforms to fight Alexander the Great, and I had also known about how once a year Zoroastrian priests in Persia used to write special prayers with saffron ink on papyrus, and then nail them onto houses and near farms to ward off pests, and bad spirits.[23] So after finding both the picturesque and the rural in Spain I had expected the same in Iran, but more so. But that is the extraordinary thing: in Spain the saffron harvest has died out because it is traditional. In Iran it has revived because it is modern. In the past ten years Iran's production has soared from 30 tons a year to 170. Spain's has gone from 40 to 5.

We were served saffron tea. It was like drinking liquid rubies: sweet, pure and a very deep red, and yet at the top it had a thin oily layer of gold. "Be careful," I was told jokingly as the drinks arrived, "or you will laugh too much." There is a wonderful warning by Culpepper, in his 1649 Complete Herbal, to the effect that someone consuming too much saffron might die of immoderate laughter, and indeed this herb is something of a natural Prozac. In 1728 the Twickenham gardener Batty Langley published the New Principles of Gardening, in which—as well as strict instructions as to the correct way to plant the corms three inches deep and three inches apart—he lists the benefits. "Too much Saffron being taken prevents Sleep, but when taken with Moderation, tis good for the Head, revives the Spirits, expels Drowsiness and makes the Heart

merry," he claimed. Seventeen centuries before, Pliny had even suggested hair of the crocus as a remedy for when the heart has been too merry. Mix it in wine, he said, and it is a wonderful hangover cure. I put my little finger into the dregs of my glass and drew wiggly lines on my notebook. A few months later they are still deep sun yellow, although if I had left them in the light they would certainly have faded.

When Ali Shariati arrived, I felt the need for a calculator, there was such a multitude of zeros in his statistics. But here are some of the best big numbers: 170,000 flowers make one kilo of saffron, which means that Iran's annual production involves (and we both started scribbling quickly on pieces of paper) twenty-eight billion flowers. How can one imagine twenty-eight billion flowers except in the context that if they were laid petal to petal they would wrap the earth twenty times, or that linked in a chain they would reach to the moon and back with even a little bit to spare at the end? Or that in Iran at harvest time, half a million people are involved with picking them? The best big numbers for the Shariatis are that each of those kilos can be sold for around U.S.$700. But here is where a great saffron myth lies: by the kilo it is indeed the most expensive spice in the world, and yet it is not expensive to use. Saffron is so potent that in recipes it is measured in pinches, not grams. A gram should last most cooks several months and many paellas.

However, the other great saffron myth is not so easily debunked: I had my own anecdote of being ripped off in Kashmir, and it seems that stories like this are as old as saffron itself. The Reverend William Harrison, back in the sixteenth century, observed that un-scrupulous dealers would add butter to the saffron to increase the weight (although, he said, you can test it by holding the stigmas by the fire and assessing how greasy they feel). In Iran the problem is that some merchants add artificial red dye—which effectively means the useless yellow stamens can be lumped in easily with the stigmas. "Yes, it's a problem," agreed Ali. "But I want to show you

something." And he took me downstairs to a laboratory, where every new batch was being given a thin-layer chromatography test. A chemist dropped a splotch of saffron dye onto metal paper, and allowed a solvent to run through it. Pure saffron leaves yellow marks like cigarette burns on the paper; additives tend to come up in an adventurous range of pinks and oranges.

I looked through the sample sheet. Now that suppliers know they will probably be caught, fewer than one in a hundred samples turn out to be adulterated. But batch A7 6125 had come in a couple of days before, and had tested bright pink. There was a tick beside it, which meant the supplier would be in trouble. I had asked the chemist earlier what the hardest part of her job was and she had laughingly said it was "quite easy, in fact." But now she reminded me of that question. "This is the hardest part," she said. "The chance of getting it wrong." If she makes a mistake and wrongly identifies a batch as adulterated, then she could harm someone's livelihood. The damage is, of course, limited—the worst thing is that the merchants will lose their biggest client. In saffron's rather murky past the punishments for faking have been more severe: for example, a man called Jobst Finderlers was once burned in Nuremberg on a bonfire of his own fake saffron.

In another part of the warehouse was a long room, with thirty women working quietly at a table, separating stigmas from stamens. This was the second sorting and perhaps partly explained why my jar of Iranian saffron is purer and redder than the Spanish—more hands have touched it to make sure it is pure. Saffron is a big seller in the Arab states. "They eat it for strength, particularly during Ramadan," Ali said. The traditional month of fasting between sunrise and sunset demands some serious high-energy eating at nightfall. "Sometimes they put ten or even twenty grams of saffron in a big samovar, and add sugar and hot water. I can't drink it and they laugh at me and say I am the King of Saffron and yet I'm not even strong enough to drink it." Actually, he continued,

# COLOR

"Arabs say that saffron is good for . . ." and he paused a little awkwardly. "Sex?" I asked, forgetting to be Islamically demure. "Er, yes," he said.

The theory that saffron is an aphrodisiac dates from thousands of years ago: the hetaerae courtesans of ancient Greece used to strew it around their bedchambers; Cleopatra apparently used to bathe in saffron before inviting a man to her divan, believing that it would stimulate the appropriate bits. History does not relate what the men thought of the color of her skin afterward, but it does relate the recipe, which is approximately 10 grams of saffron per warm love-bath. During a particularly orgiastic Roman feast, satirized by Nero's entertainment director Gaius Petronius in his outrageous book *Satyrikon*, the guests had scarcely stopped laughing at the rude table decorations when the dessert arrived, and to their snorts of suggestive delight, "all the cakes and all the fruits, when touched ever so slightly, began to squirt out saffron." But this most sexy of spices, made with a flower's reproductive organs, and smelling of a Greek prostitute's boudoir, has a curious secret. It is sterile. Those red spikes make all the boasts but they don't actually work. The saffron crocus has to be planted by hand from corms.

## PURPLE MANTLES

Ali's fields were not yet ready, but there were plenty of flowers at a town called Torbat, 150 kilometers south of Mashhad, he said. So with the help of a young chemistry graduate called Mohammed-Reza, I arranged to go there the next morning. And as we drove through a desert scattered with jagged hills, I wondered what I would see. Would it be Ebrahim's vision or would it be Ali's? Ancient or modern? It turned out, of course, that it was both.

We got to Torbat soon after six o'clock and turned off the market street into an area with high cream-colored walls and closed doors. We stopped at one and a young man opened it—he was expecting us—and behind him stood his wife, with her head cov-

ered. Mohammed-Reza might be one of her husband's oldest friends but he wasn't family, and family was strict. Mahsoud and his wife Nazanin were first cousins, Nazanin explained in excellent English as we breakfasted on flat bread and cheese and halva. They had been promised to each other early, and had inherited farmland from Mahsoud's late father: it was a way of two strands of the saffron family being joined together. We piled into Mahsoud's Peugeot and headed out into the countryside. It was dotted with high-walled enclosures that looked like cemeteries, but which Mahsoud assured me were saffron fields. His own crop would not be ready for another week, but instead he would take me to the field of a local farmer, Gholam Reza Eteghardi. Would it be a mantle, I kept wondering, or a handkerchief?

It was—in my purple square accessory reckoning—a small paper tissue. But what was wonderful was how many other purple tissues it was surrounded by. These fields were smaller than those in Spain: perhaps 25 meters by 10. But there were hundreds of them, stretching out to the distance, the mauve flatness of the scene broken up by almond trees—the farmers' other crop. If it was a mantle, it was a patchwork one. But with Mahsoud's help I did some calculations. All the Iranian crocus fields, if laid out together, are not as big as Holland, but they must be about the same size as Amsterdam, and I was not disappointed.

We drank tea and ate pomegranates, and I talked to some of the crocus pickers. Mehri Niknam was thirty. She had been a hired laborer for just five or six years, but she knew the business well. It was important in her village and she'd been picking crocuses for the neighbors since she was a child. She used saffron in the kitchen, "like everyone else—for making *shalazar*." This is one of Iran's truly democratic dishes—a rice pudding made with sugar, rose water, almonds and, of course, saffron. It is made in every kitchen in the country, whether the family is rich or poor.

I looked around: I had waited so long to be there. There were the purple fields and the women in scarves that I had imagined,

but there also was Mahsoud, standing up in the field hunched over his mobile phone. The Spaniards had that mixture of modernity and tradition too, of course, but for me, oddly, the difference between the two approaches was encapsulated in the way that they dealt with mice. Do you use chillies? I asked, remembering what I had heard in Spain, and drawing a little picture in my notebook just for clarification. "Oh no," Mahsoud said. "We stop up the hole of the mouse and then fill it with motorcycle smoke. It is very efficient."

We sped back to Mashhad that afternoon through the low mountains, past villages that were the same uniform beige as the surrounding desert. And there, at a place on the road where we could not safely stop, I saw just for a few seconds the actuality of my romantic vision of ancient Persian saffron. Three women were crouching in a violet field; behind them, in a timeless scene, were two boys racing gray donkeys toward a mud-brick village as the sun disappeared behind hills. The flowers they were picking would not give the best spice—it was late in the day—but they could not afford to waste their precious cash crop by waiting until the following dawn.

# 7

# Green

*"Carving the light from the moon to dye the mountain stream."*

XU YIN, Five Dynasties poet, talking about *mi se*

*"It's not easy bein' green."*

KERMIT, *Sesame Street* frog puppet, singing about identity

There was once in China a secret color. It was so secret that it was said only royalty could own it. It was found on a very special kind of porcelain,[1] which was called *mi se*, pronounced "mee-ser," and meaning "mysterious color." During the ninth and tenth centuries when it was made, and for hundreds of years afterward, people would wonder what it looked like, and why it was such a secret. They knew it was a shade of green but more than that they could only speculate.

Sometimes, over the centuries, robbers—or foreign archaeologists—would raid graves, and a few weeks later greenish bowls would appear in the world's antiques shops with the confident claim that this was true *mi se*. And then sometimes other, slightly more responsible, archaeologists would excavate different tombs, and a few years later other green bowls would appear in the display cabinets of the world's art museums, with the cautious speculation that this *might* be true *mi se*. But it was not until 1987, when a secret chamber of treasures was discovered in the ruins of a collapsed tower, together with a

full inventory carved in stone, that scholars knew for sure they had found some genuine examples of this legendary porcelain. On the day that the emperor had donated them eleven centuries earlier they had been locked away. And they had been hidden ever since.

When I first heard about this secret porcelain, I tried to imagine what it was like. At first I wanted it to be the misty color of the sea at dawn. I had wanted "mysterious" to denote something filmy and soul-like, suggesting something that was just out of sight, rather like the half-visible designs of dragons you sometimes find carved into some of the non-mysterious kinds of green Chinese porcelain. And then later, when I read that it was a darker color than normal, I fondly imagined this special porcelain to be like bright jadeite, with the luster of emeralds. But then I saw a rather smudgy picture of *mi se* in a museum art catalogue and I prepared myself to be disappointed. It looked dirty, olive brown, nothing special at all.

My idea for my journey shifted. It was not, I realized, simply going to be about seeing a national treasure in a display case and enjoying its direct appeal. Instead it was going to be about unravelling a different kind of mystery: the puzzle of why, despite seeming to be the most ordinary hue, this mysterious green had somehow captured the imagination of the most powerful and wealthy people in the Tang dynasty. And this search expanded into exploring other people's desire for green through the centuries, into learning more about celadon— the generic name given to all such Chinese gray-green porcelain[2]— and into finding other greens whose secrets had been lost.

Famen temple is a two-hour drive from Xi'an—the capital of China for more than a thousand years. In the eighth and ninth centuries, when it was at its peak, two million people lived in and around Chang' An (as—optimistically and in the end inaccurately—it was then called, meaning "Place of Everlasting Peace"), enjoying the prosperity of the Tang dynasty period. Every day from the walled city gates they could see the camel caravans setting out toward the west with silks, spices, ceramics, alcohol and other heady products of the Middle Kingdom. Famen was three or four

days along the road, a resting point for the camels and horses, and a praying point for those merchants who believed the blessings of the Buddha could help their expedition.

Once, this place was one of the most important Buddhist centers in China. Ever since the site was first built on at least eighteen hundred years ago, its location had proved ideal for catching big donations from superstitious traders as they set out on their long journey. And by the time of the Tang dynasty it had become a huge complex, with dozens of temples and hundreds of monks. But most importantly, it was said to contain one of the greatest treasures of Buddhism: a finger bone of the Buddha himself.

There was tremendous cachet in having a bit of the Buddha, not least because, according to records, his body was actually cremated. Quite how the abbots of Famen staked their claim to holding one of the few pieces of the Enlightened One that could have miraculously rolled out of the ashes is no longer clear, but by the seventh century the story was widely accepted. In total, eight Tang emperors went to see the relic: the seventh was the Emperor Yizong, who visited Famen in 873 and borrowed the finger to take it on a celebrity tour of the empire for a full year. It didn't save him from the Grim Reaper, though, and when his twelve-year-old son Xizong returned it in 874 his advisers and the senior monks of Famen were beginning to realize that its blessing might not save the regime either. So in an attempt to appease fate the young emperor donated one of the greatest treasure hauls ever given to a Chinese temple — which included some of that secret celadon.

I reached Famen in the mid-afternoon. Even its location sounded poetic: "south of the Qi mountains and north of the Wei river, in a mysterious land." And indeed, as we drove across the bridge over the Wei, we found ourselves in an area of curious caves cut into sandstone, with mountains behind. It seemed as if we had somehow crossed over a line and passed the first imaginary sentry post on the long journey to the west. "So fertile is the land in Zhonguan, that even bitter plants turn sweet once grown here," a Tang dynasty poet

had written. Perhaps he was speaking metaphorically, about either holiness or corruption, but in any case everywhere we looked there were sweet corns drying on three-meter-high racks, creating splotches of yellow all over the landscape.

What did I know about celadon? I knew that when I had first arrived in Hong Kong and seen it—in museums and antiques shops and people's homes—I hadn't really understood it at all. It had seemed to be about the colors I hadn't been attracted to: the non-colors, which can best be described conceptually or meteorologically, with words like misty, dreamy, ghostly, pale, foggy. But then I began to love them, to love their delicacy and to enjoy tracing the patterns—of dragons or phoenixes or lotuses—that some of the porcelain-makers incised into their underglaze, so you can just see them if you swivel them against a light. Some of the best celadons are deeply flawed. They have a deep spider's-web pattern, or "crackle," which to some Western tastes is rather strange—I hated it when I first saw it. But to Chinese people it looks tantalizingly like the fissures in jade, and they prize these dark lines on the pale green.

The best explanation I have heard about how crackle could be beautiful came from Rosemary Scott, the academic consultant to the Asian Art department at Christie's. She explained how the effect was carefully managed so that, paradoxically, the bowl became perfect by being slightly imperfect. "You can't get it too wrong; but you have to get it just wrong enough," she said. The technical explanation is that the body and glaze of the porcelain contract and expand at different rates in the kiln, creating a pressure on the outer surface. The poetic explanation is that it represents a state of exquisite elemental tension, with the earthen body being forced through the water-like glaze by the element of fire. There is a sense of life in these cracked pots, too, Ms. Scott said. "I was talking to a modern ceramicist who makes crackle glazes, and she said they keep cracking for some time after firing. You could be sitting quietly in the sitting room and suddenly there's a little 'ping.'"

I also knew that the word "celadon" did not originally relate to porcelain at all. There are two versions of where the word came

from and neither involves China. One is that it was named after Saladin, the nemesis of the Christian crusaders, who apparently once sent a big gift of forty pieces of onion-green-ware to Sultan Nureddin in 1117. But it seems odd that anyone should have named these pretty and frail export items after a tough Muslim fighter (unless of course it was mockery), and the more interesting theory is that celadon was named after the slightly dorky romantic hero of Honoré d'Urfé's best-selling novel *Astrée*.

The book came out in 1607, and later became a popular stage play. It featured shepherds and shepherdesses frolicking sexily around the pastures of the Auvergne, with the main man a peasant called Celadon who wore a pale green suit with swirling green ribbons. He plotted for hundreds of pages to win his beloved, and never quite got her: which is perhaps hardly surprising, given his embarrassing dress sense. However, the color, if not the ribbons, became instantly trendy, and suddenly all of Paris was dressed *à la celadon*. Delicate Chinese porcelain became tremendously fashionable in Europe later in the seventeenth century and, by coincidence, or perhaps not, some of it was this popular color.

Even through the pollution, I could see the rebuilt Famen pagoda from several kilometers away. In its time it must have been a wonder, a thirteen-story skyscraper dominating the landscape. What we were seeing was not the original Tang design. The pagoda that Yizong visited was only four stories high and made of wood. This brick one was first designed in the sixteenth century Ming dynasty, but fortunately for modern scholarship it did not last the millennia its architects probably intended. For years it was China's version of the Tower of Pisa—leaning more and more dramatically. Then, in a rainstorm in 1981, half of the tower slipped to the ground. The collapse killed no one but excited everyone. Because once the rubble was cleared, builders found a hidden door to a secret passageway, and the archaeologists were brought in from Xi'an to investigate.

When Yizong's son Xizong brought the finger home in 874, the

Tang dynasty, which had been going since 618, was beginning to look rocky. In terms of art, its early delicacy had turned to baroque decadence. In terms of politics, by the late ninth century the peasants were becoming angry at rampant corruption on the part of the eunuchs—who had had a stranglehold on many of the positions of power and influence in the Chinese court since the time of the first emperor in 221 B.C.—and heavy taxation by everyone who could get away with it. The Tang would fall fully in 907, leading to the anarchy of the Five Dynasties, but already in 874 everyone—except perhaps the eunuchs—saw that change was imminent. A violent uprising fourteen years earlier had already given the peasants confidence, and another rebellion was brewing in the east, which would be successful. When the finger bone was returned in a great incense-filled ceremony, it was done very publicly. "Men and women gathered, and the spectacle was one of unprecedented splendor," it was reported in contemporary annals. And then it was quietly wrapped up and, along with that valuable haul of offerings from the palace, sealed in the secret tunnel to hide it from the upstarts. The Tangs were good at tombs, and this place—in the depths of the foundations of the Famen pagoda—was particularly well concealed.

And yet how could it have been forgotten? Peasant memories are long—when the Terracotta Army was discovered a couple of hundred kilometers away in 1978 it emerged that the local people had known all along that the clay soldiers were there, guarding the hills from beneath the earth. And it seems impossible that in the sixteenth century, when the original wooden structure of Famen was pulled down and the brick pagoda built in its place, nobody even noticed the little stone door in the foundations. Especially when rumors of a treasure trove had been whispered round the temple for centuries. There must have been a deliberate cover-up on the part of the monastery heads, although I find it as great a mystery as mysterious-colored celadon that in those twelve hundred years no abbot of Famen even sneaked a look inside, to see what he had in his cellar.

In 1939 a team of builders sent in to shore up the foundations ac-

tually saw the secret door. But the Japanese army was massing on the borders of China, and the men made a pledge not to tell anyone. They kept their promise through the war, through the Chinese Revolution of 1949, and then through the Cultural Revolution in the 1960s and 1970s. It was not until the 1980s that China really felt ready to celebrate its history again. And it was then, conveniently, that the secret of Famen was rediscovered.

Today visitors can see the real chamber through an ugly aluminium-framed window, as well as a full-scale replica of it in the museum next door. The model tunnel has one side covered in glass, rather like a gerbil nest in a TV nature program. But it makes it easy to imagine what the archaeologists would have seen as they first removed the thick metal padlock and pushed open the heavy blackened stone doors, one day in April 1987.

The first things to greet the team—led by Professor Han Wei of the Shaanxi Archaeological Research Institute—were two wonderful guardian lions, with green fingernails and red cartoon-animal spots. At first, looking into the gloom, the archaeologists would almost certainly have been disappointed: apart from the lions the chamber was plain. No treasures, just some black Tang dynasty tiling. Had someone been there before them? they would have wondered. Was there nothing left for them to discover?

But then they would have seen a doorway at the end, with a fierce Door God carved in bas-relief protecting it. And after carefully working out the locking mechanism and shining their torches through into the second chamber, they must have gasped. In front of them a dusty sea of red and orange brocaded silks flowed toward a small stone stupa. Behind it was another chamber, and behind that was a hidden cupboard. Everywhere in this Aladdin's cave there were boxes and bags, from which filigree gold, blue Persian glass and my modest green bowls poured out lustily.

And most importantly for historians there were two black stone steles, on which the entire inventory was carved. If they had not found these stones, then they would never have agreed that this was

*mi se*. Up until that very moment, scholars had believed *mi se* was basically Tang exportware-with-attitude. After all, in terms of how it is made and what it is made of, it is pretty much like any other prized celadonware. But by the end of the Tang dynasty *mi se* came with such a wonderful marketing campaign—"Secret green-ware only fit for a king"—that it sold for high prices. This inventory at Famen put back the beginnings of *mi se* by at least thirty years. And it caused people to reassess exactly what it was used for, as well as what it looked like. Perhaps it really *did* start off as being meant only for emperors.

To call the chambers beneath Famen pagoda an "underground palace," as they are described in the local literature, is a grandiose claim. This is actually just a small tunnel, 21 meters long, accessed by doors less than a meter high. An adult would have to stoop to get in there, although in fact, when the archaeologists realized what they had found, some of them would probably have wanted to kneel. If not for Buddhist reasons then for the secular reason that they were present at one of the greatest Chinese archaeological discoveries of the late twentieth century. Second only perhaps to those terracotta warriors.

But there was a complication, which I will call the Mystery of the Three Extra Fingers, and I include it because—with its emphasis on mystery—it ultimately helped me understand what the "secret green" story was about. In 845—twenty-nine years before the treasure was hidden—Yizong's first cousin, Emperor Wuzong, had ordered a persecution of Buddhists. The Famen abbot had realized he had to take steps to save the finger relic from this rampaging Daoist ruler. So he created three decoys and ordered fine containers to be created for them. The craftsmen made him exquisite Chinese boxes, which, like Russian dolls, opened up to reveal ever-smaller boxes inside.

When the chamber was closed three decades later, it was decided that all the "relics" and not just the real one should be included, as an additional precaution. Looking at these three fake fingers today, it is clear the abbot may have been acting in haste

when he chose them. Two of them don't look very human, and one is as thick as a pig's knuckle. The most convincing decoy was placed in the very last chamber in the most elaborate eight-box combination, while the "real" one was in a five-box set in the third chamber, trying to appear less important.

In a small official pamphlet I found an unforgettable account of the discovery. "In order to verify whether it is the finger relics of sakyamuni [Buddha] or not, [Professor] Han licked it after having got the permission. What a wonderful lick!" In the same pamphlet the secret chinaware was singled out as exquisite, "especially for its gob, belly and bottom." With that additional information I simply had to find the porcelain and see it for myself. But where was it?

The way Famen is presented today to its millions of visitors has fascinating parallels with the cosmology of the Tang monks who hid away their treasures so efficiently by creating fakes and decoys and secret boxes, and enclosing them in four chambers. Today's Famen museum has, perhaps unintentionally, done something similar. The treasures are spread out over four separate halls, which are full of replicas mixed up with genuine objects. After each corner I turned I hoped to find my celadon, yet I was distracted by boxes and models of boxes, fake tea-ware, pretend gold, as well as by all the real treasures—bronze Buddhas and amber beasts, crystal pillows and a set of crimson silks embroidered with gold thread spun thinner than human hair.

By now it was past five; the temple would close soon and I had seen many wonders, but not the ones I was searching for. I reached what I thought was the last room, and still no secret celadon. I joked that it was living up to its name of "mysterious," but in truth I was getting worried. "There is another hall," said the attendant, and pointed to the far side of the courtyard, to a door I had not seen before. I showed my ticket and went in. There, on the other side of a room full of 121 precious gold and silver objects, were seven pieces of green pottery. A local documentary crew was filming one piece, a little bottle. The director had persuaded the security guards, in

their army-like khaki uniforms, to hold up a big red cloth behind it. They looked for all the world as if they were in a People's Revolution dance drama.

No time to see the gold, I thought, walking straight through. But I was promptly walked straight back again—by the director. "Please . . . look at the gold," he urged. So obediently, for the TV cameras, I reenacted a Western tourist's fascination for shiny things, admiring the gold alms bowls (which celadon bowls were in the process of replacing during the late Tang) and the earliest-known imperial tea set. And then, at last, I was allowed to return and see my pottery bowls.

They were brownish and plainish and—as I had feared—their beauty did not instantly strike me. In fact, with the exception of the pretty faceted bottle that the film-maker had concentrated on, they were not even particularly delicate. I suspected I might be there for some time, puzzling out the secret of their beauty. Part of me wanted to be looking at a different kind of secret-color porcelain, a later one, and perhaps even more tantalizing. In 960 A.D. the Songs ended the torment of the Five Dynasties and they stayed on Chinese thrones for more than three hundred years. They had abandoned *mi se* completely—the last time they even referred to it was in 1068 in the *Encyclopaedia of Song Institutions*—and one explanation is because they had found themselves an even more interesting porcelain to speculate about. It was called Chai-ware and was named after the tenth-century emperor Shizong (whose family name was Chai), who was an enlightened man, sharing his time between planning to reunite China and enjoying art. One day he summoned the respected master of a local kiln to the palace. "What can I make for you?" the potter asked. The emperor replied with a line of poetry: "When the storm has passed, the blue sky peeps through a break in the clouds."

The man went back to his oven in the mountains, and created something astonishing. Poets later described this porcelain as being "blue as the sky, bright as a mirror, thin as paper and as resonant as a

musical stone." It is a mesmerizing description. But in fact, and un-
fortunately, there are no known or even suspected examples of this
porcelain. Some scholars have even suggested that the mysterious
blue-ware was a gigantic hoax, perpetuated through the centuries by
earnest historians copying the details of it unquestioningly from each
other. But I wonder whether there might be a slightly different expla-
nation. After all, the very idea of this blue pottery is so breathtakingly
beautiful that it really should exist, even if it doesn't. It is almost as if,
by the simple act of describing it, writers can wish it into being.[3]

But the pieces in Famen were not blue, and they were probably
too thick to be as resonant as a musical stone. Several pieces were
even spotted with brown stains, and I remembered a conversation I
had with Rosemary Scott. When she first heard in the late 1980s
that *mi se* had been identified for certain, "we were all terribly ex-
cited: it's such a romantic story, and how often do you find a ninth-
century inventory with its objects?" But when she first saw some of
the pieces, she was a little disappointed. "I looked at them and they
still had the marks of the paper they had been wrapped in, little
traces all over, and I remember thinking why haven't they removed
it?" Then she realized that this was the finest paper available at the
time, and it may have cost more than the pots. "It was the equiva-
lent of enfolding them in silk," she said. One of the bowls I saw at
Famen still bore the blotchy depiction of a young woman with flow-
ers in her hair—a print that had rubbed off from the paper. Ms.
Scott's explanation for *mi se*'s popularity stemmed partly from the
Chinese tendency to mythologize art, in order to appreciate it bet-
ter. "The Chinese love the idea of secrecy, it makes things seem
more exciting," she said. She also pointed out that the word for se-
crecy in Chinese is ambiguous. As well as secret it can also mean
"reserved," or "held back" for the royal family.

The Famen *mi se* comes from the Shanglinhu kiln in the moun-
tains of Zhejiang province south of Shanghai, where both the clay
and the workmanship are considered particularly fine.[4] "In the chilly
autumn day, thousands of porcelain pieces as green as peaks appear

from the kilns," wrote Tang dynasty poet Lu Guimeng, in *mi se* lines
that so intrigued later scholars, and which perhaps gave a clue as to
what this celadon was about. The color comes from a small amount
of iron: the more iron the more green,[5] and this ware is particularly
iron heavy. Most celadons are made from a glaze with about 2 per-
cent iron; *mi se* has about 3 percent. Anything higher than 6 percent
is black, and was not appreciated until much later in Chinese history.

I remembered hearing a story about this green color from a Bud-
dhist monk in Ladakh in India, many years ago when I was a
teenager. Manlio Brusatin told a similar story in his wonderful
book, *The History of Colour*, although his ended differently, and
much more sadly, with madness. I prefer the monk's version, which
has always stayed with me as a parable of meditation.

We sat in the half-dark drinking salty tea, and he talked about how
a deity appeared to a boy in a dream. "I can tell you," the deity said,
"how to find everything you want in the world: riches, friends,
power. Even wisdom." "How can I do that?" asked the boy, eagerly.
It is easy, he was told. All you need to do is close your eyes and not
think about the color sea green. The boy confidently closed his eyes,
but his thoughts were full of waves and jade and the sky on a misty
morning. He tried to think of red, or of trumpets, or of the wind in
the trees, but the sea kept flowing into his mind like a tide. Over the
years, remembering his dream, he would often sit quietly and try not
to think of green. But he never quite succeeded. And then one day,
when he was an old man, he did it: he sat for a long time without
even a flicker of color in his thoughts. And he opened his eyes and
smiled—and when my monk friend got to this point, he opened his
own eyes and smiled. "He smiled," said the monk, "because he real-
ized he already had everything he wanted in the world."

The Famen museum was about to close, and the security guard
had packed away his red flag and was back at his post, making sure
nobody took photographs. It was a curious thought that—except
perhaps for Yizong, but probably not even him—this young man
and his colleagues had spent more time with the emperor's porce-

lain than anybody else ever had. He lived with these bowls and with this delicate ritual bottle. Perhaps he had the answer I was looking for. Did he like the *mi se* porcelain? I asked. "Me?" he asked in surprise. "Yes, you." He smiled, a little self-consciously. "In the beginning I didn't," he said. "In the Chinese tradition everyone likes gold and silver. So naturally I liked that stuff over there much better, and thought this was nothing." And he pointed to the other side of the room, full of the exquisite precious metalwork that twenty minutes earlier I had admired on demand for the cameras.

"But then," continued the young guard, whose name was Bai Chongjui, "after about six months I began to realize that perhaps I was wrong. I began to think this *mi se* was even more valuable than the gold and silver." What did he mean? "I mean that the gold is so common. And that this celadon is so simple, it's about nature and harmony." Bai was twenty, he had worked in that room for two years, and I am sure he was right. When I looked again at the brown-green porcelain, sitting mysteriously in its display cabinets, I could for the first time properly understand its appeal.

Imagine you are an emperor, dusted with gold, surrounded by silks, held high on palanquins, fed the most exquisite foods with jade chopsticks. Everything precious. Would you not then yearn for something earthy and real? When you can have almost anything, it is human nature to want what you are in danger of losing. And in the case of the Tang elite that scarce commodity was simplicity. The rulers of the Tang would have been brought up on a wonderful combination of cosmologies. Buddhism would have taught ideas of change and fading as signs of the temporal and temporary nature of all existence. But this would have been fused as well with a little Daoist lore, where the green but hazy mountains symbolized the pureness of nature and the possibility of immortality. So this fading, autumnal green—hazy yet hinting at a return to nature—may have seemed like the very embodiment of simplicity and also of integrity. Its blandness, to a sated appetite, would have been like a sorbet to the glutted palette.

One of the miracles of celadon is that it all comes from the mountains—from their earth and their forests. The wood was used for firing, of course, and the clay was used for the body of the porcelain. But the two together—as wood ash and kaolin—were also used for the glaze that makes up its delicate skin and jade-like color. A few days after leaving Famen, I realized what the relic and its offering were about. The finger—of a man who taught about the impermanence of things—was a reminder of the nature of illusion. And the olive green of *mi se* was (rather as in the story I learned about the first Buddhist art during my quest for yellow) a reminder of the illusion of nature.

## THE SECRETS OF CELADON

There was "secret celadon" but there were also the secrets *of* celadon. Perhaps it was nothing more than an astonishingly successful early advertising campaign, or perhaps the market genuinely believed it; either way, celadon was for centuries thought to have secret, almost magical powers. In Southeast Asia, for example, the best Chinese jars were believed to be sorcerers—nature embodied in clay to the extent that it could be tempted out as a djinn. The best jars had to be able to "talk," or at least to give a clear ringing sound when struck, and if they gave a good tone then people would consider them to be the homes of gods. In Borneo a jar owned by the Sultan was supposed to have the power of prophecy, and to have "howled dolefully" on the night before his wife died. And on the island of Luzon in the Philippines, there were famous talking jars with their own names and characters. The most famous was called Magsawi and was believed to go off on long journeys on its own, particularly to see its girlfriend, a female talking jar on the island of Ilocos Norte. Legend had it that they had a baby together: a little talking jar, or perhaps at first a little screaming jar.[6]

The Central Asian buyers had quite a different reason for wanting these bowls, and wanting them badly. It was nothing to do with

djinns, but it was more pragmatically because celadon was believed to have the potential to save its owner's life. The shelves of the Top-kapi Palace in Istanbul are full of hundreds of pieces of celadon collected by the Turkish rulers ever since they took Constantinople in 1453. According to Islamic expert Michael Rogers,[7] the most likely explanation for this collecting mania is because the Muslims believed the bowls were "alexipharmic"—meaning that they acted as an antidote to poison. "Where the idea came from I do not know, but I am inclined to suspect that the Ottomans got the idea from Europe," he told me. He had heard of an experiment conducted by the Mughal emperor Jahangir in the early 1700s. According to his memoirs, Jahangir arranged for two condemned criminals to be fed poisoned food: one ate off celadon and one off another kind of dish. "And of course both died," Professor Rogers added.

Interestingly, the mysterious myth of poison detection lives on, but with completely different-colored porcelain. A few months later I was browsing through the eclectic Pitt-Rivers Museum in Oxford when I came across a jolly reddish-brown teapot. It was just like ones I had seen being sold in antiques shops in Kabul and Peshawar, and had wondered about, because they looked so out of place. No wonder: it turned out they were made by an Englishman, living in Moscow. Francis Gardner had moved to Russia in 1766 and, finding his pots were much sought after by the Russian nobility, he stayed to make his fortune. After 1850 Gardner-ware was exported in huge quantities, especially to Asia, where it is still highly prized. According to the label: It is widely believed in Central Asia that this porcelain protects the family, as any poisoned food placed in a Gardner bowl will instantly break it.

## THE POISONER RETURNS

Earlier that day in Oxford I had tried to find the oldest piece of porcelain recorded in the British Isles. It was owned by Archbishop Warham and was apparently held at his alma mater, New College. I

learned about it from a book[8] published in 1896, which had described the cup as the "sea green or celadon kind," and I was curious to see it. It was the college holidays, but I paid a small entrance fee, and wandered in. William Warham was Archbishop of Canterbury from 1504 to 1532. There is a portrait of him in the New College dining room—a sad-looking man with bags under his eyes. Behind him are rich fabrics that seem to have been brought from the East; but there is no sign of a sea-green cup. I asked the friendly guardian at the college gate—who had been a porter for sixteen years and now was semiretired, he told me—whether he knew of the cup, and he said he did not. I admitted that the book in which I had read about it was more than a hundred years old. "I don't think it matters," he said. "Once we have something in the college we don't let it go." He gave me the address of the archivist, and I wrote to her.

The porter had been right: they still had the Warham cup, she confirmed, and sent a photograph that had been taken recently for insurance purposes. It was exquisite: so marine green that it was almost the color of seaweed, although it was mounted in a rather elaborate late medieval gold support which made it seem slightly clumsy. The compiler of the original inventory that had recorded it in 1516 had no idea how to categorize it—he had never seen anything like it before—and eventually settled on describing it as "lapis," the Latin for stone.

As for Archbishop Warham, he was a leading British diplomat, negotiating such tricky matters as the marriage of Catherine of Aragon to Prince Arthur. With the Medicis in Italy and the Ottoman Empire rising on the ashes of the Byzantines, it was an alarming, exciting time for negotiators in Europe: indeed, it was the most corrupt, murderous time that Europe has probably ever seen. No wonder Warham looked worn out in his portrait. As a diplomat in those difficult times he would certainly have had a taster for official dinners, and it was plausible that someone, having heard the alexipharmic story, would one day have given the good clergyman a celadon cup out of gratitude for diplomatic services rendered.

The New College "legend" suggests that person may have been Archduke Ferdinand, who was supported by Warham after being shipwrecked off Dorset in 1506. If the Archduke believed the stories about celadon he may well have heard from farther east, then the modern equivalent of his gift would perhaps be an exquisitely tailored, almost invisible, bullet-proof vest.

Asian art objects had begun to arrive in Europe much earlier than Warham's cup—at least since the Crusaders began bringing them home in the Middle Ages, and perhaps even since the Vikings. But when the trade routes began to really open up in the early 1600s, the "Orient" soon became the rage among the drawing rooms of Paris, London and Moscow. It didn't seem to matter whether fabrics and objects and patterns came from India or Persia, China or Japan. The difference between Asian cultures was somewhat of a blur anyway and, on European-made chinoiserie wallpapers, it was common to see Islamic trees of life with Chinese birds perching colorfully in their branches.

Green was associated with Indian mysticism, Persian poems and Buddhist paintings, and became even more popular after the Romantic period began in the 1790s, with poets like William Wordsworth reflecting the general feeling that nature was suddenly something wondrous rather than dangerous, and that, in all ways, Green was Good. But in terms of paint at least, this sentiment was to prove fatally wrong.

Chatsworth House in Derbyshire contains a striking example of how popular the color was—in a suite named after a doomed celebrity royal who stayed there seven times while under house arrest. The "Mary Queen of Scots" rooms were last seriously decorated in the 1830s by the 6th Duke of Devonshire, remembered as "the bachelor Duke" and known not only for his foppish obsession with things being stylish but for his tireless energy in making them so. One of the leading architects of the day, Sir Jeffrey Wyattville, oversaw the redecoration, and the result showcased very late Regency

fashion. All but one of the seven rooms are green, which gives the sense of walking through an exotic forest: boudoirs in the wilderness. The most striking are the hand-painted Chinese wallpapers—green tendrils creeping up the walls with extra birds, flowers and even a special banana tree pasted on top. Wallpapers from China had first been pressed onto English walls in 1650: it is extraordinary that they were still sufficiently in vogue 180 years later to suit the tastes of the fussy bachelor duke—although his timing was impeccable. In 1712 Parliament had introduced a tax on wallpapers, intending to use the money for the War of the Spanish Succession. It was not repealed until 1836—just when the duke began redecorating.[9]

These were the Duke of Wellington's rooms when he stayed as a houseguest, and they contain a portrait of Wellington's arch-rival Napoleon, painted by Benjamin Haydon. We see Bonaparte from behind, his hands clasped behind his back in agitation as he gazes out to sea. No wonder he was upset: he had just lost an empire. His mood would not have been helped at all by the interior decoration in his own house on St. Helena in the remote Atlantic, where he died. It may not have killed him—quite—but the green wallpaper in Napoleon's bedroom at Longwood House certainly helped to drive him to his deathbed.

The rules of relics are perplexing. It is, for example, perfectly acceptable to lop off a digit from the Buddha's dead body, and even to pass what is claimed to be the Messiah's foreskin down generations of Church elders. Yet to consider doing anything like that with the mortal remains of those whom we have loved more closely would be seen in most of the world as barbaric: fingers and skulls of ancestors have to be kept with the rest of them. But there is one very acceptable relic that in the nineteenth century anyone could usually claim from the body of the deceased: a lock of hair, to keep in a little box and look at sometimes, wondering whether the person's charisma might be lingering in the keratin.

Within a few years of Napoleon Bonaparte's death in 1821 (at the age of fifty-one) locks labelled "Bonaparte's hair" (which his doctor

incidentally reported at the time of his death as "thin, fine and silky") commanded quite a price on the open market. But it was not until 140 years later that one of them caused a mild sensation. After being bought at auction in 1960 it was chemically analyzed. The new owners were looking for any clue to greatness, perhaps. But what they found instead was a clue to the fall of greatness. They found arsenic, and in substantial quantities. Which led to a spate of questions. Did the ex-emperor really die of cancer, as his doctors had declared, or did something more sinister happen during his six years of exile after he lost at Waterloo?

The diaries from St. Helena were consulted for clues. Napoleon hated the weather, and was constantly pointing out how many wet days there were. He also despised the new governor, Sir Hudson Lowe, posted there soon after he arrived. "The pity of it," wrote his biographer J. M. Thompson,[10] "was that one who knew only how to command should be the prisoner of one who knew only how to obey." Lowe knew this, and hated Napoleon in return. But did he hate him enough to kill him?

There was another possible answer to the arsenic question, and it was connected to paint. Carl Wilhelm Scheele was a chemist working in Sweden at the end of the eighteenth century. In the 1770s, when he was scarcely in his thirties, he isolated chlorine and oxygen, invented a bright yellow paint (which would be named Turner's Patent Yellow after the British manufacturer who stole the patent) and then—almost accidentally, while he was in the middle of experiments with arsenic in 1775—produced a most astonishing green. He was not going to repeat his mistake on the patent front, and very soon he was manufacturing this copper arsenite paint under the name of Scheele's Green. There was, however, something that troubled him, which he confided to a scientist friend in a letter in 1777, a year before the color went into production. He was worried about the paint, he wrote. He felt users should be warned of its poisonous nature. But what's a little arsenic when you've got a great new color to sell? Soon manufacturers were using

it in a range of paints and papers and for years people happily pasted poison onto the walls.

Perhaps, historians began to think, this might explain the mystery of St. Helena's poisoner. Then in 1980 a British chemistry professor signed off his science program on BBC Radio with a little teaser.[11] If only we could see the color of Napoleon's wallpaper we might know whether this was the cause of the poison, he said. And to Dr. David Jones's astonishment he received a letter from a woman who by astonishing coincidence had a sample of the wallpaper from Longwood. An ancestor who had visited the house had stealthily torn a strip off the wall of the room where Napoleon died, and stuck it in a scrapbook. Dr. Jones tested it, and to his excitement found traces of Scheele's arsenite in its pattern, which was of green and gold fleurs-de-lis on a white background. When he learned of how wet St. Helena was he became more excited: the mold reacting to the arsenic would have made the whole atmosphere poisonous. The Scheele's Green theory explained the arsenic, and the possibility of fumes in the air gave a clue as to why the formerly active soldier spent so many of his last months lying on one of his two camp beds (he never could decide between them) inside the house. But perhaps there was not enough green there to explain the final cause of Napoleon's death. His doctors said that it was cancer of the stomach. But others said it was simply sadness.

It took the medical world a long time to react to cases of wallpaper poisoning. As late as January 1880, more than a hundred years after Scheele invented his green, a researcher called Henry Carr stood in front of the assembled members of the Society of Arts in London and held up a sample of cute nursery wallpaper. It was printed with pictures of boys playing cricket on a village green. This innocent-looking paper, he told them,[12] had recently killed one of his young relatives, and had made three of the child's siblings seriously ill. He then went on to give other horrifying examples of arsenic poisoning—an invalid who went to the seaside for a cure, and ended up almost dying from the paint in her hotel; a team of deco-

rators who developed convulsions; even a Persian cat that became covered with pustules after being locked in a green room.

It wasn't just green which contained arsenic either, he told his audience. Some blues, yellows and especially the newly invented magenta also carried poison. As well as in paint and wallpaper, he had found arsenic on artificial flowers, on carpets and on dress fabrics, where it had been used to remove chemicals involved in the dyeing process. "The production of arsenic in this country is on a scale that will surprise most people," he told the Society. "When it is borne in mind that two to three grains will destroy the life of a healthy man, an output of 4,809 tons . . . in one year, does seem a large quantity to be dealt with."

Most of his listeners were shocked and agreed with his call for an investigation. But a statement from a Dr. Thudichum[13] gave everyone else in the hall that evening an insight into why, despite all the dangers, and even despite its inventor's warning, arsenic paint had continued to be used for a hundred years. Thudichum said Carr was being alarmist. He said his eyes rejoiced at the "beautiful bright arsenical paper," and when he looked at the "abominable grays, hideous browns and dreadful yellows made without arsenic," he could not help thinking that this would be the paper he should like to have in his room.

This love of green, so tastelessly expressed by Dr. Thudichum, was one shared by many artists—for, of course, green is in many ways the most "natural" color in the world. After all, most of the world (the bits that are not covered by sea, at least) is green. Yet for artists it has long been a difficult color to reproduce, and this most "organic" of colors—the color of grass and trees and fields—has in fact often been made traditionally from metal, or, to be more accurate, from the corrosion of metal.

Cennino had four suggestions in his *Handbook* for a lively spring-oniony green to reflect the bright Tuscan light. As well as recipes for mixing various yellows with various blues, he had one natural, one "half natural" and one manufactured green on his

palette, and they all—like Scheele's disastrous recipe—contained copper. They may not have been poisonous, but none of them was quite perfect either.

The natural earth color was called "terre-verte," and was particularly good for underpainting European flesh[14]—with lime white and vermilion layered over it.[15] The "half natural" green on Cennino's palette was malachite, a mineral found in copper mines along with its cousin blue azurite and called *verde azzurro* or blue-green. It seems strange to call this basic copper carbonate "half" natural: after all, it can be found fully formed in the earth if you know where to look. But Cennino lived in a world of alchemists' taxonomies, and to him malachite was an alchemical rock. It had been cooked by the explosions of the earth, and was therefore not in a strictly "natural" state. It had to be coarsely powdered, warned Cennino, "for if you were to grind it too much, it would come out a dingy and ashy color." Pliny thought it was wonderful—because it could protect against evil spirits—and even until the late eighteenth century in Germany it was called a *Schreckstein* or scary stone, and was used to frighten demons. The Ancient Egyptians were probably the first to use malachite as a pigment—on their paintings and also on their eyelids. It made a pretty pale green eye shadow (as long as it wasn't ground too much), but was also—along with black kohl—believed to protect the lids against the glare of the sun. Thus malachite provided the earliest "sunglasses" for a civilization so cool that its people would have just loved to have worn shades.

Eighth-century Chinese artists used to grind malachite—coarsely—for the haloes of their Buddhas, and from Japan through to Tibet it was a popular pigment for hundreds of years. The best paint comes from stone the "color of a frog's back," according to the Chinese authors of the seventeenth-century *Mustard Seed Garden Manual of Painting*, "and it should be ground and dissolved in water." Actually, in its uncut form, the malachite stone itself has something approaching the texture of a frog's back anyway—or perhaps a toad's.

It is full of warty excrescences that, when sliced into a cross-section, create the pretty circle patterns for which the stone is famous.[16]

Cennino's third green was verdigris, which was "very lovely to the eye but it does not last." Leonardo da Vinci was equally worried about it a century later, warning that it "vanishes into thin air if not varnished quickly." There was another problem with this paint. Verdigris was "very green by itself," Cennino noted, but on no account should it even touch white lead, "for they are mortal enemies in every respect." The paint was usually made, rather as white lead was made, by suspending metal — in this case copper — over a bath of vinegar. After a few hours the orange metal and red wine would combine to leave a green deposit. It was sometimes called van Eyck Green[17] because the Flemish master used it so often and so successfully — unlike the Italians,[18] whose verdigris tended to blacken as Leonardo and Cennino had warned. The Flemish artists found the secret of locking the green by using a preserving varnish, and it has therefore, for the most part, lasted the centuries.

*Recipe for curing gangrene using verdigris*

One of the most extraordinary examples of this is the bright green skirt in van Eyck's *The Arnolfini Marriage*, painted in 1434. It is one of the most debated skirts in art history — mainly because of its shape, or rather because of the shape of the young woman

inside it, who looks very pregnant (even though some critics have argued that she is not). But why is it green at all? Newlyweds wanting to parade their wealth in fifteenth-century Bruges would be more likely to boast their social position through their ample use of expensive kermes red. The painting, which hangs in the National Gallery in London, is one of the most controversial pieces of fifteenth-century art: few people can agree on what it means, or indeed whether it is even a marriage portrait.

It shows a couple standing inside a richly furnished room; they are holding hands but to me they do not look as if they are in love. In fact, quite the opposite: the man looks old and cold in his fur cloak and huge hat; the woman is looking away from him, and both of them seem to exude a deep sadness. For years the painting was believed to be a portrait of the marriage of a wealthy merchant called Giovanni Arnolfini and his young bride Giovanna. But why should they have commissioned such an unhappy picture? And why are they surrounded by objects that might be read as symbolizing corruption?

On a wooden chair there is a tiny carving of St. Margaret of Antioch, a virgin martyr, who became the patron saint of childbirth—reinforcing the suggestion that this lady is pregnant. The very large and very red bed in the room rather suggests the same. More disturbing, however, is the mirror. It is decorated with scenes from the Passion of Christ (a cycle of suffering), and it also has ten "teeth" around it, reminiscent of the ten-spiked wheel under which another virgin martyr, St. Catherine, was tortured to death. St. Catherine's story, like St. Margaret's, is one of brutality—and the room in van Eyck's painting is full of objects that could signal a brutal relationship. There is a gargoyle hovering above the couple's clasped hands, and a brush that looks like a parody of male and female private parts, hung up like a trophy. As I looked at it one day, I wondered whether this object may possibly have been intended to symbolize sexual abuse, and whether this painting might actually be an allegory rather than a wedding picture.[19]

The couple have always seemed to me to look like Adam and Eve (transposed to van Eyck's own time in terms of costume) just after the Fall, and that idea is reinforced by fruit tumbling over the windowsill. And if this *was* the artist's intention, it perhaps solves the mystery of the woman's ermine-lined dress. It is green—and therefore symbolic of fertility and gardens. And it is also made of verdigris, a manufactured substance that is born from the corruption of pure metal. Although today it is almost as bright as when van Eyck painted it, the artist cannot have known for sure that his new technique would last the centuries and be named after him as a result. For him verdigris would have been a seductive green paint that sometimes turned black: a perfect pigment, perhaps, to represent the fall of humanity.

Verdigris is often described as coming from somewhere else. So "verdigris" means "Greek Green" in English, while the Germans call it Spanish green, "Gruenspan," although it probably arrived in both places via the Arabs. The Greeks themselves describe it as "copper flowers," or more vividly "fur-tongue," perhaps because of how the verdigris deposit on the copper plate looks the way one's mouth feels after a heavy ouzo session. In France this paint was usually a byproduct of the vineyards; in England it was often made with apple cider vinegar.

Verdigris was popular with artists until the mid-eighteenth century, but it was also used enthusiastically by housepainters—and with the rise of orientalist decoration fantasies, those wealthy households in Europe that were lucky enough not to have access to Scheele's Green would have been likely to include at least one verdigris room. The chinoiserie fashion spread to America as well, and by the eighteenth century many grand rooms in the colony were festooned with Chinese wallpapers and daubed with Orient-inspired paints. Everyone who was anyone, it seemed, wanted green for their drawing rooms and dining rooms, and that included the first President of the new republic. Even, perhaps, at a time when he ought to have had more on his mind than how to redecorate his home.

# COLOR

The house at Mount Vernon in Virginia is very small for a President of the United States. In fact, in its "original state"—the term used to describe what it looked like when George Washington was enjoying his boyhood there—it was fairly small even for a farmer of the United States. Yet for nine years—between Washington's election as President in 1789 and John Adams taking up the post in 1797—it was one of the most important buildings in America.

When I visited, on a weekday in springtime, there were so many people trying to squash into it that the line snaked out of the house and along the garden as far as the slave quarters. We were entertained by people in eighteenth-century costume pretending to be friends of the Washingtons and filling us in on the family gossip. After an hour we were able to go into the house—through a side room, which led into the building via a covered walkway. This is not how visitors used to go into Mount Vernon in the old days; there is, in the center of the house, a hallway through which guests used to enter, "greeted by Mrs. Washington herself," our guide announced grandly. It was also a place where they used to do a quadrille or two after dinner to keep warm in the winter, he continued. We all looked rather doubtfully at the space. The hall is so small they would be hard pressed to fit in a single salsa couple today, and I imagined a party full of very little people in big skirts and hats joggling against each other gamely, exclaiming brightly about how there was plenty of space and wasn't it amusing.[20]

In the early 1770s, while the soldier-farmer was still living mostly at home, he spent hours poring over the eighteenth-century equivalent of *Architectural Digest* magazine. It was called *The City and Country Builder's and Workman's Treasury of Designs*, published by an opinionated English freemason called Batty Langley in 1756. (Batty is apparently a Christian name, not a description of this man's more preposterous ideas, although it could have been.) The heavy old volume is still in the Mount Vernon resource library. I read it there, as peacocks strutted outside the window, and I imagined Washington sitting in his white-walled study flicking

through its pages, then occasionally spinning round on his chair (he loved having a chair that spun) to look over at the Potomac River, while he daydreamed of having English house designs in his American home.[21] His interest in house design should not be underestimated. He was a freemason—one of the earliest in America—and he believed that architectural proportions were set by divine law. An elegant Palladian window, and the careful measurements of his new rooms, were not only about having somewhere nice to feed guests. Instead they were about symbolically constructing God's will, and being seen to do so.

But then in June 1775 he was called in to be commander-in-chief of the Continental army, fighting for independence against the British. He would see his home only once in the next eight years, and on that occasion it was from a distance, across the Potomac River. He left the estate in charge of his relative, Lund Washington—and there is an interesting series of letters between the two. There was the saga of the joiner who only managed to finish the rough carpentry in the dining room although he had been asked to complete all the finer work as well. And then there were the exploits of "the stucco man" employed to plaster and paint the ceiling of the little dining room, now apparently considered one of the finest examples of colonial decorative art today, but at the time the source of considerable consternation. How hard it was to find good workmen nowadays, Washington complained. Especially in wartime.

He was a disciplinarian in charge of an army of twenty thousand men, and he dealt firmly with subordinates who—as his successor John Adams once said—quarrelled "like cats and dogs." But in the middle of a battle, or in the days leading up to it at least, his letters reveal he was fussing over housepaints and timber.[22] At first I felt uncomfortable with this. Should he not have been doing more important things? But then I thought about how lonely and bored the man must have been. It is nice in a way to think of him sitting in his tent, nostalgic for home and imagining each step of the

improvements he could make to his boyhood home to make it fit for the statesman he had become.

Washington returned home on Christmas Eve 1783 to take control of the Campaign of the Large Dining Room. There were more disasters with workmen, but eventually in 1787 the room was ready to be painted. Plantation tradition encouraged the man of the house to decorate the public rooms, while women's taste was reflected only in the private rooms. Martha Washington preferred yellows and creams, although she was brave about woodwork— which was in greens and blues. But it was George who chose the pistachio color for the large dining room, to complement the gleaming white of his new Batty-inspired Palladian window.

He and his men had routed the English, but he saw no reason not to adopt English taste in his home. So it was neoclassical for the window, and chinoiserie for the walls. He found the bright green was "grateful to the eye" and less likely to fade. He would have been pleased, no doubt, to know that green was once the color that emperors had loved, although he would probably have shaken his head and said that America had left all that old stuff behind. There was a minor hiccup in September 1787, when he wrote to a relative to say that he was "sorry to find that the Green paint which was got to give the dining room another coat should have turned out so bad," but once that "verdegrease" had been replaced he was thrilled with the result. The views of the garden that the Palladian window was designed to show off looked spectacular against the green: like a double celebration of nature. Washington liked it so much that he immediately painted his small drawing room the same color—although perhaps he would have done well to research his paint better, because with lead white on the finishes it didn't take long for the verdigris to react chemically, and darken.

Two years later it was in the large dining room, surrounded by a Chinese-inspired green color and by his cheering family and compatriots, that Washington learned he was to be the first President of

the United States. And nearly two hundred years later it was the outrageously bright colors of this dining room after they had been restored with authentically hand-ground paints which prompted a radical reassessment of thinking about how people in America decorated their houses in the eighteenth century.[23]

## THE LOST GREENS

Europeans stopped using verdigris in the nineteenth century, but the Persians used it in their paintings until the beginning of the twentieth century. For Muslims, green is often a holy color—the color of the Prophet Muhammad's cloak—and often when miniature artists wanted to portray a particularly important man they would give him a verdigris halo. Court scenes in Persian miniatures symbolized power, and could be painted in any number of gem-like colors. But the sexier scenes were often set in green bowers. A garden was symbolic of love, and a wilderness represented an environment where normal rules didn't apply. So of course the greens were particularly popular, setting the scene for the mild erotica that the Persian miniaturists were so good at. The artists had their own special recipes for this color, at least one of which was lost until recently.

At first it had been a casual observation, although an intriguing one. One day, in her laboratory at the Art University in Tehran, conservator Mandana Barkeshli was struck by something curious in a series of sixteenth-century miniature paintings done by Mughal artists in India. She noticed the paper had burn marks wherever a certain shade of green appeared. Yet when the same pistachio shade had been used in Persian paintings there had been no corrosion. "I couldn't understand it," she said when I met her at the Islamic Museum in Kuala Lumpur. After all, the Mughal tradition had come directly from Persia just a few years earlier, in 1526, when Babur had conquered northern India, bringing Islamic art,

artillery and gardens into the predominantly Hindu subcontinent. So it would make sense if the artists from both places had used the same materials. And yet clearly they had not.

The research was to take three years. First Dr. Barkeshli studied the paper for clues but found nothing. Next she studied ancient texts and learned that verdigris—known as "zangar"—was made with a similar recipe to that used in Europe and China, although sometimes sheep-milk yogurt was used instead. One particularly *Arabian Nights*–like touch, described by Sadiqi Beg Afshar in his seventeenth-century text *Qanoon-al-sovar*, demanded the hanging of "broad swords made of thin copper" over a well, and leaving them for a month. She experimented with various alternatives (although not the sword bit) yet the answer, when she found it, came not from any formal painting treatise, but from a love poem.

In the sixteenth century, the poet Ali Seirafi had written a verse to his beloved, adding a word of advice to others who wanted to make their feelings permanent. "The smiling green pistachio that resembles your beautiful lips whispers tenderly," he wrote, in words that were probably intended as loving, although I wonder whether the lady would have found them so flattering. "Mix saffron with zangar," he continued more practically, "and move your pen with it gracefully." Disturbing lip imagery notwithstanding, for Dr. Barkeshli this was the clue she needed. "I was so happy I cried," she told me.[24]

A few months later, visiting the Lahore Museum in Pakistan—which was once under the directorship of Rudyard Kipling's father, and known by their family as the Wonder House—I saw some Mughal miniatures of hunting scenes. The green fields on which the horsemen and deer were prancing and dying were fringed with brown marks of corrosion. These artists had clearly not read their contemporary love literature carefully enough and had failed to include the crucial ingredient of saffron. Interestingly, Cennino had a very similar recipe. "Take a little verdigris and some saffron; that is, of the three parts let one be saffron," he advised readers, prom-

ising that: "It comes out the most perfect grass-green imaginable." But he did not seem to know that his yellow herb could also save his green from corroding the parchment, or if he knew, then he did not say.

In the Rijksmuseum in Amsterdam I saw a curious example of how an artist has consciously used the corrosive power of green. A color woodcut, printed in 1887 by the innovative Tagohara Kunichika, shows the actor Kukugoro V performing as a ghost. He rises with shocking pallor out of the bodies of two other theatrical characters, and his head is covered with green that has burned into the paper until it is brown and spoiled. The effect was apparently deliberate: the dangerous ectoplasm destroying even the paper on which its image is painted.

## A ONE-POT DYE

Celadon travelled from China to Europe, and knowledge of verdigris went originally from Persia to Europe. But probably one of the last times green color technology moved lucratively in that east-west direction was in 1845. That year an official team from France went to China to investigate the potential for new trading items. China had just lost Hong Kong Island to the British a couple of years before, and the French wanted to see whether they could find anything for themselves. They came back with objects, not territory. But among the porcelain and textiles and mineral samples was something less obviously valuable. Just a few pots of green mud. But for a while it seemed that they were going to prove to be the greatest treasure of all: these unpretentious pots promised to revolutionize European dyeing, in the same way that cochineal had revolutionized it three hundred years before. The mud was called Lo Kao, or Chinese Green, and it caused huge excitement because it was the first one-pot natural green dye.

If artists had problems with greens, then the situation for dyers was even worse. Green had never been an easy color for them, and

it tended to require them dipping the cloth into two vats—a blue one and a yellow one. Together with the problem of adding mordants and getting the right temperatures and concentrations, all this dipping meant that the chance of getting the same shade twice was fairly low. And when dyers did manage to achieve some kind of consistency it was highly prized. The legends of Robin Hood and his merry men, for example, describe them as wearing "Lincoln Green." I had always imagined it to be for camouflage, but the truth is they were wearing it to show off. The green cloth was the pride of Lincoln, made of woad (a blue plant) and weld (a yellow one). It was also called "gaudy green," and it was expensive. Wearing it was a way for the legendary bandit to laugh at his Nottingham rivals and show how he was stealing from the rich to clothe the poor.

We can see another example of the problems of greens in the experience of English designer William Morris. In the 1860s Morris decided to help revive medieval textile arts—and in order to give ordinary people the sense of living in a medieval castle, he created wallpapers that looked like antique tapestries. His papers were mostly blue, with a little red, just like the old tapestries Morris had admired. But if he was trying to be authentic, he had made a mistake. In the Middle Ages, dyers made their yellows from a plant called dyer's weld, and their greens were made by overdyeing the yellow with blue woad. But weld fades, and after seven hundred years of hanging on castle walls medieval tapestry forests tend to be misty blue where once they were gaudy green. We can only imagine what the original works looked like. But they were probably surprisingly similar to the bright textiles of the nineteenth century that Morris was so passionately deriding as garish.

So for dyers, the apparently fade-resistant Lo Kao was a double boon, and the French traders were sure it was going to make them a fortune. With this Chinese gunge it was now a childishly simple process to make a good green. The recipe went along the lines of: Put mud in pot. Boil. Add cloth to pot. Clean and dry. What was not

simple was the process that the suppliers in China had to go through to make the green mud in the first place. It was made from two Chinese varieties of buckthorn trees: *Rhamnus utilis* and *Rhamnus chlorophorus*, the former meaning useful, the latter meaning greenish. Buckthorn was already a familiar plant for European dyers. Common buckthorn, or *Rhamnus cathartica* ("cathartica" because of what it does to your bowels if you dare eat the yellow berries), had for thousands of years been stripped of its leaves to make yellow dyes and paints. Since the seventeenth century its berries had also been boiled (for the length of time described charmingly as a wallom or wallop, meaning a bubble or two[25]) with alum to make a watercolor paint. It was called "sap green," and was considered a bad pigment. Its image was further tarnished by its other name, "bladder green," which did not, as some may have suggested, describe its yellowy color but referred to the pig's bladders that artists stored it in to keep it moist.

Lo Kao was made neither from leaves nor berries but from bark—which the Europeans do not seem to have thought of. Perhaps this is not surprising: it was an astonishingly complex process. The bark would be boiled for several days and then a length of cloth would be thrown into the mixture. Several days later the cloth—now brown—would be removed from the bark broth in the evening, and left to dry through the sunshine of the next morning. When the clock struck midday the cloth was brought inside, and in those places where the sun had touched it, it would be green. The cloth was then boiled again until the green pigment soaked off into the pot. The sediment was collected, dried, exported and sold for extraordinarily high prices.[26]

But coal-tar dyes were waiting in the wings, as I would find in my search for violet, and Chinese Green was so expensive that it was one of the first dyes to be completely displaced by synthetics in the 1870s. Indigo and madder lasted a little while longer in the world's dye vats, but Lo Kao green vanished from them almost immediately. There was a rapid procession of new colors: iodine

green arrived in 1866, methyl green in 1874, and synthetic "malachite green" dye was discovered twice, apparently independently, in 1877 and 1878. They have all been displaced by better, cheaper dyes since, although people still use malachite green today (to get rid of mold on goldfish, although it has the rather unfortunate effect of leaving them as greenfish for a while).

The new synthetic green dyes headed straight from European laboratories toward Asia. For me their impact is summed up in a carpet I saw in Pakistan, woven in the 1880s or 1890s. Most of the carpet is dyed traditionally with madder and indigo, but in the center are three small diamonds, one a brash synthetic mauve, the other two bright emerald green. Today they look odd; they clash with the natural dyes. But when the carpet was made, probably in a nomad's tent on the steppes of Central Asia, those little bright squares were probably all the synthetically dyed wool the weaver could afford. They would have been a demonstration of the flash of modern colors that to her must have represented a wonderful future. Green color technology had headed from east to west for so long, celebrating nature. And now it was heading the other way—celebrating technology.

# 8

# Blue

*"Notre Dame de la Belle Verrière:*

*the only window, as far as I know, to which*

*in former times people knelt by hundreds in adoration,*

*and before which they still occasionally burn a candle."*

HUGH ARNOLD, *Stained Glass of the Middle Ages*

*I*n the National Gallery in London there is an unfinished panel by Michelangelo, showing Christ being carried to his tomb. It is curious on several counts. First, John the Evangelist—who is braced to take the weight of the Messiah—looks disturbingly like a woman. His hands and neck are muscular, but beneath his star-tlingly bright orange gown[1] he appears to have female breasts. Second, the dead Christ, far from weighing the painting down, appears to be floating a few millimeters above the ground sus-pended on straps of bondage linen. And third, although the rest of the work seems to be almost finished or at least drawn out in de-tail, the whole of the lower right corner is blank. It seems to have been reserved for a kneeling figure, but it has not even been started.

One afternoon I was staring at the painting—*The Entombment*, dated 1501—trying to make sense of it in the fading light. The colors were disconcerting: not just John's nearly fluorescent dress but Mary Magdalene's ugly olive robes. And although all the mourners were grouped around the dead man, only one—Joseph

of Arimathea—was actually looking at him. One woman was staring to the side in grief, but another was examining her fingernails, while John and Mary Magdalene seemed to be glaring at each other almost competitively. The composition seemed less about a team coming together than about individuals realizing they were once more alone.

Suddenly a crowd overtook me and an answer to some of my questions appeared during what turned out to be one of the National Gallery's short talks for visitors. The lecturer agreed that John's androgyny was perplexing, although I learned later that the oddly prominent nipples could be because the vermilion paint had blackened over time and created shadows where the artist wanted highlights.[2] On the floating corpse question, this was a painting of the raising of the sacrament—a subject that had become newly fashionable in Rome at the beginning of the sixteenth century. But most interesting for me, in this odd work, was the account of the kneeling figure.

It was probably intended to be the Virgin Mary. But the only blue paint that was deemed worthy for her holy robe in Renaissance Italy was ultramarine, the most expensive of colors except for gold. That corner was probably blank because the paint had not arrived from the patron—and the twenty-five-year-old artist could never have afforded to pay for it himself. He would have cursed for a while, and sent messengers to harry the sponsors and suppliers to make them speed up their delivery and allow him to finish this altarpiece,[3] thought to be destined for the Sant' Agostino in Rome. But then in the spring of 1501 Michelangelo left both Rome and that canvas to carve his David in Florence, and he never returned with his blue paint to finish the Virgin's robe.

## BEYOND THE SEAS

One day many years ago somebody told me that all the true ultramarine paint in the world came from one mine in the heart of

Asia. And that before it could be squeezed sparingly onto any European artist's palette (mixed with linseed oil or egg like an exotic blue mayonnaise) it had journeyed in rough sacks on the backs of donkeys along the world's ancient trade roads. I wasn't sure that I believed this outrageously romantic description, but after that I dreamed of a mountain with veins of blue, inhabited by men with wild eyes and black turbans, and when I woke up I knew that one day I would go there.

My search for this one particular blue was to lead me to other blues as well. I learned how, trying to imitate the beauty of ultramarine, artists and craftsmen experimented with paints made of copper and blood. And I learned how miners discovered cobalt, a strange and rather nasty interloper of a mineral, which the Chinese used for their most valuable porcelains and with which the medieval glaziers caused sky-colored lights to dance around cathedrals. It made me begin to ask about the color of the sky itself—a child's question, but one to which few adults know the answer, although we know we should. But those things came later: my first task was to go out and get the paint that Michelangelo was awaiting so eagerly during those months in early 1501.

Ultramarine is a word that has always seemed to me to taste of the ocean. It has a smooth, salty sound, suggesting a bluer blue than even the Mediterranean can reflect on a sunny morning. But medieval Italians had no intention of summoning specific sea-color images when they gave this marine name to their most treasured paint. *Oltramarino* was a technical term meaning "from beyond the seas," and was to refer to several imported items, not just paint. And this particular *oltramarino* certainly came from way beyond the seas: the paint is made of the semi-precious stone lapis lazuli. It is found only in Chile, Zambia, a few small mines in Siberia, and—most importantly—in Afghanistan.

With the exception of a few Russian icons which may have been painted with blue from Siberia, all the real ultramarine in both Western and Eastern art came from the last of these places—from

one set of mines in a valley in north-east Afghanistan, collectively called Sar-e-sang, the Place of the Stone. It was where the Buddha's topknots came from; it was where the monk painters of illuminated manuscripts found their skies; it was where the robe of Michelangelo's Mother of God would have come from if he had waited long enough. And it was where I was determined to go.

On my first look at the map, however, it didn't seem so easy. Actually, when I first consulted a *Times Atlas*, I couldn't find Sar-e-Sang at all. The village was so small, squashed between the small town of Faisabad to the north and the even smaller town of Eskazir to the south, that it wasn't even marked. Which was as it should be: hard to find. After all, part of the mystery of lapis was that although for millennia it travelled to Europe and Egypt it was always known to come from a mythical land so far away that no European or Egyptian had actually been there. Even Alexander had not managed to cast his greatly acquisitive eyes on the mines when he conquered the area 2,300 years ago, and Marco Polo in 1271 had only nodded in its direction from another mountain range to the north. "There are mountains likewise in which are found veins of lapis lazuli, the stone which yields the azure color ultramarine, here the finest in the world. The mines of silver, copper and lead are likewise very productive. It is a cold country."[4]

In 2000, when I first made inquiries, Afghanistan was one of the hardest places to visit on the planet. Four years earlier, the black-turbaned Taliban had driven into Kabul. Since then they had established an absolute presence, imposing vicious rules about women not working, men not shaving, girls not studying, and nobody listening to music or taking photographs. The place was literally in the fifteenth century—according to the Muslim calendar it was the year 1420—and tourists were not welcome. Yet I was determined to go.

A few weeks later, I received a surprise phone call. It was from a friend who had just found herself with a month between jobs as well as an e-mail correspondence with an Italian doctor she had

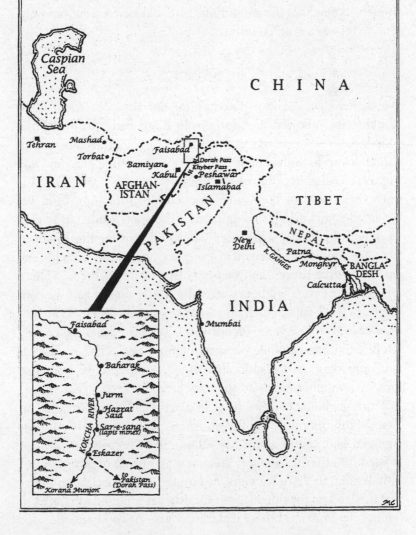

met one dusty day while cycling down the Silk Road. "Do you want to come to Kabul?" she asked, with the nonchalance with which most people would suggest a picnic. The doctor, Eric Donelli, was there working for Unicef, and had said he could arrange visas for her and a friend. I said yes immediately, with the proviso that we would try to get to the mines if we could, even though I knew that the mountains of Badakhshan were far away, and that it was a cold country.

# THE KHYBER

We waited eleven days in Pakistan for our visas. We spent them drinking tea in flower-filled gardens in Islamabad, swimming in a muddy lake at dusk and even, on one memorable day, asking camel drivers to unload their bales of sweet-smelling grass and taking us on camel-back to see the ancient ruins of Taxila. This was once the capital of the Gandharan empire stretching from Pakistan to Afghanistan, and nurturing the most skilled Buddhist workshops in history. Every day we would wait for the go-ahead from the Taliban embassy, and every day we would be told "not yet." "You'd be lucky," said skeptical Islamabad residents. "There are no tourist visas." Others were more encouraging and we continued to hope. When the call came we were at dinner. "The Taliban have given me your visa number," Eric said down the crackly satellite line from Kabul. We reached for a pen. "The number is five," he announced grandly. It seemed ironic to have waited so long for a number we could so easily have invented.

Thirty-six hours later we were in a taxi heading for the Khyber Pass. In the front seat was the obligatory armed guard—ours was eighteen and casual about his Kalashnikov. As soon as we had crossed into the "tribal area" there was an arcade of gun shops. A little farther on there were graves covered with tinsel, a reminder that the land on the other side of the Khyber was going to have different rules from any other I had ever visited. At Torkham, the edge

of Pakistan, our driver sorted out formalities while we stayed in the car, watching the border gate with fascination. Apart from a few lorries and a plastic bucket or two, there wasn't much there that Rudyard Kipling wouldn't have seen 130 years before when he was collecting images and stories for his book *Kim*. Men in turbans carried mysterious bundles of anything from cloth to bullets. Guns were everywhere and so were Kims—grubby urchins in brown waistcoats skipping away from men who chased them with sticks. For Kipling all these people would have been potential spies, working for either Britain or Russia to win control of Afghanistan. For us, bombarded with television images of a bombed-out Kabul, they were the besieged inhabitants of a disastrous land. And most of them were looking remarkably lighthearted about it, considering.

"Be demure," we reminded each other as we adjusted our newly bought scarves and crossed the border on foot. But the smiling Taliban immigration official invited us to drink green tea scented with cinnamon and undemurely we agreed. Within moments he was— at our request—stamping our hands as well as our passports with the precious Afghan entry stamp, and we were—with his permission—taking photographs of the process. The Land of Blue was not, perhaps, going to be quite as conservative as we had thought, we decided. And then we jumped into another taxi to surf through to Kabul on a day of brilliantly courageous driving over atrocious roads.

If ever a city was singing the blues, Kabul was it in those strange hazy days of Taliban rule. It was not that the place was entirely grim. Far from it. Despite what the television footage suggested, there were street markets, weddings and ordinary people just trying to follow ordinary lives. It was more that—in the reflective jazz sense of "blues"—people in Kabul tended to mix their melancholy with dark humor. Not so long ago this had after all been the party capital of Central Asia, and the spirit remained, if not the songs. One day we went for a picnic in the hills with an Afghan family. None of the children had ever been on a picnic before, even

though before the wars this had been a national pastime. "Are there landmines here?" I asked the father, a forty-five-year-old university teacher who had all but lost his job under the regime. It was a fair question: the Soviets and others had scattered their time bombs all over the country. "Do not worry," he said gravely as we made our way through cherry blossoms and bombed-out village houses. "Walk behind me, in my footsteps." The next day he was taken by the Taliban and whipped on his wrists with wire. They said it was for having a video player, but we feared it was because of the picnic. When we saw him two days later we said how sorry we were. "It was worth it," he said.

The most popular film in this landlocked place was *The Titanic*: Kabulis had even nicknamed a market the "Titanic Bazaar" because they felt the whole city was going down into the depths. "I would like to have been on the *Titanic*," said one of the local U.N. employees one day. "But it sank," we exclaimed in horror. "Yes, but there were some lifeboats. There are no lifeboats for Afghanistan," he said with the typical dark humor of his countrymen. No one could have guessed that eighteen months later there would be some "lifeboats" of sorts in the form of bombs from the U.S. and U.K. They would free *Titanic*-Kabul, although at a high price.

It is curious that in English the word "blue" should represent depressing as well as transcendent things; that it should be the most holy hue and the color of pornography.[5] Perhaps this is because blue recedes into the distance—artists use it to create space in their paintings; TV stations use it as a background on which they can superimpose other footage—so it represents a place that is outside normal life, beyond not only the seas but the horizon itself.[6] Fantasy, depression and God are all, like blue, in the more mysterious reaches of our consciousness. Until the eighteenth century it was spelled "blew," and I sometimes think of it as related to the doldrums—the areas between the tropics of Cancer and Capricorn where sailors sometimes had to wait for weeks for breezes to blow and let them resume their journeys. Thinking back to Kabul in

those days, I think of the ordinary people I met there then as waiting, quietly but rebelliously, for something to happen.

We found plenty of lapis lazuli, some in chunks of half a kilo or more, in the shop windows of Chicken Street. Once this was one of the busiest antiques bazaars in Central Asia; even in the 1970s it was famous among travellers as a place to pick up rugs from Uzbekistan, turquoise glass from Herat and treasures from all over the continent. When we saw it, it was quiet, although most of the shops were still open—just. I bought a rough blue stone from a man who had plenty of lapis getting dusty in his window. How much is it? I asked. "Anything." He shrugged. "I just need money, my stock has no value for me." I paid him a fair price, and he threw in another piece, free, for good measure.

It was strange to get the stone free, when the reason for my search was because it was once the most valuable paint material in the world—and in a way it still is. Just as Michelangelo had done, artists in Renaissance Europe would have to wait for their patrons to give them the ultramarine. They could not afford to buy their own. The artist Dürer wrote a furious letter from Nuremberg in 1508 complaining that 100 florins barely bought a pound of ultramarine. Today the paint, made from Afghan stones from a Renaissance recipe, costs around £2,500 for the same amount.[7]

Michelangelo could have used a cheaper blue mineral[8] called azurite to finish his painting if he had wanted to: indeed, he did use it to paint Mary Magdalene's strange brown dress. Azurite was sometimes called "citramarino," indicating that it came from this side of the seas, and Michelangelo would probably have got his from Germany. But azurite is a byproduct of copper mines, and it is the sister stone to malachite. So it naturally tends toward the green side of the spectrum, whereas ultramarine veers toward violet. The difference can be summed up in how artists used the two paints: ultramarine to give height to the skies, and azurite to give depth to the seas. The cheaper pigment was also much less stable:

# COLOR

Mary Magdalene's robe in *The Entombment*[9] was never intended to be that unfetching shade of olive; it had just faded that way—from the color of the sea to the color of seaweed.

It seems stupid in retrospect, but I was surprised, seeing my first piece of raw lapis, to find how very blue it was. Until then I had seen only polished stones, and not the best, and they had always seemed rather dull. The other surprise was the stars. All lapis lazuli contains speckles of iron pyrite—fool's gold—and it makes the best stones look like the firmament. No wonder some people think it is holy: it is a rock picture of the universe. And looking at it, I was reminded not of Michelangelo's painting, but of another more startling canvas hanging in the room next door.

It is *Bacchus and Ariadne*, painted by the Venetian artist Titian in 1523. I love it partly for its colors, which seem to come from a jewelry box not a paintbox, but mostly because it is the embodiment of pure lust, so always makes me smile. It shows the god Bacchus coming back from India with a drunken entourage; behind him a fat middle-aged cherub lolls over a donkey, while a debauched centaur waves the remnants of a creature he has just eaten for lunch. Suddenly our half-naked love-god sees Ariadne, grieving that her ne'er-do-well boyfriend Theseus has sailed off into the distance. With a single lascivious bound Bacchus flings himself toward her, and she half turns, to see her destiny changing. "Forget that wretch," Bacchus is shouting. "I'm here and I will give you the world—and the sky and stars as well."

The sky is the finest ultramarine, and in the top left corner is a constellation of seven stars. This bit of the picture has no perspective; it is almost like a still from a Disney cartoon, and I like to think that this is not because the conservators rubbed the canvas too hard, but because Titian wanted to show it as a fantasy, a mirage of what Ariadne could have if she followed her passion where it led. In 1968, when the painting was restored, the transformed color of the sky whipped up a storm far fiercer than any Turner prize-winner has achieved. The general public didn't like the look.

They felt it was too bright and preferred the off-greens and browns of the discolored varnish. Titian, it was argued, was a man of taste: he could never have chosen that gaudily shimmering blue.

They were in excellent critical company. Even Michelangelo had thought Titian's colors a little too much. According to his biographer, Georgio Vasari, in 1546 the older man visited the younger in his studio in Rome. Michelangelo commented afterward that he liked the coloring, but "it is a pity that in Venice one was not taught from the beginning to draw well." It was an expression of an important artistic dispute in sixteenth-century Italy. Ostensibly the argument was between *disegno* and *colore*—drawing and coloring. But more fundamentally it was about how to live life. Where—as I had seen in *The Entombment*[10]—Michelangelo planned every element of his composition and would only add colors when he knew exactly what was going where, Titian's compositions used to evolve as he stood in front of his canvases, palette laden with paint. It is the division between spontaneity and careful planning, between rash Dionysus (or Bacchus, of course, for the Romans and for Titian, who may have been making a statement) and calm Apollo—and the benefits of each approach have been debated passionately over the years, partly because it is an argument about the nature of passion and creativity itself.

We sat in the merchant's shop—among those very same shimmering blues that Titian had loved and the 1960s British gallery-goers had feared—and talked. In the late 1970s, before the Soviet Union invaded, lapis lazuli was a popular stone among Kabul's middle classes. People made glitzy jewelry out of it and they kept the stones as savings, along with silver coins. In the past few years the shopkeeper had been seeing both lapis and silver arrive on Chicken Street with increasing regularity and at lower prices. "Families have been getting rid of their treasures," he said. "We are all getting poor in Kabul." He told us about the blue mines, and about how women were banned from Sar-e-sang. Once the mines

were productive, he said, and engaged thousands of men. But then for a few months almost no lapis had come out of Badakhshan. "I don't know why," he said. I thought of a story I had heard from a foreign correspondent the night before. There had been folktales of the lapis veins drying up under the chaotic mujahideen rule in the early 1990s, "because, people said, the mine itself objected to the regime."

Suddenly the megaphone from the mosques started to call the faithful—or at least the obedient—to afternoon prayers. The merchant quickly pulled down the shutters and we sat there in the half-dark, not speaking. If he had been caught doing business at prayer time he would have been beaten, he said. "It's enough to make you not believe." When prayer time was over he rolled up the shutters. A Toyota pick-up—the unofficial vehicle of the Taliban—had parked outside the shop. The shopkeeper looked relieved to see there was nobody in the car: the government thugs had evidently gone to look for someone else.

So now I had my stones—although not enough for a whole robe probably, just a weeping handkerchief's worth. What should I do with them to make them into paint? I wondered, consulting Cennino Cennini. He is usually so scathing about pigments: one is too poisonous, another too fugitive, another is useless on fresco. But with ultramarine he goes into raptures—"a color illustrious, beautiful and most perfect, beyond all other colors; one could not say anything about it, or do anything with it, that its quality would still not surpass." However, to get paint from the stone was almost as hard as getting blood.

Lapis lazuli is a complex clump of minerals, including haüyne, sodalite, nosean and lazurite. In the best grades there is more sulphur, the yellow element curiously making the stone more violet, and in the worse grades there is more calcium carbonate, turning it gray. To make it into paint all these impurities—including the sparkling pyrite stars I liked so much—have to go. To achieve that, the color-maker had to be like a baker, lovingly kneading a dough

of finely powdered lapis, resin, wax, gum and linseed oil for up to three days. To coax out the blue, our artist-cook put the dough into a bowl of lye (wood ash) or water, and then kneaded it with two sticks, squeezing and pressing it for hours until the liquid was saturated with blue. He then separated the blue into a clean bowl, and—leaving it to dry into a powdery pigment—started again with fresh lye and the same ball of resin. The first pressing was the best—a virgin pressing for a virgin's gown. The final pressings (of what would now be a ball of mainly pyrite and calcite[11]) were called "ashes," and were less beautiful and much less valuable.

## BAMIYAN

I still yearned to reach the mines, which I had begun to call "my mines." And now I wanted to find out why the supplies had stopped. But my understanding of Afghan geography was rudimentary, and of the movements of the front line even more basic. Sar-e-sang was a thousand kilometers away by road. More importantly it was on the other side of the fighting in that corner of the country that was controlled by the opposition, the Persian-speaking mujahideen. There was no way I could get there that year to find the paint for Michelangelo's canvas—commanders were shifting sides every week and it was dangerous. I was going to have to try again the following year.

But there was another paint mission on this side of the line. The earliest recorded use of ultramarine was just a mountain away, in the town of Bamiyan, where two giant Buddha sculptures were said to have auras around their heads, painted in frescos of lapis lazuli. We wanted to go and see. And we were lucky, we were just in time: a few months later they would be dust.

The first difficulty was getting there. The Taliban were not giving passes to United Nations staff that week, and our host could therefore not go with us. So we accepted an invitation from a French charity called Solidarité. This group organized two types of .

aid—giving food in exchange for labor, and giving money. A bundle of the equivalent of even ten British pounds in the overinflated Afghan currency was as thick as this book—the biggest note was worth about five pence—so money was bulky to carry, and vulnerable to highway robbers. Hoping fervently that this was not the cash van, we jumped on board.

When war was just something that happened in other countries and roads had tarmac on them, the town of Bamiyan would have been a few easy hours from the capital. But after two decades of fighting, it was a day's journey across two passes, and past so many derelict tanks that the Afghans laughed when we wanted to stop and photograph them. "If you take photos of every ruined tank in Afghanistan then you will never leave the country," one former fighter turned charity worker joked. It was on this road that I had my most dangerous experience in Afghanistan. Not from the kohl-eyed Taliban, who waved us through every sentry post with various degrees of graciousness. But as I squatted in a ditch at the first "privacy" point we had seen in four hours—at the top of a pass—I noticed I was just a meter away from an unexploded rocket. It would have been a bad way to go.

We passed many beggars: men and boys who halfheartedly moved stones around the road all day, and waited for vehicle drivers to throw a few Afghan notes for them to chase in the wind. On the same road I also saw two travellers in a timeless scene. He was walking, she was riding a donkey, and her burka—that oppressive garment that covers the face and body, allowing women to look out on the world only through delicately laced bars—was sky blue. This was no doubt because it was the most fashionable color that season—burkas came in blue, olive, black, gold and white, and blue was the prettiest. But, with that color having such a potent symbolism when worn by veiled women on donkeys, it was impossible not to think of them as Mary and Joseph, travelling for miles to give birth to Christianity.

The Virgin Mary has not always worn blue. In Russian icons she

is more often in red, while the Byzantine artists in the seventh century or so usually showed her in purple.[12] Sometimes she is in white too—she had a big wardrobe. The trouble with color symbolism, or perhaps the joy of it, is that it is not a constant. Red could be for the birth, purple for her mystery; blue could dress the Queen of Heaven in the color of heaven; white is her innocence, black her grief. If they had wanted to, artists could have dressed her in the whole rainbow, although I don't know of any who did. Instead they shifted their thinking to what would honor her, rather than resemble her compassion; and they often decided this on the basis of cost and rarity. In fifteenth-century Holland, Mary often wore scarlet because that was the most expensive cloth; the earlier Byzantine choice of purple was similarly because this was a valuable dye, and only a few people were important enough to carry it off. So when, in around the thirteenth century, ultramarine arrived in Italy as the most expensive color on the market, it was logical to use it to dress the most precious symbol of the faith.

And from that moment it became a reserved color in Christian churches. Even today, Catholic priests change their vestments according to the occasion: they can be black, red, purple, green or white, but only in Spain, and only for one day a year—the Festival of the Immaculate Conception—are they blue. Black explicitly represents death; red is fire or love or the blood of martyrs; violet is penitence; green is everlasting life; white symbolizes the pure union of the rays of light. But since Pope Pius V standardized liturgical color coding in the sixteenth century, blue has always been reserved for the Mother of Christ, not for the men who serve her. On the other hand, in parts of France and Spain, even until the twentieth century, parents of a sick child would promise the Virgin Mary that if the child recovered, he or she would be dressed in blue from hat to boot in gratitude. In French this was called "*enfant voué au bleu.*"

And as we arrived in the town of Bamiyan we mentally gave thanks as well—to whatever deities may have been looking after us.

# COLOR

The United Nations had warned us the night before that the roads were not safe, but as we looked around we knew already that it had been worth the risk. The place was spectacular. The valley, in the shadow of the Grandfather Mountain, Koh-I-Babu, was fringed with sandstone, and we could see the two enormous Buddhas—55 and 35 meters high—guarding it, with their archways looking like sentry posts. When they were built, fourteen and thirteen centuries ago, this valley would have been packed with pilgrims and artisans, mixing with traders from Turkey and China. It was the end of the Gandharan period, and Bamiyan was full of some of the richest Buddhist art in the world. Thousands of monks lived there, and the grottoes were full of frescos and incense-filled shrines.

But when we arrived in 2000 there were just the Buddhas left, and they were in bad shape. A few months before, a commander had attacked them, saying they were pagan idols. His men shot rockets at the smaller Buddha's face and groin. The larger statue was luckier: the men had just got to the point of suspending burning tractor tires from the top of its head when the order came from Taliban headquarters in Kandahar to stop the destruction. But by then the eyes were blackened, the effect one of haunting suffering as this lonely giant gazed blindly over the valley where once it had been worshiped.

They were just plain stucco, although once—according to local mythology—one was painted blue, the other red. They used to have wooden arms that lifted for prayer at sunset: the rattling of chains and pulleys must have quietened the noise of the bazaar every evening. But in the seventh and eighth centuries, as Islam spread, the meaning of the statues was forgotten. "We only know that once upon a time the big Buddha had eyes you could see from the other side of the valley, they shone so brightly," said an Afghan charity worker over dinner that night. Were they blue? I wondered. "I believe they were green," he answered. "Emeralds perhaps."

The next morning we were given permission to visit the big Buddha; the other was only a few hundred meters away but it was

under the control of another commander. We climbed up past the military post, then up steep hairpin paths cut into the startlingly orange sand. At the top we walked through low tunnels, and then out onto the Buddha's head, which was big enough for a picnic. People had stubbed cigarettes out on it, and at the center—at the point that Buddhists would call the crown chakra—there was a hole for dynamite.

It was an extraordinary undertaking. How many artists had lain there on their backs, painting meditations all over the walls and the protective arched roof, praying that the 60-meter-high scaffolding was just wobbling, not tumbling? The frescos were faded, and some had crumbled when we saw them. But the Gandharan art—always so influenced by Greek ideas of what is beautiful—was extraordinarily delicate, with the draperies falling in classical folds. A series of Buddhas sat along both sides of the wall above us, each with their hands in a different meditation position, and each encased in a rainbow circle. And there, striped between yellow ochre and white lead and red vermilion (the Gandharans had idiosyncratic notions of the order of the rainbow), was the lapis I had travelled to see. The ultramarine still shone—just—against the ruined walls: and it was extraordinary to think that this was the first known use of the paint anywhere.[13] The Egyptians had used it as stones, but not as pigment—their own blue paints had been based on glass that had been ground up finely into powder. And I wondered then, as I sat on the head of the great Buddha of Bamiyan, whether it was in that valley far below us that somebody once, fourteen centuries ago, had sat experimenting with blue powder and brown glue, and had discovered—by adding wood ash perhaps—how to make lapis lazuli into paint.

Those Buddhas and frescos were destroyed eleven months later. No drill holes and dynamite this time. The Taliban used rockets for two days of bombardment, and allowed their photography rule to be broken, sending out images of bare arches where once there had been two guardians of a forgotten faith. In their week of fame and

destruction the statues were seen and discussed by people all round the world: people who had never heard of the Buddhas of Bamiyan were shocked that now they would be unable to see them for themselves. On most levels it was a terrible cultural tragedy. But on one level it was not. Buddhism is a faith that understands impermanence. When else in their long history could these two vast and armless trunks of stone standing in the desert have reminded so many people in so many countries that nothing lasts forever?

## A GREMLIN BLUE

Half the ultramarine in the world must have passed through Bamiyan, and along parallel roads to the north and south. And there was another blue that travelled through the town the other way, from Persia and through into China. It was not quite so valuable, but it was almost as valued. It came from mines in Persia— now Iran—and in English it was called "cobalt." Calling it "cobalt" is rather like calling it "goblin": in German folk legend Kobald was the name of a vicious sprite, who lived in the earth and resented intruders. It is a decent metal on its own, but it attracts a nasty companion in the form of arsenic, so the European silver miners who often came across it hated it, gave it the name of a gremlin, and for centuries they threw it away before it ate their feet and attacked their lungs. It was not simply the arsenic which made it seem a mysterious force: in the seventeenth century people discovered its propensity to change color on heating and used it in invisible inks; when the plain paper was held over a fire it would magically turn green where secret messages had been traced.

As an ingredient of smalt—a pigment that had been made of ground-up blue glass since the 1500s—cobalt had been used in paint for years, but in its purer form it didn't reach European paintboxes until the nineteenth century, when a scientist called Louis-Jacques Thénard managed to make it into a pigment. If he had been living today, Michelangelo would have liked this blue best. It

is expensive, and leans toward violet. It was the Persians who really first found how good cobalt was as a glaze—they used it for the blue tiles of their mosques, representing the heavens, while copper makes the turquoise, remembering the green of the Prophet's cloak. The results are spectacular. When traveller Robert Byron visited the town of Herat in the 1930s (which we would have reached, eventually, had we continued west from Bamiyan) he described the blue on the tomb of Gowhar Shad as "the most beautiful example of color in architecture ever devised by man to the glory of God and himself."[14]

The Chinese coveted this color, and for four hundred years they would swap green for blue—sending green celadon-ware to Persia and getting "Mohammedan blue" back. In the national arts library at the Victoria and Albert Museum I read how the cobalt quality varied throughout the Ming dynasty. The finest blue was in the mid-fifteenth century Xuande reign, while under the emperors Zhengde and Jiajing a hundred years later, porcelain-makers were using an excellent violet glaze. Meanwhile—and bear with me on the dates here—the "blue and white" from the Chenghua (late fifteenth) and Wanli (late sixteenth) reigns was virtually "gray and white," after those emperors imposed trade sanctions against Central Asia.[15] With the details scribbled down in my notebook I went down, with some excitement, to the Chinese gallery and tested it out. To my delight I could now tell immediately, by color alone and from a distance, when a Ming vase was probably fired. The possibilities for pretentious expertise were endless.

## SECOND ATTEMPT

The following year I was determined to get to Sar-e-sang. It was now exactly five hundred years since Michelangelo had been waiting for his blue. It was a nice conceit to go and collect it for him in the spring, when he would have needed it, even though I was half a millennium too late. It was also necessary timing. The season for

blue was very short in 2001. There would be a month or so between when the passes melted in April and when the harvest was gathered in June. After that the fighting would start again, and who knew where the front line would go?

By Christmas the political situation in Afghanistan was even more precarious than before. So in February I changed tactics. I jumped on a plane to Hawaii to see the "Gem Hunter," an American dealer who had been in and out of Afghanistan for thirty years. If anyone could help me then Gary Bowersox could. We met in Maui, where he was hosting a jewelry show, and talked for hours. He was a big friendly man who laughed a lot and told excellent stories of meeting mujahideen leaders and of smuggling himself into the country under chicken wire. He gave good advice about how to stroll into Afghanistan over the mountains, disguised in a burka (get a guide you trust and keep walking), and what to do if threatened by a yelling man with an AK-47 (smile). On the second day I asked him directly. Could I go with him on the next trip? He paused. "I'm sorry," he said. "This year is going to be tough; I'd like to, but I can't help." As I flew back to Hong Kong a few days later I felt disconsolate: I was going to have to make it on my own.

My first hurdle was a visa. I had friends in Islamabad who could help get me on the twice-weekly United Nations plane to Faisabad, the nearest town to the mines. But internal protocol insisted that I could board it only if I had a Taliban visa, just in case we crash-landed. I couldn't help but feel that if this happened then having the right documents would be the least of my problems, but rules were rules, and I applied. Of course I could have a visa, came the obliging reply from that usually least obliging of governments; all I needed was a supporting letter from my own government. Of course I couldn't have a letter, came the reply from the British embassy. "We don't recognize the Taliban as a legitimate government of Afghanistan." I was in a bind, so I decided to go to Islamabad to sort it out.

And to my surprise I popped into Afghanistan like a cork from a non-alcoholic champagne bottle. On the first morning I got a call from the friend I was staying with, who worked for the U.N. "They've decided to take you without a visa," she said. "I've sent a car—can you be ready in ten minutes?" I bundled three of her long-sleeved *shawar kameez* outfits of baggy pants, long shirts and scarves in my backpack, along with notebooks, hiking boots and Gary's book (*Gemstones of Afghanistan*), and raced out of the house, scattering my belongings behind me. Two hours later I was on a nineteen-seater Beechcraft, heading west.

In his best-selling book about Afghanistan,[16] Pakistani journalist Ahmed Rashid recounts a story he heard from an old man. "When Allah had made the rest of the world, He saw that there was a lot of rubbish left over, bits and pieces and things that did not fit anywhere else. He collected them all together and threw them down onto the earth. That was Afghanistan." And as we crossed the high Pamirs, the description seemed fair. We were flying over snow-covered mountains; somewhere beneath us were the fabled mines of Badakhshan and a village where only men were allowed to live. Looking down at the inhospitable terrain, it was almost impossible to believe that anybody could live there at all.

Badakhshan was a region under siege: most of the country was under occupation by darker forces. Only that small area—every year smaller—had held out. It reminded me of the village in the Astérix comic books—a place of indomitable fighters, led by a few powerful figures, most powerful of whom was Ahmed Shah Massood, whose career over twenty years had the status of myth. People believed he could not be killed, although in September 2001 he would die dramatically when a suicide bomb in a TV camera exploded in his face. His druid's potion was mostly hard tactics, spiced by charisma and the people's desperation not to be Taliban fodder. But his success had to be paid for, and there were few sources of battle income. The two that were publicly acknowledged

were emeralds from the Panjshir valley, and lapis from Badakhshan. The mines, I knew, would be being worked busily beneath me: the government needed the money.

After two hours the land flattened out onto a plateau, and the plane landed with a scrape and a judder on a military metal runway. Welcome to Faisabad International Airport, with the rubble of old wars—tanks and bits of plane engines—rusting at its edges. There were no immigration formalities, not even any security guards. Just a surreal few moments as the arriving passengers were greeted, and the departing passengers sent off, mostly by bearded men in jeeps adorned with logos blazing MSF, Oxfam, Afghan Aid and, ubiquitously, the U.N. with its smoky blue-and-white flag. The colors had been chosen in 1945 because they were believed to be non-aggressive and neutral: all nations share the same sky.

I had been in e-mail contact for several months with Mervyn Patterson, the representative of the United Nations Office for the Coordination of Humanitarian Affairs. He had given me encouragement from the beginning. "Glad to have confirmation there's someone as mad as I am," he had replied, apologizing that I might be disappointed at how easy it would be to get to the mines. He was there waiting for the plane, introduced himself enthusiastically, and then announced that he was just leaving on the same plane for Islamabad. But he put me in the hands of his colleague Khalid, who would look after me. I was going to have to hire a jeep and a translator, but I was lucky to have found Khalid Mustafawi. His uncle was the commander for the part of eastern Afghanistan where Sar-e-sang was located, and he had already given his permission to visit the mines.

That first day I walked to the old bazaar. A white burka strolled toward me and I salaamed her through her lace. Suddenly the veil was flung back—veils seem to have been a theme of my search for blue—and a pretty twenty-year-old appeared. "Come home for tea," she commanded. As we walked she would cover herself whenever a man appeared, and then—as later I noticed other

women doing—she would fling back the veil once she could see through her lacy radar screen that they had gone. It was flirtatious behavior: waiting until that last second and then whoosh, disappearing. "You know the neighborhood girls from your childhood," an Afghan man explained later. "You know who is pretty and you can recognize them from their shoes. The veil doesn't stop flirting," he added. "Maybe it increases it."

When I got back to the U.N. guesthouse a few hours later, there were two men lying on cushions drinking tea with Khalid. Tony Davis and Bob Nickelsberg were on an assignment for *Time*, and by coincidence they were heading to the lapis mines the next day, to learn more about how Massood paid for his fighters. Had they realized that their war-correspondent mission would from then on include exchanging bean recipes with cooks and stopping for flower-pressing they might have thought twice, but that was all in the future. We agreed to share the cost of hiring what turned out to be—at seven the next morning—a very battered Soviet jeep. "They look like shit," Tony said, "but these Russian jeeps are tough." We were to remember his words.

We headed south toward the crossroads town of Baharak, and toward the mountains. A nomadic tribe of Araps was heading for summer pastures with their flock. The "fat-tailed" sheep of Badakhshan store their excess energy in their bottoms—and in front of us for half a kilometer we could see nothing but jauntily lardy bums taking over every part of the road. The nomads halfheartedly knocked their flocks to the left to let us pass but we kept losing ground and it took nearly an hour to pass. From Baharak—having met the commander and been introduced to Abdullah, a smiling soldier turned farmer, now turned translator—we would follow the Kokcha river south. After the wealthy town of Jurm, where opium poppies competed with wheat for field space, the road narrowed into a gray gorge. In my head I was mentally following Titian's controversial scrape of sky back in time. I imagined that little daub travelling back on to the wooden palette, then to a

granite pestle and mortar wielded and bashed by a sulky appren-
tice, into sacks and then back in rapid cartoon reverse from the
port of Venice, across the Mediterranean to Syria, and along the
Silk Road, possibly along this very path . . .

"What's that noise?" asked Bob suddenly from his front-seat po-
sition. I awoke from my reverie. It is an irony that the old "silk"
roads are the least smooth pathways in the world. In rocky road hi-
erarchies this one was king, and our Soviet jeep had been protest-
ing in a language of clonks and crunches for hours. Some of the
gradients against which the engine would curse in its diesel-fumed
Russian were so seemingly impossible that it was a miracle we
achieved them each time. I couldn't hear anything different, so set-
tled back sleepily to rejoin Titian's paint. The driver, however, be-
came excited and talked rapidly in Dari—a language that shares
the word "axle" with English. "I don't like the sound of it," said
Bob ominously. It had been dark for an hour already, and we were
passing through the last major village before Sar-e-sang. We would
stop there and cover the final 40 kilometers the next day, we de-
cided. The road was so bad it would take three hours and would
not be safe in the dark.

So Mr. Haider, a gentle math teacher at the girls' school in
Hazrat Said, found himself with five guests for dinner. We arrived
in the darkness and ate one of his last chickens, which had proba-
bly not been expecting guests either. We sat up until midnight,
those bearded faces sidelit by hurricane lamps, boy children squat-
ting in the corner, eyes bright with curiosity. Yes, they were wor-
ried about the possibility of fighting this summer, and yes, they
would fight. The mine was vital to the economy. "It is a narrow val-
ley," Mr. Haider explained, and when there is not a blue rush, then
everyone is poorer. They did not use lapis themselves: the stone
was not part of local dowries. It is the same story around the world:
when we name the most valuable we tend to seek out the exotic;
we rarely choose the thing—however unusual—that can be picked
up by donkey-boys a day's journey away.

We joked about the axle that night. What if we had to ditch the car? Privately I thought it would be fun: I had been disappointed to learn that for the past five years Sar-e-sang had been accessible to jeeps. I hadn't wanted my pilgrimage to be as easy as Mervyn had promised. The next morning, after we had toured the girls' school—no benches, few books, bright faces peering out of unglazed windows—and waved goodbye grandly, my idle dream became reality. The jeep gave up the battle of the brave in an explosion of burning dust. Village men tried to push it up the hill, but didn't succeed. "These hungry people have no strength," said Abdullah compassionately.

An hour later, accompanied by two donkey-men—a man and a boy wearing torn shirts and ripped plastic boots—we strolled out of town. I had, in my bag, a photocopy of a chapter written by a traveller called John Wood, who had made the same journey in 1851. Wood too had spent the night at Hazrat Said, and had visited the tomb of Badakhshan's saint and poet, Shah Nassur Kisrow. The bit of his poetry that Wood—and, exactly 150 years later, I—was most interested in were the two lines that advised: "If you wish not to go to destruction, Avoid the narrow valley of Koran"—which referred to this very valley.

At first the way was wide—we walked along jeep tracks in the sunshine, drinking water straight from the mountain. In Wood's day the local farmers complained that wheat would not grow on their land, believing the saint had "kept wheaten bread from them, that their passions might be easier kept under." The saint had evidently been working overtime in the year 2001—nothing was growing at all in those farmlands that relied on rain. Some villages were reporting up to eighty children dying of hunger that season: for them the valley of the Koran had really meant destruction. The peaks in that area were like children's drawings of mountains. Or perhaps they were even more basic than that—scribbles made on paper to check that a pen works; impossible jagged crags glowering over the horizon. Usually, with mountains like that, I would be

aching to know what was on the other side, imagining lost king-doms full of apricots and longevity. But this time, I realized, I was on the side I wanted to be, and in a few hours, Allah willing, I would see the mine I had dreamed about.

Looking at this geology, we wondered—as perhaps anybody wonders about an ancient mine—how anyone discovered its trea-sures. There the Bronze Age farmers were, eking out a simple liv-ing on these gray limestone slopes—hunting game, herding animals, worrying about snow in winter and drought in summer—and then suddenly they were exchanging sky-colored stones with people thousands of kilometers away in Egypt. But how did they first find the lapis under all that rock? By midday the heat was in-tense: at Abdullah's urging I climbed onto a donkey and was trot-ted over a pass or two. Donkeys were much more comfortable than I had imagined, and at one point I swear I fell asleep as I rode to-ward azure under an azure sky.

## THE COLOR OF THE SKY

The nineteenth-century British scientist and motivator John Tyn-dall always said that he did his best thinking about the nature of light and colors while he was walking in the mountains. He took his holidays in the Alps. It was a place where his mind could be clear, he said, and it was also a place where, on sunny days, the sky was clear enough to think about. He was an educator, and one of the best. He would stand in front of audiences at the School of Mines, and he would teach people how to use their imagination to understand science. To explain the color of the sky, he would use an image of the sea.

Think of an ocean, he would say, and think of the waves crash-ing against the land. If they came across a huge cliff then all the waves would stop; if they met a rock then only the smaller waves would be affected; while a pebble would change the course of only the tiniest waves washing against the beach. This is what happens

with light from the sun. Going through the atmosphere the biggest wavelengths—the red ones—are usually unaffected, and it is only the smallest ones—the blue and violet ones—which are scattered by the tiny pebble-like molecules in the sky, giving the human eye the sensation of blue.

Tyndall thought it was particles of dust which did it; Einstein later proved that even molecules of oxygen and hydrogen are big enough to scatter the blue rays and leave the rest alone. But the effect of both theories is the same. And at sunset, when the air is polluted with molecules of dust—or, over the sea, little salt particles—both of which act as "rocks" rather than "pebbles" in disturbing the wavelengths of light, the sky will seem orange or even red. When Mount Pinatubo in the Philippines erupted in 1991, shooting jets of volcanic dust into the sky and killing three hundred people, the sunsets throughout South Asia were crimson. I remember smiling, ignorant of the reason, thinking how beautiful they were.

## LOSING A SHOE

On a small ridge we saw a red jeep: it had broken down. It was the King of Munjon's car, we were told by the man left to guard the vehicle. I took a photograph of him standing resignedly by a slogan on the door, which boasted "no cars satisfy me but this," and then we went down toward the serai, a one-story hotel in the middle of nowhere. The young king was there in his chocolate *shawar kameez*, looking mysterious. He had inherited the title from his late father five years ago and was trying hard to be a good charismatic leader to his Ismaili flock—Shiite Moslems in a land of the ever-rising Taliban Sunni. The car would be repaired in a day or two and meanwhile he would stay with his aunt's family in this remote restaurant. A tiny window in a wall opened with a grunt and our boiled goat with rice arrived, passed through by a woman's hand—dark and covered with three rings. The donkey-man patted

his stomach optimistically and was pleased to see we had ordered full meals for him and the boy. We could eat only a fraction of what we had been served—they ate all of theirs and the rest of ours as well.

Leaving the serai, I made two discoveries: amoebic dysentery and a boot heel that flapped as I walked. About the former I could hope to last out between rocks; the latter seemed more disastrous in this stony country. I wrapped the wretched thing with a rubber band, hoping it would hold—or at least that the others wouldn't notice and I could walk at the back with my reputation as travelling companion intact. "Your boot is flapping," noticed Bob nicely, within three minutes. So I tied my laces around it—travelling on a shoestring taken literally—and adjusted the knots every hour or so as the cord became worn through. John Wood also had boot problems. He had had to barter his Uzbek boots for leather buskins as soon as he had realized—at about this spot in the valley, when the path was broken after an earthquake—that the rest of the journey would have to be undertaken by foot. For him the march was "long and toilsome," with one Afghan member of his party falling on the road "too severely bruised to come on." For us it was, especially in the cool of the late afternoon, rather spectacular: over cliffs and through dynamited arches.

It became clear we would never reach the mines before nightfall: my boot-mending had become increasingly frayed and we were making slow progress. A lonely stony hamlet—the first we had seen on our side of the river since lunch—suddenly seemed full of promise. We were lucky: the house was owned by Yaqoub Khan, the man in charge of the government operations. He would give us dinner and a place to sleep, and would take us to the mines the next day. Yaqoub had two wives; he had just organized his third marriage with a thirteen-year-old girl. In fact, he mentioned several times, he was rather interested in whether I might like to stay in the valley myself. Even though Bob and I could understand very little Dari, we knew whenever Yaqoub was discussing this possibil-

ity with Tony because his eyebrows would suddenly bounce up and down.

In the morning we had only an hour and a half to walk. A few turns before the mine, we had to cross a stream of snow melt, and suddenly I stopped in delight. For as far back along the side valley as I could see, the white rocks were flecked gloriously with blue. I stood in the icy water for as long as I could, enjoying the colored rocks shimmering in the early morning sun around me. It answered my question about how the Bronze Age people discovered the mine in the first place: it would have been easy; all they had to do was follow the colored stones. Once upon a time this whole side valley would have been a blue rock garden, just waiting for people to enjoy it. And when they found out its value, hundreds of people arrived to do exactly that. Miners built Sar-e-sang village seven millennia ago, and walking up through it, I wondered how much it had changed. It had the feeling of a cowboy town: one dusty street full of small shops and the rest of the place a jumble of mud houses linked by paths covered with horse droppings. Afghan women were not allowed there—the government thought that families would be a distraction to the miners—and so I was the first female to have visited in six months or so. Enjoy this, I thought to myself: never again would I be the subject of such admiring attention from so many.

We drank tea while Yaqoub showed us examples of grade-one lapis lazuli. There are three main colors, he said, although to us at first it all looked much the same and we pored, confused, over the similar rocks. "The best time to assess the stone is sunrise or sunset," Yaqoub said helpfully. "When the rays of the sun lie flat upon your hand: then you can see the color." The most common is *rang-i-ob*, which means simply "color of water" and is a general word for blue. This stone is the darkest, the shade that sea goes when there is nothing but deep sea beneath it; no sand, no land, just water. The second is *rang-i-sabz* or green. I couldn't tell the difference between that and *ob*: it was only when I saw polished stones two

weeks later in Pakistan that I could see the green; they looked as if shreds of bright lettuce had got caught in the teeth of the blue.

But the greatest of the three is the extraordinarily named *surpar*, or "red feather." It was puzzling and beautiful that the best blue should be described as red. It was an ex-miner who gave the most poetic explanation. "It is the color of the deepest moment of the fire," he said. "The very heart of the flame." I thought at first I couldn't tell it from the other colors, but I found that if I felt particularly drawn to any one of the uneven lumps of stone, it always turned out to be *surpar*. It has a compelling violet tinge to it, as a blue glass vessel sometimes has when you drink toward the light. It is hard to know, because Western art historians do not distinguish between the types, but I believe *surpar* stones would have made that extraordinary blue of Titian's sky.

An explosion suddenly ricocheted around the mountain. Nobody flinched as they might do in the rest of the country: it was just the miners using dynamite, looking for a vein to bleed. That afternoon we would go up to the mine, Yaquob Khan promised. But first there was time for a warm bath: or at least a heated bucket in a dark bathroom. This was where Commander Massood bathed when he visited Sar-e-sang, Abdullah said. The commander would order six buckets of hot water, and stay there for four hours. When I emerged after half an hour I found that my boot could not be mended. There was no glue in town and this particular brand was too tough to be sewn. Too tough to be sewn, not too tough to collapse, I thought, as Abdullah and Yaquob Khan tied me into the hated shoe with nylon string.

It needed to be strong—these were tough paths. We ascended slowly, with our feet constantly slipping down the gray shale. Mine No. 1 was the closest to the town; No. 4, the one with traditionally the best lapis (although like all the others it had none at the moment), would have taken us two or three hours more. And No. 23, the last one, was much farther away than that. Getting to No. 1 was

an energetic enough trek for me. "The BBC were here a couple of years ago," said Abdullah, who had been their interpreter. "But they took hours to get up the hill: longer than you," he encouraged. My scarf had slipped and I hadn't noticed, I was panting so much. A boy appeared, bounding over the rocks and hardly seeming to notice the 25-kilo can of water that he carried on his back. We lightened his load a little, and he sped ahead.

And then, suddenly, we turned a corner, and we were there at the place I had wanted to see for so long. The opening was about three meters high and wide, and all around it were men sitting precariously on high rocks, waiting for us and waving us welcome. By the time we got there, a large pot of green tea had been brewed. We drank it sitting on rugs in a huge cavern lit by candles, while the men gathered round. The ceiling above us sparkled with pyrite stars, and I wondered for how many thousands of years people had lit fires under them and talked. There had been no good stones found for three months, they said. Why? "Because we don't have the equipment," said the engineers. We could understand why one mine or two or even fifteen might dry up at the same time. But not why all twenty-three should have done so. I remembered back to that conversation in Kabul a year ago, where I was told about the folk rumor that lapis lazuli destested repressive regimes. But if the men had their theories, they weren't going to share them.

The shafts are about 250 meters long and dug horizontally into the mountain. Or at least they are sort of horizontal: as we walked along, sometimes upright, sometimes stooped, the floor would dip down dramatically and a miner would shout a warning and hold up his hurricane lamp. Today they drill holes in the rock, and dynamite the stones out. In the past, miners used to light fires under the rock, and then they would throw icy water over it—carried from the river by the predecessors of the fit young boy who had brought up the tea water for us. Shocked by the temperature extremes, the rock would crack and the miners would uncover the

lapis. The first few hundred meters of the shaft were blackened with soot from fires lit a hundred years ago: then the whole place would have been perfumed with the scent of burning furze.

As we walked, I imagined where the rock from each section might have found its ultimate resting place. The first 20 meters would have given the stones to Egyptian tombs; a little later was where the Bamiyan Buddhas got their haloes. Early on in the blackened section was a little side passage, the contents of which may have gone to Armenia for twelfth-century illuminated Bibles. A few steps later was where Titian may have got his sky from, and where Michelangelo didn't get his robe; farther on was Hogarth's blue, and Rubens's and Poussin's: a whole art history in one little pathway.

And then, way beyond the blackened section, in the newly dynamited hollows near where my own stones would have come from, could have been the vein of another fateful lump of lapis. A piece that was ground down and used by the Dutch forger Hans Van Meegeren to make a fake Vermeer. But what Van Meegeren did not know was that a fraud had been committed on a fraudster and his ultramarine had been adulterated with cobalt. He sold the painting to the Nazi commander Hermann Goering for a huge price, pretending it was part of Holland's heritage, and after the war he was made to stand trial for collaboration. The adulterated ultramarine was both his undoing and his defense—Vermeer could not have used this paint, his lawyer argued, as cobalt had not been invented then. He was sent to prison anyway—but it was a light sentence for forgery, and for the few months until he died he was a national hero for having outwitted the enemy.

When we got back to the village some of the miners were talking excitedly. Abdullah translated. "They are saying that this is an important day at Sar-e-sang," he said. "No woman has ever been up to the mine before; they say that you are the first." I wanted to ask some of the men about their lives. "Just low key," I said to Abdullah. But it turned into the Badakhshan Talk Show: hundreds of

men followed us as we wandered around the streets, pulling up chairs for us, listening in fascination. These were all worried men, who missed their families but had to continue here, earning a pittance, because there wasn't anywhere else to go. I talked to an old snuff salesman. He had six children living on mulberries and grass in the mountains. His entire stock was ten tins of snuff, which he could sell for the equivalent of five pence each. It wasn't enough for him to buy food, let alone send anything to his family. What had been the happiest time in his life? I wondered. He drew himself up to his full tiny height, playing expertly to the crowd as he told them his story. The audience laughed heartily and looked with interest at me while Abdullah translated. "The happiest time, he says," said Abdullah, looking doubtful, "was when he was first married. He and his wife were like horses joined together."

"I broke three awls on your boots," suddenly squeaked a voice from the darkness of one shop we passed. Abdullah and I peered in to where the voice had seemed to come from—and saw a small man perched on a box with a huge old-fashioned boot in his lap like a character from a Hans Christian Andersen fairy story. The cobbler was forty-nine, but like so many of the men there he looked twenty years older. He had eight children, he told me, and none of them wanted to learn his trade. "They are too arrogant. This is a humble job." He didn't earn much, but business was fine. "When men are poor they will get their boots mended. In hard times they can't afford to buy new ones." He lived and worked in that one little room, and he had no friends. "Yes, I am happy," he said when I asked.

From Sar-e-sang the Kokcha river valley runs south for 30 kilometers, and then opens into the fertile valley of Eskazer. It is here—two hours' bumpy ride away—that injured miners are treated. When we visited the clinic it seemed abandoned, but then a smiling, almost saintly man appeared. Dr. Khalid certifies two or three deaths a year and treats about five injuries a month from the mine. "Sometimes it is dynamite, sometimes they get hit on the

head with rocks," he said. "And sometimes they just fall down the mountain: those paths are steep." Dr. Khalid sees about fifty cases of chronic bronchitis a month. "They are working without masks," he said. "Of course their lungs are damaged."

From Eskazer some of the earliest lapis donkey trains would have turned east to cross the Dorah pass into Pakistan. Those stones would have been carried down the Indus River, and from there would have travelled by dhow to Egypt. Other, later trains would have carried the lapis north and then west for the long trek to Syria and then via Venice onto the palettes of artists. And it was in this second direction that—saying goodbye to the mines and scratching tenderly at our flea-bites—we turned. We were going back the way we had come, but this time in a jeep that worked.

The European art world had effectively said goodbye, or rather "adieu," to Sar-e-sang in 1828 when a synthetic version of ultramarine was discovered in France. In 1824 the Société d'Encouragement pour l'Industrie Nationale offered 6,000 francs to anyone who could make a daub that even the twenty-five-year-old Michelangelo would have been able to afford—just 300 francs a kilo and less than a tenth of the cost of real ultramarine. Two chemists claimed the prize—Jean Baptiste Guimet of France and Christian Gmelin, from Tübingen University in Germany. They battled over the blues for several years; but Guimet got the cash, and his discovery has been called "French ultramarine" ever since.

Another useful blue pigment had been invented more than a century earlier—by accident and when a paint-maker in Berlin was actually trying to make red. One day in around 1704, Herr Diesbach was settling down to make carmine lake according to a tried and tested recipe—mixing ground-up cochineal, alum and ferrous sulphate, then precipitating it all with an alkali—when he realized he had run out of alkali. He borrowed some from his boss, but did not realize it had been distilled with animal oil. Suddenly, to his amazement, he found blue instead of red in his flask. The clue is in the "animal" element: the mixture had contained blood,

which contains iron. Diesbach had unwittingly created iron ferro-cyanide, which was dubbed "Prussian blue" and was instantly popular, particularly as a housepaint.

A hundred and forty years later, Prussian blue became the basis of something that changed the face of architecture and design forever: the first ever industrial photocopying process. John Herschel was a chemist and an astrologer, and he was also the first Englishman to take up photography. In 1842 he realized that if he held a pattern drawn on tracing paper over photo-sensitive paper and shone a lamp over both of them, the bits that were not protected by dark lines would change their chemical formula in the light. They would shift subtly from ammonium ferric citrate to ammonium ferrous citrate. If the paper was then dunked in a vat of potassium ferrocyanide, the ferrous bits would turn into Prussian blue, while the ferric ones would stay neutral. The resulting ghostly pattern of white lines on blue paper was called a "blueprint," and the word's meaning has shifted subtly to mean any design for the future, whether or not it is in photocopyable form.

Through the nineteenth century Prussian blue became less popular: some artists still liked to mix it with yellow gamboge and use it as green, but most felt it was less brilliant than other blues, and certainly less long lasting. The end of the Prussian blue era is symbolized in a decision by the American crayon company Binney & Smith. In 1958 the company changed the name of its Prussian blue crayola pencil to Midnight Blue. Why? Because teachers were complaining that schoolchildren couldn't relate to Prussian history.

When I returned to London I went back to the National Gallery. I had my best blue stone in my pocket and, feeling slightly fanciful, I stood in front of *The Entombment*, imagining the grieving mother now clad in best violet-tinged *surpar* robes, painted with the lapis I had brought back for her. A French couple walked over to assess the work. "It's rather horrible, for a Michelangelo," the woman commented to her companion, looking at that drab Mary

Magdalene and that odd John the Evangelist. They moved on, but silently I had to agree. It was not his best; perhaps he did well to leave it unfinished.

In fact for many years this painting was not even believed to have been painted by Michelangelo at all, with an all-important "?" following every attribution. National Gallery curators recently described it as "among the most troubling mysteries in the history of art,"[17] adding that although scientific tests suggested it really was the master's hand that drew this strange scene of personal suffering, "pockets of resistance remain." The British forger Eric Hebborn liked to speculate that *The Entombment* was "the work of a Renaissance colleague"—a man who had perhaps read Cennino's book and had a talent for drawing if not for coloring in. "If so, well done!" he wrote approvingly.[18]

## CHARTRES BLUE

Throughout my travels in Afghanistan I had often remembered my other most holy blue: that experience, which I described at the beginning of this book, of seeing blue light dancing through a cathedral at the age of eight and wanting to follow it, wherever it took me. As a child I wanted that recipe for blue to be lost so that I could find it, but then much later I learned that the "Lost Blue Glass of Chartres Cathedral Story" was a myth. We have not lost the recipe for that blue, contemporary glass-makers told me strictly, and I felt foolish for asking. It is a relatively easy thing to make a good blue, and involves certain proportions of cobalt oxide in a melted soup of silicon. And yet there is another more important way in which the myth is based in truth. We have not lost the recipe for Gothic blue; it is just that the world has changed, and we cannot make it anymore.

When a cathedral was commissioned in Europe in the 1200s there were many things to organize. Funding was vital; the site— on flattish ground yet where it would dominate the medieval city—

was important; the craftsmen had to be booked and the wood and stones ordered. It could take decades. Once the walls and the roof were up, it was time to bring in the painters (all cathedrals were painted in bright colors) and the glaziers. It is mostly only the work of the latter which remains.

The men who made the stained glass were strange folk. They were itinerant craftsmen who would travel from cathedral to cathedral, going wherever they were wanted. And at the height of the Gothic cathedral construction craze, it seems they were wanted everywhere, and the best of them could ask high prices. They set up their camps on the edge of the forest. It was a highly symbolic place to stay—the border between civilization and lawlessness. Forests were seen as dark places where strange spirits dwelt, and where ordinary folk should not go. They were therefore the perfect locations, cosmologically speaking, in which to perform the transformational magic involved in making glass. But the forest was also a practical place for the glaziers. Wood, in huge, unenvironmental quantities, was the main raw material—it not only fired the furnaces, but together with sand was one of the two major ingredients of glass.

The metalworking monk, Theophilus, described[19] in the twelfth century how glaziers used three furnaces—one for heating, another for cooling, and the third for melting the blown glass into sheets. The color tended to come from the metal oxides (manganese, iron and others) that were naturally found both in the beech wood and in the clay of the jars that the glass was heated in, and the final hue was hard to predict. "If you see any pot happening to turn a tawny colour, use this glass for flesh-colour and taking out as much as you wish, heat the remainder for two hours . . . and you will get a light purple. Heat it again from the third to the sixth hour and it will be a reddish purple and exquisite," Theophilus wrote, although Vitruvius[20] had written in Roman times about how glass-makers made blue glass (and a sky-blue pigment powdered from it) using soda mixed and melted with copper filings.

Nobody quite knows who the glaziers were—they rarely signed

their names—although we do know of a Rogerus who was brought from Reims to Luxembourg to work on the Abbey of Saint Hubert d'Ardenne, and there is a record of a man called Valerius who fell from a scaffold while installing stained glass in the Abbey of Sainte-Melanie in Rennes, and bounced up unharmed. But mostly it was just known that they came when they were summoned by the Church, that they sometimes spoke in strange accents, and that when they left, the new cathedral was alive with colored light. Mothers may have warned their children to stay away from the glass camps, because they would have seen the gypsy qualities in these men. But if, as a medieval child, you had crept to the fire where they were transforming sand into gems—blowing this beautiful substance into existence at the end of iron blowpipes—and had listened from the darkness, you might have heard wonderful stories of other worlds. They might have discussed the saints and the proverbs that were in the lead frames they were filling with their colors. But more likely they would have talked about the curious things they had seen, and the strange people they had met.

Today our glass-makers don't camp out for days on the edge of the forest, and they have efficient ways of protecting their vats from floating ash and over-flying birds. Perhaps it was those tiny imperfections—meaning that the warm sunlight scattered unevenly as it passed from one side of the glass to another—which made me feel on a day after rain in Chartres that something holy was there too. But perhaps those campfire stories were stirred into the slow-melting pot as well, mixed carefully into the blue and red fluxes, shifting the Gothic glass imperceptibly from the realm of craft into that of art.

## THE VIRGIN'S ROBE

Chartres gave me another postscript to the story of blue—an unexpected one. On my journeys to Afghanistan I had found out

where the color for the Virgin's veil should have come from, and I thought I had found out why it was so often blue. But I had never thought I would find out what color the veil really might have been. And in Chartres, I found an answer of sorts. The reason this town is such a pilgrimage center is because in around 876 Charles the Bald, the grandson of Charlemagne, gave Chartres a special gift. He gave them the veil said to have been worn by Mary, as she stood by the cross and wept.[21]

Today's cathedral is the fifth one on the site; the others were burned down or ransacked and each time, the story goes, the people pragmatically said the Virgin must want something better, so they raised the money and rebuilt the structure. The last big fire was in 1194, and only three things were saved: a set of three saints' windows, a stained-glass picture of the Virgin and Child from 1150, which is now known as "Notre Dame de la Belle Verrière"— Our Lady of the Beautiful Glass—and the famous relic.[22]

The veil shown in the stained-glass picture of "la Belle Verrière" is a pale color, light enough to allow the sun to flood through and depict the young woman's purity. But it is unmistakably light blue, and worn over a blue tunic. Those 1150 glass-makers would have had the "real" veil to model their design on, which is curious, because when you see the precious relic in its gold nineteenth-century box—a humble scrap of material to the glory of which this whole cathedral was dedicated—it is not blue at all. More of an off-white: the faded clothing of the melancholy mother of a martyr. Had he seen it or heard of it, and had he wanted to go for veracity rather than value, Michelangelo could as well have painted his mysterious corner figure with lead white, mixed with a little yellow. And yet if he had, I would not have had this story.

# 9

# Indigo

*Goluk: "We have nearly abandoned all the ploughs; still
we have to cultivate Indigo. We have no chance in a
dispute with the Sahibs. They bind us and beat us, it is
for us to suffer."*

DINABANDHU MITRA, *Nil Darpan*, 1860

*"The fact is, that every one of these colours is hideous
in itself, whereas all the old dyes are in themselves
beautiful colors; only extreme perversity could make
an ugly colour out of them."*

WILLIAM MORRIS[1]

My father lived in India for three years in the 1950s, before he met my mother. He used to tell me stories about Bombay mangos, Madras spices, and a puppy called Wendi, who was a great coconut hunter. But what really caught my attention was the club he belonged to in Calcutta which was, he always said, set in an indigo plantation. I daydreamed of the Tollygunge when I was a child. I wasn't in the least bit interested in the golf course, polo games or colonial bars. But how I thought about the indigo. I imagined tall trees rising to a cathedral canopy, their slim purple trunks

*318*

as lovely as kabuki actors in kimonos. And I pictured men dressed in Gandhi-white robes and pink turbans strolling through dappled glades to tap a rich blue dye into beaten tin pots.

Once upon a time, or actually several times upon a time, indigo was the most important dye in the world. At one point it helped prop up an empire, and then later it helped destabilize it. Ancient Egyptians used indigo-dyed cloths to wrap their mummies, in Central Asia it was one of the main colors for carpets, and for more than three centuries in Europe and America it was one of the more controversial of dyestuffs, and it would have been familiar to people of many nationalities. So it is rather telling that by my childhood in the 1970s I had no idea what indigo was, only that it sounded nice. And many years later, when it came to setting out on my quest, I still casually went off looking for trees.

"Indigo" is a word like "ultramarine"—it refers to where the color historically comes from, rather than what the substance actually is. So, just as ultramarine is a translation of the Italian for "from beyond the seas," indigo is derived from the Greek term meaning "from India." Sometimes the Europeans were fairly slapdash about what they described as coming from India—"Indian" ink, for example, was actually made in China—and they would cheerfully lump anything that came from roughly that direction into the category of Indian things. But in the case of indigo, they were fairly accurate, and so it turned out I had accidentally been right to have started thinking about indigo in India, even if it took me a while to find it there.

Indigo cultivation probably existed in the Indus Valley more than five thousand years ago, where they called it *nila*, meaning dark blue. It spread north, south, east and west as the best things often do—the British Museum owns a tablet of Babylonian dye recipes from the seventh century B.C. which indicates that indigo was already being used in Mesopotamia 2,700 years ago—and when the Europeans turned up in Goa in the early 1500s, greedy for profits from exotic trade, they found enough Indian indigo to be able to throw it into

*Cart full of indigo*

their holds along with camphor and nutmeg (from what is now Indonesia) and embroidered silks from all over the East. Indigo wasn't a new substance to Europe—it had been imported in small quantities since classical times for use as a medicine and a paint (Cennino had suggested slipping a bit of Baghdad indigo into clay to make a fake ultramarine for frescos), but now Portuguese, and later British and Dutch, traders were about to market it as a wonderful dye. They were confident their new color would be a winner. Indigo was not only the best blue they knew, but it had the extra cachet of being from an exotic part of the world with an exotic name at a time when the "mysterious Orient" was just about to be the rage. But before anyone could make a success of this colorful crop from the Indies, the traders first had to deal with what was almost a monopoly on blue held by the European growers of another plant. A plant called woad, which produces indigo, but much less than comes from the plant that is actually called "indigo."

## A FIGHTER'S WEED

Woad is a funny word—it sounds like "weed," and in fact the two words have the same origin. The seeds of this mustard plant, *Isatis tinctoria*, float so easily in the wind and settle in so many different soils that anything unwanted in gardens or fields became known laughingly as a "woad" and later, with a vowel change, as a "weed." It is so prolific that even today it is banned in some American states—Utah is still overrun by the descendants of seedlings planted by Mormon dyers in the nineteenth century, and California and Washington also try to chase away the blues with strict legislation. The British tend to think of woad as a war paint—a symbol of the fierceness of Ancient Britons before the Romans conquered the country nearly two thousand years ago. Schoolchildren learn that Queen Boadicea wore it as she rode fearlessly on her chariot against the invaders, and that the great warrior King Caractacus daubed his body in woad before every battle.

I visited Caer Caradoc—the hill near Church Stretton in Shropshire where Caractacus is said to have made his last stand—on a November afternoon. I tried to picture the wintry morning in 51 A.D. when a band of warriors may have stood there painting their bodies with blue dye and later lost Britain for the Britons. The wind whipped around both the rocks and my ears as I walked up the steep hill; it sounded like distant war-whoops, and made it easy to imagine an upstart leader—the charismatic son of Cymbeline—encouraging his troops before the battle. This was the second time the Romans had invaded. A century earlier, in 55 B.C., Julius Caesar had arrived with five legions, and had fought his way as far as St. Albans. In his *Commentaries on the Gallic Wars*, Caesar wrote about the peculiar practices of the Britons. The men, he said, lived on milk and meat, dressed in skins, and shared one woman between ten or twelve of them. "All the Britons stain themselves with *vitrum*," he continued in a sentence that has been frequently

dissected by historians, "which gives a blue color and a wild appearance in battle."

The question is, was *vitrum* a reference to woad or was it something quite different like glass—the blue paint the Ancient Egyptians used, perhaps? It is impossible to know, but we can be certain that two thousand years ago woad had arrived in Britain—some seed pods were recently found in a pre-Roman grave at Dragonby in Humberside—and it is a fact that the Britons had something of a reputation for body paint. In his *Natural History* Pliny (who was right about things almost as often as he was wrong) asserted that the Britons used a plant called "glaustum" to make themselves blue.[2] Indeed, he continued, young women used to stain the whole of their bodies with it and then process naked at religious ceremonies, their skin "resembling that of Ethiopians." But this time, in 51 A.D., no religious ceremonies (nude or otherwise) seemed able to appease the Celtic gods. Over the previous nine years, since they landed in 43 A.D., the Romans had proved to be unstoppable as they moved slowly up the country, and Caractacus had become a guerrilla leader.

There are two ways in which the half-naked Britons in his small army could have stained themselves with woad, and they encapsulate the problems that dyers using woad and other indigo plants have struggled with over the centuries. Because the curious thing about these crops is that despite their reputation they cannot easily be made into dyes. If you take the green leaves of the first-year growth of the woad plant (the second year it contains almost no indigo), crush them, macerate them and leave them to ferment and dry, you can make a blue compost. I once tried painting my body with woad compost suspended in alcohol. But the part that I had daubed on my arms disappeared with the sweat of the first hill I walked up—which suggests the color might have been too temporary for battle—although inexplicably the woad that I had painted onto my feet lasted in uneven blotches for several days, attracting concerned comments about my "bruises."

However, if Caractacus's dyers had really wanted to fix the woad

as a dye they would have had to go through a complicated and almost mystical chemical process[3] with their vats, down in the Iron Age village that you can still just see signs of at the bottom of the hill. They would first have had to remove the oxygen from the vat—by fermenting or "reducing" it—after which the liquid that remained would have been a yellowish color. The magic of indigo is that the blue color only appears *after* the object being dyed (whether it is a textile or an arm) is taken out of the pot, and meets the air again.

And this second way—smearing blue-green scum (which had been scooped off the top of the pot, and which smelled like rotten pondweed) onto their pale torsos—is perhaps the method the Ancient Britons used to dye themselves a semi-permanent blue. But why would they have done it? Was it just to scare the Romans—or would that ritual painting have had other purposes? One possible reason for warriors to use woad is a highly practical one—it is an extraordinary astringent. Wearing it into battle is rather like rubbing on Savlon *before* walking through a cactus plantation, and having it available after battle is like preparing a primitive field hospital in advance. The liveliest proof that I have heard of woad's miraculous healing ability comes from a tattoo expert in Santa Barbara, California. Pat Fish has punctured thousands of Celtic crosses onto human skin since she learned to use tattoo needles in the early 1980s. Actually she's done most designs except the Devil ("Anyone who would feel comfortable with Satan on their skin I don't feel comfortable with touching their skin"). But the one thing she will never make again is a tattoo out of woad.

"It was about five years ago," Fish said when I called her. Her client had a theory that Caractacus and other Celtic warriors had woad tattoos—and he decided to test it out on his own body. Woad was forbidden in California, because it is such a weed, so the man made it into a tincture and mailed it from his home in Canada. "He was scared to take it over the border by car with him, just in case he was caught." It was rather endearing, she agreed, that a

man covered in macho body markings should be afraid of violating a local bylaw. Fish tattooed a Celtic knot on his ankle, using the tincture as a pigment. On day one, it looked good, but two days later the leg started to swell. "On the fourth day things were worse. We went to the doctor, who said, Oh, Pat, what *did* you do?" she remembered. It was then that she learned that woad was so good for wounds that it had healed the punctures from her needles and allowed the skin to reject its own pigment. "There was this shiny pink tissue all raised on his ankle in the shape of a Celtic knot. I've never seen such a perfect scar. But there was no blue in it at all."

The man's theory was not altogether unfounded, however—indigo from various plants has been used in tattoos as far afield as Nigeria and Persia, although probably not in tincture form, and some historians have suggested that Caractacus may not have needed to paint himself from a fermenting woad vat because he was already permanently painted. In the 1980s a number of bodies were discovered in the Lindow peat bogs in Cheshire, near Manchester. They caused considerable excitement—one murder suspect even confessed to killing his wife—before scientists identified the bodies as having lived in 300 B.C. Very cautiously—because the bodies were rotten, and the peat contained its own trace minerals—archaeologists confirmed that metals had been found on the skin of at least one body, and speculated that the Celts may have been covered with blue tattoos.[4]

Tattoos in European culture have often represented stepping outside the boundaries of society, whether to indicate bravery, piety (Armenian Christians used to mark themselves to show they had made an important pilgrimage), impiety (one of the paintings in William Hogarth's satirical *Marriage à la Mode* at the National Gallery in London shows a woman with a tattoo etched onto her breast: his eighteenth-century audience would have recognized this as a sign of a convicted criminal), machismo (in Hong Kong, Triad members can be identified by their dragon tattoos) or simply eccentricity. And the pigments they have used have been just as

varied as the social signals they have given. The Tahitians used to make their tattoo pigments out of burned coconut husks; native American tribesmen used to put spiders' webs and burned fern ash into their tattoos; Maoris used to mix soot made from burned caterpillar corpses mixed with fish oil[5] for their sacred *mokos*, while European sailors have tended to use charcoal soot for the "indigo" color (black on pale skin tends to go blue), or even gunpowder—which burns into human skin leaving permanent marks.

The arrival of brighter colors on the tattooist's palette coincided with Impressionism. As artists queued up to buy new paints for depicting dancers or water lilies, tattooists were experimenting with the same colors for making mermaids and roses. One of the first tattooists in the U.K. to experiment with new colors was a famous artist called George Burchett. The story is that Burchett was one of the first to try Winsor & Newton's Winsor Blue and Winsor Green paints. When Burchett died in 1953 his company continued to sell pigments bought from L. Cornelissen & Sons artists' supplies shop in London—according to Lionel Titchener, who is head of the Tattoo Club of Great Britain and also founder of the British Tattoo History Museum in Oxford which, when I visited, was in an untidy state in his back room, owing to artifact overflow. Titchener confirmed that by the late 1950s, U.K. tattooists were beginning to import pigments from the United States—they had all gone through a laboratory test to make sure they were safe. And by the mid 1970s very few tattooists were using artists' pigments for their colors. "In the early 1970s, Ronald Scutt published his book *Skin Deep, the mystery of tattooing*," Titchener told me. "He did some research on the pigments, and sent me a list of Winsor & Newton colors that he considered were safe to use for tattooing." The colors used today are similar to the Winsor Blue and Green used in the old days "but today they are all laboratory tested, to check for any harmful impurities."

Titchener has recently become a consultant to the European Union—which has expressed its intention to limit the pigments used on Euro-tatts. However, the problem is twofold. First, there is

something about tattooing that is all about *not* being part of a world that bureaucrats can bind up in red tape.[6] Second, the onus is on the tattooists to prove the pigments are safe "and no chemist in the world will put it in writing: they are much too afraid of getting sued." As for Caractacus, if he did have tattoos they would probably have been colored with copper pigments, or perhaps iron. Either way the European Union would probably not have approved.

## WOAD AND THE MIDDLE CLASSES

It was in fact a European Union-style protectionist policy which caused the greatest problems for indigo merchants wanting to introduce their new dye into sixteenth- and seventeenth-century Europe. Nobody had bargained for the intense lobbying power of the middle-class woad growers. The medieval German city of Erfurt, including its university, was built on this blue, while many of the most splendid houses in Toulouse were also constructed on the profits from woad. The outside of Amiens Cathedral in northern France shows two woad merchants, carrying a huge sack of blue — testifying to the wealth of the dyers who could afford to help sponsor the construction of the church. The first part of the woad-making process involves taking the fresh leaves, grinding them to a pulp, rolling them into balls the size of large apples and then leaving them to dry in the sun. The French call them *cocagne*, and even today *"pays de cocagne"* (which can rather prosaically be translated as "woad balls country") is a popular metaphor for a land of riches.

"I had men and horses, arms and wealth. What wonder if I parted with them reluctantly?" asked Caractacus some months after his defeat on the Welsh borders, in a famous speech requesting clemency that resulted in him being pardoned and allowed to stay in Rome as a celebrity exile.[7] But 1,500 years later middle-class merchants in Europe were damned if they were going to have to

say something similar to the indigo merchants. Of course they fought back—and at the beginning it looked as if they were winning. In 1609 the French government attached the death penalty to the use of indigo rather than woad. In Germany the dyers made annual declarations that they did not use the "devil's dye." However, anyone wanting to ban indigo had the problem that—once the dyeing was finished—it was impossible to detect which of the two blues had been used. So the defenders of woad had to rely on the dyers' honor and—perhaps more reliably—on the gossiping of neighbors.

In England the woad lobbyists managed to get indigo certified as poisonous—it isn't—and because of this it was officially banned until 1660. Nobody paid much attention, however: in England there was less support for woad than on the Continent as most was imported. It was not that woad did not grow well, but the problem was the drying: the prevailing wind is from the southwest and it seems to bring most of the Atlantic with it.[8] In Britain the law was cheerfully defied from at least the 1630s onward as the gentlemen of the East India Company made sure the dyers of blue were amply supplied with the illegal Indian import. Woad was fine for coloring wool, people found, although adding Asian indigo to the woad vat resulted in a cheaper and stronger color. But to dye the cotton that was now beginning to arrive from India, dyers realized they most certainly needed the stronger vat that came from imported indigo. Most blue vats in Europe were, in fact, a mixture of the two plant extracts.

The commercial dealings of the East India Company men were, reluctantly, supported by the Puritans. What could these stern wearers of black and white do, after all, to get their dark clothes darker and their white clothes whiter? For while woad or indigo are important as "bottom" colors for black dyes (to stop the logwood black from fading quickly in the sunlight) another factor is their ability, in the form of laundry blue, to give white clothes a new lease on life. In poorer parts of India you can sometimes see older

gentlemen in the streets radiating what seems to be ultraviolet from their white clothes. A taxi driver in Delhi explained it to me one day: "In India white clothes have to be washed so many times that in the end they are quite blue." But what a very admirable blue, he added proudly, "and so much better than throwing old white clothes away as you do in your European countries."

Despite the energetic promotion of indigo from the mid-seventeenth century in Europe, woad wasn't wiped out — quite. For years it was still often used as a base dye in indigo vats to help the fermentation process — as recently as the 1930s it was used with indigo to dye police uniforms in Britain, and in the past few years the European Union has backed a £2.2 million project to (in its own words) act as "an agronomic blueprint" to establish natural indigo as a commercial product, used in paints, textile dyeing and printing inks. The ten partners — from England, Germany, Finland, Italy and Spain — of this "Spindigo" project are experimenting with woad and other indigo plants to try to overcome the problem that both the supply and quality of natural indigo tend to be inconsistent. This is the possible future for woad. But by the late seventeenth century woad was mainly out, and indigo was very much in.

## INDIGO IN THE OTHER INDIES

Many years after hearing my father's stories of the indigo plantation I found myself in Calcutta. And I couldn't resist visiting the Tollygunge club. The colonnaded white building was being restored. Men dressed in grubby white dhoti loincloths hung off ladders and swung on chandeliers to restore this place to the grandeur it felt it deserved. There was a distant shout of "fore" from the golf course, and the chef was serving mulligatawny soup and lamb with mint sauce for lunch. But of the indigo — or rather of my childhood vision of indigo — I saw no sign at all. Perhaps I had missed it because I was looking for trees, and as I was to learn later it actually grows as a shrub. But probably it had simply disappeared from

view, just as in the early 1600s indigo disappeared from the list of major export commodities from India.

The reason for this disappearance was not because blue was suddenly bad—quite the opposite, it had never been so popular—but because the other Indies had started to grow it, and they could do it more cheaply and better. The European traders may have found a way around the legal injunctions against importing indigo, but this crop was to prove to have other tricks up its sleeve. It wasn't so much about the sky blue being mixed with stars as about it being mixed with meteoric dust. Soot and dust were nearly the same color as indigo, and unless buyers were careful they found their "nil" (from the Sanskrit) was worth less than they thought. It wasn't always the indigo farmers' fault: some of the adulteration happened by accident. But by the seventeenth century Indian indigo had acquired a bad reputation for impurities and the industry had restructured itself for other economic reasons. Indeed, it is ironic that the point at which the English began calling this dye "indigo" from the Greek and not "nil" was when the supplies from India slowed down. In fact, if the dye was going to be renamed in the seventeenth century, it really should have been called "caribeego."

The French started the West Indies indigo industry—on the islands of Sainte Domingue (now Haiti), Martinique and Guadeloupe. The climate was perfect, but that was not the only reason for indigo's success. Indigo is a crop that has involved a great deal of misery—because it has usually relied on forced labor. In the West Indies this meant slaves. It was not only the Europeans who did it this way. The Yoruba slaves on the West Indian plantations may well have known indigo cultivation in their home villages in West Africa: there too, for the thousand years or so since it had been introduced by Arab traders, it had usually required slaves to grow it. It was used to honor the god of thunder and lightning, and even today the Yoruba of Nigeria are still famous for their indigo textiles.

By the 1640s Caribbean indigo was eclipsing Indian blue: in

1643 the governor of the East India Company[9] called the rival French product "deceitfull and counterfait," although of course the real problem for him was that it was rather good quality. And then everything changed. By 1745 the English were at war with the French, and suddenly the French source of blue was lost. The English Admiralty started to look elsewhere for suppliers. They could never have expected that their supply problems would be partly answered by a small industry kick-started a few years earlier by a teenage girl with an absent father, a sick mother and a problem with agricultural saboteurs.

Eliza Lucas is a remarkable figure in the story of indigo.[10] She was born in Antigua, where her father was an officer in the English army. In 1738, when she was fifteen, she, her parents and her sister Polly went to live in Charles Town, which she described happily in letters as the "gayest" town in South Carolina (a reputation it maintained: it was to be the place where the scandalous Charleston dance was invented in the 1920s). The plan was to start farming the three plantations they had inherited from Eliza's grandfather and to make a new life away from the battlefields. But in 1739 Lieutenant Colonel George Lucas was drafted back to Antigua, in preparation for what everyone realized was to be an inevitable showdown with the Spaniards. Eliza's mother was ill, or at least hysterical, but for him to refuse the commission would have been treason. So he left Eliza in charge of the farms. Father and daughter would write to each other often, and their letters would become part of America's heritage, but they would never see each other again. George would die eight years later as a prisoner of war in France, and Eliza would become one of the most famous women in early American settler history. This was partly because she was the mother of some of her country's earliest political sons—Thomas and Charles Cotesworth Pinckney. But it was also because of indigo.

Eliza Lucas Pinckney is portrayed in American history books as a certain variety of nation's mother, an eighteenth-century exam-

ple to her twentieth-century sisters. She is usually shown as an enlightened young woman who educated her slaves, put family duties first, and most importantly embraced with calm fearlessness those American virtues of risk-taking and hard work. Stories about Eliza make a great deal of how she—as she told a friend in a letter—used to rise at five, "read till Seven then take a walk in the garden or field, see that the Servants are at their respective business then to breakfast." The first hour after breakfast was spent playing music, the next hour "In recolecting [sic] something I have learned least for want of practise it should be quite lost," and the rest of the day was spent teaching her sister and two slave girls to read, and in what she called "scheming." Scarlett O'Hara, eat your fictional heart out: this woman was the real thing—a Southern belle who controlled her life exquisitely. She was as spirited as she was devout, *and* she got her man—in the form of a lawyer called Charles Pinckney, the grandson of a privateer who had gone to Jamaica in 1688. Pinckney proposed to Eliza a scarcely decent four weeks after his wife died in 1744. They married four months later, when the bride was twenty-one.

But this was in the future. Eliza's connection with indigo began in 1739 with the arrival of an envelope from Antigua, from which a handful of yellow seeds spilled out. While Eliza was a pragmatist, and her mother a doubter, her father was a dreamer. George Lucas conjured up images of lucrative crops springing fully ripened from the paper twists of seeds he would send tucked into his correspondence. One time he sent alfalfa, another time he believed ginger plants were going to solve the Lucas cash-flow problem. But the one idea that really triggered both their imaginations was indigo. "I have greater hopes for the indigo than any of the rest of the things I have tried," she wrote.

The first harvests were wildly unsuccessful. For two reasons. The first was the weather: "we had a fine crop of Indigo Seed upon the ground . . . and the frost took it before it was dry," Eliza wrote apologetically. "I picked out the best of it and had it planted but

there is not more than a hundred bushes of it come up." The second reason was more worrying: sabotage. In 1741 George sent a man called Nicholas Cromwell to help Eliza process the dye—to ferment it in vats and dry it into cakes for export. Cromwell, however, did not want her to succeed—after all, why should he compromise the value of his own family's crop back home—and he deliberately ruined the vat. He "made a great misery of the process . . . said he repented coming . . . and threw in so large a quantity of Lime water as to spoil the colour," Eliza recalled many years later in a letter to her son Charles Cotesworth. At the time she had told her father that Cromwell was a "mere bungler," and had fired him.

The following year, she tried again—Eliza was nothing but determined. And to her dismay the crop was eaten by caterpillars and shrivelled by the sun. The fourth year was even worse, and it was only in 1744 that Eliza produced South Carolina's first successful harvest of indigo. Later she gave seedlings to other plantation owners—on the theory that if they were going to grow enough South Carolina indigo to supply the needs of English dyers, then they needed to present a united front. By 1750 England was importing 30,000 kilos[11] of indigo from the Carolinas, and by 1755 the export total had reached nearly 500 tons. This was not the first time that indigo had been grown in the Americas. There had been some attempts by settlers in the Carolinas before, and other indigo crops had been grown in other southern states. Eliza would have known about these, but perhaps she did not know that other indigo species had been used traditionally by native Americans, and that they might have withstood the weather and insects better than her imported seeds.

For centuries the Mayans in the Yucatán peninsula had made a vivid turquoise for their frescos by mixing a local species of indigo with a special clay called "palygorskite." Europeans did not understand the way the pigment was made—by trapping indigo molecules in a lattice of clay, and imprisoning them—until 2000.[12] It

was so bright—as intense as the copper-enamelled tiles on the most beautiful Persian mosques—that up until the 1960s people believed Mayan Blue was made from metal, not from a plant. The Aztecs went one step farther than the Mayans: they used indigo as a medicine as well as a dye, called it *iquilite* and worshiped it. They also, memorably, daubed their sacrificial victims with it before they pulled out their hearts.[13] When the Spanish arrived and conquered, they banned the death symbolism but kept the pigment.

## MAYAN BLUES

The Dominican church of San Jerónimo Tlacochahuaya is one of the treasures of the Oaxaca Valley in central Mexico. From the outside it seems like a formal example of early Spanish baroque; but inside it is a sixteenth-century riot of painted flowers and tendrils making a joyful jungle over all the inside walls. It is a celebratory Garden of Eden, and is a striking contrast with the more orderly depictions of nature in most European churches of that time. The designs were painted by indigenous artists. They used their two main native pigments—indigo and carmine—and today the original paints are there, still bright even though they are largely unrestored. But if the colors did not fade inside the church, then they certainly faded from memory outside it. For almost the entire twentieth century, cochineal, indigo and almost all other natural pigments were scarcely even thought about in the Oaxaca Valley, or indeed anywhere else in Mexico. But then in the 1990s there was a change in European and American fashion for so-called "natural" things, and suddenly *everyone* started looking at the old colors.

It took me an hour to cycle from San Jerónimo church to the village of Teotitlán del Valle. Almost every village in the Oaxaca Valley seems to have its handicraft speciality—one does black pottery, another seems to make its living from beaten metal nativity scenes, while another specializes more modestly in tortillas (and those

women walk for miles every morning with a hundred flat breads balanced in baskets on their heads). But Teotitlán is Rugsville, a village with three thousand souls and at least four times that many carpets decorated with Picasso doves, Zapotec zigzags or cute renditions of the Mexican countryside complete with big hats and donkeys.

Benito Hernández's place is the first homestead I came to after I had turned off the main road. It was a hot day; I wanted a rest and some water before pushing onto the village three kilometers away, and what is more I could see a big sign outside advertising "Natural Dyes." I couldn't resist, so I dropped in to hear his story. A couple of bored-looking weavers were standing at two looms under a wooden shelter. I was disappointed to see that they were making cheap carpets, using thick synthetically dyed threads. But the sheds behind told a different story. In one corner there were cochineal beetles sitting fatly on prickly pears ready to give up their blood to the carpet cause.

Benito was away tending his fields, so his younger sons, Antonio and Fernando, showed me round. *"Pase por aqui,"*—pass this way—twelve-year-old Antonio said politely, with the well-practiced air of a tour guide. Together we poked our noses into terracotta pots that lay covered and half buried in the earth. They stank. Antonio took a stick and pulled out a soggy lump of wool from one smelly brew. The dye was from wild mangrove plants, he said, and would turn the wool into the color of coffee. They did not have indigo just then, but he told me that indigo (which his father was apparently cultivating in his own fields) smelled almost the same, although it was of course bluer. I remembered that the year before I had seen a similar pot—terracotta orange and with a heavy lid—in a weaving village on Lombok Island in Indonesia. Smeared around its lip, almost as if it had been caught in the illegal act of drinking the sky, was a light cerulean stain. The villagers would mix the indigo with ash, they told me, to make it alkaline. And sometimes they would keep dipping the wool in and out for a year or more, "to make it as blue as we can."

In one part of the shed there was a battered wooden cupboard, full of intriguing pots and bags and smells. Antonio took out a pestle and showed me how his father rolled dried leaves from the indigo bush over a slab of volcanic stone. It was now stained blue, but it also contained husks of flour. It had been his grandmother's, the boy explained; she had used it for making tortillas.

"It's so expensive to use indigo," said Benito, joining us just then, his fingernails dirty from the fields where he had been tending his dye plants. He explained how ten years earlier he had realized that the only way to embrace the future was to delve into the past. "The foreigners were asking for natural colors, and we had forgotten how to make them." So he started asking questions. First he asked his hundred-year-old grandfather, "but he didn't remember much." Other old people could remember even less, so Benito did the research himself—learning how cochineal could make sixty shades of red, how yellow could be made from turmeric root from Chiapas, and how indigo could, with the right recipe, dye wool all the shades of blue, "from turquoise to sapphire."

Benito explained how he did it. He took the plant then he dried it, rolled out the leaves on that heirloom tortilla stone, and fermented the powder in nopal juice—the juice of the same cactus leaf on which cochineal beetles live—which was like a natural sugar. "We do that for six months, and when we take it out of the pot it is green like clay," he said. Like clay it could be molded in their hands, and when they left it in the sun it turned as blue as midnight. Did he use urine? I asked. Benito shook his head. "The old people told me to but no I don't." He paused. "It's so hard to get urine nowadays." I laughed, but he was being serious.

He was well advised, certainly, not to bother: the stench would frighten the tourists away, and today there are many more pleasant chemicals to use. But not so long ago stale urine, containing ammonia, was a standard addition to an indigo vat, as a reducing agent. It was one of the cheapest ways of casting the spell to transform indigo from a pigment into a dye. And it was perhaps one of the rea-

sons that, where there was a caste system, dyers were usually among the lowest of the ranks.

In the eighteenth century the main source of urine for the whole of the English dyeing industry was in the North.[14] History has rather generously rewritten the story of Newcastle upon Tyne, and credits the city for exporting coal and beer. But two hundred years ago its citizens peed for England. It seems extraordinary now to imagine first that London could not provide its own natural resource, and second that Newcastle should have organized an efficient system whereby its people would have been—presumably—paid pennies while spending them, and where pots of urine were transported around the country by ship.

In other parts of the world—including Pompeii in the first century (where archaeologists found a urine pot outside a dyer's shop for passers-by to make their offerings) and parts of Scotland even as late as the twentieth (Jenny Balfour-Paul tells of how housewives in the islands used to keep a urine pot permanently on their peat fires for dyeing Harris tweed[15] with woad)—the local people used to provide what was needed. And indeed, if Benito ever runs out of his commercial reducing agents, he has, if he but knows it, an excellent natural resource in his two younger sons. The best alkaline ingredient for the vat is apparently the urine of a pre-pubescent boy.

I cycled up to the village, and found a bewildering choice of both stories and rugs. Almost every house sign advertised "anil" and each weaver had alarming stories about how their rivals pretended they were using natural dyes when they were not. Overwhelmed, I paused to return my bicycle—and by a curious coincidence I met precisely the person who could answer my questions. John Forcey had been a Methodist missionary in Oaxaca for many years, but more importantly for my own quest he had just written a book[16] specifically about the dyes used by a young prizewinning couple living in Teotitlán. He could take me to meet his weaver friends if I liked, he said. I liked.

I was surprised at how young they were. María Luisa Cruz was

twenty-seven, Fidel a year younger. While Fidel kept weaving, making a distant clack-clacking in another room, María Luisa took us into the display room, and we sat in the semi-darkness, talking. "It was hard to get started," she told me. "We were teenagers and we had just got married." The normal pattern would have been for them to work for their parents until they could support themselves. "But we wanted to be independent." They had the skills—Fidel had been carding wool since he was five and weaving since he was twelve—and they certainly had the dreams. But they didn't have the pesos. Synthetic dyes cost money, and they did not see why they should spend it when the hills were full of free colors. So, in their early days of marriage, they would wake up early and wander the hills and eventually—with a smattering of ancient knowledge and a mass of youthful enthusiasm—they found their first weaver's "paintbox." They discovered salmon-pink colors in the *muzgo de roca* rock lichens, deep browns in cooked wild walnuts, and blacks in the branches of mimosa trees. But it was in the pomegranate— its fruit, rind and bark fermented and stewed—that they found the most beautiful set of natural dyes, running from deep olives to burned oranges to gold.[17]

Then María Luisa's tone suddenly changed. "It is mysterious working with color," she said, leaning forward to impart a different kind of story. "If an agitated or angry person sticks their nose into the room where we are dyeing wool, then"—and she paused for effect—"the indigo will not *subir*." I turned to John for elucidation, but he had not only stopped interpreting but was suddenly standing on the other side of the showroom, apparently examining the diamond details on a carpet with tremendous interest. He reluctantly interpreted María Luisa's theory that the presence of angry human energy in a room could change a standard chemical reaction and stop the dye from fixing. "At first I didn't believe it myself," she continued, unfazed by John's reaction. "But then last year some Japanese tourists came into the room where we were dyeing. They were all noisy and with cameras clicking, and afterward

nothing we could do would make the dyes fix." Mischievously I asked John why he was uncomfortable with this: couldn't this be a reminder that it is a very miraculous universe out there? "Obviously I don't agree," John said quietly. "But they are my friends, and I don't want to upset them."

As I write this a few months later in the University of Hong Kong library, someone has just sat down at the desk beside me. He has removed his books loudly from a crackly plastic bag while his phone has started to emit metallic Mozart. He is charged with the swirl of the city; his noise and energy are disturbing my concentration. I can understand how the indigo may have felt. In her book *Indigo*, Jenny Balfour-Paul includes a section on the "sulky vat"— a folk theory that seems to appear wherever indigo is made. In Java the dye was said to get depressed when a husband and wife fought; in Bhutan pregnant women were not allowed near the vat in case the unborn baby stole the blue. But my favorite story was of how women in the High Atlas Mountains of Morocco believed the only way to deal with a vat that didn't work was to start telling outrageous lies. Dyers were known for deliberately spreading "blackness" around the community. Maybe it did improve the blue, but it also gave a wonderful structure for a community to deal with vicious rumors, and to dismiss negative stories as nothing more than a failed indigo vat.

Perhaps it was the rumor of a cantankerous djinn in the pot, or perhaps it was its resemblance to the sky, or perhaps it was the way the color appeared magically, once the textile hit the air, but indigo has often been considered a mystical color. And one of its mysteries today is that it is part of the spectrum—one of the seven official colors, and yet the one that doesn't quite belong. Should indigo be here at all, having a separate chapter to itself? I'm glad it is, glad I didn't have to squash its stories apologetically between blue anecdotes in the previous section. But if you look at a rainbow it is hard to find a stripe of midnight in the place where blue fades to violet. Indeed, some people argue that it isn't there at all.

## ISAAC'S INDIGO

Indigo gatecrashed the rainbow party at the time of the Great Plague in England. It is not a coincidence: many things changed between 1665 and 1666. London alone lost around 100,000 people, all the universities closed down, and a twenty-three-year-old called Isaac Newton was one of thousands of students who were sent home. Instead of studying at Cambridge he stayed in Lincolnshire and spent the time making sense of the world, at a time when it probably made less sense than usual. It wasn't just the plague that would have been confusing; Newton had been brought up as a Puritan, and yet five years before, in 1660, the coronation of Charles II had marked the beginning of Restoration decadence and Catholic extravagance.

That year, his room was the center of the expansion of human knowledge. From behind the door, which he mostly left closed, Newton began to understand the world in terms of absolute physical rules. He crystallized his understanding of gravity; he began to formulate theories of the planets; and with the help of two prisms he had picked up at a local fair, he discovered that the colors of the rainbow were held within white light. Not only did he start putting forward theories that colors were varying wavelengths of light, he also upped the list of colors in the official rainbow from five to seven, adding orange and indigo and giving Mr. Roy G. Biv his name.[18] The reason he probably opted for seven was because it was a nice cosmological number. We remember Newton as a scientist, the man who opened the way to modern thinking. But in fact he was also a sorcerer—an alchemist, a most unusual Christian by today's reckoning, whose understanding of the world embraced its total mystery as well as its all-encompassing rules. For Newton, six was insignificant. But there were seven planets (Pluto and Uranus had not yet been spotted, although ironically the telescope that Newton helped improve would ultimately ruin the neatness of the sevens); there were also seven days of the week, and seven musical notes, and he

was damned if there were not going to be seven colors of the spectrum. Curiously, in China there are believed to be five elements, five tastes, five musical notes and five colors (black, white, red, yellow and blue), so the idea of coinciding numbers is shared between the two cultures, even if the numbers themselves are different.

But why indigo? What was indigo to Newton, apart from the color of the naked bodies taken out of the plague houses? As a dye it was controversial—it would have been talked about a great deal when he was a boy. A couple of generations before, the main blue in Lincolnshire had been woad; then in danced indigo from India like Bacchus from his revels. But it was usually seen as a dye rather than an actual color. If Newton wanted a seventh shade to make up his mystical harmony of colors, he could have picked the turquoise[19] that separates green from blue, or he could have separated pale violet from deep purple as the spectrum disappears into darkness. But he chose indigo, and he chose it to separate blue from violet.

We think today of indigo as being a midnight blue—the color worn by the navy, or perhaps the color of jeans, which were originally (after the Bohemian immigrant Levi Strauss invented them during the California gold rush in around 1850) dyed in France with indigo grown in the West Indies.[20] But as we also know from jeans, which can range from stone-washed pale to nearly black, indigo can give many different results. In the eighteenth century English dyers used to classify many official shades of indigo, which (from light to dark) included: milk blue, pearl blue, pale blue, flat blue, middling blue, sky blue, queen's blue, watchet blue, garter blue, mazareen blue, deep blue and navy blue—and one word for woad in French is *pastel*, which suggests paleness.[21] Who is to know what shade of indigo Newton had in front of him when he was inspired to give his rainbow color that name? Could he have had a bedspread in pearl blue in his room? A friend's milk-blue handkerchief on his desk? Perhaps, when he made his decision, Newton was just thinking of one of those.

Sitting in their marbled libraries, nineteenth-century thinkers

argued passionately about why the Greeks didn't seem to have a word for blue—British Prime Minister William Gladstone even suggested they didn't have a word for it because they were color-blind to it. So it is appropriate that it was an Englishman who gave the modern rainbow not one blue but two.

## A REBEL'S COLOR

In May 1860, 116 years after Eliza's crop started to make an impact on the American economy, a man called Plowden Weston addressed an audience at the Indigo Hall in Georgetown, South Carolina. It was a boring speech which went on for so long that his listeners can hardly have avoided drowsing off—I did the same myself for a moment, poring over the leaflet[22] 141 years later in the well-heated New York Public Library. The moment of interest (for me) was when Weston spoke of the utter irrelevance of the Winyaw Indigo Society, which he was addressing. "The excellent men who founded it probably thought that the business by which they gained their properties was likely far to exceed in duration the infant society which they put in being," he said. But of their grand-children and great-grandchildren, of whom many were in his audience: "not one . . . even remembers the cultivation of indigo."

Mr. Weston's audience in South Carolina would not have disagreed. Indeed, the observation would probably have earned him a (rare) murmur of appreciative laughter. But just two months later, and on the other side of the world, a group of men who had been forced to remember the cultivation of indigo would start a series of riots. In the early nineteenth century indigo had returned to India with tremendous energy. England had lost America, and also much of the West Indies. But its citizens still needed blue. What an excellent idea, someone in the East India Company must have thought, to turn back to India for the bulk of England's dyeing requirements. It was just bad luck for some of the Indians that they did.

In Hindu India, blue is often a lucky color, the color of Krishna,

the god who dances through the world, making both love and fun. And on the island of Java[23] where Hinduism arrived in around the fourth century A.D. (and did not give way to Islam until the thirteenth century) you can still tell that a shadow puppet represents a noble character from its blue or black face. So it is ironic that the history of indigo over the past four hundred years has not been noble or lucky at all for those who have been forced to be involved with it.

In 1854 a young artist called Colesworthey Grant made a visit to India. Before he left he made a promise to his sisters that he would write regularly—and five years later the letters were published, along with some 160 engravings, as *Rural Life in Bengal*.[24] I read them in the sprawling Indian National Library in Calcutta as swirling fans almost turned the pages for me. Today his letters are important documents about life on an indigo plantation, although I cannot help but feel that the Grant sisters must have been disappointed to plow through so many pages of technical information lightened by almost no brotherly gossip about the colonies.

Grant stayed for a long time (probably too long, as far as his hosts were concerned) at Mulnath, the home of a planter called James Forlong. His host—he told his sisters—used to rise at four and then spend the morning riding twenty miles or more around the property. He told his servants in advance where he intended to take his breakfast, and Grant was much impressed to see that when he arrived at the chosen place, toast and tea would be hot and ready, the servants having "walked there through the night." Grant noted with great excitement the air of animation around the factory when it was time to gather and process the indigo. The farmers would bring in their indigo to be checked by a man "who with an iron chain of precisely six feet in length measures round the girth of the plant, and as much as this embraces is termed a bundle." The system was open to abuse—if the measurer pulled the chain tightly, the farmer would get less for his leaves—so there would be plenty of squabbling and bribery involved.

About a hundred bundles were placed in each vat—which measured about seven meters square and a meter deep—and clean river water was pumped in. "The liquid, of a dull or sometimes bright orange colour, but at first of horrid odour, is allowed to run out," Grant wrote to his sisters with an artist's eye for color. "As it spreads on the floor, the orange colour is exchanged for a bright raw green, covered with a beautiful lemon-coloured cream or froth."[25] The leaves and branches were then removed (and dried as manure or fuel), at which point the real action started, with ten men jumping into the vat, up to their hips, armed with large flat bamboo oars.

*Colesworthey Grant's engraving of workers beating the indigo*

It sounds like a vile job—but rather to his surprise, Grant concluded that the workers seemed to be enjoying themselves. They had been brought in from the tribal areas 200 kilometers away, and their task involved leaping energetically around the vats and beating the liquid with their oars "until the whole contents [were] in a

whirl" and the surface became covered with heaps of blue foamy soapsuds. For Grant it had the atmosphere of a party, full of songs and joking and a group dancing action that reminded him of the quadrilles he and his sisters had learned in Surrey. What was more, when they emerged after some two hours of indigo aerobics, the men were as deep dyed as Caractacus's woad warriors—and far from minding they celebrated their wild appearance with plenty of laughter. They were not so much "blue devils," Grant concluded, as "merry devils."[26]

By contrast, however, there were other people who were not merry at all when it came to dealing with indigo—and those people were the farmers. It was not just the fact that they had to pay bribes to the measurers and other plantation workers that the farmers objected to. It was that they had to grow indigo at all. The problem lay in the system. English settlers were not allowed to own more than a few acres[27] (the loss of America, when settlers demanded their own government for their own land, was too recent and too raw), so they had to persuade Bengali farmers to do the work for them. But the farmers often wanted to grow rice on their land, not indigo, so the English settlers (who were called "planters" even though they were by law not allowed to do much planting) tended to resort to tactics that usually worked: beating and bullying.

Colesworthey Grant's host—who had started a school and a hospital and was generally well respected in the community—was one of just two liberal planters in Bengal in the 1850s. The others were harsher men—often from the lower classes and therefore scorned by the better-educated administrators—who thought nothing of throwing farmers in prison or sentencing them to be whipped for not repaying money they had been forced to borrow.[28] One of the most notorious planters was a man called George Meares, who regularly burned down the homes of farmers who would not grow indigo for him, and who in 1860 managed to get an order passed forbidding rice to be grown on lands that had ever grown indigo. A series of events that have been dubbed the "Blue Mutiny," and

which would eventually lead to the curbing of this iniquitous system, started a few weeks later.[29]

It started in the village of Barasat—one of the plantations closest to Calcutta. The farmers began a noisy protest, and all around Bengal men followed their lead—and were thrown into prison hundreds at a time until the cells overflowed. There were rumors of a plot to kidnap the Viceroy, Lord Ripon—upon which the newspaper *The Englishman* declared that "we are on the eve of a crisis."[30]

Much later, the missionary James Long would recall sitting down with his Sanskrit teacher one April morning in 1860 and looking up to find fifty men crowding round his window, waving a petition. Soon after, Long (who had been supportive of the indigo farmers' cause) was asked to translate a play by a postal worker called Dinabandhu Mitra. The chief villains in *Nil Darpan—The Indigo Mirror*—are shambling, violent versions of George Meare, cruel colonials who indulge in rape, beating, corruption and the encouragement of prostitution. They speak in half-sentences peppered with explicit swear words—while the farmers are invariably fluent and articulate in their protests at what is happening to them under the brutal British system. "Owing to the beating this man has got, I think he will be confined in bed for a month," a Bengali chides one of the Englishmen called Wood, after he has nearly killed one of the farmers. "Sir, you have also your family. Now, what sorrow would affect the mind of your wife if you were taken prisoner at your dinner-time?" Wood replies by calling the man what is variously translated as a "cow-eater" or "sister-fucker." It is, it seems, too late for any compromises.

*Nil Darpan* was not a subtle drama but it was an effective one. The play swept through Bengal, spawning political activism, and—in Long's translation and in conjunction with what happened in Barasat—it would spread awareness about the indigo issues to the highest echelons of the British political system. It would also lead the missionary to be sent to prison, for allegedly translating

libellous material. It would not be quite the end of indigo's injustices—Mahatma Gandhi's first act of peaceful civil disobedience was in northern Bihar[31] in 1917 when he went to support indigo peasants who felt mistreated—but it was the beginning of the end.

I had no idea what I was looking for in Barasat—just a half-hour suburban train ride from Calcutta. I just wanted something—anything—that could give me a clue to the history of the place, to somehow sense the atmosphere that spawned the indigo riots of 1860. But the trouble was, all the buildings were twentieth century; most were built in the 1960s and 1970s. And the fields had long since returned to rice cultivation. "I'm looking for an old building," I said, feeling faintly ridiculous, to gentlemen drinking tea beneath roaring fans at the government offices. They were friendly and assigned my case to a young man called Sunil, who first took me to the information office, then to the courthouse—where the personal assistant to the Chief Magistrate (who was teaching his teenage children how to use a computer) told me that I was in luck. There was just one old house left in Barasat. I found myself following Sunil down little streets lined with rubbish and shoe shops until we turned a corner. And there, huddled against a 1960s apartment block, was a most extraordinary sight—a ghostly ruin of something that once had been a grand house, with a great balcony on the second floor, and huge colonnades stretching to the sky. And beneath the ivy, in the afternoon sunshine, the columns were a glorious shade of blue.

It had been built for Warren Hastings, the first Governor General of India, and had later been used throughout the nineteenth century as the home of British administrators. Accompanied by a gathering crowd, I stepped over the cracked and stained marble of the front steps, and pushed the door. It opened, and we all crunched over rubble into the semi-darkness. Everything was broken and trashed; weeds had taken over the grand staircase, which had scarcely a stair intact. One room smelled like homemade

wine. Alcohol? I asked. "No—sewage," a man said. But it turned out that I had misheard and it was sweets, made from sugarcane, with the debris left to ferment in a corner. A more pleasant smell than indigo's fermentation.

Standing there, I could imagine a party in the 1850s—carriages arriving, a string quartet, people laughing with drinks in their hands, hanging over the balcony to see who was coming. There would be the District Magistrate, of course, and the army officers from the barracks of Barrackpore. Then there would be the cotton kings and jute kings, and men of the East India Company with their wives and daughters swishing up the stairs in fine silks. And then I imagined a collective intake of breath at a new arrival: one of the indigo planters—"not quite our type," the snobby colonial ladies might have whispered behind their fans. But then the party would continue despite the swaggering presence of whichever bullying planter had arrived. Times have changed, the wives of the military officers would say with a sigh as they resumed their dancing, just before their safe Victorian world really turned upside down.

For in that decade everything began to change: on a fateful day in 1857 at the arsenal of Dum-Dum—which I had passed on the train—an Untouchable would ask a Brahmin for a cup of water and the seeds would be sown for the Indian Mutiny, and ultimately for the fall of the British Empire, with the indigo riots playing their part in its decline. And for indigo the tide was turning too. In a literal way—the course of the river system was shifting to change the pattern of agriculture in the area—but also in a metaphorical way. In 1856, as I would find in my search for violet, a man would find a way of making synthetic dyes out of tar, and the days of natural indigo would be almost over.

## THE LAST INDIGO PLANT

The Calcutta Botanical Gardens are off the tourist track, in the southern part of the city on the Howrah side of the river. A red

brick wall surrounds their 100 hectares, and the gate is so unpretentious that my taxi driver missed it the first time. As recently as the early 1990s someone had built turnstiles and ticket offices as well as little glassed-in buildings to the side which were perhaps meant to be a visitors' center but now—appropriately for a botanical garden—were overgrown with weeds. There were no maps, no sense of being somewhere or going somewhere, just security guards smiling and waving me on, and paths lined with mahogany trees leading into wilderness. There were gardeners, I found out later, but I got no sense of much recent tending. Just of nature grown very wild and very tall, rather as I had seen at Warren Hastings's ruin. "Where are the offices?" I asked. And a thin man led me several kilometers in the heat, past overgrown and locked palm houses and a lake covered with giant Victoria lilies floating like green cake tins on its surface.

We finally arrived at a dilapidated 1960s building. "I would like to ask about indigo," I said optimistically to the men at the door. I had no appointment and wondered whether they would wave me away. But instead they asked me to sign their registration book. When I paused at the column where I had to write whom I was meeting they said, "Dr. Sanjappa," so I wrote it down. I waited in a room full of specimen lockers that smelled of mothballs and then was led into an air-conditioned office with the words "Deputy Director" outside.

Dr. Munirenkatappa Sanjappa was sitting at his desk, dressed in a purple batik shirt covered with a design of silver leaves. On his wall was a tattered engraving of William Roxburgh, the superintendent of the gardens from 1793 to 1813. I had read Roxburgh's enthusiastic letters about experiments with both indigo and cochineal, and was pleased to see what he looked like—a small man with a keen face and bright eyes who, although dressed in the stuffy cravat and jacket of Georgian England, looked as if he'd be happier in a gardening shirt. Roxburgh was something of a hero in the Botanical Gardens, Dr. Sanjappa said; he had done many good things for In-

dian botanical history, and one of them was commissioning three thousand paintings of indigenous plants, in the 1780s.

It would be amazing if they still had any of the paintings, I mused. "Oh yes, we have all of them—thirty-five volumes," he said, and sent a colleague off to the archives. The man came back with volume eight—the indigo-bearing chapter. As I opened it, the leather cover fell off in my hand, and I found myself looking at 220-year-old paintings of twenty-three varieties of *Indigofera*. Although I had seen pictures of indigo in books, it was only then that I appreciated just how varied this species could be. There was my old friend *Indigofera tinctoria*, which had been the main commercial plant in both the East and the West Indies, and which I had still not seen in the flesh, so to speak, and beside it was the well-named *Indigofera flaccida* with its floppy leaves. Another page was dedicated to *Indigofera hirsuta* with its tiny blue beard-growth, and my new favorite, *purpurescens*, with its gloriously generous purple flowers, guarded by battalions of round leaves standing in rows along the stem. The colors had not faded much in two centuries, although sadly the paper had long ago started its journey toward disintegration in the tropical humidity.

"Some people think *tinctoria* is the best one for dye," Dr. Sanjappa said. "But Roxburgh always said that *coerulia* had more blue. The name means sky, of course." He told me how *Indigoferas* could grow anywhere from the hottest deserts to the highest mountains, and that there were several hundred species. Most were bushes, he said, but although none rose to the cathedral canopy I had imagined as a child, one variety could grow to three meters or more if it was allowed. One other thing the *Indigoferas* had in common, apart from a vague bluish tinge, was tiny double hairs, which under a magnifying glass looked like flying seagulls.

Even for a director of a nation's most important herbarium, Dr. Sanjappa seemed to have an extraordinary knowledge of this specialist subject. Indigo had been the subject of his doctoral thesis, he explained, and even though his work now involved many other

things, he was still fascinated by this species. "Actually, of sixty-two varieties of indigo in India, I have collected fifty-eight," he said. Of these he had actually discovered six, naming most after the environment they grew in, although one—*Indigofera sesquipedalis*—was named half jokingly because its leaves were half a foot in length, and Dr. Sanjappa loved the Latin word for this. On one Himalayan indigo expedition, he told me, he and three others camped at 17,000 feet and walked up through the thin air at 20,000 feet every day for forty days, such was their keenness to complete their collection.

I had my own less energetic indigo expedition to undertake. Could Dr. Sanjappa tell me where in the gardens I could find some indigo? "There is none," he said. "It is rather sad." And we both reflected on how sad it was, and how extraordinary it was that—once again—cultivated indigo should so completely have disappeared from the land where it was born. And then Dr. Sanjappa remembered something. "Perhaps there is one: I saw it a few months back, growing wild. Perhaps it is still there—unless the gardener has cleared it." I asked him to mark it on the map he had given me—it was about two kilometers away—and then I opened the old book of paintings again to remind myself of the pattern of *tinctoria*'s leaves and flowers, to make sure I recognized it. Dr. Sanjappa made up his mind. "You will never find it on your own," he said. "I will call for a jeep." As we walked outside together I realized he was limping. What happened to your leg? I asked. "Oh, it was just a polio infection when I was six months old," he said. I then realized the enormity of the expeditions he had told me about. A Himalayan climb of 3,000 feet every morning armed with collecting equipment is a tough feat for anyone. For Dr. Sanjappa, his search for indigo was nothing less than heroic.

Our expedition included two drivers and three guards armed with *lathis*—the traditional Indian police sticks—who had leapt in the back of the car. "I do hope the indigo is still there," Dr. Sanjappa said as we pulled up in an unpromising part of the forest.

"Yes, yes," he exclaimed in excitement before we had even climbed out of the vehicle. And there it was, my *Indigofera tinctoria*, the possible seed descendant—I like to think—of the plants that Roxburgh had kept so long ago. And Dr. Sanjappa was right: I could never have found it on my own.

I once interviewed the Swiss conductor Charles Dutoit, who, when he was a student in the 1960s, had talked his way into page-turning for a concert conducted by Igor Stravinsky in New York. What was the great composer like? I wondered. "Short," was Dutoit's surprise answer. "I had expected a man of his musical stature to reflect that in his physical stature. But he didn't," he said, still disappointed so many years later. And this particular indigo plant was the same for me: very short. It was not even 80 centimeters high, and quite lost in the middle of the pulsating life force of the Calcutta Botanical Gardens.[32] It had tiny delicate round leaves and even smaller, cheeky pink flowers only a millimeter or two long. But the saddest thing was that it was being choked to death by a strangling weed. When I mentioned it, the three guards turned gardeners. They leapt to the rescue and cleared the little plant of the vines that were slowly killing it.

It wasn't the grand indigo tree of my childhood dream, but something much more vulnerable. And I like to think of it still growing there, holding out bravely against the weeds, a tiny legacy of Bengal's history.[33]

# 10

# Violet

*"I will tell you.*
*The barge she sat in, like a burnish'd throne,*
*Burn'd on the water: the poop was beaten gold;*
*Purple the sails, and so perfumed that*
*The winds were love-sick with them."*

WILLIAM SHAKESPEARE: *Antony and Cleopatra*, II ii

*T*he story of how modern purple dye was discovered has become a legend in the history of chemistry: a spring evening in London, a teenager packing up after a day spent trying to find a cheap cure for a killer disease, an accidental drip on a laboratory basin, and suddenly the world changed color. What is less well known is how it also set off a chain of events that led to the rediscovery of two long-forgotten ancient dyes: the color of Cleopatra's sexy sails and that of the Temple of Solomon.

In 1856 William Henry Perkin was eighteen and something of a prodigy at the Royal College of Chemistry. He and his classmates had been looking for a synthetic alternative to quinine, the malaria remedy that until then was only found in the bark of a South American tree. His teacher had noticed that some of the substances left over from gas lighting were very similar to quinine, and he had persuaded his students to try to work out how to add hydrogen and oxygen to coal tar and make their fortunes.

Perkin loved chemistry, and he had set up the top floor of his

parents' house in the East End of London as a laboratory. It was there that, washing his glass flasks one evening, he noticed a black residue. As he explained to a news reporter many years later during a visit to America, he was about to throw it away when he paused, thinking it might be interesting. "The solution of it resulted in a strangely beautiful color," he told the journalist. "You know the rest."[1]

I used to live just 50 meters away from where Perkin grew up, near Shadwell Basin in Docklands, and I remember one day noticing a blue historical plaque on the side of a housing estate. It told me that this was where the first "aniline dyestuff" was invented in March 1856, in a home laboratory. I went home and looked up aniline in the dictionary—it is, as I would remember much later during my quest for indigo, derived from "nil," the Sanskrit word for that dye—and I imagined a color as blue as the plaque. It was years later that I learned that Perkin had accidentally made mauve.

He didn't call it "mauve" at first, though. He initially called his discovery "Tyrian Purple." For Perkin this would have been almost a legendary description remembered from his days learning Latin. He would have known it was an ancient dye once worn only by emperors, and he would have chosen the name to suggest a sense of luxury and elitism—no doubt to encourage buyers to part with more money than they wanted to spend. It was only later, realizing perhaps that scholarly historical references were not necessarily the way to attract buyers of high fashion, that he renamed it after a pretty French flower.[2]

Whatever the final name, Perkin was lucky: he had discovered the color of the moment. That year Queen Victoria had commissioned the French craftsman Edouard Kreisser to make a cabinet for her consort Albert's birthday. Inspired by a revival of interest in the bright enamels of Sèvres porcelain, it is a cheerful combination of turquoise and pink flowers curling around two blonde ladies in lovely purple dresses.[3] By 1858 every lady in London, Paris and New York who could afford it was wearing "mauve," and Perkin,

who had opened a dye factory with his father and brother, was set to be a rich man before he reached his twenty-first birthday. Without his discovery industrial dyers would probably have fulfilled demand by blending indigo with madder, or using lichens. But nothing had quite the totally purple appeal of Perkin's synthesized dye.

Coal tar, an organic substance that comes from very ancient fossilized trees, proved to hold the potential for thousands of colors, and Perkin's invention went on to inspire chemists to find many other petrochemical paints and dyes. Within a decade they would almost totally replace many of the colors that have been the subject of this book. Moreover, as Simon Garfield showed in his book *Mauve*, Perkin's discovery would have many beneficial medical and commercial spin-offs and would lead other scientists to the discovery of cholera and tuberculosis bacilli, to chemotherapy, immunology, and the mixed blessing of saccharine. Some of the biggest pharmaceutical companies in Europe today—including BASF, Ciba and Bayer—began as small dye works in those crazy days of trying to extract more and more colors from coal.

But the frenzy of the "mauve decade" would also revive interest in that earlier purple, from the mysterious Tyre. Within four years the French Emperor Napoleon III would send an archaeological expedition to try to find out where this place was, and whether anything remained of its riches. And some years later a number of Jewish scholars saw what Perkin had done and began what turned out to be the very slow process of unravelling the mystery of the most sacred thread in Judaism.

Tyrian purple, educated Victorians knew, was made from shellfish found in the eastern Mediterranean. But which ones, and how they were processed, was not known in those mauve days of the 1850s. The old-time dyers had disappeared with the storming of Constantinople in 1453 (or even before: possibly the last recorded mention of purple dyeing as an ongoing industry was in Benjamin of Tudela's journal in 1165 when he mentioned that the Jewish community of Thebes was famous for its production of silk gar-

ments and purple) and they had not left any records of their secrets. Nor was anyone quite sure what their finished product looked like either. Was the purple dye of Imperial Rome similar to the shade that Perkin had discovered—an almost gaudy version of the final shivers in the spectrum? Or was it a different, more mystical color appropriate for a man who had the blessings of the gods behind him to wear in public? And what—or where—was Tyre anyway?

When I decided to find purple for myself this last question was easily answered. A quick consultation of the *Times Atlas* confirmed that Tyre—or Sour, Sur or Tyr, as it is variously spelled—was the most southern port in Lebanon. It was north of the disputed Israeli border and south of the capital of Beirut. But to answer those other questions—about the nature of the dye works, about why their famous product was so highly prized, and whether it was reddish or bluish or something quite different—I decided to begin by going to the source of the dye, or at least to the source of the name of the dye.

## A FUNERAL

When I arrived in Beirut my ultimate quest was of course to find purple. But my primary aim that first morning was to find coffee. On most days this would be even easier than locating a bullet-marked wall in the city's war-torn center, but my timing could not have been worse. It was the funeral of Syrian President Hafez al-Assad, who had died a few days before, and Lebanon was closed out of respect for its more powerful northern and eastern neighbor. Even those places from which the aromas of *arabica* wafted like seductive genies to beguile me were "closed," with proprietors shooing me away with worried looks. One café owner said the fines for not grieving publicly were higher than small businesses could afford: if they had admitted a paying customer that day they could have been bankrupted.

One of the cafés where I couldn't buy coffee had a TV playing.

# COLOR

Grim-faced men in suits were escorting a coffin along a street in Damascus lined with people wearing black. It is curious that now black and only black is the color of mourning in many countries (except in parts of Asia, where people wear white), but as recently as the 1950s purple was just as appropriate at British funerals. When King George VI died in 1952, black and mauve knickers were solemnly placed in haberdashers' windows in the West End, a columnist in a British paper remembered recently,[4] while British court circulars included mauve in their rule of dress for half-mourning until around that time.[5]

Black and white seem to represent absolutes—either the total absorption of light as you leave the world, or the total reflection of the light as you return to a state of luminosity, depending on your belief in incarnation. And violet is the last color in the rainbow spectrum, symbolizing both the ending of the known and the beginning of the unknown—which is perhaps why it was also suitable. The seventh-century saint Isidore of Seville, who incidentally is now the patron saint of the Internet because of his genius for compiling facts, suggested in his *Etymologiae* that the word "purpura" came from the Latin *puritae lucis*, meaning "purity of light." It is probably not true, but it played a useful public relations role for purple right up until the Renaissance, and was perhaps instrumental in keeping it a color associated with the spirit.[6] Certainly, by the time Victorians were wearing Perkin's mauve in funeral processions, purple had been the color of grief in Britain for several centuries already: on September 16, 1660 Samuel Pepys wrote that he had gone "to White Hall garden, where I saw the King in purple mourning for his brother [the Duke of Gloucester, who had died three days earlier of the smallpox]."

Where was everyone? I wondered as I strolled through Beirut streets that had barely a car or even a pedestrian in them. When I reached the Corniche—the palm-fringed esplanade where once Beirut's playboys drove their sports cars to show off—I found half my answer: the jagged rocks beneath the road were covered with

beach towels and holiday-makers chatting and bathing. A normal holiday in the sunshine, but there was just one odd thing about it. They were all men.

It was lunchtime before I found any breakfast, so I enjoyed mid-day coffee and yogurt in the restaurant at the top of the five-star Sofitel, which was the only place I found open. My table over-looked what once must have been a chic seaside club, and my lit-tle mystery was solved. The private swimming pools far below were empty of water but packed full of sunbathing women crowded to-gether and enjoying the rays from behind high walls. My quest for imperial purple was connected with loss and luxury, with hidden things, and of course with the sea: I wondered whether my whole experience of Lebanon would demonstrate those elements quite so neatly as my first day had done.

The concierge told me that if I thought Beirut was dismal that day then the pro-Syrian Muslim towns, including Tyre and Sidon, would be even worse. Head north, to the Christian area, he advised when I told him about my search. "They won't be in mourning so much, and you'll find many Phoenician remains there. And plenty of coffee, of course."

The Phoenicians were the people I was looking for—early in-habitants of Lebanon who had arrived from the Arabian peninsula in the third millennium B.C., and established themselves all along this rocky coast. They were sea adventurers, traders, artists and car-penters, and they became known for their sophisticated steering by the stars and for their early creativity with colored glass. They were also said to have invented the archetype for the alphabet that made the words on this page possible. But, most importantly for my own search, these people also became so famous for trading the most luxurious dye in history that their very name derives from the Greek word for purple, *phoinis*. I would first find what remains of the Purple People, I decided, and then later I would look for the color they were named after. So I took the concierge's advice and hired a car.

# Color

I had been surprised earlier, when I studied the map of Lebanon, to see how tiny the country was. Its violent civil war from 1975 to 1990 has given it an international notoriety—to my generation at least, watching the hostage crisis unfold through the 1980s—quite out of proportion to its area. The whole of Lebanon is in fact a little smaller than the Falkland Islands and half the size of Wales. In just over an hour I had negotiated Beirut—and was in the town where books were born.

## The Purple People

The town of Jbail (its Arabic name) or Byblos (its Greek one) shows few signs of the country's most recent war except that the hills above it are clad in ugly concrete villas. They are owned, I was told by a disapproving Byblos resident, by Beirutis fleeing the fighting on weekends. But if—or perhaps because—it doesn't show much indication of contemporary warfare, it is one of the finest places in the country to see signs of all the other factions who have battled for this coastline for the past seven thousand years or so—including my Phoenicians.

It was almost sunset as I headed past the immaculately renovated souk, and went straight to the headland. This small area is covered with the rocks and ruins of many former residents of Byblos—starting with Neolithic settlers and continuing with the Phoenicians, Greeks, Romans, Byzantines, Umayyads, Crusaders, Franks, Mamelukes, Ottomans, Arabs, and tourists. I was a member of the last category, and so I was assigned a guide—in the form of Hyame, an archaeologist, and we wandered contentedly between the old walls until nightfall, her stories bringing this deserted place of rubble and grasses to life.

The Phoenicians were little people, Hyame told me. If a man measured 1.5 meters and was handsome with it, he would have been a most desirable catch in Byblos four millennia ago—and women were even smaller. Their houses had neither doors nor

windows, and were accessed by ladders, leading to trapdoors in the roof. They would light the dark interiors with oil lamps, which incidentally they had invented. What happened when they got too old to climb the ladders? I asked. "They didn't live very long so it didn't matter," my guide answered cheerfully.

It was a curious notion, as we stood in this quiet place, that four thousand years ago the space in front of us would have been noisy and packed with people: tiny traders doing business with tiny consumers. The shops—you can still see the "dental" pattern where each stall was grooved into the city wall—were barely deep enough to swing a candle. Those spaces now filled with weeds would once have been stuffed with cheese and capers, ropes and remedies, and special things for boats and journeys. Some of the merchants would even have had thick slabs of ice dripping dark pools in the sunshine: with Mount Lebanon so close, agents could get ice rushed down the mountain throughout the year. It would have been useful for keeping food fresh on board, or perhaps even for providing cool lemon drinks for the sweltering passengers and crew as they journeyed away from this city, carrying bundles of the papyrus scrolls that gave both Byblos and the Bible their names.

And in the old Phoenician market there would, Hyame agreed, probably have been a whole street of colors—coal-like lumps of indigo, bags of scented saffron, cakes of white lead from Rhodes, chunks of lapis coming through from Afghanistan and, of course, that valuable purple dye. For millennia this was one of the most prized products of the coastline—and it was seen as symbolic of both the heavenly world and the best of the human world. It was used in the holiest of Jewish temples (the Tabernacle—the sacred tent containing the Ark of the Covenant which the Jews carried with them in the wilderness—was to be made "with ten curtains, of fine twined linen, and blue and purple and scarlet": Exodus 26, 1) and at the same time it played an important role in secular offerings. In the sixth century B.C. King Cambyses of Persia sent a team of spies to Ethiopia, hoping they would come back with

detailed plans of how best to attack the country. They carried with them many presents—incense, necklaces and palm wine, and a precious purple cloak. According to the Roman historian Herodotus,[7] the King of Ethiopia was distrustful not only of Cambyses's intentions but also of his gifts and particularly of how the cloak came by its very special color. "Taking the purple cloak, he asked what it was and how it was made, and when the [diplomat-spies] told him the truth about the purple and the way of dyeing, he said that both the men and their garments were full of guile."

The Persians and Jews liked purple greatly, but it was in the Roman and then later the Byzantine appropriation of this dye that it·gained its real reputation—when emperor after emperor had their new clothes made from it. So I turned inland to find the Romans—and the greatest temple they ever built.

## THE FLUTTERING OF A BUTTERFLY'S WINGS

Near the famous cedars, high up on the slopes of Mount Lebanon, I picked up two Belgian hitchhikers. "We'll get our luggage," they said, and went inside their hotel to emerge with dozens of cases, and what looked like a huge hatbox. We filled the car. Alain was a butterfly collector looking for the rare Mount Lebanon Blue butterfly, and his wife Christina—now hidden under the bags—was there because he had promised her that they would stay in hotels rather than tents. Butterfly collectors were peculiar people, Alain said: "We like to camp in nature, wash in mountain streams and wake up early, just to see one specimen that is not dissimilar to another specimen." Christina concurred with an element of resignation. "I don't like to go: it's boring and they drink too much," she said.

As we drove along the curving mountain roads, Alain talked about his blues, and I talked about my purples. Butterflies, he then told me, are very good at seeing purple. In fact they have a very different range of color vision than humans. Reds are usually invisible for them, but they can see all the way up the rainbow scale

from yellow to beyond violet and into ultraviolet. How could anybody know that? I wondered aloud, and he told me that some flowers—and butterflies—appear to human eyes to be completely white. But when you look at the petals or wings under an ultraviolet detector, they are covered in ghostly markings that butterflies respond to as signals.

At that moment in Alain's story we drove past a large clump of white flowers on the roadside, and I wondered whether they had any markings that I couldn't see. For the first time I thought how arbitrary our "visible light" spectrum is. Patterns drawn in ultraviolet might make those ordinary little petals into the exotic peacocks of the botanical world, and yet we cannot appreciate them. If we could see a wider range of light frequencies then those flowers could be as entrancing as tiger orchids. But if we could see a narrower range, then who knows: perhaps I wouldn't even be able to see my original Tyrian purple. If I ever found it, that is.

## PASSION AND POWER

We could see the giant columns of Baalbek from far away across the Bekaa plain: they dominated the small dusty town that shares their name. Today Baalbek is a series of picturesque ruins, but once this was the site of the largest temple in the Roman Empire—dedicated to Jupiter, ruler of the gods. As we passed I noticed it was full of building workers, so I dropped off the butterfly collector and his wife—together with their many nets and boxes—and went to investigate.

Once a year thousands of people go to Baalbek for a contemporary ritual—a music festival that invites international stars like Sting, the Paris Opera Ballet and the members of the Buena Vista Social Club to perform in the ruins. I was there a few days before it started, and the organizers were sorting out a stage and seating. All the noisy construction work only emphasized the general destruction of the ancient building—the Temple of Jupiter was truly

a giant ruin. At one time it was twice as big as the Acropolis in
Athens. Now there were just a few walls and a lot of Roman rub-
ble—including great granite pillars from as far away as Aswan in
Egypt and Tripoli in Libya—as a reminder of the past.

*Nineteenth-century engraving of Baalbek*

But close by the newly dedicated Temple of Song was another
smaller temple that has always been dedicated to wine. This was
the shrine of the party god Bacchus (the Roman equivalent of the
Greek god Dionysus), and it had stayed relatively intact—I could
still see the carvings of eggs and cattle horns, grape leaves and
honey entwining pillars, all symbolizing fertility and fun. It was
"the nightclub" of its time, said our guide, Ghazi Ygani, pointing
out the wine cellar that was for the exclusive use of the priest, the
bartender of his time perhaps. This temple was preserved, ironi-
cally, because it was less important than Jupiter's showy complex—
the foundations were lower down to represent the god's lower
position in the hierarchy. So when the priests moved out and
decay moved in, its walls were more quickly covered by layers of

protective soil. It is astonishing now—after extensive archaeological excavations cleared the site in the 1920s—to see how far the earth has settled. High up on the wall, 12 meters above our heads, I could just see the scrawled names of German visitors. "Those graffiti were written in 1882," said the guide, as the four people in my tour group crowded into a tiny handkerchief of shade. "That was the level of the ground."

It was interesting that the rivalry between Bacchus and Jupiter— between sexuality and power—should have been fought out so visibly in the very stones of this place. Because the symbolism of purple is equally ambiguous. In terms of formal power, purple often was, and often still is, the color of royalty or of the highest vestments of priesthood. And yet in terms of unbridled revelry, if Bacchus ever had a color he could claim for his own it should surely be the shade of tannin on drunken lips, of John Keats's "purple-stained mouth," or perhaps even of Homer's dangerously wine-dark sea.

A defining moment for purple as the center of both sexuality and power was played out at a famous dinner party in 49 B.C. Julius Caesar had just won a key battle against Pompey, and Cleopatra organized a feast for the aging hero in a palace described as "luxury, made mad by empty ostentation." It wasn't just the Egyptian queen's sails which were purple—her whole palace was lined with purple porphyry stone, as those of the Byzantine emperors would be lined centuries later, leading to the phrase "born in the purple." The sofas in Cleopatra's staterooms were covered with gleaming covers: most of them, "long steeped in Tyrian dye, took on their stain from more than a single cauldron."[8] A hundred years later, this would be seen as common: "Who does not use this purple for covering dining couches nowadays?" a jaded commentator on interior design called Cornelius Nepos would ask.[9] But for Julius Caesar all this oriental excess was fairly new. Impressed, he fell into his hostess's arms—to the disgust of his generals, who suggested Cleopatra was "whoring to gain Rome." Caesar was unrepentant,

*A seductive sofa scene*

and when, a short time later, he returned to Rome, he introduced a new fashion item in honor of his two most recent conquests: the totally purple, sea-snail-dyed, full-length toga. An item only Caesar was allowed to wear.[10]

It is strange today to picture how ambitious civil servants and soldier officers in Ancient Rome must have sighed for the forbidden pleasure of wearing robes or hoisting sails that were one particular shade of reddish blue. But at some points in the history of these stone-paved streets of Baalbek that I was walking along—and indeed in every town in the Roman and Byzantine empires—had I been an ordinary person wearing clothes dyed with Tyrian purple I would have been killed. And at other points in the town's history I would have been admired: I was wearing purple—I *must* be someone important. Or at least (since they were so expensive that even the third-century Emperor Aurelian once famously told his wife they couldn't afford for her to buy a purple dress) someone very rich.

The various rules about this color over the centuries are bizarre and fairly confusing. In some reigns (Nero's was one of them, but the fifth-century Christian emperors Valentian, Theodosius and Arcadius were even more vehement) almost nobody could wear mollusk-dyed purple, on pain of execution. Sometimes (as in the

time of Septimus Severus and Aurelian in the third century) women could wear it, but only very special men like generals could join them. In other reigns—and Diocletian in the fourth century was particularly enthusiastic—everybody had to wear as much purple as possible, with the money going straight into the imperial coffers. When any new ruler appeared on the scene, powerful people must have looked to their wardrobes and wondered what they would be allowed to wear during the following season.

The Byzantine emperors continued the Roman tradition of exclusivity,[11] although the purple dye works were gradually moved north toward Rhodes and Thebes. One of the most extraordinary series of mosaics that survived the seventh and eighth centuries, when the Byzantine Christians destroyed much of their art, is in the San Vitale church in Ravenna in Italy. It shows the Emperor Justinian's wife Theodora, surrounded by attendants, covered in jewels, and wearing a deep, almost crimson, shade of purple. The Ecumenical Patriarch in Constantinople apparently used to write his formal signatures in this color[12] (he now uses ordinary black ink) while some of the most sumptuous books of the sixth and seventh centuries were written on calf vellum that had been dyed purple. The National Library in Vienna owns one of these books, and one of the most remarkable pages in it shows the story of Joseph, nearly naked and being seduced by a very insistent Potipher's wife. The writing above the painting was once silver but has now tarnished to black, while the background to this sexy scene is a soft crimson, as if it had been stained with blackberries.[13]

Purple is not the only color in history to have been bound by strict rules—in England there was a particularly rigorous ruling introduced by King Richard I in 1197 called the Assize of Cloth, effectively confining lower classes to common gray clothing; in China, during the Qing dynasty (1644–1911), there was a shade of yellow that could be worn only by emperors; by contrast (an optical as well as a political contrast) after the 1949 Maoist revolution all Chinese, whatever their rank, had to wear clothes dyed blue—

I remember a Tibetan nun telling me that when she was a child growing up in Tibet nobody but monks and nuns was allowed to wear orange or red. But purple is certainly the color that has been most legislated about, over the longest time. We don't have any true equivalent today—Perkin's moment of curiosity in the lab ensured that today we can dye our clothes virtually any garish or subtle color we want, and only the fashion gurus dictate what colors we are permitted to go out in. Perhaps the only place this kind of color coding works today is in a rigid structure like an army or a school, where small variations in uniform still signal hierarchy.

Many classical commentators wrote about this phenomenon—Pliny is one of the best sources. But he was not very impressed.[14] "This is the purple for which the Roman fasces and axes clear a way," he wrote. "It illuminates every garment, and shares with gold the glory of the triumph. For these reasons we must pardon the mad desire for purple, but why the high prices for . . . a dye with an offensive smell and a hue which is dull and greenish, like an angry sea?"

Like Pliny, I found it hard to really appreciate the appeal of this purple, I realized; nor did I understand how it could be extracted from mollusks. The national mourning was over, and it was now time to go to the town of Tyre, to try to find out how it was made, and what it looked like.

# TYRE

There were only two hotels in Tyre, my guidebook told me. One, it claimed, was nasty, the other expensive. But as I drove around the town, lost in the dark, I spotted a third. It was called Hotel Murex—after the Latin name for the species of shellfish, *Murex brandaris* and *Murex trunculus*, that I was looking for.[15] I have never quite figured out why I find murex such an ugly word. Perhaps it sounds too much like the kind of name a toilet-cleaner manufacturer would invent, along the lines of "Murex: We make sure your bacteria

don't breed." But I didn't want to let my etymological prejudices get in the way of my quest, so I parked the car and checked in.

It was music night at the Murex. An Arab band was making the restaurant jump, and men danced with men, women with women, in a raucously joyful wall-thumping party that lasted through to the early morning. The hotel had opened just a few weeks before, and was owned by a rich émigré Lebanese family. I talked to their son, who was in his mid-twenties. He said he lived in Africa, traded diamonds and dreamed of marriage with his fourteen-year-old girlfriend. "When she is ready, of course." His parents had chosen the hotel name because they felt it was a celebration of the past wealth of Tyre, and of a time when the whole Mediterranean world had heard of their city.

In the lobby there was a display case of marine artifacts, and the centerpiece was a large murex shell. It was about the shape and size of a triple-scoop ice cream—although with a thinner cone which curled—and it was vanilla colored. According to Pliny, murex catch their prey by piercing them with their spines—and the many spikes were certainly fairly sharp, although I did wonder whether they were quite sharp enough. I once saw a large collection of shells from the murex family—some of them (*Murex palmarosae*, for example) were as evil looking as a lionfish, others were like strange delicate skeletons. Most of them have some kind of potential for purple (which comes from a gland near the anal opening: Pliny was quite far wrong when he suggested nicely that it was a mouth), but the best are *Murex brandaris*, which live in mud, and *Murex trunculus*, which can be found on the rocky bottom of the sea floor.

This one was *trunculus*, and it had been found by one of several muscular men in singlets who seemed to hang around the reception desk. I asked him where he found it, and he said he could show me. He had found it as a shell a few kilometers away, but we hatched a plan to go out in his brother's fishing boat and search for live murex, which, he said, were rare but possible to find. I had an image of

dropping cockles tied to pieces of string into the sea to "attract the purples, which go for them with outstretched tongues," just as Pliny described. But the next morning, when we were booked to go out on the boat, the waves were too rough for an expedition.

In 1860, four years after Perkin's purple had been invented, Napoleon III sent a team of archaeologists to Tyre, to try to locate the island fortress and see what remained of the Phoenicians. "One can call Tyre a city of ruins, built out of ruins,"[16] pronounced Ernest Renan, who was in charge of the excavations, when he saw what was left. Today there are now even more ruins—the most recent war has left its own bullet-marked devastation. Where the old ruins happen to be near the new ones it gives a strange impression that history has concertinaed: two thousand years of war and peace blended together in the universality of crumbled walls.

I found it hard to imagine, as I strolled through modern streets on reclaimed land toward the busy and smelly Phoenician port, what Tyre must have been like when the French team arrived. It was desolate—even twenty years later a visiting English traveller wrote that "The streets are most wretched . . . while windowless mud-floored hovels nestle among huge fragments of polished granite and porphyry columns prostrate in rubbish," and was able to conclude that the prophecy by Ezekiel in around the sixth century B.C. ("I will make you a bare rock; you shall be a place for the spreading of nets; you shall never be rebuilt"—Ezekiel 26, 4) had apparently come true. Although God must have been merciful, since when I visited the place had certainly been rebuilt—with plenty of concrete.

When Renan arrived he pronounced the job almost impossible. The town's curse had meant it had been attacked and besieged many times; archaeological scavengers had taken what they could of the Greco-Roman marble and disturbed the major sites, and after digging five trenches and uncovering almost nothing it seemed to the team that there was little left. Then suddenly their luck seemed to change, and they discovered stone sarcophaguses

from 500 B.C. and a Byzantine church with its mosaic floor miraculously preserved. But to Renan's disappointment he did not find remains from the era he was really looking for, and Roman Tyre would be allowed to sleep a little longer—until the early twentieth century, when an entire Roman town was discovered to the southeast. It included a triumphal archway (which no doubt was first opened with a ceremony in which the important officials wore plenty of purple) as well as a necropolis full of carved tombs, a hippodrome worthy of any epic chariot race, and, most important for my own quest, murex dye vats. The latter might be rather humble looking, but they are what made this town famous. Indeed, they are probably what paid for everything else.

I tried to get there on my second full day in Tyre, when once again the storm waves made it too dangerous to go fishing for shellfish. But I don't think many tourists go to the archaeological site to find the antique purple dye baths, and access is limited. The guards at the ruined city kept shooing me away from this overgrown corner of the site—why didn't I want to stroll under the monumental archway or examine the grand gravestones like everyone else?—and I had to resort to devious methods to get a good view. These mostly involved pretending to look dreamily at the sea and then dashing across fallen marble columns when the two men were looking the other way.

The most telling thing about the dye vats is their location. They are very much on the edge of the old town, on the side where the wind would blow the smell away. With Tyrian purple—as I had learned in my quests for indigo and madder and many other organic dyes—the beauty of the color is in the effect rather than the process. Purple was a very smelly business: there is an extraordinarily wide difference between the sublime nature of this luxury product and the urine-and-lime nature of its manufacture. In the vats it stank (although it was only many months later that I would really appreciate quite how much it stank), and it was hardly surprising then that the good citizens of the cities that benefited from

the business were adamant that they wanted the factories on the most windward edges of their backyard.

The murex baths I saw were about the size of a dining table for six, and deep enough for a man to stand submerged to his waist (or a Phoenician man to stand submerged to his chest) in them—though if it had been me, only the abuses of slavery or a very large salary would have managed to persuade me to do it. They were lined with white stone, which looked almost like a classical version of concrete—crumbling around the edges. Far behind them were tall columns that the archaeologists had raised again to celebrate the extraordinary past of this city, but the murex baths were among the fallen columns. Even though they had been carefully excavated there was a sense—with their weeds and deliberate isolation from the "nice" parts of town—that they had been left once again to be forgotten.

When people in the nineteenth and twentieth centuries started to try to reconstruct the dyeing process of Tyrian purple they first looked to Pliny, who, after all, had visited the city in the first century A.D. so probably knew what he was talking about. The trouble is, the process was secret (and terribly complicated), and neither Pliny nor the others got the details quite right. He wrote about cutting out the vein of the murex, steeping it in water to which the equivalent of a kilo of salt to every 100 liters had been added, then after three days heating it, and after nine days straining it and leaving the wool to soak.[17] The only problem was, it didn't quite work. In brief,[18] the problem is that as soon as the shell is broken and the colorless liquid exposed to the atmosphere, it turns into the purple pigment—which is not soluble in water. In fact, despite its reputation, like indigo (to which it is chemically very closely related), shellfish purple is a pigment and not a dye. So, I wanted to know, how did the ancients fix it onto their clothes?

What I was more concerned with knowing immediately, however, was how to fix it onto my fishing line, and on my last morning in Tyre I met my fisherman friend again at the reception desk.

Can we go out in the boat today? I wondered. He called his brother on his mobile, and sounded as if he were negotiating. "No," he said eventually. "It is still too rough out there. My brother isn't risking going fishing today."

So I went to the beach instead. I wasn't resting from my quest—this was a very special beach, the place where the mystery of purple technology was first revealed. Today the beach at Tyre is a perfect bay of white sand, fringed with beach huts and bars. But once, according to local mythology, this was the place where Heracles—whom the Phoenicians worshiped as Melkart and the Romans knew better as Hercules—went for a lonely and historical walk with his dog.

I imagined the demigod striding out in his lion skin, worrying about the labors ahead of him, and absentmindedly throwing a stick across the pure white beach for his demidog to fetch. And then I imagined the animal bounding up a moment later, wagging its tail, with dye dripping from its teeth, and the master, astonished by this extraordinary color, carefully picking a specimen of *Murex brandaris* out of its mouth. It was a mythical discovery that would not only solve any short-term Phoenician financial problems but—given that every toga demanded the death of some ten thousand murexes—in the long term would put several species of sea creatures on the nearly-extinct list.

Some versions of the story add a female love interest in the form of the nymph Tyrus, who—on seeing what she felt was the beauty of the dog's stained saliva—demanded that her boyfriend make her something equally beautiful, and so, as a Herculean labor of love, he obediently invented a special technique for dyeing silk. As if to illustrate the story I was imagining, a crowd of young Tyruses in tiny multicolored swimsuits suddenly rushed into the water and started giggling and splashing water over each other. A few meters away there were other young women swimming—but these were fully dressed, their headscarves and long-sleeved shirts drenched with salt water. They were also laughing and splashing, oblivious

to the curious juxtaposition of two lifestyles on one beach. There is a story told locally of a U.S. army battalion storming the beaches in the 1980s, to rescue this Middle Eastern country from its tragic civil war. The Americans wore full battle gear as they rushed out of the water, but the only people there to witness their dangerous maneuvers were a few Lebanese ladies sunbathing in bikinis. It is hard to say which group was more surprised.

As I looked across the perfect sand to the almost perfectly still water, it was hard to believe that the sea was really too rough to go fishing. The Mediterranean is like that here, confirmed the man from whom I bought a soda. "It looks nice, but you have to be so careful." I had to leave that afternoon. It seemed I had been so careful I had missed my murex.

## A DYE FADES

On the way back to Beirut I stopped for a while in the Phoenician port of Sidon, just half an hour north of Tyre. The purple had been called Tyrian purple, but it could as well have been called Sidonian or Rhodesian (indeed, at one point in the Middle Ages there could have been an English bid for a Bristolian purple after a seventeenth-century traveller found purple-giving mollusks on that estuary and scholars confirmed something similar was used on old French, English and Irish illuminated manuscripts[19]). I wanted to investigate a curious landmark I had seen on the street map of the city. It was labelled "murex hill," and it promised to be a mound of the mollusks that I had been looking for so unsuccessfully. I was hopeful of finding a broken shell or two to add to my growing collection of pigment souvenirs. It was mid-afternoon when I got there, and I drove round the tricky one-way system three times: up past the school, the apartment high-rises, the run-down cinema, and the locked Muslim cemetery, where I stopped and peered through the railings.

But to my dismay I found no sign of crumbling old shells or

even any grassy Roman hillock. On the fourth circle I finally realized what was happening. The whole steep hill, with its roads and buildings and human headstones, was artificial, a gigantic graveyard for millions—no, billions—of tiny creatures that died to allow Ancient Romans and Byzantine emperors to be born—and live and reign—"in the purple." No wonder there were none left for me to find, I thought. They had used them all up.

Back in Beirut I reached the National Museum a few minutes before closing time. Once, not so long before, it had been at the very center of the line that divided the Christians from the Muslims in this troubled city. Most young Lebanese people had known it only as the place where the shelling started—until 1998 they had never seen the treasures that twenty-three years before had been hastily sealed in concrete where they stood, to protect them from the war.

There, dwarfed by the 3,300-year-old tomb of King Ahiram which holds some of the world's first alphabetic writing, and overshadowed by the collections of Arab and Phoenician jewelry, was a small display case which held what I thought I was looking for. It was labelled "Tyrian purple," but when I saw it I nearly choked with surprise. Because it wasn't purple at all: it was a lovely shade of fuchsia. I suddenly wanted to smile. I had an image of Roman generals holding up their arms in triumph beneath suitably triumphal arches—clad from victorious head to victorious toe in pink.

Could this color, dyed onto a fluffy ball of unspun wool by a Lebanese industrialist called Joseph Doumet, really be the color of history and legend? The color I had been searching for? It is hard to know. Pliny mentioned several different murex colors, quoting another historian as saying "the violet purple which cost a hundred denarii a pound was in fashion in my youth, followed a little later by Tarentine red. Next came the Tyrian dye which could not be purchased for a thousand denarii a pound." The latter was, Pliny commented, "most appreciated when it is the color of clotted blood, dark by reflected and brilliant by transmitted light."[20] This,

he suggested, was why Homer used the word for purple to describe blood. This pink wool in the National Museum—which I later discovered had involved tin as a mordant, to make the color stick— was not the color of clotted blood, or indeed of anything even vaguely like purple. It was very pretty, I decided, but it did not mark the end of my search.

In his book, *Color and Culture* John Gage finds the reasons for the purple cult of Rome and Byzantium "very difficult to define,"[21] but he does have an intriguing theory about it. The Greek words for purple seem to have had a double connotation of movement and of change. Perhaps this is accounted for by the many color changes involved in the dyeing process, but it is also, of course, the condition required for the perception of luster and of lustrousness itself. It is a theory borne out by Pliny's description of clotted blood. And as I have found with so many of the most valuable colors I have gone looking for—especially sacred ochre in Australia, but also the best reds and the velvety blacks and, of course, that precious metal gold—one of the most important elements of their appeal is the way they have shone. It has somehow lifted a color or a substance from the level of secular to sacred—as if, by reflecting back some of the pure light of the universe, it embodies something holy. Or wholly powerful, at least.

As I flew back home the next day it was hard not to be disappointed. Even though this was the "home" of purple, it seemed that, apart from the little shred of experimental evidence at the museum, there was almost nothing of this color left in Lebanon at all. As I had seen so symbolically in Sidon, it seemed that murex had been subsumed into the historical structure of this ancient-modern country, while on the surface it was nowhere to be seen. But a few days later I cheered up on learning of another seashell purple which was perhaps even as ancient as the Mediterranean version but which, extraordinarily, seemed to have lasted right up until the end of the last century—and, if I was lucky, even to the present day.

# THE PURPLE OF THE MIXTECS

In a description of their visit to Central America published in 1748, the Spanish brothers Jorge Juan and Antonio de Ulloa described how the dyers of Nicoya in Costa Rica extracted purple from shellfish. There were two methods. The first method involved pressing the poor animal "with a small knife, squeezing the dye from its head into its posterior extremity, which is then cast off, the body being cast away." The second method kept the creature alive. "They do not extract it entirely from its shell but squeeze it, making it vomit forth the dye. They then place it on the rock whence they took it and it recovers, and after a short time gives more humor, but not as much as at first." However, the brothers reported, if the fishermen got over-enthusiastic and tried the same operation three or four times, "the quantity extracted is very small and the animal dies of exhaustion."

The ancestors of these Costa Rican dyers were the famous pearl-fishers of Queipo. Until about the seventeenth century they used to row to secret locations and then, clutching a heavy stone to their chests, they would sink down to depths of 25 meters or more to harvest their catch—holding their breath for at least three minutes. In 1522 Gil Gonzales de Davila, an emissary of the conquering King of Spain, visited the area, and found both pearls and purple, giving the area a double reputation for luxury. He brought back a dye sample of this *purpura* for the King, who gave it the grand brand name of New World Royal Purple, and, perhaps remembering the Roman precedent, demanded exclusive use.

In 1915 Zelia Nuttall, an archaeologist who was busy studying a series of ancient cartoon paintings made by the Mixtec people, made a visit to the Mexican seaside town of Tehuantepec. She was instantly struck by the purple skirts worn by some of the richer women in the marketplace, and, although she wasn't a textile expert, wrote an article about what she had seen.[22] Most women wore hand-woven "turkey-red" skirts with narrow black or white stripes.

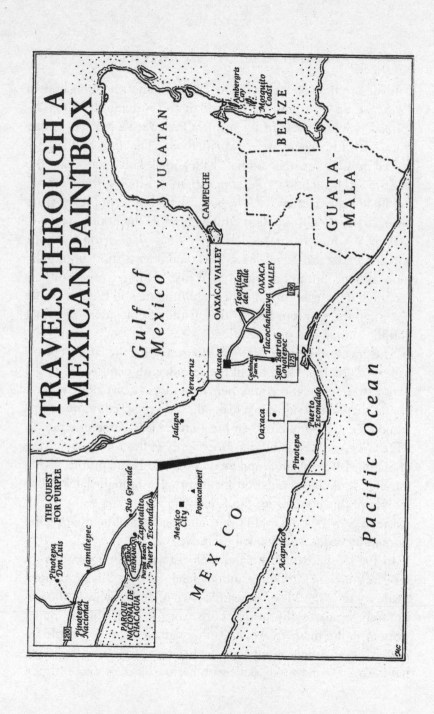

# TRAVELS THROUGH A MEXICAN PAINTBOX

**YUCATAN**

**CAMPECHE**

*Gulf of Mexico*

Veracruz

Jalapa

Ambergris Cay

Mosquito Coast

**BELIZE**

**GUATA-MALA**

### OAXACA VALLEY

Oaxaca

Teotitlan del Valle

OAXACA

Tlacochahuaya VALLEY

Cochineal Farm

Tlacolula

San Bartolo Coyotepec

190

175

Oaxaca

Puerto Escondido

Pinotepa

Mexico City

Popacatapetl

**M E X I C O**

Acapulco

*Pacific Ocean*

### THE QUEST FOR PURPLE

Pinotepa Don Luis

Jamiltepec

Rio Grande

Zapotalito

Pinotepa Nacional

HERMOSO

Purple Beach

Puerto Escondido

PARQUE NACIONAL DE CHACAGUA

200

But the purple skirts that had attracted her attention were made of two widths of cotton, "united by a fine cross-stitching of orange or yellow," which—a little patronizingly—she decided revealed a sophisticated understanding of complementary coloring. They cost ten dollars: three or four times the price of the other skirts.

The skirts particularly intrigued her because of the way they echoed some of the pictures she was studying. These were a series of pre-Columbian paintings on deerskin, containing coded information about the people and the gods depicted on them in a very two-dimensional way. The British artist John Constable famously disparaged them, but then, as fans of the codex reassured themselves, in the same speech (which he gave to the Academy of Art in London in 1833) he pronounced the Bayeux tapestry to be almost as bad.

At that time they were owned by an English aristocrat—Lord Zouche of Harynworth—but they are now known as the Nuttall Codex. What Nuttall noticed was how the *purpura* skirt color was identical to a beautiful purple paint she had seen on the codex, painted more than four hundred years earlier. One page "contains pictures of no fewer than 13 women of rank wearing purple skirts, and five with capes and jackets of the same color." Even more striking, the codex also included pictures of eighteen people with their bodies painted purple: "in one case it is a prisoner who is thus depicted. In another a wholly purple person is offering a young ocelot to a conqueror, an interesting fact, considering that ocelotskins were usually sent to the Aztec capital as tribute by the Pacific coast tribes." And in another it was the high priest—shown twirling fire sticks and performing a sacred rite—who was wearing a closely fitting mauve cap.

One of the weavers in Tehuantepec showed Nuttall a basket full of twisted and dyed cotton thread that had just been brought on mule-back from a town farther along the coast. "Lifting one of the thick skeins, [the weaver] slipped it over her brown left wrist, and proceeded to show how she, as a child, had seen the fishermen at

Huamelula obtain the dye from the *caracol*, or sea-snail." Even by the time of Nuttall's expedition the caracols had become so scarce that the fishermen were having to travel farther and farther away, even as far as Acapulco, to fulfill the orders. "Although Tehuantepec matrons still consider one of these somewhat in the light that our grandmothers regarded a black silk dress, as associated with social responsibility and position, fewer and fewer purple skirts are ordered every year, and the younger generation of women favor the imported and cheaper European stuffs," she wrote. "Not more than about twenty purple garments were woven at Tehuantepec last year, and it is probable that before long the industry will be extinct."

Her prediction, she would have been glad to discover, was premature. In the British Library I found a brief academic monograph[23] that described a successful Mexican dyeing expedition ten years before. So, armed with several photocopies of the article, I set off with a friend for the Pacific coast of Mexico, hoping I was not a decade too late to find the mysterious sea snails that weep purple tears.

Popocatepetl, the volcanic guardian of Mexico City, was spewing forth its red anger as we flew down to Puerto Escondido, making for a bumpy journey. The volcano-fuelled turbulence had the unwelcome side effect of tipping a smelly cargo of fish over my bag. I had come to find sea creatures, and it was, I thought pragmatically as I double-washed my luggage, perhaps a good augur for my search that they had already come to find me.

Puerto Escondido means "hidden port," although in the past twenty years or so the place has been very much unhidden by the hordes of surfers and sun-seekers who descend every season, and evidently support whole families of T-shirt sellers. It is not a promising place to look for old traditions of any kind. A few boats go out to sea every night, arriving back at dawn for a fish auction on the sand, but most people there are outsiders, come to cash in on tourist dollars. A few locals had heard vaguely of the purple: Alfonso, a teacher of Spanish who we saw sitting open-shirted every morning at Carmen's coffee shop looking for new customers

among the tourists, said he had heard the snails were sometimes known as "margaritas." My friend—a food writer who carried a compass to determine which location would be perfect for cocktails facing the sunset every evening—brightened visibly, but this was, apparently, nothing to do with salt around the edges of their shells. Alfonso wished us *mucha suerte*—good luck—in our search, and told us we'd need it. Later Gina at the tourist office reinforced the good-luck wish. "I think almost nobody does that dyeing anymore," she said. But she told us to look out for two local characters called Juan and Lupe, describing them as "Puerto Escondido's first surfers: still here, still hippies." I would recognize them by their black Labrador retrievers, she said, and by their red-blue hair, colored apparently with Mexico's natural sea dye. I imagined them as latter-day New World Hercules, walking their dogs along the beach and discovering purple. But during our two days in the town I didn't spot them. They were probably sleeping, Gina said.

On the third day we hired a white VW Beetle and set off into the interior. The coast may be where the dye is, but the dyers have often been from inland. In the old days, before there were buses, teams of men used to set off from their villages in the mountains every November to walk the 150 kilometers down to Puerto Angel. In their knapsacks there would be bleached cotton skeins entrusted to them by women in the surrounding area. The men would stay at the coast, slinging their hammocks between palm trees on the beach every night, until the rough early springtime weather made their search too perilous to continue. Every few years one or two dyers would die, swept out to sea by freak waves, but most would return home with their threads now permanently purple and reeking of sea garlic.

The first town we reached was Jamiltepec, about 60 kilometers from Puerto Escondido. According to my article it was there that Santiago de la Cruz, one of the last remaining dyers of Mexican purple, ran a small artisan shop. But when we asked, neither the shopkeepers nor the taxi-drivers had heard of Santiago or—more

worryingly—of any handicrafts shops. Wondering whether we might have travelled halfway round the world for nothing, we ate lunch at a street-side *taquería* beside the Jamiltepec marketplace. News of our search had already travelled around the marketplace, and one of the many women crowding round to watch us eat said she knew someone who might have heard of Santiago. She called over an old man, who nodded and led us through the stalls until we reached a tiny shop. It was about the size of the Phoenician stalls I had seen in their ruined state in Byblos, although this one was concrete and wouldn't last the centuries. There was a woman there who was, promisingly, surrounded by shawls with mauve tassels. She told us Santiago was at home, but he would be at the shop in the late afternoon. Her name was Ofelia, and she was his sister.

We spent the time going into Pinotepa Nacional, a market town that houses many of the 350,000 Mixtec people in Mexico. It has a large covered marketplace—and it was there that I found the clothes I was looking for: the same purple, red and blue striped skirts, or *posahuancos*, that had so attracted Nuttall's admiration eighty-five years earlier. It was mainly the older women who were wearing them. Until recently Mixtec women used to go topless, but now they wear gaudy floral aprons to cover up. I asked an elderly onion seller whether I could take a photograph of her purple skirt. She shook her head, but then we both heard a chorus of disapproval from the butcher's shop behind us. Two young women who were working there spoke teasingly to her: "Go on, don't be a spoilsport," they seemed to be urging in Mixtec. So she shrugged and smiled for the camera, after which her young friends cheered.

In the late afternoon we made our way back to Jamiltepec. Santiago was sitting in his chair, embroidering a white shirt. He glowed with pleasure when he heard that we had come from Hong Kong to find him. "You are lucky," he said sternly. "I'm an old man. I could have been dead by now and then how would you find the *caracola*?" He was a young-looking fifty-one-year-old, but he had been ill with diabetes for the past eight years. "*Una tortilla per*

*día*,"—just one tortilla a day—he groaned, shaking his head at the gastronomic tragedy. Santiago had become interested in the indigenous dyeing traditions sixteen years earlier, when he had first gone to find the mollusks, accompanying an old man who had once been one of the regular itinerant purple-collectors. Since then he had gone whenever he could. Local people thought he was eccentric, but he ignored them. He agreed to take us down to the purple coast the next day, although he warned we might have a problem getting a fishing boat to take us. "It is dangerous: we have to go with other people. One to find, and one to watch. People die doing this."

We met him just after dawn, and set off to the coast. As we drove he told us of the three colors of the *caracola* dye—a curious echo of the Mexican flag, though with a seashell rather than an eagle at its center. "First it is white," he said. "And then it becomes green, and then it finishes as purple or red, which we call *morado*." Because of the white, the process is called milking. In 1983 a Japanese company that called itself Purpura Imperial was given a contract by the Mexican government to collect purple for kimonos, he said. But they killed the snails rather than preserving them as the Mixtecs did, and eventually, after several years of lobbying by environmentalists, the contract was retracted and the Mixtecs were given the exclusive rights to dye with *purpura* in Oaxaca.

Japan has a long history of celebrating purple: violet has traditionally been the color of victory in competitions, it is the color of the cloth used by Shinto priests to wrap the most precious objects of the temple, and it is the color of the costume and tassels of the highest-ranking sumo referee. They call it *murasaki* (which sounds astonishingly similar to "murex"), and this was the adopted name of the author of the great work of eighth-century literature, *The Tale of Genji*, who called herself Lady Murasaki or Lady Purple. The Japanese had their own purple-giving shellfish—*Rapana bezoar*—but it was very rare and most purple was made with a plant

from the borage family called *murasaki-so*—in English, gromwell.[24] It is hardly surprising, then, that they were willing to pay a fortune for Mexican purple. Although perhaps the company had not bargained for the diplomatic problems it would cause and clearly had not cared about the environmental ones.

At a police checkpoint we turned right, toward Zapotalito, where most inhabitants are the descendants of escaped African slaves who founded their own free communities on the Mexican Pacific. It is a dusty fishing village, lined with houses where pigs and chickens roam. Santiago stopped at one house, and came out a few minutes later, amazed at our luck. "There is never a spare boat," he said, shaking his head, "but today we have *mucha suerte*. My friend has been painting his launch, so he didn't go out fishing this morning. His son will takes us out after breakfast." Santiago had been on about five purple expeditions with foreigners in the past decade. He remembered one couple who had accompanied him for the husband's research. They had taken one look at a local restaurant in Zapotalito and walked out, noses wrinkling in spousely unison, announcing that they could not possibly eat there because of the wife's delicate stomach. "Are your stomachs delicate?" he asked us. We assured him not, and we had a day of sampling excellent fresh fish—even for breakfast.

As soon as the tide was right we met the four boys who were to take us. They had green acrylic splashes on their bare feet from their boat-painting. We sped through the lagoon, past the fishing hamlet of Cerro Hermoso—Pretty Hill—and out into the open sea. Hold on tight, they said. The water was not rough, but I took hold of the seat politely. "No, really tight." And then, as we bobbed in the waves and waited and then bobbed a little bit more, I suddenly understood. A big wave rose up behind us, Fabian the driver thrust the motor to maximum, and we surfed in on its crest, landing with a judder on the white sand of a deserted beach, distracting a flock of vultures from their lunch of giant turtle.

We headed toward the rocks, which fringed the coast for as far as we could see, and started looking, even though I was not very sure what I was looking for. Santiago was the first to find a *caracola* or sea snail: it was the size of a Matchbox toy car and, unlike the spiky Lebanese murexes, it was rounded and dark gray. He picked it up and blew on it. "Look," he said, and as we all gathered round it started to weep as if with fury at being removed from its rock. The tears swiftly became milky white, and Santiago rubbed it gently against the skein of white thread he had wrapped loosely around his shoulder. It was a simple way of getting over the problem that purple was a pigment not a dye: strictly speaking, Santiago was not dyeing the cloth—he was painting it.

As he had promised, it made a stain that was fluorescent lime green, which within a few minutes turned yellow and then purple, like a bruise. The dye is a naturally light-sensitive compound—the purple appears in reaction to the sunshine, otherwise it stays green. It is curious to think that this natural chemical compound could, if anybody had ever found a way of fixing it, have been used to make the world's first photographs. We could have inherited ancient photo-images of Aztec rituals or thousand-year-old baby pictures, all held in crazy hallucinogenic color contrasts with this organic dye. For a moment, as I took a picture of Santiago happily holding his little shell, I imagined the image developed as a violet wash, with lime-green spots where the shadows lay.

From our rock fortifications we could see a man with a snorkel far below us in the sea, diving down for what seemed ages. I was so impressed, I timed it: he averaged more than ninety seconds each time. I liked to think he was a pearl-fisher, following the traditions of his ancestors, although Fabian less romantically thought he was probably collecting lobsters. If the man looked up and spotted us through his foggy mask, we must have seemed a curious sight as well. Four boys, a man and two blonde women separating out among the spiny rocks, then clambering back to touch a piece of

white cotton with a little shell, before moving away again. Occasionally a wave would drench us, and we would wipe the water from our faces as if crying.

We spread out along the rocks, enjoying the triumph of finding a particularly impressive specimen of *Purpura pansa*, of tugging the creature until it gave up its sunny bathing spot with a reluctant slurp, of blowing on it, then the wonder of watching the color turn on the thread. I wanted to take one, just one, home for my collection. "Here's one," said Santiago, holding an example at random. "You could put it back or take it." Put it back, I said, thinking rather greedily that it wasn't the biggest one. "That's right: leave it to live another day," he said approvingly. "The *caracola* are sacred: we believe it is bad luck to kill them," he added. I had had so much good luck that day I didn't want to risk it. I left them all.

With no skein over my own shoulder I instead set one *caracola* on my white nylon watch strap. It mottled quickly to bright purple, and smelled strongly of spring onions. For the next month I had to break the habit of thirty years and take my watch off at night, lest my dreams were too full of the sea. Even now, as I write six months later, I can still smell the garlic. Experts say that even with textiles a century old or more you can know if they were dyed with *caracola*—or murex depending on your continent—by rubbing them gently between the fingers and sniffing them. It is a funny thought that, even wafting clouds of jasmine and saffron perfumes, the emperors of Ancient Rome would probably have left a cloud of garlicky, fishy smells in their wake. Perhaps there were so many other smells in Rome that "eau de murex" was celebrated for its sophistication. Perhaps it was the scent of power.

I found a cave where the rocks were prettily stained with mauve: it must have represented millennia of snail trails. Suddenly I heard the brittle sound of shells cracking, and looked around. It was fifteen-year-old Rico, who, bored with searching, was throwing the used mollusks at the rocks. Santiago scolded the boy. Killing the *caracola* is what the Japanese people did—it is not the behavior of

Mexicans, he said. "See how these people have come all the way from Hong Kong to see our purple: we have to value it."

We slung the skein over the boat. It made a good photo: the lilac threads against the green boat, with the amateur dyeing team standing triumphant behind, holding out our stained hands. But this, I had already realized, was not the purple that Pliny described, the almost-black that in the right light provides a glimpse of another color that we don't have a word for. This was mauve, lilac, lavender, whatever flower words one can summon. But it was not conceivably ox blood. Was there some mistake? Had we left out some critical step in the dyeing process (hardly impossible, as the dyeing process I had just witnessed must be one of the simplest ever devised)? In the eighteenth century the Ulloas had recorded that the cotton varied in weight and color according to the hour it was dyed—a finding that he had thought curious, but which had its echoes among the dyers of the Mediterranean. Perhaps, I thought, the ox-blood hour was later in the afternoon.

Back in Jamiltepec, Santiago invited us to see his home. It was a one-room building with a mud floor and two gray hammocks where he and his sister slept, separated by a curtain. The only pieces of furniture were a wooden chair and a sewing machine driven by foot pedals, with which he made artifacts for tourists. I promised to send him photographs, and a copy of this book. The other people who had come had always promised and never sent anything. "But it's another world, isn't it, for them," he said, both wistfully and wisely.

The next day we visited a hill town called Pinotepa Don Luis. When we arrived after 40 kilometers of muddy driving it was like shifting back physically in time: the only thing modern, it seemed, was us. The whitewashed village square was full of men in white, women in purple, all moving around chatting and selling things to each other. We parked and walked back with our cameras. But in those five minutes, and as if by magic, everyone had vanished. The whole place was empty except for a man quietly painting the

cast-iron benches white, and I really wondered whether I could have imagined the earlier scene.

The mystery was solved twenty minutes later, when we found a curious restaurant in a back street. It consisted of strong wooden trestle tables and benches laid out under a canopy that crossed the street. On one side women stirred great cauldrons of coffee and terrifyingly fatty beef stew (at last, I thought, I had found the ox-blood color), heated by wooden fires. On the other side, in a garden, a dozen women were busy making tortillas in the old-fashioned way, on ancient metal plates heated by wood fires. We were invited to join in, and everyone laughed when our tortillas were full of holes. The more gregarious women beckoned us to sit and placed bowls of fatty stew and coffee in front of us. We offered to pay and they shook their heads firmly.

On the other side of the covered street there was an old man dressed immaculately in white, pulling pale cloth-like bits of inner cow from a bucket of offal, stretching them out. He was the village leader and he spoke no Spanish, only Mixtec. We felt we had either slipped a century or were on a film set. For a dedicated searcher of purple skirts it was heaven: almost all the women over forty were wearing them, although some definitely had an aniline look. Most of the women wore aprons, but one septuagenarian, tending her cauldron in the background, was bare breasted in the old style. "Is it always like this?" I asked a friendly-looking young man on the next-door trestle table. "Oh no," he said, with a broad smile. "This is my wedding."

After we had got over our horror, he introduced me to his friend's mother, Elvira Leyva, who he said might be able to tell us about the significance of the stripes in her skirts. I had been told the patterns of blue, red and purple in the weave might vary, depending on what village it was made in. "No," she said, laughing. "The stripes don't matter, we just choose the design we like." She owned five *posahuancos*, which she wore in succession, with one kept back for "best." She could remember her own mother giving

yarn to the itinerant dyers, who would go down to the coast, and return a few months later having "painted" the thread. "That doesn't happen much anymore: most of these are synthetic." It was a shame, she said, as the more you washed the old *posahuancos*, the better the purple color became.

Elvira had never worn any other clothes, and laughed when I asked whether she got tired of them. "The people who wear it, we wear it forever," she said. She was sitting next to a woman dressed in black, who was introduced as her *consuegra*, the mother-in-law of her child. They were the same age and had gone to the same school, but one had worn only Spanish clothes, the other only Mixtec. "It's always been like that in Pinotepa," Elvira explained. "Some people do wear purple, and some people never do. The Spanish people never do."

One of the never do's is her own daughter, who is in her early twenties and has never worn a purple skirt in her life, not even when she was little. "She didn't want to," Elvira explained. Did Elvira also feel it was a shame that the custom would end with her generation? She laughed. "Oh no. My daughter is independent. She can do as she likes." Then she added: "I'm not sad at all. This is just the way life is; things change."

## THE SECRET OF TEKHELET

Sometimes you travel a long way to find something, and yet when you find it, it is closer to home than you think. That's what happened to me with "Tyrian" purple. I thought I would find it in Tyre, and I found only empty vats and a steep hill built out of seashells—and even the fragment of dyed wool I saw was not purple at all. I then thought I would find it in Mexico, but although I was entranced by watching that transparent stain turning mauve in the sunshine, I knew the Romans had used a different method.

In England I met a dyer called John Edmonds. I contacted him because I had heard he had experimented with two hundred

different dye recipes (including woad) for a project at the Chiltern Open Air Museum—and he ended up helping me on my indigo quest. But what really fascinated me were more recent experiments he had done with a quite different kind of blue—a seashell color that was used to make the sacred tassels on the Jewish *tallit* shawl. Its story is one of loss and rediscovery—several times over.

Here was the problem. According to the Torah—the first five books of what Christians call the Old Testament—God told Moses to tell the Israelites to make "fringes in the borders of their garments [and] put upon the fringe of each corner a thread of blue."[25] The Talmud, which is the book of Jewish laws, went farther and specified that the blue had to come from a special source. It was vague about exactly what that source should be, although it was emphatic that it should be from a particular kind of sea creature with a shell.

The purpose of the fringe and the shawl are to remind Jewish men of their sacred responsibilities. The twelfth-century sage, Maimonides suggested the blue was "similar to the sea which is similar to the sky which is similar to God's holy throne." Another explanation from a modern-day commentator[26] suggests that the white on the *tsitsit* represents logical things, and blue represents mystical things, and only together can they fully remind us of the wonders of the universe. Whatever the symbolism, all these color-coded reminders were forgotten in around the seventh century, at the time of the Muslim conquests. It had probably been the exclusive domain of Jewish dyers to dye these sacred fringes—non-Jews were probably not trusted not to use indigo—and none of them had thought to write the formula down for posterity.

So for 1,300 years the Jews had no blue in their *tsitsit*, or if they did have blue, then it was the wrong one. But then Perkin's discovery of coal-tar colors began to stir long-forgotten memories.[27] Inspired by the new dyes, a Rabbi Leiner in Poland decided to do some investigations into the old ones.[28] Leiner's theory was that the "*hillazon*," mentioned in the Talmud as the source of the *tsitsit*'s

proper blue, was a squid, and in the 1880s he was delighted when chemists showed him that it was indeed possible to make a very fine blue from squid sepia—by adding a few iron filings to the brew—and within a few months thousands of Jews were wearing blue sacred threads.

But there was a problem with Leiner's recipe—a problem that was not discovered until 1913, when a London University student decided to make this the subject of his postgraduate thesis. Isaac Herzog was no ordinary student—he would later become the first Chief Rabbi of the State of Israel, and his son Chaim would become its President. And he was fascinated by the problem of purple, especially after sending some of Leiner's dye to the laboratory, only to find to his amazement that it wasn't even organic. In fact, the laboratory told him, he was in proud possession of an excellent example of Prussian blue. The squid wasn't essential at all for the dyeing; the color depended far more on the iron filings.[29]

Over the years Jewish scholars experimented with other species. The problem they faced was that however they put the pigment from the shellfish in the vat, everything usually came out purple— and although the Hebrew word *tekhelet* can suggest both violet and blue, they were convinced the historical color veered much more toward the latter. In 1908 a scientist called Paul Friedlaender discovered that imperial purple is chemically very closely related to indigo: no wonder the early Jews had so much trouble telling the two apart.

Then, in the 1980s, a chemist called Otto Elsner noticed something else extraordinary. He observed how dyeing done on a sunny day came out blue—but on a cloudy day it was purple. This seemed to provide part of the answer the Jews had been looking for. Elsner had established that it was indeed possible to get blue from purple by involving a photo-chemical reaction—and his discovery had the additional theological neatness of embracing something holy that was, like the world itself, born of light. But Elsner had used modern chemicals in his experiments, and he and his

colleagues were still faced with a more elusive problem: how did the ancients make that pigment into dye? Alkali solutions would do the job efficiently, which was good; but they would also dissolve wool, which was bad. There was evidently a critical step in the manufacturing process missing, but who could have guessed that the mystery would be solved by a gentile with a jam jar and some pickled snacks?

The Israeli researchers contacted John Edmonds after they learned of his experiments with woad, and wanted to know if he had done anything on purple. Edmonds said he would like to try, and a few weeks later a package arrived for him in the post. It contained a small vial of pigment from *Murex trunculus*, and some wool. He was excited by the opportunity to test his theory that if Tyrian purple contains indigo then perhaps, like woad and indigo, it needs to have the oxygen removed from the vat before it can become a dye. And what more convenient ingredient for achieving this than the rotting meat of the mollusk (which would cause the bacteria to putrefy and use up the oxygen)? The Israeli researchers had not sent Edmonds the murex meat in their parcel, "so I went out to the supermarket and bought some pickled cockles—which are similar—and when I got home I washed out the vinegar."

He heated the pigment and shellfish in a bain-marie, keeping it at an alkali level of pH9. He then left the solution to steep for ten days at 50 degrees Centigrade, during which time it changed from purple to green (and Edmonds's wife decided she *really* didn't like this dyeing business because of the smell). The first time he dipped a cloth into the liquor it turned purple. But later he found that if the dissolved greenish liquor was exposed to light, any cloth he put into it turned green and then—in the air—turned blue. He had, he thought, found the recipe for the Jewish holy blue made from a purple vat. The missing ingredient, in addition to sunlight, had been a biological reducing agent—the bacteria in the rotting bodies of the murex shellfish. Today, however, non-purists might

choose to use sodium dithionide, better known as Color Run Remover. It does a similar job and is a lot less pungent.

All this happened in November 1996. Professor Zvi Koren, head of Chemical Technologies at Shenkar College of Engineering and Design in Israel, and his colleagues have subsequently come to similar conclusions about the way the Jews dyed their *tsitsit*. At a conference on archaeological dyes in Amsterdam in November 2001, Professor Koren showed a slide of people collecting *Murex trunculus* on the rocky coast of Israel. "Here *we* are," he said, pointing to some excited-looking scientists. "And here are the snails," he added, pointing to small gray blobs on the rocks. And then finally he pointed to a bearded man sitting on the rocks enjoying the sunshine. "And here is the rabbi, looking over to make sure we don't eat the murex. Because it is definitely not kosher."

Like the best jokes, Koren's was based on truth. In a strange way, *tekhelet* in Jewish tradition might be said to be about playing with the edges of what is allowed. It is literally on the fringe of a garment, and it is metaphorically on the very fringe of what is permitted to Jews. Tyrian purple—or in this case Tyrian blue—is one of the least kosher of colors. Shellfish are as anathema to Jewish menus as pork, so it is curious that one of the most sacred Jewish garments should be made from them.[30]

At the same conference, John Edmonds and artist Inge Boesken-Kanold were demonstrating a purple and blue dye vat. The demonstration was taking place in another part of the building—to get there I needed to walk down three floors, walk along the street for 20 meters, go through another door, and then walk up three floors. But I didn't need directions: I could smell the vat from the moment I reached street level. Even from there I found myself gasping; and by the time I had climbed up to the room itself the stink was almost unbearable. This, I realized, was why Tyre had banished its dyers to a remote corner of town. But as Edmonds and Boesken-Kanold hung their little sample cloths up to dry, I could

see why the good people of Tyre had put up with their olfactory suffering. Because there, like little miracles of the dye pot, were examples not only of a vivid purple, as bright as anything Perkin created, but of a sky blue from the same source. There in that smelly room was the legendary Tyrian purple—the symbol of power and greed and luxury that I had chased around the world to find. And next to it was its bluer twin, which had the same constituent elements but with a little sunlight mixed in with them as well, to remind the Jews not to forget the more mystical side of the universe.

Perkin's extraordinary discovery of modern dyes that day in 1856 had—years later—resulted in rediscoveries of how to make two of the oldest, and most revered, colors in the world. As with so many stories in my historical paintbox, it turns out that the old secrets were not lost after all. They were just waiting for someone to discover them again.

# The End of the Rainbow

How many shades can a walnut be? What is the color of a healthy liver? How can you describe the ideal organic strawberry to a buyer on the other side of the world? What shade do you want your car to be? Or your hair? Or the sapphire in your engagement ring? How can you measure the color of pies? Writing and researching this book have shown me how hard it is to describe color—to explain the gleam of insect blood or the natural luminescence of a piece of precious Chinese green-ware or the ruby-like resonance of a glass of saffron tea. So I decided to end by meeting someone who had made it his business to do just that: work out how to describe the exact shade of a color to somebody halfway across the world.

Lawrence Herbert is sometimes called the Color King. "Or even the Color Magician," he volunteered, when I met him at the Pantone color palace in a sprawling piece of industrial greenbelt just off the New Jersey Turnpike. Herbert's mission in life—ever since he took a temporary job at a small and ailing printing company (which produced color charts) in 1956 and bought it out within six years—has been to create an internationally accepted standard of colors. "My dream was that someone should be able to call a supplier in California from their home in Acapulco and say I'd like to buy rose pink paint, or whatever. And that when it arrived it was exactly right."

In the natural world—where the color of an ochre might depend on the exact place where it was mined, or where an "indigo" dye could be dozens of different shades, depending on the dipping time, the alkalinity and even the sunniness of the day—making

colors has traditionally been an imprecise although often highly symbolic activity. But at Pantone, which has grown to be the biggest color-specification company in the world, color is all about precision. Herbert and his colleagues started by dividing the world into fifteen basic colors, including black and white, making up about a thousand shades. He later introduced even more elaborate systems, including colors with evocative names like wood violet, moss tone, sulphur spring and doe. Pantone sells the basic "catalogue" in fan-like books—and if you have one and your contact has one, then you can both know exactly what shade you are talking about. It started off as a service for printers, but the expanded system has proved to have a myriad of uses.

Pantone color standards have been used for renovating the tiles in the mosaics of San Marco in Venice, for giving official definitions of the colors used in national flags, including the Union Jack and Japan's Rising Sun, and for measuring the color (and sometimes therefore the quality) of gemstones. But one of the company's proudest innovations does not have to do with art or heraldry or jewelry but with medicine. "We've just developed cards that can identify the fat content of a liver by color prior to a transplant," Herbert told me. The cards have already saved lives by cutting down on rejection rates. "Previously measuring color was based more on art than on science. Now we can be exact."

The oddest color-matching job he had ever accepted was a commission from a goldfish breeder to calibrate the different colors of the shimmering koi that are so valued throughout Asia. "About twenty fish arrived in little bags, and I put each of them into a tank and moved them around until I'd put them in some kind of arrangement in terms of color," he remembered. How would you assign names for twenty shades of fish, I mused, thinking of the famous story about the Inuit of Canada distinguishing between dozens of shades of snow[1] (a story which is apocryphal but which has captured so many people's imagination that it is a phenomenon in itself), or of the amazing statistic that in Mongolia there are

more than 300 words for the colors of horses. "We won't do names anymore," he said. "In the next round we're eliminating them."

I felt a little like John Keats, appalled at Newton's audacity in taking the magic out of the rainbow. "But the names of colors are history," I said, thinking of how mummy brown and ultramarine and Scheele's green and Turner's yellow and so many color names hold entire histories of deceit and adventure and experimentation in their syllables. "But we are dealing with science and measurement," he explained patiently. "This is a digital world now, and computers don't need names but numbers. People talk about 'barn red' but they never saw a Scandinavian barn in their life. And what does 'lipstick red' mean anyway?"

Today we can have our houses and our cars and our clothes any color we like—without any reference to nature or to anything more symbolic than the fashion world's decisions about what colors are "right" for next season. And so perhaps it is not strange that we do not seem to need or even want to be reminded of their history anymore. I could understand what Herbert was saying—he needed to adapt to new demands from the computer and Internet market—but I was relieved that I had encountered him toward the end of my researches. And I felt glad that I had made my paintbox journeys when I could still explore worlds of approximation and poetry, before the colors began to lose their words.

When I was two days from finishing the first draft of this book, a friend called from New York in great excitement. "There's a text message on CNN. They say someone's found the color of the universe," he said. And what color is it? "I'm not sure, I missed it." He left the TV news running as we talked, and then suddenly he said: "Here it is again." I grabbed my pen and wrote down that scientists at Johns Hopkins University had discovered the color of all the light in the universe. And that it was pale turquoise.[2] I had no idea what it meant, but it suggested that my journey was not over. And that there was a whole world—no, a whole universe—of color stories still to find.

# BIBLIOGRAPHY

Albus, Anita. *The Art of Arts (Kunst der Künste)*. Trans. Michael Robertson. New York: Alfred A. Knopf, 2000.

Anderson, James. *Correspondence for the Introduction of Cochineal Insects from America*. Madras: Joseph Martin, 1791.

Angeloglou, Maggie. *A History of Makeup*. New York: Macmillan, 1970.

*Artists' Pigments: A Handbook of their History and Characteristics*, vol. 1. Ed. Robert Feller. Washington: National Gallery of Art, 1986.

*Artists' Pigments: A Handbook of their History and Characteristics*, vol. 2. Ed. Ashok Roy. Washington: National Gallery of Art, 1993.

*Artists' Pigments: A Handbook of their History and Characteristics*, vol. 3. Ed. Elizabeth West Fitzhugh. Washington: National Gallery of Art, 1997.

Ayres, James. *The artist's craft, a history of tools, techniques and materials*. Oxford: Phaidon, 1985.

Baer, N. S., A. Joel, R. L. Feller and N. Indictor. "Indian Yellow." In *Artists' Pigments*, vol. 1, pp. 17–36.

Bahn, Paul. *The Cambridge Illustrated History of Prehistoric Art*. Cambridge: Cambridge University Press, 1988.

Baker, Christopher, and Tom Henry (compilers). *The National Gallery Complete Illustrated Catalogue*. London: National Gallery, 1995.

Baker, Ian. *The Dalai Lama's Secret Temple: Tantric wall paintings from Tibet*. London; New York: Thames & Hudson, 2000.

Balfour-Paul, Jenny. *Indigo*. London: British Museum Press, 1998.

Ball, Philip. *Bright Earth, the Invention of Colour*. London: Viking, 2001.

Bardon, Geoffrey. *Papunya Tula: Art of the Western Desert*. Australia: JB Books, 1991.

Beare, Charles. *Antonio Stradivari, The Cremona Exhibition of 1987*. London: J. & A. Beare, 1993.

Berlin, Brent, and Paul Kay. *Basic Color Terms; their universality and evolution*. Berkeley: University of California Press, 1969.

Berndt, Ronald M., and Catherine H. Berndt. *The World of the First Australians, Aboriginal Traditional Life, Past and Present*. Canberra: Aboriginal Studies Press, 1987.

Binski, Paul. *Painters*. London: British Museum Press, 1991.

Birren, Faber. *Color; a survey in words and pictures, from ancient mysticism to modern science.* New York: New Hyde Park, 1963.

Boger, Louise Ade. *The Dictionary of World Pottery and Porcelain.* London: Adam & Charles Black, 1971.

Bomford, David, and Ashok Roy. *Colour.* London: National Gallery, 2000.

Bomford, David, Jo Kirby, John Leighton and Ashok Roy. *Impressionism.* London: National Gallery in association with Yale University Press, 1990.

Bomford, David, et al. *Italian Painting before 1400, Art in the Making.* London: National Gallery, 1989.

Boulter, Michael. *The Art of Utopia, a new direction in contemporary Aboriginal art.* Tortola: Craftsman House, 1991.

Bowersox, Gary, and Bonita Chamberlin. *Gemstones of Afghanistan.* Tucson, Ariz: Geoscience Press, 1995.

Bridge, Dave. "Wad." In *Beneath the Lakeland Fells, Cumbria's mining heritage.* Cumbria: Red Earth Publications, 1992.

Bridgeman, Jane. "Purple Dye in Late Antiquity and Byzantium." In *The Royal Purple and the Biblical Blue: Argaman and Tekhelet.* Jerusalem: Keter Publishing House, 1987, pp. 159–65.

Brusatin, Manolo. *A History of Colours (Storia dei colori).* Boston, MA.: Shambhala, 1991.

Bryan, Michael. *Bryan's Dictionary of Painters and Engravers.* New York; Port Washington: Kennikat Press, 1964 (Ist ed. 1903).

Burton, Richard (trans). *The Kama Sutra of Vatsyayana.* Benares: Hindoo Kama Shastra Society, 1883.

Bushell, Stephen Wootton. *Oriental Ceramic Art.* New York: Appleton & Co., 1896.

Byron, Robert. *The Road to Oxiana.* London: Macmillan, 1937.

Callow, Philip. *Vincent Van Gogh, A life.* London: Allison & Busby, 1990.

Carvalho, David Nunes. *Forty Centuries of Ink, or A chronological narrative concerning ink and its background.* New York: Bank Law Publishing Co., 1904.

Cennino, Cennino d'Andrea Cennini. *The Craftsman's Handbook (Il Libro dell'Arte).* Trans. Daniel V. Thompson. New York: Dover Publications, 1960 (first pub. 1933).

Cennino, Cennino d'Andrea Cennini. *A Treatise on Painting.* Trans. Mrs. Merrifield. London: Edward Lumley, 1844.

Chaloupka, George. *Journey in Time: the world's longest continuing art tradition.* NSW: Chatswood, Reed, 1993.

# BIBLIOGRAPHY

Chambers, David, and Brian Pullan (eds). *Venice, A Documentary History 1450–1630*. Toronto: University of Toronto Press, 1992.

Chauvet, Jean-Marie, Eliette Brunel Deschamps and Christian Hillaire. *Chauvet Cave, the Discovery of the World's Oldest Paintings*. London: Thames and Hudson, 1996.

Chenciner, Robert. *Madder Red, a history of luxury and trade, plant dyes and pigments in world commerce and art*. Richmond: Curzon, 2000.

Ciba Review. *Madder & Turkey Red* (39), *Indigo* (85), *Black* (1,963). Basle: Society of Chemical Industry, 1937–70.

Clark, Kenneth. *Looking at Pictures*. London: John Murray, 1961.

Cole, William. "Purple Fish." In *Philosophical Transactions*, vol. 15. London: Royal Society, pp. 1,278–86.

Corbally Stourton, Patrick. *Songlines and Dreamings, Contemporary Australian Aboriginal Painting*. London: Lund Humphries, 1996.

Costaras, Nicola. "A study of the materials and techniques of Johannes Vermeer." In *Vermeer Studies*. Washington: National Gallery of Art, 1998, pp. 145–61.

Cummings, Robert. *Art: an eye-opening guide to art and artists*. New York: Alfred A. Knopf, 2001.

Dampier, William. *Captain William Dampier's voyages around the world*. London: James & John Knapton, 1729.

Darwin, Charles. *Charles Darwin's Beagle Diary*. Ed. Richard Darwin and Richard Keynes. Cambridge: Cambridge University Press, 1988.

Delamare, François, and Bernard Guineau. *Colour, Making and Using Dyes and Pigments*. Trans. Sophie Hawkes. London: Thames & Hudson, 2000.

Diaz-Mas, Paloma. *Sephardim*. Chicago: University of Chicago Press, 1992.

Dodd, George. *The Textile Manufactures of Great Britain*. London: Knight's Weekly Volumes, 1844.

Donkin, R. A. *Spanish Red: an ethnogeographical study of cochineal and the opuntia cactus*. Philadelphia: The American Philosophical Society, 1977.

Dorment, Richard, and Margaret MacDonald. *James McNeill Whistler*. London: Tate Gallery Publications, 1994.

Dorn, Roland. "The Arles Period: Symbolic Means, Decorative Ends." In *Van Gogh Face to Face*. Detroit: Detroit Institute of Art with Thames and Hudson, 2000, pp. 134–71.

Dossie, R. *The Handmaid to the Arts*. London, 1758.

Downer, Leslie. *Geisha, the secret history of a vanishing world*. London: Headline, 2000.

Dreyfuss, Henry. *Symbol Sourcebook: An Authoritative Guide to International Graphic Symbols*. New York: Henry Dreyfuss, 1972.

Eastlake, Charles. *Materials for the History of Oil Painting*. London, 1847.

Edmonds, John. *The History of Woad and the Medieval Woad Vat*. Little Chalfont: John Edmonds, 1998.

Edmonds, John. *The History and Practice of 18th century Dyeing*. Little Chalfont: John Edmonds, 1999.

Edmonds, John. *The Mystery of Imperial Purple Dye*. Little Chalfont: John Edmonds, 2000.

Egerton, Judy, with Martin Wyld and Ashok Roy. *Turner, The Fighting Téméraire*. London: National Gallery, 1995.

Elkins, James. *What Painting Is*. London; New York: Routledge, 1999.

Emmison, Frederick George. *Elizabethan Life: Home, Work and Land. From Essex wills and sessions and manorial records*. Chelmsford: Essex County Council, 1976.

Field, George. *Chromatography: or a Treatise on Colours and Pigments and of their Powers in Painting*. London: Charles Tilt, 1835.

Finlayson, Iain. *Denim, an American Legend*. Norwich: Parke Sutton, 1990.

Fitzhugh, Elizabeth West. "Orpiment and Realgar." In *Artists' Pigments*, vol. 3, pp. 47–80.

Fitzhugh, Elizabeth West. "Red Lead and Minium." In *Artists' Pigments*, vol. 1, pp. 109–40.

Flood, Josephine. *Archaeology of the Dreamtime*. Sydney: Angus & Robertson, 1983.

Gage, John. *Colour and Culture, practice and meaning from antiquity to abstraction*. London: Thames & Hudson, 1993.

Gage, John. *George Field and His Circle: from Romanticism to the Pre-Raphaelite Brotherhood*. Cambridge: Fitzwilliam Museum, 1989.

Garfield, Simon. *Mauve: How one man invented a colour that changed the world*. London: Faber & Faber, 2000.

Gega, Lama. *Principles of Tibetan art: illustrations and explanations of Buddhist iconography and iconometry according to the Karma Gardri School*. Darjeeling: Jamyang Singe, 1983.

Gettens, Rutherford, and George L. Stout. *Painting Materials: a short encyclopaedia*. New York: Dover Publications Inc., 1966.

Gettens, Rutherford, Hermann Kuhn and W. T. Chase. "Lead White." In *Artists' Pigments*, vol. 2, pp. 67–82.

Gettens, Rutherford, Robert Feller and W. T. Chase. "Vermilion and Cinnabar." In *Artists' Pigments*, vol. 2, pp. 159–82.

Gettens, Rutherford, and Elizabeth West Fitzhugh. "Malachite and Green Verditer." In *Artists' Pigments*, vol. 2, pp. 183–202.

Glaser, Hugo. *Poison, the history, constitution, uses and abuses of poisonous substances*. Trans. Marguerite Wolff. London: Hutchinson, 1937.

Goethe, Johann Wolfgang von. *Goethe's Color Theory (Farbenlehre)*. Ed. Rupprecht Matthauei. New York: Van Nostrand Reinhold, 1971.

Grant, Colesworthey. *Rural Life in Bengal, Illustrative of Anglo-Indian Suburban Life. Letters from an artist in India to his sisters in England*. London: W. Thacker & Co., 1859.

Gulik, Robert van. *The Chinese Maze Murders*. London: Michael Joseph, 1962.

Hackney, Stephen, Rica Jones and Joyce Townsend (eds). *Paint and Purpose*. London: Tate Gallery Publications, 1999.

Harley, R. D. *Artists' Pigments c. 1600–1835, a study in English documentary sources*. London: Butterworth Scientific, 1982.

Hayes, Colin. *The Complete Guide to Painting and Drawing Techniques and Materials*. London: Phaidon, 1979.

Hebborn, Eric. *The Art Forger's Handbook*. London: Cassell, 1997.

Herbert, William. *A History of the Species of Crocus*. Stamford Street: William Clowes and Sons, 1847.

Hibi, Sadao. *The Colors of Japan*. Tokyo: Kodansha International, 2000.

Hirst, Michael, and Jill Dunkerton. *Making and Meaning: The Young Michelangelo*. London: National Gallery, 1994.

Hopkirk, Peter. *Foreign Devils on the Silk Road, the search for the lost cities and treasures of Chinese Central Asia*. London: John Murray, 1980.

Hulley, Charles E. *Ainslie Roberts and the Dreamtime*. Melbourne: J. M. Dent, 1988.

Hulley, Charles E. *The Rainbow Serpent*. Australia: New Holland Publishers, 1999.

Humphries, John. *The Essential Saffron Companion*. London: Grub Street, 1996.

Hunt, Holman. *Journal of the Society of Arts*, April 23, 1880, pp. 485–99.

Januszczak, Waldemar (ed.). *Techniques of the World's Greatest Painters*. Oxford: Phaidon, 1980.

## BIBLIOGRAPHY

Jidejian, Nina. *Tyre through the Ages*. Beirut: Dar el-Mashreq, 1996.

Jones, Philip. "Red Ochre Expeditions: An Ethnographic and Historical Analysis of Aboriginal Trade in the Lake Eyre Basin." In *Journal of the Anthropological Society of South Australia*, 1983, pp. 10–15.

Josephus. *Jewish Antiquities*, books VII–VIII. Trans. Ralph Marcus. Cambridge, Mass.: Harvard University Press, 1934.

Kemp, Martin (ed.). *Leonardo on Painting*. Yale: Yale University Press, 1985.

Kling, Blair. *The Blue Mutiny: the Indigo Disturbances in Bengal, 1859–1862*. Philadelphia: University of Pennsylvania Press, 1966.

Kuhn, Hermann. "Zinc White." In *Artists' Pigments*, vol. 1, pp. 169–86.

Kuhn, Hermann. "Verdigris and Copper Resonate." In *Artists' Pigments*, vol. 2, pp. 131–58.

Langmuir, Erika. *National Gallery Companion Guide*. London: National Gallery Publications, 1994.

Lao Zi. *The Tao Te Ching*. Trans. Man-Ho Kwok, Martin Palmer and Jay Ramsay. Shaftesbury: Element, 1994.

Lin, Yutang. *The gay genius: the life and times of Su Tungpo*. New York: John Day, 1947.

Liu Liang-yu. *A Survey of Chinese Ceramics*. Taipei: Aries Gemini Publishing Ltd, 1991.

Lucan. *Civil War*. Trans. S. H. Braund. Oxford: Clarendon Press, 1992.

Marohn Bendix, Deanna. *Diabolical Designs; paintings, interiors and exhibitions of James McNeill Whistler*. Washington: Smithsonian Institution Press, 1995.

Marshall, Ingeborg. *The Red Ochre People*. Vancouver: J. J. Douglas, 1977.

Mayer, Ralph. *The Artist's Handbook of Materials and Techniques*. New York: Viking, 1991.

McBryde, Isabel. "Goods from another country: exchange networks and the people of the Lake Eyre Basin." In *Australians to 1788*. Fairfax: Syme and Weldon Associates, 1987, pp. 252–73.

Menonville, Thierry de. *Traité de la Culture du Nopal . . . précédé d'un Voyage à Guaxaca*. Paris: 1787.

Merrifield, Mary. *Medieval and Renaissance Treatises on the Arts of Painting*. New York: Dover Publications, 1999 (1st ed. 1849).

Meyuhas, Ginio (ed.). *Jews, Christians and Muslims in the Mediterranean World after 1492*. London: Frank Cass and Co. Ltd, 1992.

Milton, Giles. *Nathaniel's Nutmeg*. London: Hodder & Stoughton, 1999.

# BIBLIOGRAPHY

Mitra, Dinabandhu. *Nil Darpan or the Indigo Planting Mirror*. Trans. "A Native." Calcutta: C. H. Manuel, 1861.

Moorhouse, Geoffrey. *Calcutta*. London: Weidenfield, 1972.

Morgan, Ted. *Wilderness at Dawn: the settling of the North American continent*. New York: Simon & Schuster, 1993.

Morphy, Howard. *Aboriginal Art*. London: Phaidon, 1999.

Morris, Jan. *Venice*. London: Faber & Faber, 1983.

Mosca, Matthew. "Paint Decoration at Mount Vernon." In *Paint in America, the colors of historic buildings*. Ed. Roger Moss. Washington: Preservation Press, 1994, pp. 105–27.

Nassau, Kurt. *The Physics and Chemistry of Color, The Fifteen Causes of Color*. New York: John Wiley and Sons, 1983.

Neidje, Bill. *Australia's Kakadu Man*. Ed. Stephen Davis and Alan Fox. Darwin: Resource Managers, 1986.

Newton, Isaac. *Opticks: or, a Treatise of the Reflexions, Refractions, Inflexions and Colours of Light*. London: Sam Smith and Benjamin Walford, 1704.

Nuttall, Zelia. "A curious survival in Mexico of the use of the Purpura shellfish for dyeing." In *Putnam Anniversary Volume*. New York, E. Stechert & Co., 1909, pp. 368–84.

Nuttall, Zelia. *The Codex Nuttall: The Peabody Museum Facsimile Copy*. New York: Dover Publications, 1975.

Osborne, Roger. *The Floating Egg, Episodes in the Making of Geology*. London: Jonathan Cape, 1998.

*Paint and Painting, an exhibition and working studio sponsored by Winsor & Newton to celebrate their 150th anniversary*. London: Tate Gallery, 1982.

Paludan, Ann. *Chronicle of the Chinese Emperors*. London: Thames and Hudson, 1998.

Parkinson, John, herbalist to the King. *Theatrum Botanicum or the Theatre of Plants, or An Herbal of a Large Extent*. London: Thomas Coates, 1640.

Perilla, Francesco. *Chio L'Ile Heureuse*. Paris, 1928.

Peterson, Nicholas, and Ronald Lampert. "A Central Australian Ochre Mine." In *Records of the Australian Museum*, vol. 37 (1). Sydney: The Australian Museum, 1985, pp. 1–9.

Petit. *The Manufacture and Comparative Merits of White Lead and Zinc White Paints*. Trans. Donald Grant. London: Scott, Greenwood & Son, 1907.

Petroski, Henry. *The Pencil: a history of design and circumstance.* New York: Alfred A. Knopf, 1989.

Pinckney, Elise. *The Letterbook of Eliza Lucas Pinckney 1739–1762.* Ed. Elise Pinckney. Chapel Hill: University of North Carolina Press, 1972.

Pinkerton, John. *Collection of the Best and Most Interesting Voyages and Travels in All Parts of the World*, volume XIII. London: Longman, Hurst, Rees and Orme, 1812.

Plesters, Joyce. "Ultramarine Blue, Natural and Artificial." In *Artists' Pigments*, vol. 2, pp. 37–66.

Pliny the Elder. *The Natural History.* Trans. John Bostock and H. T. Riley. London: Henry G. Bohn, 1842.

Ponting, K. G. *A Dictionary of Dyes and Dyeing.* London: Bell & Hyman Ltd, 1980.

Rao, Amiya. *The blue devil: indigo and colonial Bengal, with an English translation of Neel darpan by Dinabandhu Mitra.* Delhi: Oxford University Press, 1992.

Rashid, Ahmed. *Taliban, Islam, Oil and the New Great Game.* London: I. B. Tauris & Co, 2000.

Reade, Charles. *Cremona Violins. Four letters descriptive of those exhibited in 1873 at the South Kensington Museum.* Gloucester: John Bellows, 1873.

Riddell, W. H. *Altamira.* Edinburgh: Oliver and Boyd, 1938.

Rosetti, Gioanventura. *Plictho de Larte de Tentori che Insegna Tenger Pani Telle Banbasi et sede si per Larte Magiore Come per la Comune.* Venice, 1548.

Rowlands, John. *The Age of Dürer and Holbein, German Drawings 1400–1550.* London: British Museum, 1988.

Roy, Ashok, (ed.). *Artists' Pigments: A Handbook of their History and Characteristics*, vol. 2. Washington: National Gallery of Art, 1993.

Rudenko, Sergei. *Frozen Tombs of Siberia.* London: J. M. Dent & Sons, 1970.

Rumphius, Georgius Everhardus. *The Ambonese Curiosity Cabinet.* Trans. E. M. Beekman. Yale: Yale University Press, 1999.

Sagona, A. G. (ed.). *Bruising the Red Earth: ochre mining and ritual in aboriginal Tasmania.* Carlton, Victoria: Melbourne University Press, 1994.

Sandberg, Gosta. *Indigo Textiles: technique and history.* London: A. & C. Black, 1989.

Sargent, Walter. *The Enjoyment and Use of Color*. New York: Scribner, 1923.

Schama, Simon. *Rembrandt's Eyes*. London: Penguin, 2000.

Schweppe, Helmut. "Indigo and Woad." In *Artists' Pigments*, vol. 3, pp. 81–109.

Schweppe, Helmut, and Heinz Roosen-Runge. "Carmine." In *Artists' Pigments*, vol. 1, pp. 255–79.

Schweppe, Helmut, and John Winter. "Madder and Alizarin." In *Artists' Pigments*, vol. 3, pp. 109–42.

Seale, William. *The President's House: A History*. Washington: White House Historical Association, 1986.

Shackleford, George. "Van Gogh in Paris: Between the Past and the Future." In *Van Gogh face to face: the portraits*. London: Thames & Hudson, 2000.

Sloane, Patricia. *Primary Sources: selected writings on color from Aristotle to Albers*. New York: Design Press, 1991.

Smith, Joseph. *Safflower*. Champaign, Ill.: AOCS Press, 1996.

Smith, Ramsay. *Myths and Legends of the Australian Aborigines*. Sydney: Angus & Robertson, 1930.

Spalding, Frances. *Whistler*. Oxford: Phaidon, 1979.

Spanier, Ehud (ed.). *The Royal Purple and the Biblical Blue: Argaman and Tekhelet*. Jerusalem: Keter Publishing House, 1987.

Starzecka, D. C. (ed.). *Maori Art and Culture*. London: British Museum Press, 1996.

Stead, I. M., J. B. Bourke and Don Brothwell (eds). *Lindow Man, the body in the bog*. London: British Museum, 1986.

Strehlow, Theodor. *Songs of Central Australia*. Sydney: Angus & Robertson, 1971.

Taylor, Hilary. *James McNeill Whistler*. London: Studio Vista, Cassell Ltd, 1978.

Theophilus. *On Divers Arts*. Trans. John G. Hawthorne and Cyril Stanley Smith. New York: Dover Publications Inc., 1979.

Theroux, Alexander. *The Primary Colours*. London: Papermac, 1996.

Theroux, Alexander. *The Secondary Colors*. New York: Henry Holt, 1996.

Thom, Laine. *Becoming Brave: The Path to Native American Manhood*. San Francisco: Chronicle Books, 1992.

Thompson, Daniel. *The Materials of Medieval Painting*. London: Allen & Unwin Ltd, 1936.

Thompson, James Matthew. *Napoleon Bonaparte*. London: Basil Blackwell, 1988.

Thompson, Jon. "Shellfish Purple: The Use of Purpura Patula Pansa on the Pacific Coast of Mexico." In *Dyes in History and Archaeology*, vol. 13. York: Textile Research Associates, 1991.

Toch, Maximilian. *Materials for Permanent Painting*. London: Constable and Co. Ltd, 1911.

Townsend, Joyce. *Turner's Painting Techniques*. London: Tate Publications Ltd (2nd ed.), 1999.

Travis, Anthony. *The Rainbow Makers. The Origins of the Synthetic Dyestuffs Industry in Western Europe*. Bethlehem, Pa.: Lehigh University Press, 1993.

Turner, R. C., and R. G. Scaife. *Bog Bodies, new discoveries and new perspectives*. London: British Museum Press, 1995.

Tweedie, Penny. *Spirit of Arnhemland*. Australia: New Holland Publishers, 1995.

Varley, Helen (ed.). *Colour*. London: Marshall Editions, 1980.

Vasari, Giorgio. *Lives of the Most Eminent Painters, Sculptors and Artists*. Trans. Gaston Duc de Vere. London: Macmillan and the Medici Society, 1976. (1st ed. 1912).

Wang, Kai. *The Mustard Seed Garden Manual of Painting. A facsimile of the 1887–1888 Shanghai Edition*. Trans. Sze Mai-mai. Princeton, NJ: Princeton University Press, 1977.

Warner, Langdon. *The Long Old Road in China*. London: William Heinemann, 1926.

Whitefield, Susan. *Life along the Silk Road*. London: John Murray, 1999.

Whorf, Benjamin Lee. *Language, Thought and Reality*. London: Chapman and Hall, 1956.

Willard, Pat. *Secrets of Saffron: The Vagabond Life of the World's Most Seductive Spice*. Boston: Beacon Press, 2001.

Wilson-Bareau, Juliet, and Manuela B. Mena Marquez. *Goya: Truth and Fantasy, The Small Paintings*. Madrid: Museo del Prado in association with Yale University Press, 1994.

Winter, John. "Gamboge." In *Artists' Pigments*, vol. 3, pp. 143–56.

Wood, John. *A Personal Narrative of a Journey to the Source of the River Oxus*. London: John Murray, 1841.

Zollinger, Heinrich. *Color: A Multidisciplinary Approach*. Zurich: Verlag Helvetica Chimica Acta, 1999.

# NOTES

## PREFACE

1. Baker, *The Dalai Lama's Secret Temple*, p. 175.

2 Nassau, *The Physics and Chemistry of Color, The Fifteen Causes of Color*.

3. Peacocks' tails and butterflies and mother-of-pearl all derive their iridescence through physical causes. They don't contain pigment, but instead their colors come from their uneven surfaces, covered in tiny grooves which refract and split up the light rays.

4. Newton published *Opticks* in 1704. He explained in the preface that he had delayed the printing: "To avoid being engaged in Disputes about these matters."

## INTRODUCTION

1. Cennino learned from the Florentine artist Agnolo Gaddi, who learned from his father, Taddeo Gaddi. Taddeo was the son of Gaddo Gaddi and also worked closely with Giotto di Bondone. Giotto is considered by many to be the founder of the Renaissance Italian art tradition. He took the skills his master Cimabue learned from Greek icon painters, and shook them up with radical ideas about how to mix colors and tell stories in paintings. We know very little about Cennino himself, except that he was born in the 1350s, that by 1398 he was working on a commission in Padua, that some of his paintings can be found in San Gimignano in Tuscany, and that his *Handbook* was probably written in the 1390s.

2. *Il Libro dell'Arte* was first printed in Italy in 1821; it was first translated into English in 1844 by Mary Merrifield, into French in 1858 and into German in 1871. All the quotations used in this book are from Thompson's 1933 translation, published as *The Craftsman's Handbook*.

3. Merrifield, *Medieval and Renaissance Treatises on the Arts of Painting*, p. xlvii.

4.. Cadmium red hue is a petroleum-based pigment: it is the same color as cadmium red, but it contains no cadmium. According to Winsor & Newton cadmium hue is brighter, cheaper and more transparent; cadmium red is more opaque, more expensive and has better covering power. It is less orange.

5. *Journal of the Society of Arts,* 23 April 1880, pp. 485–99.

6. Holman Hunt was partly right to attribute the problem to ignorance, but as color chemist Maximilian Toch explained in 1911, another problem for nineteenth-century artists was that the atmosphere of big cities was now contaminated with acid gases, from the burning of coal on a large scale. Toch, *Materials for Permanent Painting,* p. 7.

7. I am indebted to Bomford et al., *Art in the Making: Impressionism,* and the Tate Gallery, *Paint and Painting,* for this section on colormen.

8. Cennino recommends artists wanting to create the effect of a velvet fabric to do the drapery with pigment mixed with egg yolk, but then to use a miniver brush to depict the cut threads, in a pigment mixed with oil.

9. In his *Materials for the History of Oil Painting,* Charles Eastlake quotes Aetius as describing both linseed and walnut oils. "It has a use besides a medicinal use, being applied by gilders or encaustic painters, for it dries, and preserves gildings and encaustic paints for a long time." And Maximilian Toch refers to records from the time of thirteenth-century King Edward I (possibly for the King's own Painted Chamber) which included orders for several gallons of oil, as well as paint, gold and varnish. Toch, op. cit., p. 15.

10. Pablo Picasso's relationship with color dealer Sennelier (whose wood-lined shop at 3 Quai Voltaire in Paris must be one of the most atmospheric places to buy art supplies in the world) led to the invention of oil pastels in the 1940s. Ordinary pastels—powdered pigments mixed into a paste or "pastel" with just enough resin or gum to bind them—had been popular in France since the early eighteenth century (and a craze by 1780). But they crumbled easily; the new oil pastels were more robust and could be used on a wide range of different surfaces.

11. Callow, *Vincent van Gogh, A life,* p. 199.

12. At the beginning of his career van Gogh was strongly influenced by a comment made by Théophile Gautier that the peasants in paintings by Jean-François Millet seemed to be painted by the earth they were sowing. Van Gogh sought a similar meaning in the brown materials he chose for his most famous peasant painting, *The Potato*

*Eaters*, now in the Van Gogh Museum in Amsterdam. Dorn, "The Arles Period," in *Van Gogh Face to Face*, p. 145.

13. Shackleford, "Van Gogh in Paris," in *Van Gogh Face to Face*, p. 96.

14. Van Gogh realized that good-quality paint was vital. And when (in the few months in 1889 between cutting off his ear and admitting himself to a mental hospital) he was inspired by the freshness of springtime in Provence, he wrote a letter to his brother Theo, urging him to purchase paints in Paris and send them without delay. "The flowering time is over so soon and you know how this kind of subject delights everybody," he wrote.

15. Personal interview. Michael Skalka, National Gallery of Art, Washington, D.C.

16. The "second-best bed" was the one that a sixteenth-century married couple used. Their "best bed" was the one reserved for guests. Shakespeare made the expression famous because he left the "second-best bed" to his wife Anne in his will. Historians are divided about whether this was an unloving legacy, or whether on the contrary it may have been a sexy one, with him wanting to honor their nights spent together. The one in the Birthplace is not the original.

17. Morris, *The Lesser Arts of Life*, an address delivered before the Society for the Protection of Ancient Buildings, London, 1882.

18. In the seventh century, St. John of Damascus said: "I worship the creator of matter who became matter for my sake, and who willed to take his abode in matter; who worked out my salvation through matter."

## OCHRE

1. Clark, *Looking at Pictures*, p. 15.

2. Thompson, *The Materials of Medieval Painting*, p. 98.

3. Thom, *Becoming Brave: The Path to Native American Manhood*, p. 43.

4. Marshall, *The Red Ochre People*, p. 41.

5. Sagona, *Bruising the Red Earth*, p. 133.

6. *Papunya Tula: Genesis and Genius*, Art Gallery of New South Wales, August—November 2000. This was the first major retrospective of the Central Desert Art Movement since it began in the 1970s, and was held as part of the Sydney 2000 Olympics.

7. I am indebted to McBryde, "Goods from another country," Sagona, *Bruising the Red Earth* and Jones, "Red Ochre Expeditions," in Pa-

pers Presented to the South Australian Museum, for this section on ochre expeditions.

8. Peterson and Lampert, "A Central Australian Ochre Mine," in *Records of the Australian Museum*, vol. 37, p. 1–9.
9. Similar ceremonial trading patterns existed all over the continent. Ronald and Catherine Berndt described how in north-east Arnhemland in the early twentieth century the Gunwinggu people of Oenpelli traded spears with people to the east; nets with the people from the northern coast; European goods and bamboo spears with those to the south-west; and two varieties of red ochre with those to the south, near the Katherine River. Berndt and Berndt, *The World of the First Australians*, p. 131.
10. Jones, op. cit., p. 10.
11. Masey, *Port Augusta Dispatch and Flinders Advertiser*, June 9, 1882. Quoted in Jones, op. cit., p. 12.
12. One story of acrylic paints suggests part of the early development of this medium may have happened in Australia. The Australian artist Ainslie Roberts was apparently allergic to both turpentine and linseed oil, so his friend Sidney Nolan suggested he try PVA glue, which he did. This was later to develop into acrylic paints, an important breakthrough in the story of house and artists' paints. Hulley, *Ainslie Roberts and the Dreamtime*, p. 81.
13. Morphy, *Aboriginal Art*, p. 164.
14. This version is adapted from the story of Kirkin in Smith, *Myths and legends of the Australian Aborigines*.
15. The *South China Morning Post*, January 13, 2001, quotes Noel Nannup, Aboriginal chief executive in the West Australian government's Aboriginal Heritage Unit, saying that if the Dreaming trails were not walked for a while, they would hibernate. In order to walk them again, they had to be awoken by stones that were sensitive to the earth's magnetic field, causing the pathways to reveal themselves. A lightning storm was considered the best condition in which to "feel" the trails, he said.
16. The Tiwi kinship names translate to the rule that the only cousin you can marry is your father's sister's child—all other first cousins are taboo.
17. One nineteenth-century missionary to the Tiwi islands apparently tried to ban traditional funeral rituals, but as he travelled across from Bathurst Island to Melville to protest about a funeral, he fell out of

his boat. It was proof, the Tiwi people decided, that their Ancestors were worth paying attention to.

18. Hulley, *The Rainbow Serpent*, pp. 21–2.
19. Harley, *Artists' Pigments c. 1600–1835*, p. 120.
20. Diabetes and kidney failure are two of the worst health problems for older Aboriginal people in Australia today.
21. According to Chaloupka there are three main white pigment Dreaming sites in the north-west plateau: Gundjilhdjil near the Kanarra shelter; Wamanui in the land of the Mandjarrwalwal; and—the most prized of all—Majjarngalgun, along the Gamadeer river near Maburinj.
22. Bardon, *Papunya Tula: Art of the Western Desert*, p. 45.
23. Neidje, *Australia's Kakadu Man*, p. 48.

## BLACK AND BROWN

1. Vasari, *Lives of the Most Eminent Painters, Sculptors and Artists*, part II, p. 121.
2. Bomford, Kirby, Leighton and Roy, *Impressionism*, pp. 169 and 71.
3. Julian Bell, *What Is Painting?*, p. 11.
4. Bahn, *The Cambridge Illustrated History of Prehistoric Art*, p. 144.
5. ibid., p. 109.
6. Chauvet, Deschamps and Hillaire, *Chauvet Cave, the Discovery of the World's Oldest Paintings*, p. 57.
7. Bahn, op. cit., p. ix.
8. The Coate family grows about 1.5 million willow stems a year on 85 acres. Half are burned into charcoal, the rest are used for baskets, picnic hampers and (for old times' sake) a few traditional lobster pots.
9. For this section on graphite I am indebted to Petroski, *The Pencil*; Dave Bridge, "Wad"; Carvalho, *Forty Centuries of Ink*; and information from the Keswick Pencil Museum.
10. The den of the graphite thieves was the George Hotel in Keswick. The pub is still there: you can sit by the fire on an old panelled settle marked 1737—as I did, to thaw out—and imagine the smugglers plotting how to get their stolen haul to Flanders while the King's red-coated soldiers tried to catch them red- (or black-) handed. The George is a good bar for such subversion: it has three exits apart from the front door. One exit passes through a Jacobean doorway into the kitchens, and there are two different doors through which to escape from the stable-yard at the back.

11. The United States started its own pencil industry in 1821 when Henry David Thoreau's brother-in-law Charles Dunbar found a graphite deposit in New England. The Germans had a small graphite industry from at least the early eighteenth century—a church register at Stein near Nuremberg mentions a marriage between two "black-lead pencil makers" in 1726—but they did not introduce Conté's French process until 1816, when a Royal Lead Pencil Manufactory was established in Bavaria.

12. CIBA Review, 1963 (I).

13. These fountain-pen inks are made with dark petrochemical dyes—which do not provide a true black. Instead they work by adding "opposite" colors as a disguise. So dark aniline green is matched with a red, and dark aniline purple is matched with a yellow. This gives the appearance of being black, but the trick is revealed when you drop the "black" ink onto wet blotting paper and see it separating into its constituent colors.

14. The artist was also known as Hsia Kuei; notes for this painting are from the National Palace Museum.

15. Hebborn, The Art Forger's Handbook, p. 22.

16. Carvalho, op. cit.

17. There is another curious ingredient in almost every ink made today, an ingredient which is rarely advertised, but which, like the oxidizing chemicals in registrars' ink, is also present for legal reasons. Every year a different tracer is put into commercial ink batches. It is a tool for forensic experts to determine when the ink was made. A document dated 1998 would be rather suspicious if the signature was written in ink that was manufactured in 2002.

18. Edmonds, The History and Practice of 18th century Dyeing.

19. Schama, Rembrandt's Eyes, p. 216.

20. The most controversial black paint—to our modern thinking, at least—was probably ivory black. It is hard to verify how much of the pigment was actually sourced from elephant tusks and how much from ordinary animal bones.

21. When social anthropologists Brent Berlin and Paul Kay were researching color terminology in different cultures (in a controversial 1969 study that has nevertheless been quoted in almost every work on color ever since), they found that every human society distinguished between light and dark, but that there were some (they named one in Papua New Guinea and one in Australia) who did not appear to have

words for any of what we call "colors" at all. They then found a curious consistency. Those languages with just three colors inevitably had black, white and red; the fourth and fifth colors to be added were green and yellow in either order, and the sixth color would always be blue. But not until then, according to their report, would there ever be any linguistic acknowledgment of brown, which was inevitably seventh—even in those agricultural societies where one might imagine the colors of the earth were more significant than those of the sky.

22. http://www.tintometer.com/history.htm

23. Charles Darwin wrote about his interest in seeing cuttlefish at Quasil Island—not only the way they "darted tail first, with the rapidity of an arrow, from one side of the pool to the other, at the same time discolouring the water with a dark chestnut-brown ink," but also their chameleon-like ability to change their color. In deep water they became brownish purple, he noted, but in the shallows they became yellowish green—or rather "French gray, with numerous minute spots of bright yellow." Darwin, *Beagle Diary*, p. 31.

24. Hunt, *Journal of the Society of Arts*, 23 April 1880, pp. 485–99. Maximilian Toch was also rude about Reynolds's carelessness. "During three years of his career, he painted on an average one portrait every three days. He was just as careless at times in his imitative style as he was in the selection of his pigments, for many of his clients refused to accept the pictures because they did not resemble the sitter." Toch, *Materials for Permanent Painting*, p. 188.

25. Cumming, *Art*, p. 228.

26. Bomford, Kirby, Leighton and Roy, op. cit., p. 33.

27. Salmon, *The New London Dispensatory*, 1691.

WHITE

1. Kemp, *Leonardo on Painting*, p. 71.

2. For information on this painting I consulted Dorment and MacDonald, *James McNeill Whistler*; Bendix, *Diabolical Designs*; *paintings, interiors and exhibitions of James McNeill Whistler*; Taylor, *James McNeill Whistler*; and Joyce Townsend, senior conservation scientist at Tate Britain.

3. Merrifield, *Medieval and Renaissance Treatises on the Arts of Painting*, p. cli, and Albus, *The Art of Arts*, p. 294.

4. Johannes Vermeer: *Young Woman at a Virginal*. Information from Langmuir, *National Gallery Companion Guide*.
5. The Dutch call this paint *scheel* (scale) white; the English often call it flake white.
6. Winsor & Newton, *Product Information: Health & Safety Leaflet*, 1996.
7. The cartoon is reproduced in Angeloglou, A *History of Makeup*.
8. Downer, *Geisha*, p. 95.
9. Glaser, *Poison, the history, constitution, uses and abuses of poisonous substances*.
10. Petit, *The Manufacture and Comparative Merits of White Lead and Zinc White Paints*.
11. Joyce Townsend. Private correspondence.
12. The Chinese alchemical writer Ko Hung wrote in A.D. 320 that ignorant people could not believe that red lead and lead white were products of the transformation of lead, just as they could not believe that a mule was born of a donkey and a horse. Fitzhugh, "Red Lead and Minium," p. 111.
13. Ironically, according to British colorman George Field lead white is more likely to be affected by sulphur when it is not exposed to light, so cave paintings are particularly vulnerable. Field, *Chromatography*, p. 99.
14. Both red lead and white lead have changed color in the Dunhuang caves. Gettens describes how red lead will turn chocolate brown in color, especially when exposed to light. Out of doors it may also turn pink or white because of the formation of (white) lead sulphate. Gettens and Stout, *Painting Materials: a short encyclopaedia*, p. 153. Conservators at the British Museum describe how lead white becomes black when it reacts with hydrogen sulphide, an air pollutant. The black can be removed by treating it with a solution of hydrogen peroxide in ether. (www.thebritishmuseum.ac.uk/conservation/cleaning3.html)
15. On May 30, 1925 Chinese and Indian police under British command fired on demonstrators in Shanghai: they killed eleven people and the deaths kindled anti-foreigner sentiments all over China. It was, in a way, the Tiananmen Square massacre of its time, although on that occasion it was the British who had given the command to shoot.
16. Warner, *The Long Old Road in China*.

17. Gettens also identified carbon black, kaolin, red ochre, red cinnabar, blue azurite, red lead, indigo, green malachite, a kind of safflower and an organic dye that was probably gamboge. Many were not local. "It is only by far-reaching trade intercourse that these substances can be assembled in any one place or even in any one country today," Gettens wrote with some excitement.

18. One of the first X-ray images ever made was of a woman called Berthe Roentgen. In 1895 her husband Wilhelm had just discovered the existence of X rays and to celebrate the occasion he took a picture of his wife's hand. The radiation passed through her skin but was absorbed by the much more dense bones and her wedding ring, which appear as white blocks.

19. The x-radiograph of *The Death of Actaeon* is reproduced in Januszczak, *Techniques of the World's Greatest Painters*, p. 36.

20. Before the 1920s, paint-makers experimented with a mixture of zinc white and lead white to reduce the toxicity, yet still give good covering power in oil. Between the 1920s (when titanium paint was in commercial production) and the 1970s (when lead white stopped being used on a large scale on buildings) you could find white house paints that included zinc, titanium and lead. Norman Weiss, University of Columbia, New York. Private conversation.

21. G. K. Chesterton told the story of how he once went out sketching the cliffs of the English Channel. He realized he had used up his most important chalk—the white one. He was just about to return to town, cursing, when he began to laugh, because below him were tons of white chalk. He only had to pull up a bit of grass and cut out what he needed for his art. Hebborn, *The Art Forger's Handbook*, p. 32.

22. The other options were whites made of tin and silver. Medieval scribes had used both of these for manuscripts, but they were scarcely worth the metal they were made from—they tended to perform badly in oil, had very little body and blackened in sunlight. Tin and silver whites were rarely used after the printing press arrived in 1456 and were generally abandoned after the seventeenth century.

23. Winsor & Newton, letter to G. H. Bachhoffner, 1937. Microfiche, New York Public Library.

24. Kuhn, "Zinc White," p. 170.

25. In order to turn the blood-like ore into the snow-like oxide the French developed a system of purifying the ore and then oxidizing it. But in 1854—according to legend—the Americans devised a quicker,

cheaper method. One night, the story goes, a nightwatchman called Burrows was walking round the factory of the Passaic Chemical Company in Newark, New Jersey, when he noticed that one of the fire flues was leaking. He was not unduly worried and casually stopped up the hole with an old fire grate. It wasn't heavy enough for his purpose so he took some bits of ore and coal from the zinc refining company next door, piled it on top, and went back to his patrol. A few hours later he was astonished—and probably horrified—to see white clouds of zinc oxide hovering above the grate. He told the story to his bosses; they investigated and the following year they took out a patent on the American "direct" process, which was so much more efficient than the French method that by 1892 all American zinc paint was being made that way. History does not relate whether Mr. Burrows profited from his discovery. New Jersey certainly did: many of the first paint manufacturers in the United States were located near Newark, which benefited from its proximity to the Franklin Mine—a source of many useful minerals for paint—and to the port of New York.

26. Scholars are divided on whether the White House was white from the beginning. Paint analysis has not been conclusive. It was certainly white by 1814.

27. Birren, *Color; a survey in words and pictures, from ancient mysticism to modern science.*

28. Seale, *The President's House: A History.*

29. It was not only white paint which gave Whistler trouble. Gold and black proved to be even worse. When you stand in front of *Nocturne in Black and Gold: The Falling Rocket* today, it is hard to imagine that this scene of fireworks cascading above a misty Battersea Bridge should have caused pyrotechnics to explode in the British art world. But in 1878 the painting inspired John Ruskin—who once commented that the duty of a critic was "to distinguish the artist's work from the upholsterer's"—to write a scathing review. "I have seen, and heard, much of Cockney impudence before now," he wrote. "But I never expected to hear a coxcomb ask 200 guineas for flinging a pot of paint in the public's face." Whistler took exception and sued, resulting in the notorious "pot of paint" trial.

30. As Eric Hebborn noted with admiration, masters like Rubens, Velázquez and Rembrandt made their works more luminous by generous use of this heavy white ground. Hebborn, op. cit., p. 94.

31. Elkins, *What Painting Is*, p. 9.

# NOTES

## RED

1. I am indebted to Townsend, *Turner's Painting Techniques*, for this section on Turner.
2. Joyce Townsend, Interview.
3. ibid.
4. *Comanche Language Book*, Comanche Language and Cultural Preservation Committee, 1995.
5. Alum is also, apparently, an effective natural underarm deodorant.
6. Ciba Review, 1,430.
7. Aleppo was Muslim from the seventh century, while Izmir was captured from the Byzantines by Tamerlane in 1402; Castile was under Arab control until 1223.
8. Originally the term "lake" referred to lac, which is a sticky resin exuded by an Asian insect called *Laccifer lacca*, and from which we get the word "lacquer." Now it refers to any pigment made from a dye. Dyes like kermes or cochineal are not strong enough on their own to color wood or canvas, so they need to be made into something that can. Early methods of making carmine lake involved dyeing cloth, boiling it in alkaline solution and adding alum. When it dried out, the color would have attached itself to the metal salt and artists could mix the resulting powdery pigments with oils or egg. Lakes are more translucent than many other paints, so are traditionally used as the top layer—because they allow other colors to show through.
9. On February 15, 1541 the Venetian artist Lorenzo Lotto recorded in his expenses book that he took 6 ounces of kermes, worth 6 ducats an ounce (total 37 lire, 4 solti), from the Bolognese architect Sebastiano Serlio, "on account of certain credit that I have with him." This was more than thirty times more expensive than employing a nude model for the day (1 lira, 4 solti). Chambers and Pullan, *Venice, A Documentary History*, p. 439.
10. Rudenko, *Frozen Tombs of Siberia*, p. 62.
11. Donkin, *Spanish Red: an ethnogeographical study of cochineal and the opuntia cactus*.
12. Edmonds, *The History and Practice of 18th Century Dyeing*.
13. There is a small plantation called Tlappanocochli—meaning "color" in Mixtec—in the Oaxaca Valley in central Mexico. I visited it one Sunday when it was closed—but from outside it was evident that this

was a cottage industry, and nothing like the scale of the operation I had seen in Chile. It was started recently, as a revival.

14. Anderson, *Correspondence for the Introduction of Cochineal Insects from America*.

15. Pliny, *The Natural History*, p. 33.

16. Gettens observed that natural cinnabar was less likely to darken than artificially created "wet-process" vermilion. Gettens and Stout, *Painting Materials: a short encyclopaedia*, p. 172.

17. It is this reputation for reliability which, according to Michael Skalka at the National Gallery of Art in Washington, D.C., may explain a small mystery about one particular cinnabar that is not red but green, and which is made of neither mercury nor sulphur. "Green cinnabar" or "zinnobar" is a synthetic mixture of chrome yellow (which is no longer produced) and Prussian blue, sometimes mixed with white. According to Maximilian Toch, when chrome green was first made, one manufacturer called his product cinnabar green, "intending to convey the idea that [it] was as permanent as cinnabar red or native vermilion. The name has stuck to it in the trade." Toch did not recommend it, supposing that the color had all the defects of both of its ingredients. Toch, *Materials for Permanent Painting*, p. 110.

18. Egerton, et al. *Turner, The Fighting Téméraire*.

19. Field, *Chromatography*.

ORANGE

1. Stradivari often Latinized his own name to Antonius Stradivarius and labelled his violins accordingly.

2. *The Red Violin* directed by François Girard, 1998.

3. Claudio Rampini in *The Strad*, March 1995.

4. Beare, *Antonio Stradivari, The Cremona Exhibition of 1987*.

5. During the Spanish Inquisition many *marranos*, or forced converts, were put on trial. If they were found guilty of practicing Judaism in secret they were given the option of confessing. Those who did not confess were burned at the stake; those who did confess were strangled first, before being burned.

6. Smith, *Safflower*.

7. Poppy seed oil is made from the seeds of *Papaver somniferum*, the opium poppy, but it does not have the same intoxicating properties

as the milky sap of the seed pods. Poppy oil production is a by-product of the pharmaceutical industry. In most countries it is strictly controlled.

8. Today tragacanth (named from the Greek word for goat's horn because of its appearance) is used in cosmetics and to give prepared foods like ice cream and pies more body.

9. Perilla, *Chio L'Ile Heureuse*.

10. Hackney, Jones and Townsend, *Paint and Purpose*, p. 13.

11. The original painting is in the Huntington Art Collections in San Marino, California.

12. Private correspondence, Ian Dejardin, Dulwich Picture Gallery.

13. In 1217, just two years after the Pope's announcement that Jews should wear patches, King Henry III of England ordered Jews to wear white linen or parchment badges representing the tablets of the Ten Commandments.

14. *Frank Lloyd Wright and the Art of Japan*. Japan Society, New York, March 2001.

15. Gage, *George Field and His Circle*, p. 29.

16. The French cloth-makers hired some Greeks from Salonica to help them with the recipe. Salonica had been a major center of dyeing and cloth-making since the time of Martinengo: it was a place where Sephardim settled, and established their businesses.

17. *The Death of Nelson*, at the Walker Art Gallery in Liverpool.

18. The Color Museum in Bradford quotes a worker in the early nineteenth century describing the Turkey Red Dyers: "I always remember the water side from Bonhill Bridge to the Craft Mill. It was a seething mass of humanity. People walking four and five across, to and from work. You could smell the Craft when it closed at night, off the workers walking by."

19. It is basically madder with a little lemon juice, mixed with alum and left overnight. Conversation with Harald Boehmer, November 2001.

20. In the thirteenth century the terrifyingly named Teutonic Knights killed anyone who picked up amber without permission.

21. Reade, *Cremona Violins*.

22. *Genuine receipt for making the famous vernis Martin*. Paris, 1773, held in the British Library.

23. Information from the Sibelius Museum website.

24. Both Newton and Field ascribed colors to musical notes (Dreyfuss, *Symbol Sourcebook: An Authoritative Guide to International Graphic*

*Symbols*). But it is not known whether they were synaesthetic. Indeed, the concept of synaesthesia was not known when they were alive.

## YELLOW

1. Field, *Chromatography*, p. 83.
2. Baer, "Indian Yellow," pp. 17–21.
3. Gega Lama, *Principles of Tibetan Art*.
4. Captain Sherwill, *Statistics of the District of Behar*, 1845. Held in the British Library.
5. Brian Lisus. Personal correspondence.
6. George Field did not believe that the mango theory was true: "It has also been ascribed, in like manner, to the buffalo, or Indian cow, after feeding on mangoes; but the latter statement is incorrect. However produced, it appears to be a urio-phosphate of lime, of a beautiful pure yellow colour, and light powdery texture; of greater body and depth than gamboge, but inferior in these respects to gall-stone." Field, op. cit., p. 83. Winsor & Newton likewise do not subscribe to the theory that this paint was made from urine that had been evaporated and formed into balls. Instead the museum (at Winsor & Newton's factory in Harrow) describes it as the earth on which cows fed with mangoes or mango leaves have urinated.
7. Man Luen Choon is at 27–35 Wing Kut Street, Sheung Wan, Hong Kong.
8. According to Eric Hebborn, Van Dyck used orpiment with enthusiasm but his secret was to apply it on areas that had been underpainted with other yellows. "It is amazing how a whole area of relatively dull yellow such as yellow ochre can be made brilliant with just a well-placed touch or two of brighter yellow." Hebborn did not, incidentally, know about the easy availability of orpiment in Chinese shops. He recommended not even trying to forge a painting that contains it: "If you really can't finish your painting without a bright yellow, damage the area where the orpiment should be and then skillfully retouch the damage with the modern chrome yellow and zinc- or flake-white mixture." Hebborn, *The Art Forger's Handbook*, p. 98.
9. The formula for realgar is AsS while orpiment is $As_2S_3$. This effectively means that, of the two, realgar contains more arsenic.
10. By 1758, when Dossie wrote his book *The Handmaid to the Arts*, both orpiment and realgar had been banished completely from artists'

palettes. If they were used at all it was "to color the matted bottoms of chairs, or other such coarse work."

11. Rumphius, *The Ambonese Curiosity Cabinet*.
12. Winter, "Gamboge," p. 144.
13. van Gulik, *The Chinese Maze Murders*.
14. I am indebted to saffron consultant Ellen Szita, who has helped with this section.
15. Herbert, *A History of the Species of Crocus*, p. 21.
16. Milton, *Nathaniel's Nutmeg*, p. 20.
17. Thompson, *The Materials of Medieval Painting*.
18. These jokes or rebuses were common in coats of arms. The city of Oxford, for example, is represented by a picture of an ox crossing a river.
19. Emmison, *Elizabethan Life: Home, Work and Land*.
20. www.uttlesford.gov.uk/saffire/history/history.html
21. In a good year the field could produce 5 kilos of saffron, although 2000 had not been good.
22. Willard, *Secrets of Saffron*, pp. 98–101.
23. The practice of painting houses with red or yellow continues, although today Zoroastrian priests tend to use red paint or ink rather than saffron.

## GREEN

1. The Chinese term is porcelain; Western terminology tends to call it "stoneware."
2. Celadon includes those pieces with green glazes that owe their colors to reduced iron oxide, rather than those owing their colors to oxidized copper, which are much brighter green than true celadon-ware.
3. A Chinese scholar, Dr. Chen, has suggested that the mythical Chai ware is in fact *mi se*, after Shizong was given this precious imperial ware as a royal gift. In which case the poem would be more important for its mention of the clouds than that of the peeping blue sky.
4. The earliest greenware was made two thousand years ago, although none of it survives. Then, in the late sixth century, it was reinvented, according to legend, by a civil servant called Ho Chou. He hadn't wanted to make it for its own sake but had been trying to replicate green glass, the recipe for which had been lost two hundred years before. Within forty years the first Tang emperor was commissioning

imperial celadon-makers to create bowls that were "thin in body, translucent and brilliant as white jade." The rich Tangs loved it, and soon celadon kilns were opening up all over the country, wherever there was enough wood and good clay.

5. The color of celadon depends partly on the atmosphere in the kiln: reduction leads to greenware like *mi se*, oxidation leads to brownware.

6. Dawn Rooney. Personal correspondence.

7. Michael Rogers. Personal correspondence.

8. Bushell, *Oriental Ceramic Art*. Written by an Englishman who had worked for many years as the British legation's doctor in Peking, and had become fascinated by oriental ceramics.

9. The chinoiserie style was to last for a further decade or so until the Victorians wanted a change, and decided to revive Gothic, Greek, Pompeian, Egyptian, Byzantine, Baroque and indeed virtually everything *but* East Asian traditions instead.

10. Thompson, *Napoleon Bonaparte*.

11. www://grand-illusions.com/napoleon/napol1.htm

12. *Journal of the Society of Arts*, 1880.

13. It is likely that this was Johann Wilhelm Ludwig Thudichum, a controversial scientist in Victorian London, who at the time was researching the effect of cholera on the brain.

14. Michelangelo's *Manchester Madonna* in the National Gallery shows the underpainting of the flesh in *terre verte*, a practice that seems to have been popularized by Giotto and continued spasmodically until Tiepolo in the eighteenth century. Hebborn, *The Art Forger's Handbook*, p. 105.

15. Sometimes the pinkish pigments have faded from old paintings, leaving the faces a sickly green. Roman and Byzantine artists liked the effect, and their mosaics of people's faces have green stones mixed up with the pink ones, to cool a ruddy complexion. Gage, *Colour and Culture*.

16. In the nineteenth century the "Iron Tsar," Nicholas I of Russia, had a monopoly on the world's best malachite, which was found in the Urals. In the 1830s his wife Alexandra commissioned a room of green-veneered furniture in the Winter Palace at St. Petersburg, which they called the Malachite Chamber and used as a formal drawing room.

17. Gettens and Stout, *Painting Materials: a short encyclopaedia*, p. 170.

18. Cennino's translator, Daniel Thompson, observed that verdigris in

river landscapes by Baldovinetti and Domenico Veneziano must have been green once, but had now turned to a mahogany brown. Thompson, *The Materials of Medieval Painting*.

19. The theory of the painting being an allegory seemed even more likely after it was discovered that the Arnolfinis didn't actually get married until 1447: reported in BBC2's documentary *Mystery of a Marriage*, November 1999.
www.open2.net/renaissance/prog1/script/script1.htm

20. The hall is lined with fake-grained wood—yellow pine dressed as red mahogany, which would have been fashionable in the 1790s and in-deed the 1970s but looked much too faux for the 2000s. Washington would probably have seen it first in Philadelphia, and he evidently loved the fake graining technique, because he also had it in his study.

21. The picture that probably caught his attention was Plate 51: it gives the precise proportions for the grand window he eventually chose for his dining room—a Palladian window, so named after the sixteenth-century Italian Andrea Palladio, who first created such a thing in memory of Ancient Rome.

22. Letters from the collection of the library at Mount Vernon.

23. Mosca, "Paint Decoration at Mount Vernon," p. 105.

24. Later, once she knew what to look for, Dr. Barkeshli not only discovered saffron mixed with verdigris in a real sixteenth-century paintbox, but she found other references. "The verdigris which is made out of yo-ghurt chars paper," advised sixteenth-century artist Mir Ali Heravi. "To prevent this, add a small amount of saffron to make the pigment stable."

25. Harley, *Artists' Pigments*.

26. In Paris in 1845, according to Chris Cooksey, a British scientist who has studied Chinese Green, and who provided much of the informa-tion for this section, it cost 224F a kilo, rising to 500F a few years later. In London in 1858 it cost nearly 16 guineas a kilo. Its popularity in-creased when people realized how exciting it was to have a dye that gave a violet rather than a blue-yellow sheen, and yet which still looked green. It was warmer than the old woad-weld mixture. Dyes in History and Archaeology conference, Amsterdam, November 2001.

BLUE

1. John is often dressed in red, but rarely in such a vivid orange.
2. Similar blackening of vermilion paint can be detected in the opaque

red sash of the angel in the (also unfinished) *Manchester Madonna*, also held at the National Gallery in London. There is an apocryphal story that *The Entombment* may have been used as a fishmonger's slab, in which case the salt water from the fish would have speeded the darkening of the vermilion. Private correspondence, National Gallery.

3. Langmuir, *National Gallery Companion Guide*.
4. Polo, *The Adventures of Marco Polo, as dictated in prison to a scribe in the year 1298*, chapter 29.
5. *Brewer's Dictionary of Phrase and Fable* (Millennium Edition) suggests that the term "blue movie" is "fancifully derived from the custom of Chinese brothels being painted blue externally." However, according to the *Oxford English Dictionary* "blue" has referred to indecent or smutty conversation since at least the early nineteenth century.
6. In his *Theory of Colour*, Goethe wrote that "there is something contradictory in [blue's] aspect, both stimulating and calming. Just as we wish to pursue a pleasant object that moves away from us we enjoy gazing upon blue—not because it forces itself upon us, but because it draws us after it."
7. Price from Kremer Pigmente in Germany.
8. In 1347 an ounce of ultramarine, ordered for the Chapel of San Jacopo in Pistoia Cathedral, cost the equivalent of £4. On the same order form an ounce of azurite cost five shillings and sixpence: onetwelfth of the price. *Italian Painting before 1400, Art in the Making*.
9. Hirst and Dunkerton, *Making and Meaning: The Young Michelangelo*.
10. Eric Hebborn said the painting illustrated the care the Old Masters took in their underdrawing—not because they had time to waste; quite the opposite. *The Entombment* shows the stage after the preliminary drawing and before the final layer, which would probably have consisted mostly of oil glazes. Hebborn, *The Art Forger's Handbook*, pp. 105–6.
11. The Tate, *Paint and Painting, an exhibition and working studio sponsored by Winsor & Newton to celebrate their 150th anniversary*, p. 14.
12. Gage, *Colour and Culture*.
13. Gettens and Stout, *Painting Materials: a short encyclopaedia*.
14. Byron, *The Road to Oxiana*. The author had perhaps not realized that Gowhar Shad was a woman.
15. The best blues were from the Xvande reign (1426–35), followed closely by the Zhengde (1506–21) and Jiajing (1522–66) reigns, which both pro-

duced blue and white with a rich violet blue that was distinctive for its intensity. The worst were the Chenghua (1465–87) and Wanli (1573–1619) reigns. Boger, *The Dictionary of World Pottery and Porcelain.*

16. Rashid, *Taliban, the story of the Afghan warlords,* p. 7.
17. Baker and Henry, *The National Gallery Complete Illustrated Catalogue,* pp. 97–8.
18. Hebborn, *The Art Forger's Handbook,* p. 106.
19. Theophilus, *On Divers Arts,* p. 57.
20. Vitruvius, book VII.
21. Some accounts suggest the "veil" may actually have been the tunic Mary wore while giving birth.
22. A study done by a textiles expert in 1927 confirmed that it could have been woven in the first century A.D. It is locked up for 364 days a year, and then every August 15, on the Feast of Our Lady, it is paraded around the town.

## INDIGO

1. Morris, *The Lesser Arts of Life,* an address delivered before the Society for the Protection of Ancient Buildings, London, 1882.
2. One theory to account for the name of the town of Glastonbury in southwest England is that it was once a woad—or *glaustum*—dyeing center.
3. Edmonds, *The History of Woad and the Medieval Woad Vat.*
4. Turner and Scaife, *Bog Bodies, new discoveries and new perspectives.*
5. Starzecka, *Maori Art and Culture,* p. 40.
6. Tattoos are also restricted in the United States. According to Pat Fish, in L.A. County there is a law that all tattooing has to be done with FDA-approved ink. "Which is a problem because there is no FDA-approved ink."
7. *The Annals of Tacitus,* chapter XIV, pp. 29–30.
8. John Edmonds. Personal correspondence.
9. Harley, *Artists' Pigments,* p. 201.
10. For the section on Eliza Lucas I consulted Morgan, *Wilderness at Dawn,* and Pinckney, *The Letterbook of Eliza Lucas Pinckney.*
11. Morgan, op. cit., p. 260.
12. Professor Giacomo Chiari, Dyes in History and Archaeology conference, Amsterdam, November 2001.
13. Balfour-Paul, *Indigo.* I am indebted to Jenny Balfour-Paul for many of the references in this chapter.

14. Edmonds, op. cit.
15. Balfour-Paul, op. cit., p. 125.
16. Forcey, *The Colors of Casa Cruz.*
17. ibid.
18. ROY G BIV is probably the most common rainbow mnemonic among American and British schoolchildren. In Britain the other popular contender is "Richard of York Gave Battle in Vain," which describes how King Richard lost to the Tudors at the Battle of Bosworth Field, the white rose of the Yorks ceding to the red rose of the Lancastrians (white losing to color). Indian schoolchildren tend to learn it "backwards" as VIBGYOR, while my new personal favorite is "Rats of Yarmouth Go Bathing in Venice," with its suggestion of subversive gray elements in the midst of a colorful carnival. Sarah Ballard. Personal correspondence.
19. Since the Middle Ages, English-speakers have named turquoise after the country—Turkey—the stone was said to come from, even though it is more likely to have come from Persia, now Iran.
20. Levi Strauss wanted to make the strongest possible overalls for the gold miners (who destroyed their clothes very quickly by filling the pockets with stones and, if they were lucky, nuggets), so he imported a blue cloth from the French town of Nîmes (it was called *serge de Nîmes*, hence denim). It was only many years later that the trousers were named "jeans" after the Genoese sailors who transported the cloth. Denim has been colored with aniline dyes since around 1900.
21. Balfour-Paul, op. cit.
22. An address delivered in the Indigo Hall, Georgetown, South Carolina, May 4, 1860, on the 105th anniversary of the Winyaw Indigo Society by Plowden C. J. Weston.
23. While the English swung their indigo loyalties from one continent to another between the seventeenth and nineteenth centuries, the Dutch were fairly consistent in their demand for Javanese blue. Throughout that time local chiefs were forced to grow indigo (as well as pepper and other spices) without receiving much in return. England briefly took charge of Java between 1811 and 1816 during the Napoleonic Wars, and the Governor, Thomas Stamford Raffles, wrote a book describing his horror at the brutal system of enforced labor. But had he looked at his own country's attitudes to indigo farmers he would have been equally shocked.
24. Grant, *Rural Life in Bengal.*

25. Grant was puzzled about what color the indigo liquid was—at first it was dark orange, then light green, then darker green, "so that I am puzzled to tell you what precise colour it really has, for being, like the sea, exposed to the sky . . . the light green, through a variety of beautiful changes, gradually darkens into a Prussian green, and from that—as the beating continues and the colouring matter more perfectly develops itself (the forth having almost entirely subsided) into the intense deep blue of the ocean in stormy weather."

26. In 1855 aboriginal tribal people in a different part of Bengal rebelled against moneylenders, landowners and the indigo planters in what was called the "Santal Rebellion." So outside Mulnath the blue harvest was evidently not such a joyful occasion.

27. A 1795 law stipulated that private entrepreneurs would hold no more· than 50 bigahs of land (one bigah is 1,600 square feet and enough to grow eight cakes of indigo, or give eight rupees in profit at 1850s prices). At the time a European would expect to earn about 400 rupees per month.

28. In 1860 William James was twenty-eight and a magistrate in the indigo-growing area of Nadia. He observed the unfairness of the indigo contracts—which were often forged—and developed an interest in devising a way for people to determine whether an illiterate person had or had not been present at the signing. It inspired him to investigate the possibilities of fingerprinting, and while his recommendations were eventually ignored, this was the first time fingerprints had been seriously offered as legally binding marks. Kling, *The Blue Mutiny*.

29. ibid. I have used this book extensively in this section on Bengal indigo.

30. Moorhouse, *Calcutta*, p. 67.

31. The last commercial indigo in Bengal, before the recent resurgence, was in 1894. But the crop continued to grow, in very small quantities, in Bihar and in other parts of India.

32. When tended carefully, *Indigo tinctoria* can grow into a bush of up to two meters in height.

33. Since I visited Bengal I have learned of a scheme to grow indigo in Bangladesh to supply the increasing demand for natural dyes in Europe and America. The Aranya project was started by Ruby Ghuznavi in the 1990s. By 2002 it was cultivating 50 acres of indigo—not only a small but promising legacy of Bengal's history, but also a hope

for indigo's future on the sub-continent—without forced labor and as a non-polluting alternative to synthetic dyes.

## VIOLET

1. The *Little Rock Gazette,* quoted in Garfield, *Mauve.* I am indebted to *Mauve* and to Travis, *The Rainbow Makers,* for much of this section about Perkin.
2. The name came from the French description of this color as being like the petals of the mallow plant. Curiously, while the English called it "mauve," which in the nineteenth century they pronounced "morve," the French tended to refer to it as "Perkin's purple." Both markets were evidently thought to want something exotic and foreign.
3. Victoria & Albert Museum, *Inventing New Britain: The Victorian Vision,* April–July 2001.
4. John Sutherland, *Guardian,* August 6, 2001, p. 7.
5. Varley, *Colour,* p. 218.
6. Gage, *Colour and Culture,* p. 27.
7. Jidejian, *Tyre through the Ages,* p. 281.
8. Lucan, *Civil War,* chapter 10, pp. 115ff.
9. Pliny, *The Natural History,* 9, 63, p. 137.
10. For the classical and dyeing references in this chapter I have made extensive use of Edmonds, *The Mystery of Imperial Purple Dye;* Bridgeman, "Purple Dye in Late Antiquity and Byzantium"; and Jidejian, op. cit.
11. Justinian in the sixth century reinforced a ban on "forbidden silk"— which scholars take to mean that it was dyed with purple—and Constantine in the tenth century was so fond of the color that he was nicknamed Porphyrogenitus, meaning that he had been born "in the purple," which perhaps referred to the color of the walls of the birthing room of the Byzantine emperors, but certainly signified immense privilege.
12. Thompson, *The Materials of Medieval Painting,* p. 156.
13. Sixth-century Christian artists used Tyrian purple for the most precious books. Cheaper documents used cheaper dyes, though, and one type of lichen became so popular for staining books that it is still called "folium," from the same root as "folio," meaning leaf of paper.
14. Pliny, op. cit., 9, 34, p. 126.

15. A third species, *Thais haemastema*, also gives a good purple dye, but it is found farther west in the Mediterranean, and probably was less important to the Phoenicians.
16. Quoted in Jidejian, op. cit.
17. Pliny, op. cit., 9, 62, p. 133.
18. Edmonds, op. cit., p. 10.
19. In 1685 a naturalist called William Cole found purple-giving shellfish on the shores of the Bristol Channel and made the observation that if the dye was placed in the sun it changed color. "Next to the first light green will appear a deep green; and in a few minutes this will change into a dull sea green; after which, in a few minutes more, it will alter into a watchet [i.e. blue]; from that in a little time more it will be purplish red; after which, lying an hour or two (supposing the Sun still shining) it will be of a very deep purple red; beyond which the Sun can do no more." Cole, "Purple Fish," p. 1278.
20. Pliny described how the blackness was achieved by dyers using two different types of shellfish: the small buccinum and the larger *Murex brandaris*, or *purpura*. The buccinum gave a crimson-like sheen to the *purpura*, as well as the "severity" which was in fashion. Their recipe involved steeping the wool in a raw, unheated vat of *purpura* extract and then transferring it to a buccine one. Op. cit., 9, 28, pp. 134–5. Pliny, after praising this velvety black effect of antique murex-dyed robes, noted that in his own time people seemed to favor a lighter shade of purple.
21. Gage, op. cit., p. 25.
22. Nuttall, "A curious survival in Mexico of the use of the Purpura shellfish for dyeing," p. 368.
23. Thompson, "Shellfish Purple: The Use of Purpura Patula Pansa on the Pacific Coast of Mexico," pp. 3–6.
24. Hibi, *The Colors of Japan*, pp. 60–2.
25. Numbers (or Bümidbar), 15: 37–38.
26. Rabbi Soloveitchik, "The Symbolism of Blue and White." In *Man of Faith in the Modern World*. Ed. Abraham Besdin. Israel: Ktav, 1989. Quoted on the P'til Tekhelet website, www.tekhelet.com
27. Elsner, "The Past and Present of Tekhelet," p. 171.
28. One of the problems is that the Hebrew word for this color—*tekhelet*—can mean both blue and violet; it was the metaphor of the sea and the sky which led to Jews believing it had been more blue than violet.

29. Many years later, when Radzyn was destroyed by the Nazis, Herzog was the only person with the recipe, leading to the ironic circumstance that he was responsible for both discrediting and preserving Leiner's process.
30. A similar paradox can be seen in ancient Jewish sacred manuscripts. If the parchment is calf vellum then it must be made from the skin of an animal that has been killed in a kosher way—through being bled to death. But there appear to be no rules about whether the ink with which it is written should or should not be kosher.

## The End of the Rainbow

1. The story of the Eskimos having a large number of words for the colors of snow probably started in 1911 when social anthropologist Franz Boas suggested they had four word roots for snow. (Boas, *The Handbook of North American Indians.*) This was picked up in 1940 in an MIT journal that future generations of linguists used freely: "We have the same word for falling snow, snow on the ground, snow packed hard like ice, slushy snow, wind-driven snow, flying snow— whatever the situation may be. To an Eskimo, this all-inclusive word would be almost unthinkable; he would say that falling snow, slushy snow, and so on, are sensuously and operationally different things to contend with; he uses different words for them and for other kinds of snow." (Whorf, *Language, Thought and Reality.*)
2. This finding was announced in January 2002. Three months later Johns Hopkins University made a second and slightly embarrassed announcement that the "color of the universe" was not actually turquoise but beige, due to a computer bug. "It's our fault for not taking the color science seriously enough," admitted assistant professor of astronomy Karl Glazebrook who had co-authored the study. He added that the discovery was actually just meant to be an amusing footnote to a large-scale survey of the spectrum of light emitted by 200,000 galaxies, but "the original press story blew up beyond our wildest expectations." It referred to a mathematical calculation of what you would see if you had the universe in a box, and could see all the light at once. The newly calculated color, described more formally as III E Gamma, looks like off-white house paint. However, Glazebrook's favorite tag is "cosmic latte."

# LIST OF ILLUSTRATIONS, MAPS AND PHOTOGRAPHS

Illustrations

Maps

*Travels Through a European Paintbox*
*Travels Through an Australian Paintbox*
*Travels Through an Afghan Paintbox*
*Travels Through a Mexican Paintbox*

Photographs

Page 1
Bottles of powdered pigments. Reproduced courtesy of Winsor & Newton, Harrow. © Winsor & Newton.

Artists at Papunya, Australia. Reproduced courtesy of Geoffrey Bardon. © Geoffrey Bardon.

A natural paintbox at Jumped Up Creek, Australia. © Victoria Finlay.

Page 2
A pattern book from 1763 © Victoria and Albert Picture Library.
A sampler from the 1860s © Victoria and Albert Picture Library.
*A Girl with a Baby*, Joshua Reynolds. Reproduced courtesy of the Dulwich Picture Gallery, London. © Dulwich Picture Gallery.

Page 3
Dunhuang Caves, cave painting, China. Reproduced courtesy of CIRCA Photo Library / © Tjalling Halbertsma.

Manuscript of Pliny's *Natural History* (1465). © Victoria and Albert Picture Library.

Cochineal bugs on a cactus leaf. © Victoria Finlay.

Page 4

*The Entombment,* Michelangelo (1501). © National Gallery, London.

Saffron poster from Consuegra. © Victoria Finlay.

Page 5

Red trays. Reproduced courtesy of Winsor & Newton, Harrow. © Winsor & Newton.

Antonio Stradivari. "Parke" violin (1711). Reproduced courtesy of J & A Beare, London. © J & A Beare.

Page 6

Krishna playing flute to cows, Indian temple (North India). Reproduced courtesy of CIRCA Photo Library / © Martin Palmer.

Sprig of indigo. © Royal Botanic Gardens, Kew.

Santiago de la Cruz in Mexico. © Nell Nelson.

Page 7

Yellow *cuerda seca* tile (1600s). © Victoria and Albert Picture Library.

Miner from Sar-e-sang in Afghanistan. © Robert Nickelsberg.

Lapis Lazuli for ultramarine paint. Reproduced courtesy of Winsor & Newton, Harrow. © Winsor & Newton.

Page 8

Window depicting *Notre Dame de la Belle Verriere* in south choir, thirteenth century (stained glass), Chartres Cathedral, Chartres, France. © Bridgeman Art Library.

Indian Yellow nuggets. Reproduced courtesy of Winsor & Newton, Harrow.© Winsor & Newton.

# CREDITS

Permission to use copyright material is gratefully acknowledged to the following. While every effort has been made to trace all copyright holders the author apologizes to any holders not acknowledged.

The quotations from *The Dalai Lama's Secret Temple: Tantric wall paintings from Tibet*, by Ian Baker, 2000 on page 1 is © Thames & Hudson; the quotations from *The Ambonese Curiosity Cabinet* by Georgius Everhardus Rumphius, translated by E.M. Beekman, 1999 on pages 218 and 219 are by kind permission of Yale University Press; the quotation from *Chauvet Cave, the Discovery of the World's Oldest Paintings* by Jean-Marie Chauvet, Eliette Brunel Deschamps and Christian Hillaire, 1996 on page 76 is © Thames & Hudson; the quotation from *Looking at Pictures* by Kenneth Clark, 1961 on page 25 is by kind permission of John Murray; the quotation from *What Painting Is* by James Elkins, 1999 on page 133 is by kind permission of Routledge; the quotation by Harvey Fierstein on page 11 is by kind permission of Harvey Fierstein; the quotations from *Colour and Culture* by John Gage, 1993 are © Thames & Hudson; all quotations from *Painting Materials: a short encyclopaedia*, 1966 by Rutherford Gettens and George Stout are by kind permission of Dover Books, New York; all quotations from *The Art Forger's Handbook*, by Eric Hebborn, 1997 are © Cassell; the quotation from *The Essential Saffron Companion*, by John Humphries, 1996 on page 225 is by kind permission of Grub Street, London; the quotation from *Leonardo on Painting* edited by Martin Kemp, 1985, on page 108 is © Yale University Press; the quotations from *The Artist's Handbook of Materials and Techniques* by Ralph Mayer, 1991 on pages 2 and 111 are by kind permission of Faber & Faber and Viking Press New York; the quotations by Desmond Morris on pages 77 and 78 from *The Cambridge Illustrated History of Prehistoric Art* by Paul Bahn, 1988 is by kind permission of Cambridge University Press, Cambridge; the quotation from *Taliban: Islam, Oil and the*

# CREDITS

*New Great Game* by Ahmed Rashid, published by I. B. Tauris & Co. on page 299 is by kind permission of I. B. Tauris & Co.; all quotations from *The Craftsman's Handbook* by Cennino Cennini and translated by Daniel Thompson, 1933 (1960) are by kind permission of Dover Books, New York; the quotation by J. M. Thompson on page 263 is by kind permission of Basil Blackwell, Oxford; all quotations from *The Long Old Road in China* by Langdon Warner, 1926 on page 120 are © William Heinemann.

# Index